GARB

A FASHION AND CULTURE READER

160201

Edited by Parme Giuntini
and Kathryn Hagen
Otis College of Art and Design

PEARSON

Prentice
Hall

Upper Saddle River, New Jersey 07458

Library of Congress Cataloging-in-Publication Data

Garb : a fashion and culture reader / edited by Parme Giuntini and Kathryn Hagen.
 p. cm.
 Includes bibliographical references and index.
 ISBN 0-13-111910-9
1. Fashion design. 2. Fashion designers. 3. Clothing trade. 4. Fashion—Psychological
aspects. I. Giuntini, Parme P. II. Hagen, Kathryn.
 TT507.G37 2007
 391—dc22 20006023637

Editor-in-Chief: Vernon R. Anthony
Editorial Assistant: ReeAnn Davies
Marketing Assistant: Les Roberts
Managing Editor—Production: Mary Carnis
Manufacturing Buyer: Cathleen Petersen
Production Liaison: Janice Stangel
Full-Service Production: Emily Bush/Carlisle Editorial Services
Composition: Carlisle Publishing Services
Media Production Project Manager: Lisa Rinaldi
Senior Design Coordinator: Miguel Ortiz
Cover Design: Amy Rosen, K & M Design
Printer/Binder: RR Donnelley Harrisonburg
Cover Printer: RR Donnelley Harrisonburg

Pearson Prentice Hall™ is a trademark of Pearson Education, Inc.
Pearson® is a registered trademark of Pearson plc
Prentice Hall® is a registered trademark of Pearson Education, Inc.

Pearson Education Ltd. Pearson Education Australia PTY, Limited
Pearson Education Singapore, Pte. Ltd. Pearson Education North Asia Ltd.
Pearson Education Canada, Ltd. Pearson Educacion de Mexico, S.A. de C.V.
Pearson Education—Japan Pearson Education Malaysia, Pte. Ltd.

10 9 8 7 6 5 4 3 2 1
ISBN: 0-13-111910-9

We dedicate this book to our patient and loving families and friends who have supported and encouraged us in making Garb *a reality.*

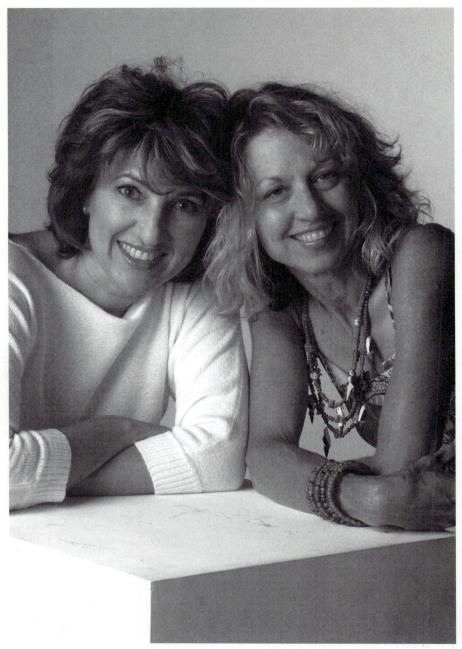

Parme Giuntini (left), Kathryn Hagen (right). (Photo: James Stiles)

Contents

Acknowledgments

Since this book is a compilation of the efforts of many people, we would like to acknowledge those who made valuable contributions that have brought this project to life. Thanks first of all to all the essayists who contributed their time, wisdom, and talent. Our special thanks to Tinker Beatty, who was enormously helpful with the initial editing and organization. Her enthusiasm about the book helped us see the light at the end of the tunnel. Special thanks to James Stiles for outstanding photographs that captured the spirit of the project and to Jeff O'Connell for his valuable insights in helping us select from thousands of images. Our video interviews would not have been possible without Kevin Kelly's excellent filming and editing expertise. Thanks to all the interviewees for their time and enthusiastic cooperation and to the artists who willingly shared their work and thoughts about fashion and its intersection with fine art. A special thanks to Isa Gordon for her help with the Cyberspace essay and Beata De Campos for her help locating and identifying images from Vivienne Westwood.

We would like to thank the following reviewers: Sarah Alexander, Art Institute of California-San Francisco; Jennifer Clevenger, Radford University; and Kenol Lamour, Centenary College.

Thank you to Vern Anthony and Emily Bush who are undoubtedly the most patient and understanding of editors. They graciously granted our requests for changes and additions and made working for Prentice Hall a pleasure.

Our greatest thanks go to the two men who have cheerfully and patiently endured this lengthy process: Paul Giuntini and J.C. Love. We could not have done this without their support.

JAMES STILES, BFA SCHOOL OF VISUAL ARTS, NEW YORK

Mr. Stiles been a working photographer for over 20 years specializing in fashion, portraits, and fine art. His work has been exhibited internationally and in New York City, with such notable photographers as Robert Mapplethorpe, and Helmut Newton, as well as in a few one-person shows including The MBM Gallery, SoHo, and New York City. His clients Include Canon Cameras, AT&T, Kenneth Cole, RCA Records Details, and G. Q. Magazines, Grey Advertising, and O&M Advertising.

Photo Courtesy of Jared Gold.

Introduction

The emergence of visual culture as a transdisciplinary and cross-methodological field of inquiry means nothing less and nothing more than an opportunity to reconsider some of culture's thorniest problems from yet another angle.

Irit Rogoff, "Studying Visual Culture," in *Visual Culture Reader*, ed. Nicholas Mirzoeff (London: Routledge, 1998), 16 (14–26)

Fashion is powerful. The right tie or the wrong shoe can make or break you whether your scene is world politics or the local junior high. Photographs of President Bill Clinton showing the chief executive exercising in well-worn athletic clothes reinforced his fabled "common touch" with the public as effectively as any speech he ever gave. Actors such as Matt Dillon and Russell Crowe were criticized for customizing traditional men's formal wear when they appeared at the Oscar awards: A bolo tie with a tuxedo suit can be a perilous combination.

Meanwhile on the fashion show catwalks of our global culture, an undulating line of impossibly beautiful models walk, wearing equally improbable fashion, most of which lacks real-world function and has little to do with our daily lives. Nevertheless, the apparel circus continues to seduce and confound an enraptured audience. Supermodels get younger and thinner as youth culture dictates the funky but fabulously expensive aesthetic. Photos are taken, articles written, and large sums of money change hands.

Vivienne Westwood's subversive approach to high fashion in the 1980s set off a round of changes that have ricocheted throughout the couture world. Contemporary designers such as Alexander McQueen, Donatella Versace, and John Galliano have demonstrated a more extreme sense of irony and over-the-top showmanship that walks in lockstep with a media-saturated, looking-for-thrills, postmodern epoch. They are very different animals from the likes of Cristobal Balenciaga, Coco Chanel, or even Ralph Lauren. Forced to give aesthetic credence to youth and marginalized subcultures, they sport the jaded air of a contemporary Nero fiddling while Paris burns. Self-indulgence permeates their genre, worn like a badge of pride.

The term *fashion* identifies increasingly embattled territory, a complex field occupied by a growing army of commentators who often seem to be at odds. The conversation about fashion has expanded into a free-ranging discussion engaging scholars from a variety of fields and theoretical approaches to cultural commentators, fashion writers, and industry critics. All expound on the pros and cons of the body and its accoutrements from vastly different vantage points. Strict definitions are hazardous given the shifting discourse, although pundits in sociology, anthropology, cultural studies, and history

generally concur that fashion identifies a system that changes according to
various waves of influence emanating from sources both deliberate and co-
incidental. Even a critical theorist such as Roland Barthes was interested in
the mass distribution of popular fashion magazines and their ability to con-
struct a common narrative and ultimately develop it into an ideology.[1]

Like any ideology, fashion has its own myths and symbols, its doc-
trines and debates, its critics and its zealots. Couture or high fashion is only
a single layer in the body/clothing system and, arguably, a Western product.
While mass media makes it more visible, it does not necessarily guarantee its
acceptance as evidenced by millions of people throughout the world who
wear different forms of contemporary or traditional dress. Those who fol-
low the more extreme fluctuations of fashion, becoming surfers on the
aesthetic waves of changing modes, can find themselves replacing spiri-
tual constructs with those of style and commerce. Such is the fate of the
fanatic; ideology begets obsession.

Everyone dresses, and for everyone, dressing, regardless of how mini-
mal, is a social construct. We all pull on, button or zip up, strap on, and wig-
gle into a wide range of apparel that encompasses everything from a child's
hair barrette to black leather pants on a rock and roll singer. Dressing can
be as mundane as pulling on a uniform or laced with a myriad of emotions
ranging from the excitement of the bride in symbolic wedding attire to the
somber tones of a widow wearing black. That "second skin" that we cannot
shed, that we exchange with alarming frequency to suit a mood or event, is
our daily companion, claiming the most intimate relationship of any cultural
product.

Clothing is too narrow a term for this broader idea of everything we
put on our bodies to construct and display the most individual and per-
sonal forms of private and public identity. Fashion historians and cultural
anthropologists employ a range of terms including dress, costume, and
clothing, all of which we found too restrictive for our purposes. Our
choice to use the term *garb* offered the broadest spectrum of under-
standing. As a noun, it refers to the wide range of apparel from textiles to
tattoos, invoking notions of fashion and style with connotations of
modernity, innovation, and capitalism, as well as traditional attitudes
toward dress, all of which cohabit the postmodern world.[2] As a verb, it
conveys our acknowledgment of dressing as a conscious act, intimately re-
lated to the construction of a social identity with all its attendant choices
and cultural consequences, regardless of or in response to contemporary
fashions.

[1] Roland Barthes, *"Economy of the System."* The Fashion System, trans. Matthew
Ward and Richard Howard (Berkeley: University of California Press, 1990), 277.
Originally published in 1963.
[2] Joan Entwistle lucidly explains the discussion around the term *fashion* and its use
by historians, anthropologists, and sociologists in *The Fashioned Body: Fashion, Dress
and Modern Social Theory* (Cambridge: Polity Press, 2000), 40–48.

However we construct that identity from couture to ready-to-wear; designed to go together or to intentionally contrast; our own, borrowed, or rented—the daily ritual of decorating our bodies involves us in a complex relationship with the fashion and advertising industries, mass culture and aesthetics, personal preference, and workplace demands. Unlike tribal societies or contemporary religious sects whose conformity in dress visually signals ideology, tradition, and stability, the postmodern, urbanized consumer is socialized to equate control over appearance with the most basic expressions of individuality and personal identity. Consequently, we are continually invited to experiment, to reinvent, to discard the old, to use what we wear to show who we are. Daily dressing propels us into a retail consumption process ranging from exclusive boutiques to the Internet, all guaranteeing that choice is readily available irrespective of age, size, race, gender, ethnicity, or cost. This activity further implicates us in a web of social relationships and meanings predicated on our ability to discern and interpret visual codes of dress. It is not merely the variety and proliferation of dress and accessories that complicates contemporary society as much as the shifting messages that they communicate. The same practices of looking that apply to understanding and negotiating visual culture with its myriad images and multiple layers of meaning are equally relevant to interpreting contemporary dress.

Our relationship with dressing the body extends beyond clothing as performing identity. What we wear also has both materiality and history, frequently luring us into a cycle of care and concern that can end in such extremes as nostalgia or disinterest. Dressing involves an array of tangible objects that protect and reveal but also get soiled, wet, wrinkled, torn, and worn out and consequently need to be washed, pressed, dry cleaned, folded, mended, and altered. Favorite clothes may last for years like the stereotypical "comfy old sweatshirt," but few have space to store any but the most sentimentalized apparel. Like second-rate museum artifacts gathering dust in storage, these objects are too good to throw away, too bound up with personal memory, but no longer significant players in daily dress. Photographs or videos document their moments of glory, offering a visual alternative to the actual garments. This cycle of desire, display, and disposal is thoroughly embedded in postmodern society, which encourages us to view the process as natural and inevitable; discarding the old or outdated means acquiring the new. Few objects can boast such a complex matrix of relationships, associations, and meanings. Nevertheless, the ephemeral aspect of contemporary clothing and accessories along with their abundance, similarity, and rapid cycling have conspired to hamper more critical assessments until recently when interdisciplinary approaches to dress and fashion have emerged.

If clothing in its many permutations is as relevant to material culture and identity as writing or architecture, then a conversation formerly dominated by traditional academics must now accommodate more diverse voices, including designers becoming more vocal about their work and its status as a cultural product. Historically, most designer commentary

has appeared in glossy fashion magazines, interviews, or the occasional coffee-table book rather than more critical scholarly books and journals. While all designers may not choose to tackle the issues of semiotic interpretations of dress, they should not be excluded from the discussion for which they provide the product nor presumed unequal to the task of serious engagement with the subject. This is certainly the trend for art colleges and design departments that expect their students to think and write critically about design despite the perception that their industry is predominantly corporate and commercial. The surge of interdisciplinary and crossdisciplinary approaches encourages a broadening of the discussion and a blurring of outmoded lines between those who make and those who analyze.

This is the spirit in which we assembled *Garb*. The contributors range from published poets to English literature professors, creative writers to art historians, fashion illustrators to practicing artists, art critics to college presidents. Many are faculty at Otis College of Art and Design, and their ideas provide a richly diverse cross-section of disciplines and backgrounds. The mix produces a body of commentary personifying a broad range of perspectives and theoretical approaches that mirror the complexity of postmodern attitudes toward dress, fashion, and culture. Some of the essays read like a personal narrative, others are more scholarly or theoretical; many of them use personal observation as a springboard to broader issues of gender, diversity, or class. All the authors share the common position that what we wear is a pivotal point of critical discussion and a significant contributor to any construction of culture.

Adding an additional richness to *Garb* are four hours of filmed interviews of men and women, some of whom use their fashion training in unique and unexpected ways. Emerging designers mix with seasoned professionals, and lengthy interviews provide a forum for the sharing of complex personal histories and ideas. Designer comments on the future of fashion, the increasing globalization of the industry, and the price that many of them are willing to pay to maintain artistic independence offer intriguing and provocative insights into the design field. For some of them, the arbitrary line between artist and designer has been breached: Their medium is textiles, and their work makes powerful statements about beauty, diversity, and culture. Why is selling a design considered a more commercial transaction than selling a piece of fine art?

Elizabeth Wilson describes getting dressed as bricolage. Garments and accessories turn everyone into a walking collage with the capacity to interact with its audience.[3] Wilson's metaphor implies that everyone is an artist using the medium of clothing and accessories to construct a conscious personal identity. For this reason *Garb* also focuses on the activity of dressing

[3] Elizabeth Wilson, *Adorned in Dreams; Fashion and Modernity* (New Brunswick, NJ: Rutgers University Press, 2003), 249.

as a complex network of choices that can depart from fashion dictates to address social change and culture. From the stereotypical parodies of women getting dressed amid piles of discarded clothing to the husband soliciting wifely advice on which tie to wear, the dressing ritual is fraught with decisions predicated on individual self-presentation. These are concerns that are now surfacing among fashion history scholars who recognize that for postmodern societies the concerns of fashion and anxiety are closely interrelated.[4]

Equally important to understanding the influence of garb in the material culture of contemporary life is its ubiquitous prevalence in visual culture. As consumers we expect to be inundated with retail advertising, which is endemic in magazines, newspapers, television, catalogues, and on the Internet. These are the expected and overt spaces of commercial display, and we respond to them based on varying degrees of desire, critical awareness, and economic ability. We do not, however, question their essential function, which is to sell, and, consequently, we expect visual deception even if we do not or cannot identify the specific elements of ads or fashion illustrations. Equally, if not more, influential in determining and structuring social attitudes and consumer trends is the connotative role of garb in all facets of entertainment media and in the obsessive fascination with celebrities who routinely launch a variety of fashion trends simply by wearing them on screen or in public. Popular culture magazines such as *People* and *Town & Country* regularly run photo spreads spotlighting celebrities or social leaders at various entertainment events or caught at impromptu moments in which what they wear and how they wear it is the connotative subtext to their success and recognition.

For these reasons, the images in *Garb* are intended to act as a counterpoint to the text, sometimes illustrating, sometimes elucidating, but often problematizing the issues raised. More than an accompaniment, they provide a parallel visual text that we hope will facilitate interest and discussion. In some cases, the images address the flexibility of clothing to transcend function and communicate critical messages beyond their expected or typical associations. This can happen as easily within a fashion advertisement as it does in fine art.

Beyond the efforts of all the contributing authors and interviewees, we hope that our collaboration with *Garb* offers an interdisciplinary model for scholarly collaboration among faculty representing different disciplines. Even in an art college, it is not typical for a illustrator/fine artist and an art historian to combine their research interests. *Garb* was the result of our shared passion for fashion, culture, theory, and art, as well as a persistent belief that our students' creativity and critical skills would benefit from

[4] Alison Clarke and Daniel Miller, "Fashion and Anxiety." *Fashion Theory: The Journal of Dress. Body & Culture*, vol. 6, no 2, June 2002, 193. See also Rebecca Arnold, *Fashion, Desire and Anxiety: Image and Morality in the 20th Century* (London: I. B. Tauris, 2001).

engaging the discourse of fashion and culture beyond design problems and industry concerns. Garb represents our position that a critical discussion of fashion and culture should involve scholars of diverse disciplines, as well as critics and designers.

Parme Giuntini, Ph.D.
Director, Art History
Otis College of Art and Design

Kathryn Hagen, M.F.A.
Professor, Illustration
Otis College of Art and Design

NOTES:

Kelly Doyle wearing a man's suit which is part of her personal wardrobe. (Photo: James Stiles)

Part I Mainstreaming

Spencer Steward wearing a suit coat that formerly belonged to the late actor Terry Savales. The black velvet jacket was produced under the actor's own label. (Photo: James Stiles)

Mainstreaming

Parme Giuntini and Kathryn Hagen

There's one wardrobe change and one hairstyle. So you change one thing, that really has a big effect on the totality. So like Tom's suit – he's got the best tailor in Kowloon, not in London, not in New York and LA. So the cut is a form. It says "not domestic" and that's what I wanted to say. The idea of the character was to be very specific about whole contexts which we knew, but you only see the fraction of it, but the fraction suggests things without being expository or metaphoric.

Michael Mann, director of *Collateral*, talking about his main character played by Tom Cruise. *Los Angeles Times,* June 13, 2004 E.1.

In the 2004 film *Collateral,* Tom Cruise plays a paid assassin, a character living on the edge. He wears a very specific disguise: an expensive, custom-made suit, the stereotypical uniform of the high-powered, jet-setting businessman. Such corporate camouflage shields his intense, frightening character while allowing him to blend in easily with an elitist, fashion-savvy L.A. night scene.

The suit's the thing. Not unexpectedly, the audience subliminally associates critical aspects of the character through his macho but mainstream power garments. Why not? Association is an integral part of the way that we respond to clothing and its connotations. As Kenneth Berger notes later in this book in his essay "The Outmoded, the Reactionary, and the Revival of the Suit," despite an uncertain context for the suit today, contemporary audiences would never mistake Cruise's character for the corporate cog articulated in the 1950s film *The Man in the Gray Flannel Suit.* The expanded visual culture of mass advertising, with its increasing emphasis on fashion to delineate status, has produced an inordinately savvy viewing audience.[1]

What does such a fashion characterization tell us about mainstreaming? First, it defines the mainstreamers as those whose agenda precludes setting

[1] The Los Angeles–based rock-and-roll designer Henry Duarte designs for male fashionista clients such as Johnny Depp. Although Duarte now dresses in hip rock-and-roll jeans and tees, when he envisions himself wearing suits on a regular basis, he has a well-thought-out list of inevitable lifestyle ramifications that would follow such a drastic wardrobe change. These would include high-profile sports cars, architecturally important homes, and a more consciously crafted celebrity image, which would constitute a "suit" way of life. For him, clothing dictates lifestyle, rather than the reverse.

themselves apart from the crowd. The river of life has many tributaries, but mainstreamers want to stay in the "primary corridor," so to speak. They strive to be at the center of the action, to be the life of the party—yes, even to be a leader of the upscale pack. Such a central position, if one seeks leadership, requires a well-thought-out, careful self-presentation. As Frauke von der Horst argues in her essay about women and power, "Skirting the Issue," that role excludes the wearing of skirts.[2] Certainly, the mainstream uniform will vary, depending on which stream one is "swimming" in, but it will consistently allow the wearer to blend with his or her environment.[3]

Indeed, unlike the conservative, authoritative associations of the establishment, the term *mainstream* also flows with semiotic connotations of merging, cohesion, and amalgamation. It neither sets trends nor challenges them. Even its translation into fashion and style retains a comfortable degree of uniqueness given the late twentieth-century insistence that fashion must be individually interpreted lest we all become style slaves. As a result, mainstream fashion has insidiously taken command, often appropriating the very styles that seek to criticize it, defusing them of their sting, and representing those styles in the vast retail arenas of department stores, chain stores, and discount outlet complexes that accommodate the bulk of the buying public. The often negative and pejorative connotations linked with the establishment and conservative styles no longer dominate what we think of as mainstream style. To some extent, this may be the result of such designers as Jill Sanders, Calvin Klein, and Donna Karan, who offered simplified, even classical, approaches to fashion that resonated with high-end consumers as well as the greater public, in particular with women barraging the corporate, political, and academic worlds and in need of a fashion identity that meshed a feminine and a professional consciousness.

Nor do the terms *establishment* and *counterculture*, the twin legacies of the 1960s, carry the same political charge or iconic associations with specific styles of dress. An aggressively postmodern contemporary world decries the homogenization of society and assumes the existence of various subcultures, recognizing that they can occupy an explicitly separate space but, more often than not, they are also integrated into what we now refer to as *mainstream society*. Their very difference supplies a visible piquancy to mainstream culture. Unless a subculture actively transgresses acceptable moral or social boundaries, it is apt to be tolerated regardless of the oddities of its participants' dress. Moreover, it is increasingly difficult to dress to one's

[2] Franke von de Horst, "Skirting the Issue," or "Why Won't You Show Your Pretty Legs Anymore?" in *Garb*, eds. Parme Giuntini and Kathryn Hagen, (Upper Saddle River, NJ: Prentice Hall, 2006, 13–24)

[3] The nineteenth-century champion of modernity, Charles Baudelaire, understood the intricacies of fashionable male dress in urban Paris as he crafted a persona for himself as a dandy that retained the status of gentleman, distinguished himself from the vulgar bourgeoisie, aligned himself with the ideology of artistic individuality, and separated himself from other dandies—not an easy task given that he was limited to black suits and white linen.

politics, social convictions, or sexual orientation unless the goal is to communicate an extreme position. Gay and straight men walk around in jeans, leather jackets, and baseball hats. Both are apt to team pastel or boldly striped dress shirts with well-cut business suits or to opt for a black, tab-collar tuxedo shirt. The "lipstick lesbian" is virtually identical to any fashion-conscious woman while "butch lesbians" look like millions of heterosexual females who typically run around in jeans, sandals, and T-shirts, sans makeup.

This is a very different world from the early 1950s, and its middle American culture when the fashions for mom, pop, buddy, and sis were clearly articulated and buttressed by advertising, film, and the newly emerging television medium with its growing list of family programs (Figure 1). Not only were subcultures then more identifiable, but they also kept their distance from the mainstream "pack." Somewhere in the maze of the 1960s, U.S. perceptions of style acquired politicized connotations that bubbled up amid the explosion of a youth culture both wary of adult authority and enamored with the search for personal identity. They were fueled by a growing and vocal peace movement that often conflated conformity with social and political intolerance, by rousing cries of civil rights activists and the strident criticisms of emerging feminists who mocked the naturalization of gendered society and its attendant styles.

Such issues were clearer in the 1960s. Not only were the lines emphatically drawn—they were highly visible. The boundaries of mainstream taste were more generic and, therefore, more vulnerable to attack. Wearing tie-dyed natural fabrics, granny gowns, peasant shirts, frayed jeans, Birkenstocks, long loose hair, and beards framed identifiable social critiques on mass consumption, racial and social injustice, sexuality, and antiwar sympathy (Figure 2). Adopting such stylistic signifiers in whole or part registered a growing lack of confidence in the status quo and signaled a willingness to explore other options. Such choices signified the wearer's association or compliance with a range of ideas that challenged the establishment. To challenge the 1960s status quo was, for mainstream America, an attack on everything from morality to good taste. This diversity of opinion reached such extremes that at times it resulted in traumatic divisions, often pitting parents against children in tense arguments about values, ethics, loyalty, and morality.[4]

[4] The history of politically coding dress extends well into antiquity, where it was frequently used to make bold statements about power and authority. During the Classical Age, Greeks refined the nature of sculpted dress to reinforce their claim to physical and rational superiority, which is the reason that elegantly draped Lapiths battle Centaurs across the Parthenon metopes. Those barely moving draperies reminded the observer of the incredible ease with which the ideal Greek body dispatched the enemy. From the Phrygian cap and its associations with political liberty to Filippo Marinetto's plea to Italian Futurists to abandon traditional clothing and embrace new styles and fabrics as a necessary step to modernity, coding clothing or stylistic elements of dress to signify political change or register social dissatisfaction appears to be both transhistorical and transcultural.

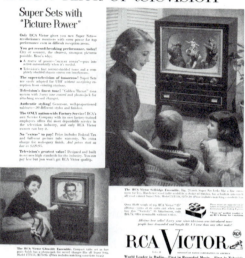

Figure 1. Television advertising in the 1950s reflected the conservative and family-oriented focus of American popular culture.

Figure 2. Long hair, headbands, beads, fringe, and jeans typified the "hippie dress" associated with 1960s youth culture and reinforced their political rebellion, often unconventional lifestyles, and criticism of establishment authority.

If the 1960s mark a moment in modern U.S. history when fashion, style, and politics abruptly collided in a marked, visible way, it is in great part because of the attention that mass communication paid to recording not only changes in dress, but also the political and social contexts in which those changes occurred. I was a teenager in the sixties but, thanks to television and periodicals, the recollection of those events is indelibly part of my cultural memory. Woodstock, feminist and civil rights rallies, and the onslaught of folk music and hard rock bands flashed then across TV screens and filled the pages of weekly magazines in full color. Like myself, many Americans first encountered the range and reality of counterculture dress and style through this media barrage. The repeated visual presence of these subcultures or countercultures as they came to be known in established mainstream publications not only made them familiar, but also validated their existence for the public.[5] Retail did not initially promote what appeared as a ragtag, do it yourself style; such a controversial move would have had serious consequences with corporate shareholders and small investors. Nevertheless, counterculture fashion had already gained a foothold in the public eye, one that we take for granted today.

The immediacy of this kind of visual culture began with the Industrial Revolution in the second half of the 1800s.[6] The arrival of cheaply manufactured clothes coincided with new marketing practices, department stores, mail order catalogues, advertising, and mass communication. Demographics shifted to accommodate growing urban populations with discretionary income who, in turn, were increasingly shaped by a capitalistic economy that encouraged the continual consumption of goods. Fashion for the masses was

[5] The most popular weekly news and culture magazines were *Time, Newsweek, Life,* and *Look*. Americans could expect to find full- and double-page photographs, as well as critical and explanatory essays.

[6] The mass exodus from self-employment venues, where public and private life comingled, created a new public stage. Gentlemen wore specific costumes and employed props, such as expensive silk hats and leather gloves, and acted a role of goal-oriented, mainstream behavior. This newly created professional stage is what sociologist Erving Goffman calls the "public space." Ruth P. Rubenstein, *Dress Codes: Meanings and Messages, in American Culture* (Boulder: Westview Press, 1995), 43. He divides this virtual arena into three categories: *front stage, backstage,* and *outside region*. The *front stage* is where participants dress specifically for the social/professional demands of their particular occupation. Failing this, they invite colleagues' disapproval and risk undermining their careers.

The *backstage*, where one prepares for these public performances, is less restrictive. Goffman offers the example of a barbershop as a backstage venue for customers who are perfecting their appearance. However, the same space is *front stage* for the barber/stylist, who must dress according to the code imposed by his/her specific clientele.

The street is an example of an *outside region,* public but anonymous, where even mainstreamers can act out in ways that they could not in the professional arena. Thus "street culture" and the more relaxed expressive fashions reflect the resulting attitude that "anything goes." *Ibid.*

Figure 3. Ready to wear retail ad from *Harper's Bazaar*, 1873.

a nineteenth-century invention, and it walked hand and glove with a growing visual culture represented in magazines, posters, and advertisements (Figures 3 and 4).

Fast-forwarding to the twenty-first century, the social and political impact of dress in postmodern society is integrally aligned with consumer awareness of rapid changes in dress and fashion, the desire to interpret those changes, and the ability to sift through the plethora of styles and dressing practices that stream past us each day in both material and visual culture.

At a more critical and ideological level, concerns are voiced about the passive acceptance of mainstream fashion, its increasing globalization, and the often unacknowledged and unresolved class and gender connotations that it naturalizes. Back to Tom Cruise's "power suit." Can it ever truly shed its associations of masculine authority, unlimited economic capital, and elitist European fashion hegemony? And, if not, what are the consequences for

THOMAS WHITE & CO.'S
(NO. 41 SOUTH SECOND STREET,)
FALL AND WINTER FASHIONS.

Figure 4. Ready to wear retail ad from *Harper's Bazaar*, 1873.

those adopting it? Can a female leader communicate as much power dressed in a burka? Does a Nigerian president clad in brightly colored native robes run the risk of looking exotic or decorative standing next to a black suit? Both of these examples demonstrate alternative mainstream fashion. Perhaps in the globalized world of the future, mainstream will be redefined, and it might not come out Armani.

Nicole Hagen modeling classic wool jodhpurs by designer Marie François Girbaud. Originally belonging to editor Kathryn Hagen, the jodhpurs are now the property of Otis College of Art and Design and used in model drawing classes. (Photo: James Stiles.)

Skirting the Issue, or "Why Won't You Show Your Pretty Legs Anymore?"

Frauke von der Horst

My standard wardrobe included many skirts; some flared out from a gathered waist, supported by petticoats; others combined with a Chanel-inspired jacket to form a suit. I have felt the comfort of a summer skirt with a light blouse or the warmth of a wool tweed suit in fall. All these outfits were coordinated with accessories that I had spent considerable time collecting. I was fashionable, I was tasteful, I was attractive in a skirt.

In the second half of the 1970s, after a few comfortable years spent in pants and having developed a sense of fragile independence in divorced single parenting, I ran into the question "Why won't you show your pretty legs anymore?" I was visiting my family in Germany, where my mother eagerly sought ways to lure me into shopping sprees. On every outing she would check out the skirts in my size and present various models to me. Each time I informed her anew that I preferred wearing pants. She would find blouses I could wear with pants, but then she would offer a skirt to go with the newly purchased blouse. I declined by reiterating my standard answer. After we had performed this ritual in many variations, she finally cried out in exasperation, "Why won't you show your pretty legs anymore?" My mother's question was surely an expression of her desire for me to be happy. That promise of happiness—in the form of a husband—in her view could only be procured by a skirt. The efforts to put me in one made it very clear that as the object of the male gaze, I would have to provide pleasure by exposing my legs. This certain pleasure would be a promise of further pleasures.

Of course, this happened in Germany long ago, so I like to think of it as one of those Grimms' fairy tales from which I learned to appreciate the power of the skirt. Had Cinderella even half a chance in a pantsuit? Would Sleeping Beauty ever have woken up in jeans? I have always been taught that peril emanated from women who attempted to "wear the pants in the family." Would Hansel and Gretel have spent even one night in the woods had their father, who loved them dearly, been able to assert himself against his scheming and overbearing wife? Powerful women are demonized as witches and ogresses, as they are metaphorically "put into pants." These are women who upset the patriarchal order by asserting their power over men.

13

A woman may access that power if she does so indirectly, without challenging the order overtly. While the social order puts women in their place, it allows for legroom. I had learned this and put the lesson to a test when I wanted to challenge a parking ticket issued by campus police in the 1970s. In preparation for the encounter, I returned to one of my retired skirts: a pale lime-green wool gabardine miniskirt, buttoned down to the left thigh, the prêt-à-porter design by Cacharel complementing my strategically positioned legs. The visual language made the argument convincingly for the male officer in charge. The ticket was dismissed.

Today's assumptions about the skirt are very different from those made before the 1970s, when radical feminism challenged, among other traditions, the skirt as the distinctive attire for women. At that time, corporate dress codes began to allow women to wear pants in the office as an alternative to the skirt—but only in a pantsuit. Now it seems that pants and skirts are equivalent alternatives. Yet, following some of the history with a few select representative examples, it seems to me that there is a continuum of learning that loads the symbolic level of such an innocuous item as a skirt with references. Embedded in the tension between the skirt as an apparently value-neutral alternative to pants, and the now historical obligatory skirt for women, there remains a residue of negative connotations.

To access the full lexical meaning of the word *skirt*, I consulted two commonly used sources. The definition for skirt in *Funk & Wagnalls New Standard Dictionary of the English Language* (1963) offers this:

Skirt: To lie or move along the edge of; border. . . . That which lies on or along the outer edge; margin. . . . the under side of the fore quarter, in butchering.
Skirting: (Slang, U.S.) A girl or woman.

This compares to a single entry for *pants* as "trousers, drawers." In the singular form of the word, *pant* reveals after "to breathe out quickly or with effort; utter gaspingly or convulsively; as, he *panted* forth his hope" or "To long after" as well as "To heave, as the breast; pulsate; beat. To move languidly or with intermissions" and "To bulge and shrink successively: said of the plating of iron or steel hulls of vessels." These successive explanations are followed by the phrase "To go panting," without a further explanation. The margin as a denotation for *skirt* is explicit; a marginal position for women is connoted when the word is used to define gender. Pant on the other hand resonates with masculinity, power, and evokes sexuality.

The *Oxford Paperback Dictionary* published in 1983 is more succinct. It lists this as meanings for *skirt* as a noun: "1. A woman's garment hanging from the waist, this part of a garment. 2. (*vulgar*) a woman. . . . 5. A cut of beef from the lower flank." In its verb form, skirt is given two entries: "1. To go or be situated along the edge of. 2. To avoid dealing directly with (a question or controversial topic, etc.)". In declarative conciseness, this reference work parallels a garment, a woman, and a piece of meat all captured in the same word. The secondary use of the word as a verb adds to

the fray connotations of marginality and slyness. These connotations certainly reverberate in Brewer's mystery, *Witchy Woman,* when he sets up a community of women and sums them up in the clearly derogatory collective of "a bunch of skirts."[1]

From the toddler's first picture books to the restroom icon at international airports around the globe, the identifier of the female human is still the skirt. International signage includes a familiar visual language for gender differentiation. In all public places we encounter the universally known image that assigns gender to public restrooms. It was designed in 1974 using the short skirt as the global signifier to replace language-specific indicators for women. Certain doors in public places are marked by stylized figures. The significant difference is established in the lower half of these bodies. One body image has a triangulated shape that refers to the wearer of a skirt ending at about knee level. The other image depicts with two slender rectangular marks a person in long pants (Figure 1). The international signifier that one is gratified to espy at times of urgent need is probably cause for consternation. It is simply read as a symbol of gender and not one of required corresponding attire. Neither a woman in a sari, a teenager in jeans, nor a Scotsman in a kilt will slow down to ponder the choice of doors. Yet one sign iconically invites only those persons in short skirts to enter through the door. The sign reveals a temporal and geographic specificity from a Eurocentric perspective. The assumption leading to the rhomboid shape as differentiation is based on the observation of and abstraction derived from a particular shape of skirt worn by women in Western culture at the time. The second cultural observation implies the skirt as the norm in women's apparel. In 1974, again in Western culture, young women were seen in miniskirts. The more modest length took the hem down to knee level, a length that corresponds to the icon for women on doors in public places. This length lays bare the shape of the ankle and the curve of the calf. Thus, the leg-displaying skirt is understood worldwide as the iconic marker for "woman" in general.

Earlier in the century, the display of legs became an event. One such event was captured in the famous photo of Marilyn Monroe in her air-lifted skirt. Another Hollywood star built a career on her legs: Marlene Dietrich made film history on the basis of the pleasing shape of her legs revealed in the movie *Blue Angel.* In the plot of the film, however, those celebrated legs were almost as destructive to their admirer as Eve's apple was to Adam. While film posters of the leggy actress vied for an audience, the represented admirer was undone by their allure. In this example, the moral depravity of a woman who reveals too much and the associated danger such women pose for men even of impeccable character are an intricate part of the plot. As the basis for the story, it couples the pleasure with the danger of the male gaze. The skirt then functions as protective cover—in that it hides an attraction—to that which lies hidden in its various forms.

[1] Steve Brewer, *Witchy Woman* (Denver: Intrigue Press, 1999).

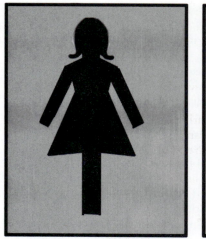

Figure 1. Restroom icons. (Illustration: Kathryn Hagen).

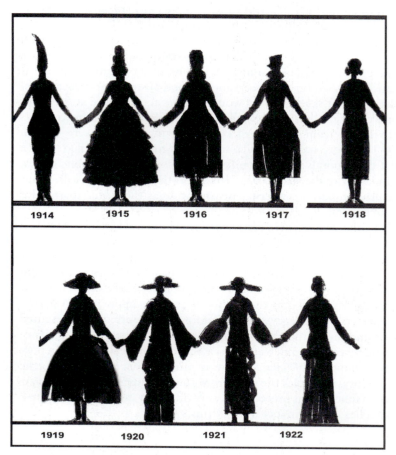

1914 1915 1916 1917 1918

1919 1920 1921 1922

Figure 2. Dress silhouettes 1914–1922. (Illustration: Kathryn Hagen).

The German Dada artist Kurt Schwitters captured the gender dynamic based on a skirt that allows the contemplation of a woman's legs in the rhyme "Die Frau entzuckt durch ihre Beine, ich bin Mann, ich habe keine."[2] He created this verbal image in the 1920s. His whimsical observation that women create delight by virtue of their pretty legs is followed by his assertion that as a man he does not have legs at all. There is a practical lesson to be learned. If you are a young woman with pretty legs, you can successfully contest a parking ticket by wearing a miniskirt. In this sense, the utilitarian value of the poet's legs as eye candy might indeed be negligible. However, while in the 1920s fashion did reveal publicly more of women's legs, suffragette and other women's movements had laid claim to the "New Woman" who could get an education, vote, and make decisions about her life and her body. Thus, the modern woman found independence and comfort in the fashion of the twenties, while men exploited it for the erotic pleasure it permitted.

HISTORICAL PERSPECTIVE

When one looks back on the shape of women as represented in the last three centuries, one sees that identifying women by showing a skirt displaying legs is a twentieth-century phenomenon. A few examples may serve as evidence of how over time the appearance of women in Western culture has been molded in a variety of skirts. Likewise, it becomes clear that while the shape of a garment is shaping women, the social context will alter the meaning of its representation (Figure 2).

For the eighteenth century, I have chosen to introduce two canonic paintings. In *Mr. and Mrs. Andrews,* the famous portrait of a couple from the English gentry by Thomas Gainsborough, Mrs. Andrews displays a dainty set of feet peeking out from an enormous spread of skirt extending from her narrow waist to a distance about twice the size of her torso (Figure 3). The appearance of her skirt in frontal display corresponds to the geometric shape of a horizontal rectangle. The body shape of the woman can not even be guessed, as it is hidden under the massively constructed skirt. Mr. Andrews, on the other hand, appears quite comfortable in clothes tailored to follow the lines of his body. He seems suitably attired for the outdoor activities of a country gentleman, while his wife with her cumbersome skirt is hard to imagine in even slightly strenuous activity. She is to be looked at and admired for her taste and her dainty little feet. They are both allure and promise, the assurance of the actual woman who is both visually present and absent. The skirt is performing its function by refusing and alluring the pleasure. Eighteenth-century philosophers declared men to be universal humans with rights and excluded women as a particular other for which the

[2] My literal translation: Woman charms with her legs, I am a man [hence] I don't have legs.

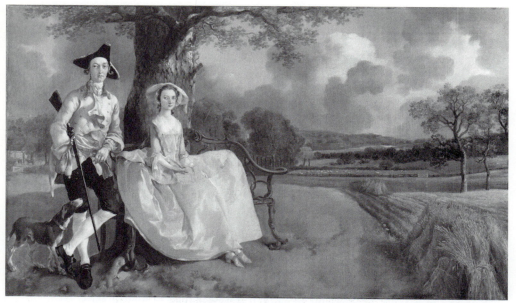

Figure 3. *Mr. and Mrs. Robert Andrews*, c. 1748–50. Thomas Gainsborough. Oil on canvas. The National Gallery, London.

skirt becomes the symbol. In the case of Mrs. Andrews, the spread of her skirt parallels the spread of his land, and she is part of his possessions.

In 1788, forty years after the portrait of the Andrews, the French painter Jacques-Louis David painted a Parisian couple, *Antoine Laurent Lavoisier and His Wife*. She stands next to her husband, casually leaning on him while he is seated at a table with a scientific apparatus in front of him. He looks up to her. Her appearance is that of a partner to her scientist husband, whose experiments she recorded and sketched. Accomplished women could find sympathetic resonance in enlightened circles, as is evident in a number of successful female artists, among them Marie Anne Pierrette Paulze Lavoisier. Her active life is given a visual frame in a white muslin dress with a bustled skirt that is gathered but not cinched in the waist, allowing breathing room. Compositionally, her skirt is as prominent as that of Mrs. Andrews. A huge qualitative difference in the possibilities for eighteenth-century women appears in the context of these portraits (Figure 4).

The nineteenth century ushered in Napoleon and his empire, visually expressed in a new style. The Empire style changed the silhouette of woman with its raised waistline and a loosely falling skirt. It allowed comfortable movement and deep breathing. The German Romantic artist Caspar David Friedrich painted a woman greeting the day with open arms. Her slender figure can be seen as a sign of yearning for a new era of self-determination. However, styles instead returned to the corseted and bustled skirt, which forced fashion-bound women into contorted postures. The extended derriere of the skirt characterizes these garments; it is this bustled form that

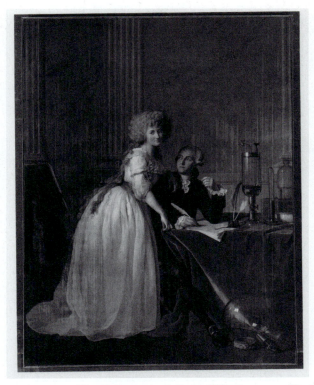

Figure 4. *Antoine-Laurent Lavoisier and his wife,* Jacques-Louis David, 1788, oil on canvas, The Metropolitan Museum, New York.

gives Georges Seurat's *Sunday Afternoon on the Grande Jatte* its focal point. Once again, women of society were expected to represent their gender in painful discomfort. The static quality of the pointillist image echoes prescriptive social conduct, particularly the restrictions of the foreground figure in her fashionable confinement. After 1890, the silhouette of women created by their attire deemphasizes the skirt, placing the accent instead on the sleeves of the garments. As the bustle disappeared from day dresses, the new skirt style flared smoothly from a narrow waist over the hips and fell to a subtley widened hemline at the ankles. The shape of this fashion statement is characterized in the Gibson Girl, an image derived from a cartoon character drawn by the American artist Charles Dana Gibson. For twenty years between 1890 and 1910 he satirized society with his image of "The New Woman" who was competitive, sporty, emancipated, and beautiful. Her clothes were fashionable in both the United States and Britain and set a fashion for skirts worn with embroidered blouses (Figure 5).

However, the New Woman as the Gibson Girl compared to the image of Mrs. Andrews includes a surprising component. The English lady got to show off both her pretty feet while the Gibson Girl may reveal no more of

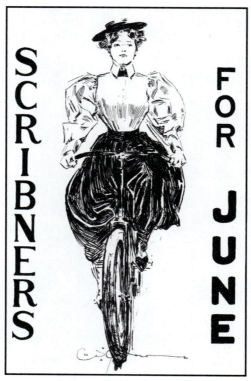

Figure 5. Founded in 1887, *Scribners* was a popular magazine and Charles Dana Gibson's famous Gibson Girl a familiar featured illustration.

the lower half of her body than the pointy tip of one fashionable shoe. In both cases, propriety kept the legs of the women well hidden.

By contrast and worth pointing out in this discussion, Mr. Andrew's legs are well shaped, with slender ankles and amply rounded calves. Prior to the nineteenth century, men's attire displayed their legs, and artists captured them with dutiful flattery. Pretty though they may be, his legs are no match for the well-turned leg of Monsieur Lavoisier, as Jacques-Louis David featured in the portrait of Lavoisier and his wife. Yet attention to the leg as a symbol of male pride and powerful masculinity could not be made clearer than in the stately Baroque portrait of Louis XIV by Hyacinthe Rigaud. With these examples, I want to argue that a "pretty" set of legs can function equally as signifier of male power, provided that the social conventions arrange for such a reading. In our culture, the shape of our rulers' legs is simply not an issue. Take the 1981 image of the newly wed British crown prince photographed with his young wife on their honeymoon in Scotland. Leaning on a fence, Prince Charles in his kilt remains visually secondary to his wife, Diana. I think that I am not alone in having no idea how his legs

are shaped. In twentieth-century media language, the leg as a sight is associated with the female gender. In this sense, Schwitters is justified in stating that his or any other bourgeois male's legs are aesthetically of no consequence or are even nonexistent. On the other hand, his phrase clearly identifies the pleasure of the gaze as male, heterosexual, and delighted by a modern fashion, which allows for indulging in the enjoyment of the raised hemline on the skirt in early twentieth-century women's fashion. The skirt, as it edges at different levels of the leg, has become a gender-specific notion.

SKIRT IN THE LANGUAGE OF POPULAR CULTURE

Popular literature reveals and disseminates commonly held attitudes and values. Among popular readings, the randomly picked mystery novel sometimes leads to surprising encounters. *Witchy Woman,* the third Bubba Marbry mystery, by Steve Brewer (1996) was reprinted in 1999 in paperback. The jacket cover invites the reader into a "wry examination of manhood in the 90s." The detective and an assistant are assigned the task of extracting a wealthy heiress from a compound where women live, with vaguely defined cult rituals, in a refuge from men. In their first attempt, the men are foiled by the women and chastised by their employer: "You two can't outrun a bunch of skirts in the woods."[3] After this emasculating slight, the hero is immediately reempowered: "He handed me my gun." The reader is given the information that the women are smart, capable, and different, that they are thought of as witches—and that most of them wear pants. The leader of the women is singled out for a description of her apparel: "Unlike most of the others, she wore a skirt, a full, black number decorated with white stars and half-moons."[4] Men think of women as inferior to their power, and they don't think much of a man who can't stand up to women. All these attitudes are summarized in the dismissive expression "a bunch of skirts." The dictionary definition echoes the attitude wrapped in the use of the word *skirt* as it is thrown at the detective.

A much more complex use of the skirt as indication of the duplicity of women marks a 1951 movie version of *The Taming of the Shrew* with a modern twist. In *Never Wave at a WAC,* Rosalind Russell plays a prominent and fashionable Washington socialite. She hosts parties, cuts ribbons, poses for photo opportunities, and does it all in designer perfection, including the tight-fitting skirts that follow her curves down to just about a hand's width above the ankle.

She is divorced from a man with whom she still shares a house, where she totally dominates him. In a turn of the plot, she is tricked into enlisting in the Women's Army Corps, where she encounters her former spouse, who

[3] Brewer, 71.
[4] *Ibid.,* 56.

now has complete power over her. He has designed special-action overalls
for extreme weather conditions. Capriciously, he adds her to the women al-
ready selected to test the clothes and singles her out for particularly harsh
conditions. In the process, he foils two dates with her fiancé, who helps her
get out of the army commitment. In the competition between the two men
vying for her, she is shown at first as a fashion plate. The party scene shows
her well suited for the ambitious officer. By contrast her ex-husband appears
thoroughly out of place. In the army, where she has to obey his orders and
exhaust herself in the most unattractive way, she experiences the pride of
achievement. In the process, she learns to understand her ex-husband and
love him as a real man.

The attire of the actors in general and Russell in particular visually
underlines the development of the plot. As she arrives on the base, her de-
signer clothes mark her as singularly out of place, as does her outrageous
behavior. In one particular shot through the dormitory, the camera
catches the sensibly flared skirts of the women in contrast to her slender
silhouette. The individuation is replaced by army uniformity with pants for
boot camp exercises and slightly flared skirts for parades. They are soldiers
and women. In this environment, the dynamics of power are clearly de-
fined: Subordination is an absolute. Her acceptance of that subordination
makes her into a better person who feels a need to serve her country and
to take her place as a useful member of society. This rather sappy comedy
was made with the support of the U.S. Defense Department and the
Women's Army Corps, and it features a guest appearance by General Omar
Bradley. I think it is fair to say that it reflects the official view of women in
the 1950s. As a twentieth-century version of *The Taming of the Shrew*, it
takes down the indirect power of women, which they derive from their sex
appeal, and promotes a "higher" order whereby women subordinate will-
ingly to the "better" judgment of men.

The standard gender division of men in pants and women in skirts,
as proposed by the international signage, appears simple and practical.
However, the apportioning of the skirt to women is neither universal nor
simple. As a global signifier, it skirts the issue of men in skirts. As a gender
issue in Western culture, it embodies all the tensions that have been
addressed directly by feminists. In its particular form, it confesses to the
visual availability of women's legs to the male gaze. Yet the discussion of
the pleasure of the gaze presumes a pleasurable sight. Such discourse,
however, skirts the issue of the undesirable woman, who is old or unat-
tractive. The danger of the allure is carried by the desirable, the young, and
the beautiful.

It seems to me, after looking more closely into the use of the skirt as a
symbol, that it functions as a "theater of operation" in the battle of the sexes
from which I retired into pants, much to the chagrin of my dear mother.

NOTES:

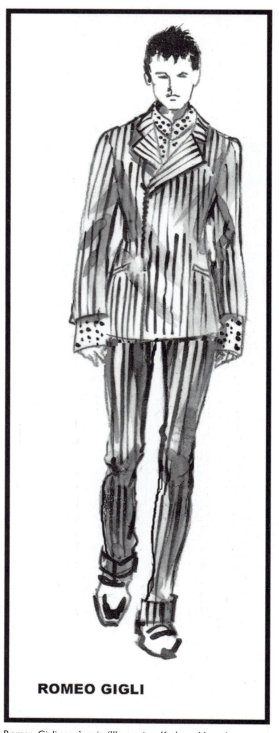

ROMEO GIGLI

Romeo Gigli men's suit. (Illustration: Kathryn Hagen)

The Outmoded, the Reactionary, and the Revival of the Suit

Kenneth Berger

In a *New York Times* article from August 2002, fashion columnist Guy Trebay asserted that the business suit, after a decade of diminished sales and stature, had finally made its triumphant return. The 1990s, he explained—as a period of financial optimism built on the seemingly boundless success of global free markets—engendered a socially permissive environment in which the traditional division between proper work attire and everyday clothing had grown increasingly diffuse. In this environment, as Trebay described it, "Corporate officers dressed for work in gym suits, bankers turned up at the office dressed for golf. Even presidential candidates lost track of the symbolism that used to come in every politician's starter kit and began campaigning dressed like the guy who mows your lawn."[1] With the turn of the economic tide at the end of the decade, however, optimism turned to anxiety, and the suit, reassuring and professional as always, reemerged, Trebay concluded, to reclaim its privileged sartorial status. Yet, it might be asked, does this reemergence really constitute a decisive victory for the suit, or might these shifts in its status imply that the suit's cultural function has been somehow redefined? What explanations, beyond those determined by the ebb and flow of the market, might account for these shifts? And what, with all this in mind, does the suit's present situation ultimately tell us about the state of contemporary culture?

According to art historian Anne Hollander, the modern tailored suit, in its initial incarnation, was first introduced approximately two hundred years ago. This new garment, produced only in the domain of men's fashion, appeared during a period predicated both on a renewed interest in classical culture and on the residual puritanism of the Protestant Reformation.[2] While women's fashion at the time continued to emphasize detailed costuming for the principal purpose of ornamental display, the man's suit was instead oriented toward refined modesty and functional simplicity. "At the Neo-Classic moment," writes Hollander, "tailored suits put a final seal of disapproval on gaudy clothes for serious men, whatever their class."[3] With its turn away

[1] Guy Trebay, "When the Going Gets Tough, the Tough Put on Suits," *New York Times*, August 18, 2002, WK3.

[2] Anne Hollander, *Sex and Suits: The Evolution and Modern Dress* (New York, Tokyo, and London: Kodansha International, 1994), 79.

[3] *Ibid.*, 7.

from decorative adornment, however, the man's suit was also often viewed as inexpressive and unimaginative, particularly compared to the more "theatrical" female clothing of the period. For Hollander, though, such theatricality underscored a "conservative" association with seventeenth- and eighteenth-century modes of dress, while contemporaneous men's fashion, in contrast, took a "radical leap" forward that paralleled other cultural advances of modernism.[4]

The tailored man's suit, in particular, embodied this leap and as such developed to "express classical *modernity*, in material design, in politics, and in sexuality."[5] Aesthetically, it was devised to minimize bodily differences among men and to invoke the idealized male form of antiquity. It lent itself to diverse civic uses and was easily adapted to emergent modes of production and consumption. Arising in an era of technological rationalization and revolutionary political reform, the suit not only offered versatile function and widespread availability, but also provided a democratizing uniform for everyday life, a uniform that would ostensibly help level and even order the social world. Under these conditions the tailored suit emerged as one of the quintessential garments of modernity and as emblematic, in particular, of modern masculinity.

Over the past two centuries, the suit's overall design has experienced only minor alterations, and the association with traditional modernity and with the cultural economy of masculinity has remained intact (Figures 1 and 2). Regarding the latter, however, the suit's more recent history has also been determined in part by recognition of its connotative attachment to what Hollander calls "official power."[6] If the faceless "man in the gray flannel suit" once suggested anonymity and therefore neutrality, then in the last half century that figure has been increasingly seen as claiming a position of presumptive normativeness. The suit, in other words, to the extent that it continues to signify modernity and masculinity, has concomitantly come to imply exclusion, authority, privilege, and so forth. This development, in turn, has informed a partial reorganization of the role of the suit in contemporary society, both in terms of the appropriation of traditional male clothing within the sphere of

[4] *Ibid.*

[5] *Ibid.*, 113. The subsequent assertions in this paragraph also follow from Hollander's account. See, in particular, 103–115.

[6] The notion of "connotative" meaning—as it appears in a given sign (or object)—is derived from the writing of French theoretician Roland Barthes, who, in a number of essays, distinguishes this meaning from the sign's "denotative" or "literal" meaning. The connotative dimension of the given sign, then, can be understood as the culturally coded or myth-producing aspect of that sign. It is thus the connotative signifying function of the suit that is under consideration in this essay. For an example of Barthes's use of connotation and denotation, see "The Photographic Message," in *Image, Music, Text,* trans. Stephen Heath (New York: Hill and Wang, 1977), 15–31. See also Hollander, 113.

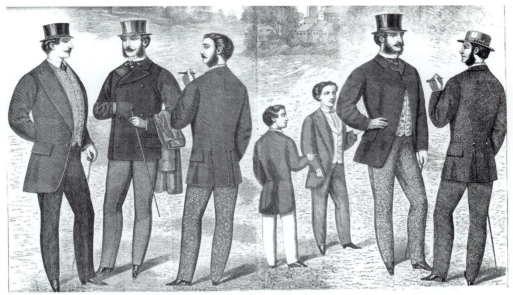

Figure I. This *Harper's Bazaar* fashion plate shows the newest silhouette for men in 1858, which included the sack coat that eventually replaced the more-fitted frock coat.

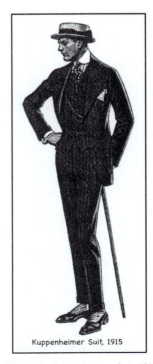

Kuppenheimer Suit, 1915

Figure 2. Kuppenheimer Suit, 1915.

women's fashion and of a broader rejection of such clothing by those invested in repudiating cultural convention.[7]

In either case, however, the established signifying function of the suit—to "express classical modernity"—has been complicated over the last few decades by various reconsiderations of the status of modernism itself. Modernism, that is, has been less and less able to sustain its role as that category designating the dominant cultural order of the present. Whether viewed as outstripped by the increasingly abstract and derealizing conditions of globalized capital or discredited as built on foundationalist myths and totalizing narratives, modernism is today most often understood as an exhausted social and historical formation.[8] As such, the cultural forms that once operated to reflect the modern world now instead represent modernity's obsolescence and, in turn, either are rendered outmoded as well or are forced to redefine their own respective cultural purposes.

The notion of the "outmoded" itself has been subject to various theorizations in the twentieth century, perhaps most famously by German social philosopher Walter Benjamin. According to Benjamin, the outmoded object, as a kind of cultural "ruin," occupies a special position within the framework of capitalist production in that it possesses a distinct revolutionary status.[9] This status, as Benjamin conceived it in the 1930s, arises paradoxically

[7] On this count, Hollander asserts both that "the male suit is no longer universal for men" and that "[f]eminizing variations" of the suit have been "invented chiefly for use by women during the last fifty years." In her view, however, the suit, in comparison to current forms of "post-modern . . . throwaway" clothing, still has "a way of looking superior" and thus continues to demonstrate the virtues of modernism. This is to say that, for Hollander, the development in the last half century of female fashion based on modern male dress shows not only the versatility of modern design, but also the growth of "modern consciousness." See, Hollander, 114–115 and 196–199.

[8] For the most well-known versions of these two formulations, see, respectively, Fredric Jameson, *Postmodernism, or, The Cultural Logic of Late Capitalism* (Durham, NC: Duke University Press, 1990), and Jean-Francois Lyotard, *The Postmodern Condition: A Report on Knowledge*, trans. Geoff Bennington and Brian Massumi (Minneapolis: University of Minnesota Press, 1984).

[9] The logic that Benjamin applies to outmoded objects applies for him as well to outmoded images, spaces, practices, and so forth. For a discussion of the outmoded as "ruin," see Walter Benjamin, "Paris—Capital of the Nineteenth Century," in *The Arcades Project*, trans. Howard Eiland and Kevin McLaughlin (Cambridge, MA and London: The Belknap Press of Harvard University Press, 1999), 3–13. For a discussion of the revolutionary status of the outmoded, see Walter Benjamin, "Surrealism: The Last Snapshot of the European Intelligentsia," in *Reflections*, ed. Peter Demetz, trans. Edmund Jephcott (New York: Schocken Books, 1978), 177–192. According to Benjamin, it was the Surrealists—in their various uses of abandoned and antiquated forms of culture—who were "the first to perceive the revolutionary energies that appear in the 'outmoded'" 181. See also Hal Foster, *Compulsive Beauty* (Cambridge, MA and London: MIT Press, 1993), 157–164.

from the fact that modernity, in envisioning the period to follow, anticipates a "utopia that has [already] left its trace in a thousand configurations of life, from enduring edifices to passing fashions."[10] For Benjamin, in other words, the outmoded cultural forms of the present, as "residues of a dream world," appear as reminders of the unrealized utopian ambitions of the past.[11] These cultural forms, then, abandoned by a society that values only the new, reemerge at the moment of their obsolescence to call attention to the repressive conditions through which that society is structured.[12]

It would be an overstatement, of course, to suggest that the suit is now outmoded, as it has clearly maintained a persistent presence in contemporary fashion and has, as Trebay points out, experienced renewed success over the past few years in particular. At the same time, however, it is clear as well that the suit's once unassailable stature has diminished substantially in the last half century and that this diminished stature is due largely to the growing obsolescence of the suit's earlier (modernist) signifying function. In this context, then, the recent effort to revive the suit might not be sufficiently explained as the pragmatic attempt, at a moment of economic uncertainty, to reassure culture through a return to traditional fashion. This is not to say that the suit has failed to have a reassuring effect or that it no longer successfully expresses modernist values such as stability and order. Rather, it is precisely the suit's continued capacity to express such values, and to represent "classical modernity" in general, that is at issue here. To the degree, that is, that the impulse to revive the suit reflects the social and economic anxiety of the last few years, this impulse also reflects a more deeply rooted desire to revive the lost historical moment that the suit still represents. The suit's return to prominence, in other words, carries with it a desire, whether conscious or otherwise, to transform the present by resuscitating the modernist past.

This past, however, can be resuscitated only through reinstating the very myths and narratives that themselves led to modernism's decline. The suit, then, insofar as it has been revived to help reestablish such myths and narratives, operates, in this context, to invert the critical function that Benjamin attributes to the outmoded. For Benjamin, as we saw, the outmoded is put to use to confront contemporary society with the repressed utopian dreams of a prior time, while the suit, in contrast, is utilized, in the scenario presented here, to obscure the conditions of the present by reasserting the myths of the past. This distinction, in its reversal of Benjamin's terms, serves to underscore a more significant division between the revolutionary imperative that Benjamin identifies with the outmoded and an antithetical reactionary impulse that has broadly pervaded the social and

[10] "Paris—Capital of the Nineteenth Century," 4–5. Here, Benjamin develops his argument following from Michelet's famous phrase, "Each epoch dreams the one to follow."

[11] *Ibid.*, 13.

[12] See Rosalind Krauss, *A Voyage on the North Sea: Art in the Age of the Post-Medium Condition* (New York: Thames and Hudson, 1999), 41.

political climate of the last several years. Under these circumstances, therefore, the revival of the suit appears not as an isolated response to the economic chaos of the current period, but it emerges instead as a symptom of this larger reactionary turn.

It has not been the aim of this discussion, then, to evaluate the suit's merit as a mode of dress, nor has it been to contemplate whether the suit itself will ultimately be abandoned, rethought, or revitalized. What is of concern in this context, rather, is the purpose to which the suit's traditional signifying function is now being employed. As Benjamin's analysis of the outmoded illustrates, a given society, in returning to the cultural forms of the past, not only defines its own orientation in the present, but also lays its groundwork for the future. In the case of today's society, this return to the past has, at least since the late 1990s, laid a groundwork too often defined by retrogressive myths and paranoid projections. The revival of the suit, as it has been presented here, constitutes one example of this increasingly prevalent state of affairs.

NOTES:

Kevin Kelly modeling a police uniform. (Photo: John Livzey)

Uniformly So

Parme Giuntini

Uniforms have a bad rap. They are the mandated, the compulsory, the util-itarian, the unflattering, the unfashionable, the uncomfortable. They con-strict and define, standardize and depersonalize. Intended to communicate the wearer's clear and unambiguous identification, uniforms are associated with institutionalized authority, professional identification, and service in-dustries.[1] They signify employment, affiliation, and hierarchy at the expense of individuality and personal expressiveness. No one really wants to believe that any creative innovation or individual accomplishment takes place in a uniform, although we seem to make continual exceptions for athletic teams, military heroes, and medical and emergency personnel. In those cases, the tendency is to promote the personal achievement despite the uniform, somewhat negating the relationship between the two and treating the uni-form as an accessory to the person. Paradoxically, despite a negative response to wearing uniforms, no postmodern society can imagine a world without them. Even science fiction writers and filmmakers visualize the future replete with uniforms, perhaps unisex, definitely spandex-driven, often colorful, but uniforms all the same.

Framing uniforms as the antithesis to individuality and self-expression is so ingrained in contemporary U.S. culture that it is almost a cliché. Most Americans tolerate uniforms, wearing them as necessary, but reserving the right to criticize or satirize them, in their assertion of the individual over the communal. Perhaps this explains the somewhat bland flavor of U.S. military uniforms. With a few exceptions, such as the blood stripe of Marine dress blues or the elegant gray, calf-length braid-trimmed West Point greatcoats, the United States armed services have never embraced or exploited uniforms with the same enthusiasm as Europeans. One of the inevitable consequences of an Enlightenment nation throwing off the shackles of colonial domina-tion was the parallel disdain for uniforms, with all their class and hierarchi-cal burdens. Americans prefer styles that are modern, pared down, and bereft of ostentation, gladly abandoning the outmoded historical and cere-monial elements that enliven so many European styles. Imagine how drab Buckingham Palace would be without its bearskin-topped Queen's Guards, the Vatican without the Swiss Guards, or Athens without its gaily colored, pantalooned sentries replete with their pompommed shoes? Then imagine

[1] Fred Davis, *Fashion, Culture and Identity* (Chicago: University of Chicago Press, 1994), 11.

an American reaction to White House guards wearing eighteenth-century uniforms?[2] They would be laughed off the street.

Whatever their perceived onus, uniforms are pervasive in U.S. society. The late postmodern obsession with branding, advertising, and consumer loyalty has boosted wearing and designing uniforms, offering a consumer-based culture the opportunity to simultaneously clothe employees inexpensively and advertise effectively.[3] According to Stan Herman, the man responsible for revamping the sartorial statements of McDonald's, Federal Express, United Airlines, and Amtrak, conflating uniforms with drabness and conformity is outmoded thinking, inconsistent with the way uniforms are conceptualized and function today.[4] He sees himself as "dressing companies," not designing uniforms, and his approach considers not only the desired corporate image and job requirements, but also the individual preferences of the people who will be wearing the clothes, plus a dash of distinctive style.[5]

Even allowing for the economic benefits, enhanced esprit de corps, customer security, adaptability, and increased productivity that seem to parallel uniforms in the workplace,[6] uniforms as desirable clothing remain a hard sell for most workers, at best an employment compromise. For most of us, choice is a defining factor in dress, and it is irrevocably linked with personal style,

[2] The European examples date from the fifteenth through the nineteenth centuries when they were actual military dress. With the exception of the Vatican Guards, the Beefeaters and Athenian guards wear ceremonial uniforms.

[3] Uniforms are increasingly being adopted by retail and service industries based on the premise that a uniformed worker communicates a higher standard of efficiency and professionalism. Consequently, there is a much higher level of sensitivity and competition around uniform design and selection.

[4] Innovation, style, and image were key words to describe American designer Ralph Lauren's 2006 Wimbledon uniform makeover. While players are still held to traditional tennis whites, the 570 umpires, line judges, and ball boys and girls were released from 129 years of Wimbledon green (intended to help them blend into the grass court environment) and inaugurated into retro-style cream and navy designs that promoted what the new chief executive of the All England Lawn and Tennis Club, Ian Ritchie, described as a sexy and fashionable presence for a premier sporting event that is televised internationally. Sam Greenhill, "New Clothes Please: Team Wimbledon Gets a Makeover." *Daily Mail*, June 22, 2006. In Lexis Nexis cited July 23, 2006.

[5] Janice Matsumoto, "Stan Herman: On Style in the 21st Century," *Restaurants & Institutions*, vol. 110, no. 3, 23.

[6] The consensus of professional and business publications supports uniforms as the preferred "workwear" in service and retail industries. Uniforms are easily identifiable, present a consistent appearance, can be designed with various adaptable elements that function in different weather or under diverse conditions, and can accommodate an unlimited range of hierarchies from janitors to front-counter personnel without sacrificing the critical logo and corporate identification. Customers also prefer the security of doing business with uniformed workers since it increases the sense of customer satisfaction and reinforces the professionalism of the company.

self-expression, and creativity. So wedded are we to this mantra that it is an easy slide to invest an inordinate degree of power to uniforms, to cast them as the nemesis of individuality, and to believe that wearing one will somehow hamper an ability to think critically or imagine without bounds. While the wearing of a uniform frequently involves commitment, loyalty, or allegiance, it does not necessarily erase one's personal presence or conscience. In fact, a uniform guarantees nothing; it merely signals an expected behavior.

Paradoxically, when consumers hang up their uniforms and start handing over credit cards for the latest fashions, they assume their choices are unique, individual, and personally expressive. Few question the commercial and design realities of the retail clothing they buy. In truth, decisions on trends, style, color, fabric, and design are made in a step-by-step, multilayered collaboration of commercial fashion and trade that can take as long as two years. Rigorous in its attention to detail, the process is governed by professionals, not just the expected name designers and major manufacturers but also more tangential experts such as color forecasters who work on four-year projections that determine the combinations, shades, and variations of future fashions. At every juncture of design from drawing to fabric selection, from magazine layouts to ad campaigns, compromises and refinements are adjusted to fit projections of trend agencies, to satisfy the needs of national chains, and to suit regional tastes and demographics. The buying public may have choices, but the collective taste patterns for that season have already been determined.[7] Ultimately, that uniform may have a lot more in common with the jeans in the drawer and that little black dress hanging in the closet.

[7] Jukka Gronow, *Sociology of Taste* (London and New York: Routledge, 1997), 109.

(Illustration: Kathryn Hagen)

School Uniforms: Creating the Good Citizen

Joann Byce

In 1996, President Clinton's State of the Union address applauded the adoption of school uniforms. "If it means that teenagers will stop killing each other over designer jackets, then our public schools should be able to require their students to wear uniforms."[1] However, school uniforms bring up issues that far exceed the limited instance that Clinton cited. Public school districts across the United States see school uniforms as a panacea for many of the problems that plague schools today. The impetus for this push is the presumed historical success of uniforms in promoting proper behavior and academic success in private and religious schools. However, the issue of whether uniforms should be required in public schools, which cannot generally be selective but which by law are supposed to provide a free education to all students, brings up important considerations about the nature of that education and the kind of citizen the schools are educating.

Michel Foucault, a twentieth-century French philosopher, studied and analyzed such institutions as schools, prisons, hospitals, and the army, which he considered similar in their goal of creating what he called a "docile body."[2] In his analysis, he wanted to disclose the power structures that have been put in place to teach, coerce, and objectify people to achieve the model citizen who will be obedient and accept authority. In this essay, I apply a portion of his analysis that concerns how this docile body is created to the issue of how school uniforms are part of a series of practices that attempt to create the model citizen. We will see that while school uniforms are credited with improving both behavior and test scores, they are part of a larger series of tactics that attempts to create a homogeneity among students and to erase individual differences.

[1] William J. Clinton, State of the Union Address, U.S. Capitol, January 23, 1996.
[2] Michel Foucault, *Discipline and Punish,* trans. by Alan Sheridan (New York: Vintage Books, 1977 [originally published in French in 1975]), 139–165.

THE BODY MUST BE REGULATED IN ORDER TO OBJECTIFY STUDENTS

In this section, Foucault discusses a paradigm shift from a time in the seventeenth century when the ideal body was a natural phenomenon to the eighteenth century when the ideal body came to mean something that could be constructed through a series of training exercises and corrections. One ramification of this was that aptitude or talent was no longer deemed to be individual but rather that one could take "formless clay" and discipline it through corrections and training to make it smooth running and automatic, like a machine.[3] The first step in this process was to make the person shed his or her individuality to become amenable to proper training. This meant that the person would shed loyalties to others aside from the disciplining authority and would become accustomed to accepting that authority in all matters pertaining to that training.

In the U.S. Department of Education (DOE) *Manual on School Uniforms,* written in 1996 following Clinton's speech, the potential benefits of school uniforms went beyond decreasing violence and theft over designer clothing. The DOE also believed that the adoption of a school uniform policy would help students concentrate on schoolwork, develop discipline, and resist peer pressure. In a secondary sense, it would help officials recognize intruders and discourage gang activity.[4] In 1994, the Long Beach (California) Unified School District was the first major U.S. school district to implement a district wide mandatory uniform policy. Since then, several other districts have adopted a school uniform policy, including Miami–Dade and Polk Counties, in Florida, as well as many individual schools across the United States.[5]

Uniforms are understood to create a "level playing field" where students' economic differences are minimized, which was the focus of Clinton's remarks. However, students are also regulated into a standardized body where all can be treated uniformly, thereby privileging the group as a whole while minimizing individual differences. Individual differences in social and economic class, ethnicity, religion, intelligence, intellectual achievement, and social skills are seemingly made level, but there is no impact on the fact of the existence of these differences. Various forms of uniform policies are adopted by schools. In cases of mandatory uniforms, donated uniforms or coupons are distributed to those who cannot afford the clothes. Other districts with uniform policies have adopted an "opt-out" provision, recommended by the DOE's *Manual on School Uniforms,* by which parents

[3] *Ibid.*, 135–136.

[4] United States Department of Education (USDOE), *Manual on School Uniforms,* retrieved at February 8, 2001 *www.ed.gov/updates/uniforms.html,* 1996.

[5] *Ibid.*; Polk County School Uniform Page, retrieved at February 8, 2001 at *www.gate.net/~rwms/Uniform.html*; Darlene Williams, "School Uniforms: The Raging Debate," retrieved at February 8, 2001 *www.gate.net/~rwms/UniformsDWilliams.html,* 2000: Williams's article is a good summary of the school uniform movement nationally.

can choose not to have their children wear the school uniform.[6] In a survey cosponsored by the National Association of Elementary School Principals and Lands' End (a mail-order supplier of uniforms), most principals surveyed believed that uniforms helped equalize differences among students because students did not have to worry about being in fashion and therefore were subjected to less peer pressure.[7] This conclusion was obtained through the principals' visual observations and rarely through surveys of students.[8] In a student protest in Mississippi over a school's uniform policy, a compliant senior characterized the protesters as "ignorant . . . because over half their parents voted for the uniforms. I thought the students . . . had better standards than to do this."[9] In other anecdotal instances, students were deemed not in compliance with uniform codes because the colors were too faded or not an approved shade of green or blue.[10] The superintendent of schools in Polk County, Florida, where a mandatory, no opt-out uniform policy was instituted, threatened criminal charges against parents who did not comply with the policy, stating that "we feel it's contributing to the delinquency of a child."[11] These examples indicate that the pressure to conform under threat of social pressure does not necessarily diminish with the adoption of uniforms; compliance with fashion dictates is merely replaced by compliance with the dominant values of the school district.

As well, most uniform policies insist that clothes be "content neutral" or that clothes not contain written text aside from school messages. The ostensible reason for this was to prevent the display of gang insignia, but it also prohibits any kind of message not sanctioned by the school, including religious and political messages. Religious and civil rights challenges to these rules have sometimes been successful. For instance, in Pennsylvania, members of the Universal Life Church successfully sued the district because they were denied a request for an exemption to wear religious colors. In Mississippi, however, the picketing students previously mentioned were unsuccessful in protesting their school's uniform policy, which the students believed prohibited free speech.[12] Noncompliance itself triggers the by-product of lost time for students when they are forced to change clothes into "loaners," are placed in detention, sent home, or are prohibited from attending school until they comply, even when their objections are religiously or civilly based. A group

[6] USDOE, *Manual*, 2–3.
[7] National Association of Elementary School Principals (NAESP), "School Uniforms: Why & How," *www.naesp.org/misc.uniforms.htm*, 1999. Retrieved February 8, 2001. It is important to note that the survey had 750 responses out of 28,000 elementary and middle school principals who are members of the organization.
[8] NAESP, 7.
[9] American Civil Liberties Union (ACLU), "Students Rights: Dress Codes and Uniforms," *www.aclu.org/StudentsRights*, March 3, 2000.
[10] Williams, "School Uniforms," 4.
[11] *Ibid.*
[12] ACLU, September 5, 2000.

of Rastafarian children in Florida have been prohibited from attending school since April 2000. They wear their hair in dreadlocks and cover their heads outside the home, a Rastafarian form of religious expression, while the school district insists that students cannot wear long hair or head coverings.[13] Where a school's uniform policy prohibits self-expression, it has the effect of loosening the bonds of identity for the student with outside groups and reinforcing his or her identity as a member of the school group and thus subject to the authority of school values. The Rastafarian example also may indicate that there is hidden racial or ethnic discrimination occluded by the desire for conformity with certain values.

THE BODY IS SUBJECT TO COERCION

Foucault continues his discussion by describing the processes of discipline and training work. He cites an "uninterrupted, constant coercion" that works on the body and which becomes a means in itself, almost more important in the scheme of things than the result. He states that while these processes had been in place for the army and in monasteries for a long time, during the eighteenth century they were used more generally in schools and prisons and became general formulas for domination.[14] The system differed from earlier practices because if one had been a serf in earlier times, one was valued for one's labor. Under the new system, the body becomes more useful as it becomes more obedient because it is of greater utility to those in authority.[15]

Coercion implies that one can be taught "proper behavior" through an infinite series of corrections, which applies more directly to those schools having a mandatory uniform policy, particularly with a no opt-out provision. In the Polk County schools, dress is inspected every day, and any infraction is punished. Dress is made more complex by inconsistent standards among schools in the district, so that what is acceptable in one school may not be acceptable if the child changes schools.[16] This has led to intimidation and harassment. An elementary school student wore pants with a stripe down the side, acceptable in one Florida school, but when he began attending another school in the same district, he was forced to color in the stripe with a marker so as to be compliant.[17] An honor student in Florida was suspended over whether his sweater was black or navy blue during the week of the Florida Comprehensive Assessment Tests, a seeming contradiction in purpose, if uniforms are understood to be an integral part of achievement as measured by testing.[18] This measure was designed

[13] ACLU, September 18, 2000.
[14] Foucault, *Discipline and Punish*, 137–138.
[15] *Ibid.*, 137.
[16] Williams, "School Uniforms," 4–5.
[17] *Ibid.*, 5.
[18] *Ibid.*, 5.

to punish the student for not immediately admitting wrongdoing in complying with the decision of the authorities. In Chino, California, students may be issued warnings regarding noncompliance with the more relaxed uniform policy, but they can also be sent home.[19] In either case, they are removed from the classroom for a time. Perhaps even worse is the humiliation and fear of being labeled a troublemaker if a student does not comply, even when students and parents are attempting to do so. While enforcement standards vary from district to district, the focus paid to appearance over behavior or achievement becomes a constant, daily source of stress.

DOCILE BODIES ARE USEFUL

Foucault stated that docile bodies were useful because the authority that creates them can control moral variations and can construct a citizen who accepts the dominant values of that society. The process covers over any confusions and ambiguities that may exist, giving citizens their place in the hierarchy within society. This process also teaches that individual rights are subordinate to communal values, which gives more power to those in authority.[20]

School uniforms attempt to erase class and ethnic differences among students, ostensibly to avoid peer pressure when some students can dress in the "fashion uniform" and others cannot. This gives students the impression that they are all equal, but this impression is incorrect as it merely hides the differences, rather than treating them substantively. Uniforms and the coercion that surrounds students to comply also send the message to students that conformity is a desirable value and that failure to conform is a transgression that will be punished, not only through a direct corrective, but also through the tactics of intimidation and ridicule among one's peers. A student who conforms is one who will follow the rules, not make waves, accept the conditions given him or her—and who understands her or his place in society and who will proceed to the future allotted for her or him without thinking critically about these processes.

CONCLUSION

Why look at school uniforms as a visual manifestation of institutional power, rather than as an instrument for instilling good values in students, as religious and private schools have been doing for a long time? First, one must understand that religious and private schools contain a set of preexisting ethics that students do not have the power to refute. Second, the goal of these schools generally is to construct the students' identities along these values; and third, these schools contain a clear system of authority to

[19] NAESP, 7.
[20] Foucault, *Discipline and Punish*, 137–138.

achieve these goals. With regard to the effect of school uniforms on behavior, we can look at the Long Beach (California) Unified School District, the first public school to institute a districtwide uniform policy in 1996. The first year the policy was in operation, administrators claimed that, because of the adoption of mandatory uniforms, assault dropped by 67 percent, vandalism by 82 percent, and robbery by 35 percent. They also claimed a 73 percent drop in overall crime in grades kindergarten through eighth grade.[21] In 1998, two university researchers, Brunsma and Rockquemore, conducted an empirical study measuring attendance, behavior problems, substance abuse, and academic achievement in Long Beach to see if the district's claims had merit.[22] Their findings refuted the claims, stating that student uniforms had no direct effect on any of these issues and that the district's statistics were conjectural and anecdotal. Instead, the researchers concluded that other factors, such as parental involvement, proschool attitudes, and academic preparedness, were better indicators of success than were uniforms.

The DOE also stresses that uniforms should be part of an overall safety program that could include "truancy reduction initiatives, drug prevention efforts, student-athlete drug testing, community efforts to limit gangs, a zero tolerance policy for weapons, character education classes, and conflict resolution programs."[23] It does appear that if parents are involved in their children's educations, and these other initiatives are in place, the issue of wearing school uniforms or not becomes moot, except for the visual message that a uniform carries. At a time when schools are under attack for poor performance, school uniforms convey the message to the community that the children in school are under control. In the NAESP survey, 85 percent of the principals of schools with uniform policies stated that the uniforms had a positive effect on the school's image in the community.[24] This might indicate that whether or not uniforms are integral in improving students' performance, the uniform is good public relations for the school.

While districts insist that uniform policies are implemented to foster respect and achievement, evidence would indicate that wearing uniforms is only incidental to success. Despite uniforms' seeming usefulness at religious and other private schools, the uniform itself may still be a negligible part of behavior and performance there or in public districts. It seems very possible, as demonstrated by Brunsma and Rockquemore, that achievement is the product of a cluster of factors, including parental involvement, academic preparedness, proschool attitudes, and peers with proschool attitudes. It

[21] Long Beach Unified School District, "K-8 School Crime Report Study," *www.lbusd.k12.ca.us/uniform*, retrieved 1997, updated 2000.
[22] David L. Brunsma and Kerry A. Rockquemore, "Effects of Student Uniforms on Attendance, Behavior Problems, Substance Abuse, and Academic Achievement," *Journal of Education Research*, vol. 92, no. 1 (Sept./Oct. 1998), 53–62.
[23] USDE, *Manual*, 3.
[24] NAESP, 3.

also seems evident that wearing uniforms does not erase social class differences nor ease peer pressure. Killing someone over a designer jacket, as Clinton stated, is a form of intimidation, and intimidation of students has not disappeared; it has only altered. Consider the difference between respect for authority and slavish subservience to authority under threat of public ridicule, particularly in instances where a school district has a zero-tolerance uniform policy and students are routinely harassed for negligible uniform violations, like wearing a faded uniform or differing shades of blue or green. If students are taken out of school to change or for detention or suspended, how does this have a positive impact on their education? While it appears now that uniforms make little difference in school achievement, they do become symbols of the authority of dominant values. To teach students these values in public school districts is an attempt to homogenize multicultural values and to create a citizenry that is amenable to authority.

President of Otis College of Art and Design, Sammy Hoi in his ubiquitous cowboy boots. (Photo: James Stiles)

Interview with Sammy Hoi

Kathryn Hagen and Parme Giuntini

Born in Hong Kong in 1958, Sammy Hoi was educated at Columbia College and received a J.D. from Columbia Law School. Interested in the art and design world, he began working for Parsons School of Design, and by 1988, he was heading Parsons Paris. He returned to the United States in 1991 to serve as Dean of the Corcoran School of Art. Since 1999, he was been president of Otis College of Art and Design.

Parme: What do you think are the expectations of college presidents, in terms of dress?

Hoi: I think there's a big distinction between large colleges and universities versus the independent schools and smaller colleges, which can, in general, be very quirky. From my experience, university presidents tend to be very formal in their attire, analogous to a kind of corporate sartorial culture. The art school presidents tend to have a stronger sense of aesthetics, rather than the more conformist approach to dress.

Parme: Was there a formal dress code when you were in Washington, D.C.?

Hoi: Most of the places where I worked had an explicit code, which was nevertheless unspoken. Washington, D.C., though very democratic, is also very conservative. When I was working for the Corcoran museum, such a formal setting dictated a more refined appearance. Everyone came to meetings in jackets and ties.

Kathryn: Does that mean that your wardrobe has changed here at Otis?

Hoi: Certainly it's gotten more relaxed. Since I began my training in law school, wearing three-piece suits was not foreign to me, although it was not my nature either. When you encounter something unnatural, you try to position it as a foreign element, a form of resistance. So in law school I developed a very peculiar way of dressing. Whereas everyone else would put on their shirt, then tie, then jacket, and take it off again piece by piece, I would put it on and take it off like a spacesuit—all at once! At first I thought I was very lazy, but then it became a ritual and a reminder that I was adopting a different persona. I think for me the outfit was a little like a monkey suit, so if I made it a costume, I felt less compromised.

After I decided not to practice law, I rarely had occasion to dress formally until I became director of the fashion program at Parsons Paris. There, I represented an American institution to a lot of French officials and society

people, so suddenly the whole aspect of formal wear came back into play. As you know, the French are very fashion aware, though their dress is actually pretty conformist. The women would wear a scarf or carry a purse in a certain way that made it very personal and individualistic. So I got a deeper and more personal appreciation of formal dress because of their culture.

Kathryn: Did you buy a lot of suits in Paris?

Hoi: I did; actually I put together a whole Parisian wardrobe. I grew up in Hong Kong, so as a teenager my father took me to a tailor who made me suits of high-quality fabrics, but they didn't reflect my personal taste. In Paris, I was in my early thirties and I was bolder; my dress became a creative exercise, and that practice has stayed with me. Color came into play also, and even some flamboyance. My Paris experience was very formative; I learned to combine different elements, but I never went wild because of my formal upbringing and my professional position.

I think in dress you try to negotiate different aspects of yourself to present something that is truthful about who you are. So, when I left Paris and went to the Corcoran, it presented a very interesting challenge. I went from an environment that was quite formal but also very individualistic and able to tolerate quite a bit of variety of personal expression to Washington, D.C., which is much more conformist. I had to assess things quickly to see how much I could get away with, but being more confident, I decided to retain a lot of the elements of my Paris wardrobe. For example, I wore more formal coats and ties, but I also wore turtlenecks, bright colored shirts, and I kept my [cowboy] boots. In the end, people always commented favorably on my distinctive wardrobe and how it was more individualistic. It helped having come from Paris, plus I was always younger than my peers so I could get away with more.

I hope that as I age my wardrobe will grow older with me gracefully, but I feel it is appropriate, being younger, to be more exuberant. At the Corcoran, I did not feel totally comfortable wearing everything I wanted to. I actually got involved in Tibetan culture sort of midstream. In the beginning, I would wear these beads after hours or on weekends. There was nothing that explicitly codified my behavior; it was more about myself. But when I came to Otis, another layer of freedom was added. I just decided I had to be myself completely.

So now there is nothing that I do or wear that reflects any restriction, either perceived or imposed. Also, my perceptions and views of clothing have deepened and become more encompassing. In Paris, it was more about aesthetics and what pleased me, but when I went to the Corcoran, I realized that there are more performative aspects to clothing. First of all, as an institutional leader I reflect not just myself but the institution that I represent. I am very sensitive to this, especially when it comes to meetings. I know that my appearance can facilitate the outcome and the relationships being formed, so I need to know my audience.

Then there is a third part of the performative aspect that is very ritualistic. Because I come from Chinese culture, which is very respectful of others, especially elders, I am aware of a constant reciprocal gesturing with people through clothing. Whether you are paying tribute to someone or receiving it, clothing becomes a means of paying respect. So when I am going to talk to an open house of parents and students, I will dress more formally; not because I need to—southern California is very casual—but it's my way of saying that I am very serious about meeting you.

So, it is a challenge to satisfy all these performative demands and dress in a way that makes me feel I am being true to my own preferences. I am not assuming a wholly different personality but, rather, modifying my identity in ways that accommodate my perceived needs, and those of others, in specific situations.

Kathryn: Now, you have to tell us about the boots. [Sammy Hoi wears American cowboy boots all the time.]

Hoi: Well, when I first came to the U.S. from Hong Kong, I went to Hawaii where everyone was wearing flip-flops . . . so I just wore my own running shoes. But when I went to Columbia Law School, I was thrown into a preppie culture where everyone wore Topsiders [deck shoes]. They were new to me and also very comfortable, plus they had a sort of conformist glamour; so many people were wearing them. I wore them, too, except when I had to wear dress shoes, which I didn't like because they were so tight and boring. Even though I can objectively appreciate the formal beauty of well-designed dress shoes, I always find them a little deadening and dull.

I was in search of a shoe that suited my personality but that would also be extremely versatile. That is the context in which I discovered boots. In New York, I was walking along St. Mark's Place in the Village and saw this pair of boots in a window. I had always wanted to try some on, and when I did, they just felt so comfortable because I have very long strides when I walk, and they suit my natural rhythm and provide a lot of support. I discovered that you can wear boots with anything, with jeans, with suits. They were extremely versatile.

Furthermore, I realized that people began to notice that I always wear boots, which reinforced my desire to be a little more individualistic. Also, in the back of my mind I was wondering who I am culturally. Am I Hong Kong–Chinese? Am I Hong Kong–British? Chinese–American? Ultimately, it is about the East and the West—it is not a struggle or a schizophrenic identity dilemma or anything like that, but ultimately it does pose a question: How do you absorb the new culture so that you are enriched by it rather than homogenized into it? My boots became a nice symbolic indication of my enrichment, the boot being something of the West and also a foreshadowing of my coming to Los Angeles.

Parme: Does your culture encourage the wearing of symbolic items of clothing?

Hoi: My culture is probably more attuned to the ritualistic aspect of clothing. I think it makes you more aware of your environment, and your synthesis with the environment, and also the very powerful effect of the cosmos. I certainly feel that it is very important for me to be constantly in tune and in touch. It's almost like your personal universe is the universe, and so my clothing—the boots that I wear, the beads that I wear—are a constant reminder that I am in my own space, which is reflective of a larger space, which is the truth about myself and also my connection with other people's space. In that sense, they have a very integrative meaning to them. They become extremely important instruments by acting as the official representation of certain values that I truly hold. The beads are about compassion and harmony. Like the boots, they make me feel really grounded to the earth whenever I need to tune into people, because they provide such wonderful support of my physical being.

Kathryn: When women go to an event, they hope that no one will dress just like them. But men tend to want to wear things that are similar.

Hoi: My desire is to be outside defined categories and roles. Because of my background, I cannot actually be pinpointed by others—or even myself—as to which specific group I belong. So, I think my clothes and how I wear them provide a way to tie in several different identities and to keep myself flexible. Then I can shift in and out of different mindsets of cultural identities.

Kathryn: Would the term "maverick" apply to you?

Hoi: I don't really see myself as a maverick. The clothes and the boots are not that extreme. They're just me.

NOTES:

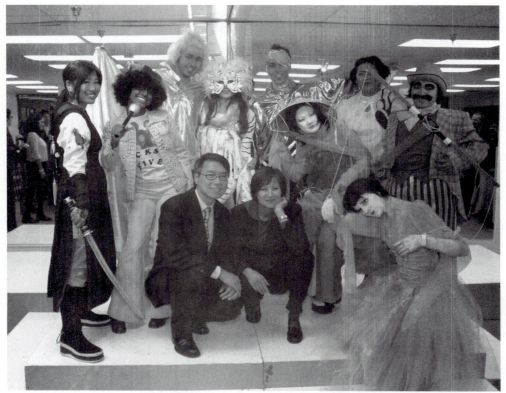

Rosemary Brantley, Sammy Hoi, and Otis fashion juniors dressed in their own Halloween Costumes, 2002. (Photo Courtesy of Otis College of Art and Design, School of Fashion)

Interview with Rosemary Brantley

Kathryn Hagen and Parme Giuntini

Rosemary Brantley is the founding and current chair of fashion at Otis College of Art and Design. Ms. Brantley began the program in 1980 and a successful designer in her own right, she has spearheaded a fashion department that consistently dominates the field for both national and international student awards. The students from her department work—and often head—design teams in every major clothing firm in the country. Ms. Brantley's educational philosophy is straightforward, farsighted, and geared toward developing raw student talent into successful professional achievement in four short years. Each April in collaboration with selected outstanding designers, juniors and seniors design and construct all the clothing for a professional runway show, an event that regularly raises close to one million dollars in scholarship money.

In an interview with Ms. Brantley, we asked her about her philosophy of education and how she thinks about fashion in general. Her design mantra is very simple: "Clothes are for people." In other words, "Fashion is not about wire or suspending fabric with monofilament. Fashion is driving design today and fashion is all about desire."

Parme: What makes the ideal fashion student?

Brantley: Talent certainly, but also drive, a strong work ethic, and time management, which is why I run the department as much like the fashion industry as possible. Students need to be aware of industry practices. They need to be competitive, develop skills, learn how to meet deadlines, and how to manage others.

Parme: What is talent?

Brantley: People can have talent of varying kinds. For some, it is right-brain, creative talent—they love to draw, but they may not like the computer. Others are more left-brained; they're great technically. A few can do it all. But the saddest thing is a talented student who doesn't have a work ethic. You can generate ideas all day, but you also have to be able to put them to work.

Parme: Describe your own sense of style.

Brantley: Don't pin any trend on me. I like trousers with straight legs and turtleneck tops with long sleeves in fabrics that breathe. My favorite sweater

is black cashmere; it cost a fortune, but then I've worn it for years. I wear black a lot because black makes me think—clears my head—and I like clothes that are comfortable. I'm not afraid to improvise, to mix high and low looks. I love wearing black trouser suits with Converse tennis shoes—a great look for L.A. . . . Hands down, my favorite item of clothing is pajamas. Flannel in winter, cotton in summer . . . long sleeves, a collared buttoned top, pockets and comfort. I like comfort.

Kathryn: Who is your favorite designer?

Brantley: Yojii Yamamoto. He's experimental but in ways that make me speechless—romantic huge black hats with beekeeper tulle—his looks are always new, always black, always subtle.

Kathryn: How do you see the future of the fashion industry?

Brantley: Globalization is changing the industry and the world. Unless designers opt for a small boutique approach, they are going to be working on big teams with all of the fabrication and production outsourced. I definitely think that L.A. is going to be the design hub for the future. Even Giorgio Armani said if he could relocate, L.A. would be the place. I really believe that New York is to some extent a decaying infrastructure. It was the city of the twentieth century. I think L.A. will be the city of the twenty-first. Long Beach is the busiest port in the world. Everything comes through here. It is completely modern and therefore a great place to study fashion. It also has a very multicultural mix of people. The weather, the money, the lifestyle, the fashion exposure—L.A. is hip, it's fast, we care about fashion and style and we're not afraid to wear it—wild or conservative. You can buy anything here.

As for globalization, for big designers like Ralph Lauren, he has to go global because he has nowhere else to go. All tariffs are going to be gone. The market will be flooded. Designers will either work in large teams or open a storefront.

Parme: Who determines what is cool?

Brantley: Well, edgy people live in certain cities—Paris, London, Antwerp, Milan, Tokyo, New York, and L.A.—that's about it. And trends come from young people in these places. Exposure is everything. Watching the Oscars is big for Irving, Texas, but for people in the know it's nothing. Everything on those shows has already been done. What you have to do is look at the fashionmakers. What are they wearing now? Lowrider pants? Then high waists will be next. We must sell what people don't have—in other words, generate a rigorous obsolescence—that's our job. We must think about where things are going next and create desire for the next big thing. Designers should also look at things like music and other key influences. And if everyone is doing something new, a good designer tries to carve out different territory.

There is also a huge trend called "mass-tige" in which famous celebrities become the front people for design companies. Everyone wants to be like the celebrities and own what they are wearing, so it makes sense to make

them the "designers." And now Karl Lagerfeld is on the cover of *Women's Wear* shaking hands with H & M Department Stores. It's high fashion for the masses, and people may wear a $12,000 fur scarf with a $10 T-shirt. This is called cross-buying: combining high and low fashion.

Kathryn: What is the purpose of your designer mentors?

Brantley: Mentors are so valuable because you have the benefit of years of experience, and they can convey the language of fashion through example. John Varvados is a designer in his forties who came out to work with the students. He is wealthy and works on Seventh Avenue. But he came here wearing a band T-shirt, a hoody, corduroy pants with no side seam like ski pants, scuffed suede boots but very expensive Italian suede, and an exquisite leather belt. He was erasing boundaries by combining such elements. But you have to know the boundaries to challenge them. Clothing is a language that can be very elitist. People on the street would not look at him and get the same information as an informed designer or customer would. Our students begin their learning by pulling cross grains in muslin, so they learn an awareness of such basic but key issues. If somebody sat across from me and I noticed that their shirt was off grain, I would have a hard time concentrating on anything else—and the students would notice as well. We teach them to really see. Our students are so aware of industry practices that they really have no competition.

Parme: What are the most interesting trends?

Brantley: I've been reading about the two hottest menswear designers in the country. One is called "Cloak." They are great, but they're not making money. They need a backer. But the other is on the West Coast, a company called "Howe." Its designer/founder, Jay Howe, had a totally original idea to tap into both the vintage trend and the ecology mandate. All his clothing is made from existing vintage garments. He goes to closeouts where they are selling thousands of leftover jackets and buys them all. Then he takes a drill bit and drills all the edges to make them frayed and oldlooking. He tears all the linings out and prints graphics on the inside that bleed through to the outside, which creates such a look of cool, sort of "rock-and-roll mystery."

Jay came from the surf industry originally, which probably made him more ecologically aware. When he got into better menswear, his solution was completely original. After seeing his presentation, all sixty-four juniors wanted to be on his team. They had never seen anything like it, and they liked the idea of taking responsibility for not creating any more waste. Finding a second use for something that already exists is better than making anything new.

Another mentor company, Patagonia, is also completely into ecology. It wants to use natural dyes, natural prints, no rubber, only drawstrings. Its theme was urban nomads. People who have to live efficiently; everything they own fits into a sack. But fashion also makes ecology expensive. Because designers say ecology is cool, people in the know will pay.

Figure 1. The designer Jade Howe mentoring a fashion student during a fitting at Otis College of Art and Design, School of Fashion. (Courtesy of Otis College of Art and Design, School of Fashion)

Parme: Has fashion with no rules contributed to a lack of what used to be called "good taste"?

Brantley: Absolutely! In fact, Annie Liebowitz, the famous photographer said, "I'm not sure we didn't look a hell of a lot better when there were rules." In those days, if you had a big bum you hid it; now people don't care. I was telling my partner that I have this favorite tunic that I wear a lot, so we made it for the line. But women don't want it. They don't hide anything anymore. Same thing with kids. When we grew up there was a sense of order about what went with what and how to look neat. Now the students that come here know nothing about ironing because they have never ironed. Clothes come out of the dryer, and they just put them on. Now with this mixing of high and low, we have to try to help them understand what works and what doesn't, but it's difficult. There is no roadmap for "cool."

Kathryn: What do you think about the reality show *Project Runway*?

Brantley: I think it's the worst form of wrongful information: TV selling a "fashion reality" that has nothing to do with the rigor and time management that creates a successful design student. They just go to the supermarket, buy some veggies, and whip up a dress. It also makes the young designers look shallow and feeds the worst stereotypes about fashion.

Parme: Who is the ideal customer?

Brantley: My ideal customer is someone like Lisa Berman, who owns a shop at Bergamont Station. She has endless sums of money, and the more "out there" fashion is what she wants it. She just has a lot of guts, and she lives and loves fashion.

Kathryn: What is your definition of a fashion victim?

Brantley: Fashion victims just think that when it's happening in fashion, you have to have it even when it doesn't suit you. It all plays into a bigger cultural trend—that it doesn't matter what you do so long as it doesn't hurt anybody else. Who cares what other people think? It's your life. Therefore, almost anything goes in fashion as well.

Sara Streeter, performance artist in a costume of her own design.
(Photo: James Stiles)

Part II Out of the Box

ZOOT
SUIT

Zoot Suit, ca. 1940. (Illustration: Kathryn Hagen)

Outside the Fashion Box

Kathryn Hagen

Hip hop is about digging through the crates, no matter what kind of records are in it. It is music made up of bits and pieces of preexisting sounds—looped, collaged, and layered until they take on a new identity.

Neil Strauss, "Rap and Rock," *The Vibe History of Hip Hop,* 1999

How postmodern. Not to mention New Millennium. The brilliance of hip hop and rap artists has been to sample iconic tidbits from the word and music cacophony that is modern culture and transform them into something dangerous and challenging and alive that resonates with youth across class, color, and economic status. But they are not alone in the process. Sometimes it seems that we are all pillaging those crates of past visions, appropriating with a vengeance, looking for fresh ways to think and act out of the box, seeking what is hip, radical, and confrontational, at least for today. We find something that resonates, add a dash of the beautiful, or infuse it with the hideous or the interestingly bizarre. Weave, twist, wrestle, and pastiche it into something "new," then toss it like a grenade into the middle of mainstream culture, hoping for a reaction. Any reaction.

Individuating from mainstream social dictates has not always been so difficult. In today's slam-bam culture, any idea with a modicum of originality is valuable currency; everyone wants to think out of the box. But historically, subgroups have exploited differences to achieve more weighty goals than notoriety and commerce, and fashion has played an important role in that battle. Because clothing is ideologically saturated, it is as much a communicator of class, race, gender, religion, ethnicity, sexual orientation, and political stance as any text. In some cases the associations, like pink for girls, blue for boys, have become so familiar or naturalized that they seem to control consciousness. These implications can approach the stereotypical or masquerade as common sense. But other garment indicators have, like rap, shocked and challenged the general populous, even generating riots and arrests. Critically investigating the power of such provocative modes is an exercise in semiotics and must be undertaken on the premise that, like words and actions, the meaning of clothing is a conscious social construct.

Clothing, accessories, literally any kind of body decoration, can indoctrinate mainstream ideologies as easily as they challenge the status quo. Garments can and do express rebellion obliquely, using stylistic twists to challenge the conventions of the conservative majority. Youth culture traditionally

detects the latest in hip, nontraditional outsider fashion, seeking to carve out an identity different from their parents. Drawn to more radical subcultures that dress in their own unique forms of outsider fashion, the privileged young will often take on the trappings of the genuinely disadvantaged. This appropriation hierarchy drives street fashion.

What is the pedigree of this so-called outsider fashion? Read against a larger cultural context, the semiotics of fashion can inscribe an arena of class. Outsider fashion has a reputation for generating design elements that are intentionally crafted to critique contemporary culture. The list approaches the canonical: little girl plastic rave wear, heroin chic, gay dandyism or cross-dressing, punk safety pins, tattoos and radical piercing. Emanating from marginalized groups such as gays and lesbians, punks, skinheads, taggers, freaks, and nerds, outsider groups create collages of disparate elements, a virtual semiotic soup that frequently defies any clear reading and can depend on a variety of references ranging from the specifically historical to the intensely idiosyncratic. The finished product is just as problematic; for some it epitomizes the ultimate cool, for others it is simply a grab bag of derision masquerading as poor taste.

The term *outsider* is laden with ambiguity and tinged somewhat pejoratively. As historians such as Edward Said and Timothy Mitchell have argued, western hegemony is enhanced by perceptions of the non-West as "the other," and subordination of the other to mainstream culture is a necessary step in the political, social, or cultural agenda.[1] While there is no arbitrary position for *outsider* and, conceivably, the term can refer to such oppositional stereotypes as freaks and nerds, it is generally associated with fringe groups, rebels, trailblazers, and with subcultures that either by conscious effort or default have adopted patterns of dress that simultaneously connote their ideological positions and recognizably locate them outside of mainstream dress. Certainly its lexicon includes the antiheroes around which our urban myths are built. Like Marvel Comic characters, such trailblazers arguably need a distinctive outfit that helps establish a personal visual identity.

On the fringe or in the eye of the storm, outsiders can generate revolutions that affect culture in profound ways. Hip hop culture is a superb example of an amalgamation of small out-of-the-box revolutions in marginalized subgroups that have coalesced and permeated popular culture in an unprecedented fashion. Although its origins are primarily African-American, almost 75 percent of the rap and hip hop audience is non-black. Often criticized for its harsh language and message, this genre has nonetheless unified youth across ethnic lines. Clothing has been a key instrument in that group identification.

[1] The notion of "the other" as a cultural construct was explored by Edward Said, *Orientalism* (New York: Vintage, 1979) and has since become an important factor of postcolonial studies. Timothy Mitchell focused on the construction of Egypt as a European fantasy in the late nineteenth century, particularly in relation to world fair and international expositions in his book *Colonizing Egypt* (Berkeley and Los Angeles: University of California Press, 1988).

In delineating the origins of hip hop, Tom Terrell argues that such up-heavals, whether social, political, or cultural, do not happen in a vacuum. Rather, they are the end products of a string of connect-the-dots factors and events that can collectively agitate and refigure the traditional boundaries of creative disciplines."[2] The ongoing symbiosis of music and fashion is instrumental in the ability of these groups to achieve notoriety and create change.

ZOOT SUITS

What are the origins of this particular brand of revolution? Certain building blocks might be found in the streets of Los Angeles in the 1940s. Early jazz culture was a profound catalyst for both white beatniks and young black hipsters, who wore the first zoot suits. First surfacing in 1930s jazz circles, the term *zoot* referred to "something worn or performed in an extravagant style.[3] Characterized by hip-hugging, shoulder-padded, draped jackets and voluminous tapered pants, the zoot suit mocked the business suit by manipulating mainstream male attire into an extreme form. By caricaturing the dress of white, male authority, the zoot suit became the perfect outsider ensemble. Furthermore, the extraordinary yardage required to construct the garment broke WWII rationing laws, turning the suit into a War Board fugitive and generating work for bootleg tailors who struggled to meet the large demands.

Alienated both from their laborer parents and middle-class America's rigidly superior stance, young, second-generation Mexican-Americans, or pachucos, living in impoverished barrios, were the first subculture to exhibit their rebellion by display—through their clothing and behavior on the street.[4] They also parted from their "natural" roots (either Indian or Spanish) by constructing the zoot suit from materials at hand. Appropriating this extreme style from musicians, they made it their own with a very long key chain dangled from the pocket and a crucifix or medallion draped over the tie. Pachucos often hid their fileros (flick knives) in their thick, greased hair, which was styled as a duck-tailed pompadour. Religious tattoos, such as the Virgin of Guadalupe, were also part of the look.[5]

So associated was the distinctive garment with Mexican-American male identity that it literally ignited and gave its name to the 1940s Los Angeles race wars. White servicemen read antipatriotism into the young

[2] Tom Terrell, "The Second Wave," in *The Vibe History of Hip Hop*, ed. Alan Light (New York: Three Rivers Press, 1999), 43.

[3] Ruth P. Rubenstein, *Dress Codes: Meanings and Messages in American Culture* (Boulder: Westview Press, 1995), 202.

[4] Candida Taylor, "Pachucos," *St. James Encyclopedia of Pop Culture:* Gale Group, 2002, www.findarticles.com/p/articles/mi_glepc/is_tov/ai_2419100928, retrieved July 29, 2006.

[5] Pachucas, the female counterparts of pachucos, wore short tight skirts, filmy blouses, dramatic makeup, and longer pompadour hairdos.

ethnic "zooters" attitudes and defiant dandyism, which they wore like a badge. *Pachuquismo*, a posture of languid detachment, was the antithesis of military discipline. The Mexican poet Octavio Paz described the pachuco as a "sinister clown" who courted the hunter by decking himself out as his prey.[6]

In the resulting Zoot Suit Riots, "grimly methodical tank forces of service men" attacked young zoot suiters, making a humiliating ritual of stripping off the expensive garments and ritualistically burning or shredding them.[7] The powerful impact of such identity murders on its victims is unmistakable. Stuart Cosgrove argues that Cesar Chavez and the future Malcom X marked their initial radical politicization and future leadership roles in race politics to their experiences in the Zoot Suit Riots.[8] The look reemerged in the 1950s in the predominantly Anglo subculture known as *greasers*.[9] But the impact of marginalized youth wielding clothing as a weapon of social protest extended far beyond the relative calm of the 1950s.

TAGGERS

Fast forward to the seventies and East Coast ghettos. Disco had taken over the clubs, marginalizing what had been an authentic black presence of 1960s folk-based soul music. Drastic measures were needed to find a new voice and identity. While mainstream youth culture was fomenting its folk-song and rock revolution against Vietnam and repressive governmental practices, by 1967 a unique art form was blossoming in the nighttime ghetto streets of Philadelphia and New York City. Kids were stealing spray paint cans and "tagging" flat surfaces—the higher the better—with huge stylized letters and designs rivaling the waning abstract expressionist and emerging pop art culture. Taggers were the ultimate outsiders. Today, graffiti art is recognized as valid creative expression, but this was not the case in the late 1960s. Often working alone, young graffiti writers risked arrest every time they tagged a surface, but still the crews persisted, expressing a range of personal, political, and social positions, even while they fought each other for territory. By the early 1980s, gallery owners, publishers, and documentary filmmakers smelled innovation and began to draw the writers into the system: Graf-artists Keith Haring and Jean-Michael Basquiat become international stars, and taggers entered the annals of popular culture.

[6] Taylor, "Pachucos," www.findarticles.com/p/articles/mi_glepc/is_tov/ai_2419100928, retrieved July 29, 2006.

[7] *Ibid.*

[8] Stuart Cosgrove, "The Zoot-Suit and Style Warfare," *History Workshop Journal* Vol. 18 (Autumn 1984), 77–91.

[9] Candida Taylor, *St. James Encyclopedia of Pop Culture*, www.find articles.com/p/articles/mi_glepc/is_tov/ai.

BREAK DANCERS

A new kind of dynamic street performance went hand in hand with graffiti. Break dancing, an aggressive, physically demanding form of athletic movement, was being invented by preteen B-boys, short for *beat, break, and Bronx boys*. Competing for supremacy in mind-blowing, scrape-the-floor moves, they were rapidly followed by B-girls who mimicked both the moves and outfits of the boys. As Daisy "Baby Love" Castro explains, "We dressed just like the guys. Windbreakers, Lees with the permanent creases in them, Le Tigre shirts, Adidas with the fat laces . . . and all that." Hip hop culture, with numerous fashion signifiers, percolated in the "violent, bleak moonscape of burned-out warehouses and deteriorating projects" of the South Bronx and other ghetto neighborhoods.[10] While the London Punks were generating an antifashion pastiche of degraded and sexualized elements, the B-kids wore clean, brand-name, all-American preppy sportswear—street but clean street, urban street prep to be exact. And they weren't afraid to match either.

REGGAE

Another origin of the exercise-gear identity of hip hop was Bob Marley and "reggae chic." Marley posed in the late 1970s both in his football uniform and in a red, gold, and green tracksuit. Within a decade, the "tracksuit and trainers" look was ubiquitous in ghetto fashions, especially hip hop. Run DMC even wrote a song called *My Adidas,* which led to a company sponsorship.[11] Mainstream capitalism wastes no time in commodifying what is hot, and the elite fashion world has become adept at adapting the street aesthetic to its luxury clothing. Most critics dismissed hip hop as a fad, a flash in the pan, only to see its strength and influence dramatically increase over the decades. The late 1980s saw an influx of a more Afro-nouveau riche identity (Think Puff Daddy) suits, fur coats, pointy dress shoes, and pimp-chic leather hats.[12] The Native Tongues movement combined African kente cloth with more preppy designer fare. Designer Isaac Mizrahi, who built his career on mining pop culture, helped bring hip hop fashion to mainstream culture. Inspired by the elevator operator of his Soho showroom, who wore a gold chain, Mizrahi married hip hop looks with high fashion to create what *Women's Wear Daily* called *homeboy chic*.[13] Todd Oldham put Queen Latifah on his runway, and Karl Lagerfeld showed women in leather jackets with gobs of gold chains (Figure 1).

[10] Terrell, "The Second Wave," 44.

[11] Sasha Frere-Jones, "Run-D.M.C.," *The Vibe History of Hip Hop*, ed. Alan Light (New York: Three Rivers Press, 1999), 43.

[12] Emil Wilbekin, "Great Aspirations, Hip Hop and Fashion Dress for Excess and Success," *The Vibe History of Hip Hop*, ed. Alan Light (NewYork: Three Rivers Press, 1999), 277–283.

[13] *Ibid.*, 280. Wibekin references *Women's Wear Daily* (*WWD*) as a credible contemporary fashion source. *WWD* is a New York-based publication and the leading fashion newspaper that targets a primarily an industry audience.

Figure 1. Karl Langerfeld for Chanel adds chains to his outfits in Fall of 1991. (Illustration: Kathryn Hagen)

In a 1997 *New York Times* article, Michiko Kakutani speculated that young black city kids adopted the dress of upper-crust whites "as a manifestation of their lack of power in American society."[14] While these kids looked for ways to escape the ghetto, young suburban white kids became "cultural tourists who romanticize the . . . ghetto life." This can explain why these *outsider wannabes* became the largest audience of gangsta rap. They embraced the music and the slang with the same enthusiasm with which they embraced the low-crotched baggy pants, athletic hats turned backward, oversized shirts, and, of course, expensive, brand-name tennis shoes of the hip hop culture.[15] This look has become so commonplace that it has bled across literally every ethnic boundary.

The mechanism inherent in modern youth culture to reconfigure its own notion of beauty, or hipness, in opposition to societal norms, is a powerful tool. Reevaluating lifestyle choices and challenging outmoded value systems

[14] Michiko Kakutani, "Common Threads: Why Are Homeboys and Suburbanites Wearing Each Other's Clothes?" *New York Times Magazine*, February 16, 1997, 18.
[15] *Ibid.*, 18.

Figure 2. A punker wearing the distinctive tribal dress that originated in London in the early 1980s. (Illustration: Kathryn Hagen)

comprise the desired function of each generation, lest civilization stagnate. As Stuart Hall states so effectively, "Hegemony can only be maintained so long as the dominant classes succeed in framing all definitions within their range so that subordinate groups are, if not controlled, than at least contained within an ideological space which does not seem at all 'ideological'; which appears instead to be permanent and 'natural,' to lie outside history, to be beyond particular interests."[16] Thinking and, yes, dressing outside the box may well facilitate the development of the original personas that can move culture forward. Rebellion is essential, and clothing can either express or suppress that outsider mentality. Today fashion regularly draws inspiration from street culture, and youth buying trends dictate a fashion agenda. It's harder and harder to be an outsider when the boundaries have been turned inside out and commodified. The inevitable result of subculture influence is alpha-culture absorption.

[16] Stuart Hall, "Culture the Media and the Ideological Effect," in J.Curran et al. (eds), *Mass Communication and Society* is cited by Dick Hebdige, *Subculture: The Meaning of Style* (New York: Routledge Press, 1979), 16.

Tween children. (Photo: Courtesy of Kathryn Hagen)

Betwixt and Between: A Landscape of Female Childhood

Parme Giuntini

She's hip, flirty, and walks with an attitude. Her metallic black-leather thigh-high skirt fits snugly on narrow hips, revealing just a sliver of flat belly and emphasizing tanned legs that end with platform sandals and electric blue toenails. Note the fuschia cropped halter top edged with a narrow ruffle and finished with a scattering of rhinestones—eye-catching but not overdone. She grabs the backpack, money for the cafeteria, the back-to-school forms; there is just enough time to kiss Mom goodbye and catch the bus. Summer is over, gotta look good. It's the first day of third grade.

It's a brave, new fashion-forward world out there, and burgeoning numbers of young girls are wearing clothes that flash all the glitz, glitter, and sexual provocation of adult female high fashion. Falling roughly between the ages of eight and twelve, this latest fashion-minded segment, called "tweens," is increasingly media savvy, brand name and style conscious—despite the fact that they are still learning long division. Caught between Barbie dolls and boyfriends, tween girls are identifiable by common interests: aspiration to be older than their age, high comfort levels with information technology and personal electronics products, and discretionary income.[1] While this category may have its exclusions and fashion pariahs in the Pennsylvania Amish or orthodox Jewish sects, tween fashionistas cut across most religious, racial, ethnic, and social groups. In scaled-down versions of low-ride pants, midriff-revealing halters, lycra or animal print micro-miniskirts, and slinky tube tops, tween girls sashay into playgrounds, elementary schools, birthday parties, and malls dressed like miniature rock stars, or what some critics dub the "Lolita Look."

Traditional or classic styles long associated with the tween age group neither dominate the market nor construct the mainstream image of youth. Instead, they occupy a problematic fashion ground of conservatism and moderation, rendering them impotent as contemporary fashion statements since their expressed purpose is to underscore the universality of classic design and ideal childhood. The recent adoption of uniforms by many public

[1] Janice Rosenberg, "Brand Loyalty Begins Early," *Advertising Age*, vol. 72, no. 7 (February 12, 2001), S2; Heather Chaplin, "Tween Picks," *American Demographics*, vol. 21, no. 12 (December 1999), 66–67.

schools, in an attempt to counter mounting juvenile unrest over fashion rivalry among students, establishes the point.[2] White blouses and navy blue skirts may offer welcome relief to parents barraged by constant demands for trendy styles, but they are meager competition to hot pink matte jersey, sassy ruffles, and designer labels.

Except for the very young, it is no longer fashionable for children to look like children, reversing a general trend that has been mainstream since the late-eighteenth-century Enlightenment advocation of modern childhood. Discarded then, along with infant swaddling, corsets, and excessive physical punishment, was a long tradition of dressing children in miniature copies of their parents' clothes, thereby maintaining hierarchies of class and status. The chief outward signifiers of this modern "enlightened" childhood were what today would be called "age-appropriate" clothes.[3] In the eighteenth century, this meant simple white muslin dresses with scooped necklines, short sleeves, sashes, and ankle-length skirts that were conveniently tucked so hems could be let out as children grew. This was the uniform for both little boys and girls until about age four.[4] Boys would then be "breeched," a rite of passage in which their infant skirts were exchanged for long, loose trousers, soft, collared shirts, and easy-fitting jackets—a style they would maintain until finishing school and entering adult life. Girls continued to wear the same style until puberty, when their developing bodies were finally laced into corsets along with simplified variations of adult female fashions.

Dressing children in styles that visibly distinguished them from adult fashion was just the opening salvo in marking out the new territory of modern childhood. By the end of the eighteenth century, the material culture of the "new child" had expanded to include toys, books, games, and puzzles all marketed toward parents eager to surround their cherished offspring with age-appropriate paraphernalia. Prominent physicians joined voices with earlier philosophers, such as John Locke, and contemporary social commentators, such as Jean-Jacques Rousseau, and admonished parents to make dramatic changes in child-rearing practices, only one of which was to adopt

[2] United States Department of Education (USDE), *Manual on School Uniforms,* 1996 retrieved June 3, 2003. *www.ed.gov/updates/uniforms.html.*

[3] Modern childhood is historically established among the European English and French landed classes who were the first to adopt new theories about child rearing and childhood advocated by such theorists as John Locke and Jean-Jacques Rousseau, as well as such physicians as John Codagan and William Bucham.

[4] Obviously, the new ideal of childhood and its attendant dress depended on families with sufficient financial means to afford these new styles and the rapidly expanding material culture of modern childhood, which included new scaled-down furniture, children's books, toys and puzzles, new diets, and constant maternal attention. Poor children continued to wear castoff clothing with no discernable style; although by the early nineteenth century, the proliferation of second and thirdhand clothing stores increased the possibility that even the lower socioeconomic groups were wearing modern dress. Obviously, throughout Europe there were rural areas in which traditional dress continued, as modern dress and modernity are linked with urban areas.

new clothing styles. These advocates urged parents to be personally responsible for their young children rather than handing them over as infants to wet nurses and maids and visiting occasionally. Fathers were advised to watch over young children as carefully as they did their horses and hounds; mothers were told to breast feed their own babies and to personally supervise meals, playtime, and early education.[5] Parents who scrupulously followed these instructions were to be rewarded with children who regularly lived past infancy and grew into healthy adolescence, obedient out of love rather than fear of physical punishment.[6]

These ground rules established the modern domestic ideal and what Anne Higonnet has termed the "romantic child."[7] During the early nineteenth century, the ideas rapidly spread throughout western Europe and the United States, popularized through magazines, novels, and advice books. Even more dramatic was the prevalence of children in visual culture. Plump, cherub-cheeked, bright-eyed, and dressed in modern clothing, children were prominently displayed in portraits, genre paintings, prints, greeting cards, and calendars, as well as advertisements for the department stores and mail order catalogues that rapidly became the mainstays of retail marketing.[8]

The eighteenth-century concern over child-rearing and domestic responsibilities influenced the redesign of children's dress and laid some general fashion guidelines for girls' clothing, but any reliance on a singular style was abandoned in the nineteenth century. Industrialization and cheap manufacturing, along with new retailing methods, fed growing consumer desires and demands. As Enlightenment notions about childhood as a time of innocence to be lovingly nurtured, valued, and protected crystallized into modern assumptions and practices, it was less necessary to restrict children to a uniform dress. In the growing consumer-oriented world of modernity, children were as much objects of display as their parents.

[5] William Buchan, *Domestic Medicine* (Walterford, England; James Lynn and Co., 1769), 2.

[6] The critical writings that grounded the Enlightenment reconfiguration of childrearing and domestic life were John Locke's 1693 treatise, *Some Thoughts Concerning Education*; Dr. William Cadogan's *An Essay Upon Nursing and the Management of Children, from Their Birth to Three Years of Age* (1748), which went through at least eleven editions in French and English before 1900; Dr. William Buchan's *Domestic Medicine* and *Advice to Mothers*, both published in 1769; and Jean-Jacques Rousseau's, *Emile*, 1762, a novel and social critique on contemporary French aristocratic child-rearing practices, which became so popular in England that it was serialized in *The Lady's Magazine*. The child-rearing practices that these authors promoted are now thoroughly embedded in western culture and considered natural and normal, but in the eighteenth century, they raised controversial issues about parental responsibility, especially for the landed classes who were accustomed to servants shouldering the major responsibility for child care.

[7] Anne Higonnet, *Pictures of Innocence: The History and Crisis of Ideal Childhood* (London: Thames and Hudson, 1998), 15.

[8] Stephen Kline, *Out of the Garden: Toys and Children's Culture in the Age of TV Marketing* (London: Verso, 1993), 52–56.

Figure 1. A *Godey's Lady's Book* (1841) advertisement for children's fashion that illustrates the similarity of adult and children's styles.

Even the most cursory survey of nineteenth- and twentieth-century girls' clothing establishes one indisputable fact: Manufacturers rapidly returned to borrowing key elements from contemporary adult female fashion. The simple garb that hallmarked modern childhood in the late 1780s was mere memory by the 1850s, supplanted by a growing range of dresses, coats, hats, footwear, and eventually sportswear that took its cue from current female high style. Fashionable late nineteenth-century juvenile girls dressed in the same pouter-pigeon bodices, bustles, high-button shoes, and lavishly beribboned straw hats as their mothers, the telling differences being shorter skirt lengths and higher necklines (Figures 1 and 2).

The pattern repeated itself throughout the twentieth century. A 1919 Larkin Catalogue advertisement for girls' plaid gingham dresses, aged eight to fourteen, promised that "the little miss will look just like the grownups."[9] Flapper era girls wore straight chemiselike dresses, double-breasted fur-trimmed coats, and cloche hats. By the late 1930s, defined

[9] Linda Martin, *The Way We Wore: Fashion Illustrations of Children's Wear 1870–1970* (New York: Charles Scribner's Sons, 1978), 105.

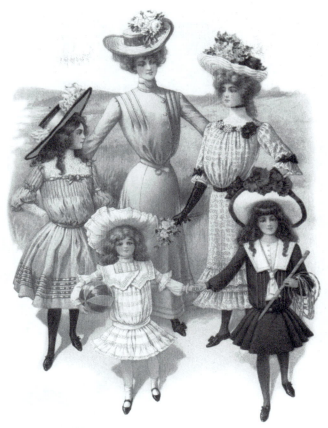

Figure 2. A *Delineator* ad from 1902 showing the newly fashionable pigeon pouter style.

waistlines, prints, and swingy bias-cut skirts were popular. Shoulders went broader in the 1940s, and girls opted for the same high-waisted trousers and crisp white blouses as film stars Katherine Hepburn and Carole Lombard. When rock and roll exploded into post World War II conservatism, girls' fashion followed the same currents: denim jeans and cropped pants, figure-hugging bodices topped by prim white Peter Pan collars, dresses with nipped-in waists, and full crinoline skirts (Figure 2).

Why the brouhaha now over nine-year-old Britney Spears wannabes dressed in hip-hugger pants and lycra tube tops? Are these styles fundamentally that different from Simplicity patterns of 1960 featuring clamdigger-length pants and sleeveless crop tops? Certainly Shirley Temple showed more flesh in crotch-length dresses with matching panties than tweens do today in biker shorts and oversize T-shirts. Clearly any discussion of fashion-forward tween clothes rapidly merges from such mundane topics as cut, color, style, fabric, and ornamentation into the more controversial territory

Figure 3. Two different examples of early 1920s girls' designs for looser, more comfortable dresses.

Figure 4. During World War II, fabric shortages necessitated fashion changes, even for children. These dresses reflected the short, narrow utility styles of the time. Postwar styles for girls would mimic the Dior New Look with fitted waists and sweeping skirts.

of gender, self-esteem, sexual exploitation, personal expression, parental control, and industry accountability. Determining the specific meaning of any fashion code is risky at best, since all coded meanings are context dependent and open to a variety of interpretations.[10] Factor in the mere mention of "adolescent girls" with sexually provocative clothing and our cultural defenses are on the attack.

Modern children's fashion history may date to the mid-eighteenth century, but contemporary cultural memory is considerably shorter. Adult consumers, with mothers being the largest group buying children's clothing, are generally influenced by nostalgic recollections of their own childhood dress, vaguely defined notions of "what children should wear or how children should look," and attention to what is fashionable and affordable. At best, this makes mothers an easy target since all three categories are relatively subjective. Not only the rules for what children can, should, or will do have changed dramatically within the last twenty years. Children, themselves, have become an independent consumer group. Parents and their children in the 5- to 12-year-old range spend an annual $30 billion on apparel, and children's influence on general spending patterns has been estimated as high as $126.1 billion and growing.[11] As a result, fashion and fashion advertising have shifted from focusing primarily on parents, whose responsibility it was to advise the child and develop standards of good taste, to the child herself, in our case that tween at the mall, who enters the stores already fully conversant with popular culture and peer pressure—and with cash in hand.[12]

Until recently, juvenile fashions avoided overtly sexy styles and clingy fabrics that emphasized the body, as well as such decorative details as rhinestones, studs, and skin-baring cutouts because mothers opted for traditional or classic styles.[13] Developed from those eighteenth-century models, these

[10] Fred Davis, *Fashion, Culture and Identity* (Chicago: The University of Chicago Press, 1992) 8–10.

[11] Market Research Reports, *Kids Market, The Market, Find/SVP*, November 11, 1998, 2.

[12] Kline, *Out of the Garden*, 52. Early twentieth-century advertising targeted women who controlled many domestic expenditures, especially clothing. Television and Internet advertising have expanded consumer markets and changed ad campaigns. Television advertising to children especially develops their sense of individual and peer identity and familiarity with market brands at a critical juncture in their development when they are susceptible to visual imagery and desire without having the critical faculties to evaluate the functional use of products beyond their immediate social needs.

[13] Textile advances such as knits, wash-and-wear fabrics, and polyester also facilitated the design and manufacture of clothes that looked, felt, and fit differently, affecting both fashion-forward and classic children's designs. In some cases, these fabrics dramatically impacted the way that children were dressed or expected to feel and play in their clothes. For example, washable knitwear became synonymous with infancy and toddlerhood, making the William Carter Company a household name.

designs are characterized by easy-fit dresses with natural or raised waistlines, sashes, puffed sleeves, smocking, piped collars, pleated skirts, and pullover sweaters. Classic styles cover the body rather than exploit it, taking into account the rounded tummies and awkward growth stages of adolescence. Variations of more sophisticated adult fashions, such as miniskirts, bandeau tops, and spandex pants, were relegated to junior sizes and older teenage girls, as much an acknowledgment of their initiation into adult fashion as of their emerging sexuality. Tweenage girls may have experimented with their mothers' or older sisters' clothes, but cultural mores drew the line at equating looking good with looking sexy when these young girls walked out the front door.

Classic or traditional clothing may incorporate some elements of fashion-forward styles but reject the play on youthful sexuality; rather, they demarcate a fashion boundary of unchanging ideal childhood, innocence, and upper-class status. Recycling of such classic designs as wool jumpers, high-waisted velvet dresses with lace collars, and kilts with turtleneck sweaters tugs at parental buyers who are nostalgic for their own remembered youth.

Arguably, the Florence Eiseman Company established the standard for classic clothing in 1945, when the first collection was offered to the public (Figure 5). Mrs. Eiseman was the first children's clothing designer to receive the Neiman-Marcus Award for Outstanding Contributions to Fashion (1955), as well as the first children's designer whose works were the subject of an art exhibition.[14] Although the company has no official design mission statement, the current president, Lawrence Eiseman, follows the same general design guidelines, standards, and looks begun by his mother when she first sold custom-made designs to Marshall Field's. Eiseman clothes are simple and understated, modestly embellished with appliqués and scalloped hems, and fabricated in the clear colors that Mrs. Eiseman believed brightened children's naturally sallow complexions. Along with internal features such as understitching, linings, generous hems, extendable straps, and high-quality fabrics, Eiseman clothes are recognizable by their unique silhouettes, fabrics, and signature appliqués.[15] Good taste, high quality, and age-appropriate designs reinforce the founder's belief that clothes should "let children be children." Although design changes are made every year, they are subtle, often only a change in fabric or color from one season to the next.[16] These clothes are intended to be worn more than a season and passed on, and like any classic design, the cut, fabric, and decoration make them as appropriate today as in the 1980s. The gray wool jumper with appliqués, seersucker sundresses, and

[14] The Denver Art Museum presented a retrospective of her work in 1984, made possible because so many people had saved Eiseman clothes.
[15] Interview with Terri Shapiro, Frank Butler, and Lawrence Eiseman, July 19, 2001.
[16] *Ibid.*

Figure 5. Children in classic clothing, including a Florence Eisemen girl's gray wool jumper with appliqué. (Photo: Courtesy of Parme Giuntini)

linen one-piece smocked rompers that I bought for my own children 25 years ago are still mainstream sellers in the Eisemen line.

Considerations of style aside, cost puts classic clothes, such as the Eiseman brand, well beyond the range of many parents today, making fashion-forward clothing even more appealing. The value of classic clothes is vested in their timeless designs and material quality, not in their trend-setting capacity. Although some department stores may carry them, top-end classic clothes are generally found in smaller specialty stores and boutiques that cater to upscale clients and are often combined with similarly upscale infant and toddler wear. The current trend toward online marketing has broadened the base of classic styles. Even the most expensive lines are now being marketed that way, although it is too soon to determine whether parents will spend seventy to eighty dollars for smocked rompers and upward of several hundred dollars for girls' dresses, unless they are already familiar with the line. In glaring contrast, fashion-forward clothing is widely marketed online and in chain department stores and mall specialty shops. Often showcased with rock music, posters, special displays, and neon lighting intended to create a hip, upbeat atmosphere,

the shopping experience is presented by these retail spaces to tween and parent alike as fun and indulgent activity, reinforcing the pleasure of consumption with the object of consumption.

Not surprisingly, classic clothing finds its largest audience in special occasions, when children are essentially on display and asked, or compelled, to wear styles frequently presented to them as "more appropriate." These are the elegant, often conservative clothes associated with Christmas, Easter, Bar Mitzvahs, weddings, and formal portraits. These are also prime retailing occasions, when parents expect to pay more as indulgence is conflated with affection. Such are the hallmarked moments when parents show off their adorably dressed children to admiring relatives and friends and, in so doing, reify cultural notions of both childhood and parenting. Why else dress little boys in velvet Eton jackets and short pants or little girls in floor-length silk and taffeta dresses that closely echo eighteenth-century styles?

Figure 6. Child in classic party dress. (Illustration: Kathryn Hagen)

Bearing little resemblance to everyday clothing in fabric, comfort, or style, classic special-occasion clothes costume children elaborately for ritual events, constructing a palpable but momentary simulacrum of historical innocence and youthful elegance for the wearer and delivering a comforting message of stability and security for viewers. So the kids spend most of their time in distressed, low-cut or butt-bearing jeans, glittery tank tops or advertising T-shirts, mismatched, camouflaged, too tight or too loose clothes. When it really counts, for the important occasions, the documenting photographs, the relatives, they look right—they look like children.

Including an essay on children's dress is somewhat unorthodox for a text addressing fashion and culture. As Anne Higonnet noted in the introduction to her book *Pictures of Innocence: The History and Crisis of Ideal Childhood,* it is risky business to write about children in many academic fields.[17] It seems that fashion, like art history, is one of those disciplines that has shortchanged the discourse on children for precisely the same reasons: The subject is "at once too dangerous and too safe, too difficult and too silly."[18] Scholarly interest and discussion about children's clothing is generally relegated to costume history texts, either as separate sections or occasionally as the subject of an entire book. Either way, the focus is primarily on stylistic development in response to or in emulation of adult fashion. Even the more current and contextually oriented writing about fashion emanating from scholars interested in cultural studies and fashion theory tends to bypass, ignore, overlook—take your pick of the terms—the little ones. Fashion departments organize curriculum around adult design, and few offer core courses in child or youth fashion. Professional success is equated with major design firms or name designers targeting an adult population. Fashion shows may include a short segment featuring children, but they are not the draw. Children's fashion at its best is, for lack of a better word, cute. And *cute* is a deadly term in any scholarly discourse.

Writing about children's dress inevitably means writing about childhood, and that opens a Pandora's box of eminent proportions. Any discussion of contemporary childhood invokes a range of topics that threaten to challenge the frame of innocence society has so carefully constructed like a playpen. The subject can and must dovetail with everything from cultural connotations to market considerations, from the roles that advertising and popular culture play to parental influence and responsibility, and finally to issues of sexuality and exploitation. Expanding the discourse on children's fashion into the more problematic realm of identity construction inevitably raises issues about responsibility—design responsibility, advertising responsibility, parental responsibility. Do we really want to

[17] Higonnet, *Pictures of Innocence,* 13.
[18] *Ibid.,* 14.

discuss the consequences of dressing young girls like their teenage sisters, complete with belly-baring low-rise pants and tube tops? Is it necessary for four-year-olds to sport genuine leather aviator jackets and distressed jeans? Does the development of personal identity and individuality really necessitate a fashion struggle every morning? Avoiding the issue is so much easier, and after all, they are just children. Isn't it jeans and T-shirts, maybe the occasional skirt? How often do they really have to get dressed up? Besides, children's clothes are all pretty much alike, aren't they? And, does it really matter, because they all look, well, cute.

Children today are a multibillion-dollar market, as much at the mercy of slick advertisements and popular culture as adults. Entertainment and toys are the usual suspect industries that parade endlessly across Saturday morning and late afternoon television and, as such, parents have learned some defensive strategies to confront and evade the unrelenting pleas to buy. Fashion's appeal is less blatant and, like a sneaky computer virus code, much harder to identify and resist. Fashion is simply ubiquitous. It is seemingly hardwired into loving parents who want their children to have the best, look the cutest, wear the latest and who want to find it cheaply, easily, and preferably on sale. Fashion occupies enormous acres of retail space especially devoted to children from the moment they leave the hospital, with chains like Kids "R" Us, Baby Gap, Gymboree, Target, and Wal-Mart providing unimagined varieties of clothing complete with hats, shoes, bags, and companion toys. Online shopping offers the possibility of wearing the latest trends regardless of local market restrictions. Mid-priced and high-end stores and boutiques cater to affluent parents and grandparents concerned about everything from clothing their progeny in organic fabrics to dressing them in miniature high-fashion styles, a trend that can start in infant sizes. Film, television, and video fill the visual culture gap as successfully as any style magazine, communicating what to wear and how to wear it within the seamless narrative of entertainment and commercial breaks. Consequently, even young children are increasingly brand name and style conscious, resistant to wearing outdated hand-me-downs, interested in crafting an individual look, and incredibly sensitive to peer pressure.

Dressing for childhood in a postmodern culture is not easy, not straightforward, and not conveniently mapped. It means navigating a complex often serpentine path between socially constructed notions of innocence, gender, sexuality, and youth with what is currently in fashion, alluringly presented, increasingly affordable, and, in the case of girls' clothing, often erotically charged but marketed as just darn cute. There's that word again. It is both the strength and Achilles' heel of any discussion about children's clothing, capable of shifting the signification of low-rise pants and cropped tops from the discourse of eroticizing the female to "Isn't she so cute with her little tummy sticking out?" Inevitably, any position about children's clothing is negotiated between the viewer and the viewed with the body of the child functioning as an unfixed and highly unstable variable. Much like the controversial photographs of Sally Mann

that jarred the beloved conventions of idyllic childhood in the late 1980s, opinions on contemporary children's fashion will always be mediated by context, personal taste, even affection.[19] Will dressing children in conservative styles ensure their innocence and inculcate a strong value system more than letting them go to school in rhinestone-decorated tank tops and miniskirts? Probably not? Maybe so. Don't they look cute?

[19] Higonnet, *Pictures of Innocence*, 203.

Randall Lavender in his own jeans. (Photo: James Stiles.)

My Jeans, Myself, and I

Randall Lavender

A serious fashion crisis recently struck me: I began to question my constant reliance on jeans—blue ones, to be exact—as the ideal, all-purpose work, play, and everything-in-between attire. I have worn jeans for all occasions over some twenty-five years: as an artist, a writer, a parent, a college teacher and administrator. But for reasons I am still struggling fully to comprehend, I suddenly found myself thinking I really *should* wear something more, well, respectable—at least to the office. So I actually decided to try not wearing jeans every day.

It may have been my forty-fifth birthday that sounded the alarm. After all, for a man of my age to run around in blue jeans day in and day out, leading meetings and teaching classes, at home and at work, raises certain questions. Have I not fully grown up, perhaps? Am I not a successful adult, and if I am, should I not dress accordingly? Such questions crept into my consciousness as I began to reckon with becoming middle-aged and with the mix of my roles and responsibilities. These questions actually led to a concerted attempt at dressing "better." I started noticing how other men my age dress, and I soon found myself wandering the men's floor in department stores, where beautiful, respectable corduroy pants and pressed linen slacks caught my eye, beckoning me to join the ranks of men who had made it, men who had achieved more than simple blue jeans could reflect. Maybe it was time to step up to my rightful place and stop dressing like the college art student I once was.

It didn't last long. Despite my best efforts over close to a year's time, it turned out I simply couldn't resist falling back, one groggy morning at a time, into my trusty blues, so well molded to my body, so seemingly suitable for the vast array of activities I find myself engaged in most days.

In observing my undeniable attachment to these mysteriously magnetic, all-purpose denim pants, I found that the same questions that had led me to attempt a change of garb still rattled around in my head, unanswered. To this day, even though I have long since capitulated to blue jeans' dominance of my personal wardrobe, I still need to address more fully the questions that led me to dare setting them aside in the first place. Why did I do it—reject my beloved denims? And why did my good intentions go unfulfilled in the end—why did I fail at dressing "better?" An art historian friend of mine, who is well versed in semiotics, put it best when she pointedly asked, "If blue jeans won the title of most-frequently-worn even after your attempts at replacing them, what are they *saying?*"

WHY DID I REJECT MY BELOVED DENIMS?

Many years ago, I went to art school to study ceramics. I was a potter, a sculptor. The life of an undergraduate art student revolved largely around studio

Figure 1. The term denim is derived from the heavy cotton "sarge de Nimes" that Levi Strauss used to manufacture overalls which were marketed to workmen like these California miners, ca. 1890. (Photo: Levi Strauss & Co. Historical Collection)

courses and art-related activities, which included loading and carrying messy art supplies and experimenting with various raw materials. My average day consisted of whatever classes and tasks had to be attended to, followed by what I loved doing: working on my art. Of course, jeans were entirely in order—kilns, clays, and glazes made of staining refractory pigments were everywhere. I wouldn't have wanted to smear all that on my neatly pressed gray Bugle Boys, which were kept reserved for gallery openings and formal dinners. Out of a habit instilled in me from childhood—safeguarding my "school clothes" by changing out of them as soon as I got home each day— blue jeans quickly became my surrogate skin. On my own at college, I no longer had "school clothes." I needed only blue jeans, which allowed me to run from biology class straight back to a wet plaster casting in progress or from a meeting with an advisor to a roaring glass furnace, without concern for the clothes I was wearing. They were work clothes, but they were also, even by the dress standards of the early 1970s, perfectly acceptable for school.

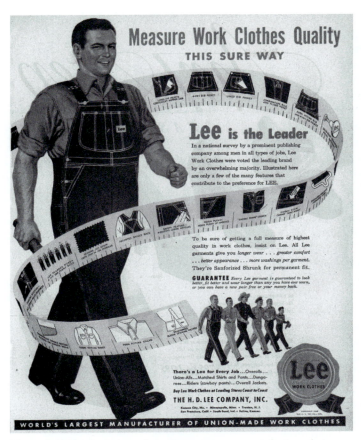

Figure 2. Unlike the designer focus that contemporary ads for jeans feature, earlier ads emphasized the utilitarian aspects of the fabric and construction. LEE® Jeans ad (c. 1930). LEE is a registered trademark of the H. D. Lee Company, Inc. Used with permission of the H. D. Lee Company, Inc.

Indeed, jeans have always been for work, ever since Bavarian-born businessman Levi Strauss and Nevada tailor Jacob Davis received a patent over 130 years ago for an "Improvement in Fastening Pocket Openings," after which they began manufacturing their copper-riveted "waist overalls" (Figures 1 and 2).[1] Soon other manufacturers, including the H. D. Lee Company, entered the overall market, offering similar sturdy work wear featuring solid rust-proofed metal buttons, reinforced thread riveting, and super-strong hidden seams. Early jeans, of course, were made of durable and comfortable blue denim. This material, now legendary, was synonymous with utility. In a turn-of-the-century *American Fabrics* magazine article, denim was touted as "an honest fabric—substantial, forthright, and unpretentious."[2] By the 1920s,

[1] Levi Strauss & Co., *History of Denim Site*. Retrieved August 19, 2002, from *www.levistrauss.com/about/history/denim.htm*.

[2] *Ibid.*

Levi's "waist overalls" were the leading men's work pants product in the western United States. Jeans were soon elevated to more mythic status when 1930s western movie stars such as John Wayne and Gary Cooper wore them, making them symbols of a life of independence and rugged individualism. And during World War II, American GIs had to guard their jeans overseas because the pants were so popular.

When the war was over, denim pants quickly became associated less with work and more with the leisure activities of a prosperous postwar society. From there, denim and jeans became symbols for the young, active, informal American way of life. By the 1980s, blue jeans had become a big part of the loosened-up, "no-collar workplace."[3] Indeed, by the end of that decade, "IBM, long known for requiring a necktie and a white shirt, endorsed business-casual dress, not just on Casual Fridays but everyday."[4] Today, millions of us wear jeans to work, where the suit once ruled. Yet for many of us, this love affair with jeans goes unexamined, even as remnants of the suit's reign linger beneath the surface—in our collective subconscious. How have we come to view jeans as so all-purpose (Figure 3)?

In my own experience, the nagging sense that I somehow needed to move "beyond" blue jeans to dress more formally grew out of a subconscious suspicion about jeans' ability to properly signify aspects of my identity that have developed over the years. Institutional affiliation, occupation, level of education, social status, and ideological persuasion can seem a lot to pile into one simple pair of pants. But I was, in a way, becoming aware that wearing jeans all the time did somehow "say" things about me that I wasn't entirely comfortable with anymore. I've since come to realize that I wasn't only seeking *to convey* other messages about myself in rejecting my jeans, but that I might also have been *rejecting something* about myself. And that warranted further examination.

As it happens, the very question of what I was really doing in trying to "improve" my dress related directly to some research I was doing at the time on certain historical influences on the field of art education. I discovered that one historical influence that had come to bias many educators had also contributed to my rejection of jeans and the corresponding rejection of certain aspects of myself that wearing jeans apparently connoted. This bias, defined by Diana Korzenik, viewed art as inferior to other subjects in the eyes of most educators, since "the ranking of prestige and priority of certain school subjects [renders] art . . . contaminated by [a traditional] disdain for work with the hands."[5] This bias extends far beyond the confines of art education or academic culture; it is present within culture at large. But surely I, an artist, a maker, a thinker about art and culture, would not subscribe to

[3] Richard Florida, *The Rise of the Creative Class; And How It's Tranforming Work, Leisure, Community and Everyday Life* (New York: Basic Books, 2002), 117.

[4] *Ibid.*

[5] Maurice Brown and Diana Korzenik, *Art Making and Education* (Champaign: University of Illinois Press, 1991), 126.

the Wrangler. Stretch is the dance to do

Figure 3. Wrangler ad (1964). (Photo: Wrangler Jeans)

such a bias—not knowingly, at least. Nevertheless, I came to understand that I, too, exercised just this kind of bias when I rejected jeans. After all, I was judging them on the basis of how they reflected upon my maturity and level of achievement. No wonder I felt the need to replace them: I was judging the artist, the maker, the one who works with his hands (myself) in the very same way Korzenik suggests that culture judges these—with *disdain*.

WHY DID I FAIL AT DRESSING "BETTER?"

For most of a whole academic year I wore only corduroy to work. With every step I took through every hall I walked, that corduroy "said" *Professor, Administrator, Middle-Class, Middle-Aged*. I had finally arrived at a place where some of my worldly attributes could be manifested through the expressive vehicle of dress. It was as if my clothes somehow affirmed something of who I'd become at that stage of life.

Interestingly, however, another set of questions arose that year, due to a creeping sense that I was actually wearing a kind of costume. Had something been lost in the change? Was that all there was to me—a teacher, a bureaucrat, a nine-to-fiver? What about the artist? The writer? What about the

guy who has worked construction and found it as intellectually gratifying as most any other activity? What about the guy who cooks dinner, does the laundry, medicates a sick cat, and helps his seventh-grader with science projects? I might have come to terms with certain aspects of myself in my new corduroy garb, but it struck me that I was losing touch with other aspects of my identity in the process—aspects such as manual skill, love of hard work, and simple honesty. Somehow my view of myself as a creative, self-motivated, and independent person was slipping away, day by day, as my jeans lay neatly folded and stacked on a shelf. I wasn't aware of it at the time, but the temptation to slip back into my jeans on workdays gradually mounted—at first one day here, one there—until I'd "cheat" once a week, then twice, and so on with regularity until I finally gave up altogether. In the end, it seems, the dressier clothes simply weren't *me*.

This got me to wondering just how clothes reflect a person's identity. Of course, scholars have long identified connections between identity and dress. Sociologist Nathan Joseph explains the importance of a 1970s phenomenon: the *casual* look. "Clothes . . . described changes in feelings and identity—the expression of persona through dress," he writes. "Expression of the inward is more sincere and important than hypocritical conformity to the outward convention."[6] Could Joseph's notion of "outward convention" explain why I felt as if I were wearing a costume during my year out of jeans? Where age is concerned, it seems there are many conventions of dress, jeans having become a dominant one only in the early 1960s. In a 1963 *Journal of Home Economics* article, Karlyne Anspach suggests, "Casual clothes are *young* clothes. In them you . . . do things, have fun."[7] Indeed, it seems that by the end of that decade, jeans were the hippest, coolest garments around. "Tough as a tumbleweed, trim as a rawhide thong and pre-shrunk to boot," reads one period advertisement for Wrangler jeans, contrasting sharply with a jeans ad of fifty years earlier that promised such enticing attributes as "longer wear, better fit, and more washings per garment."

If jeans had come to represent youth by the late 1960s, the next decade elevated them, along with other clothes, to even higher levels of expressive power. As Joseph explains, the mid-1970s designated clothes as "the individual's impression of himself rather than his definition of the situation, the latter being of secondary importance."[8] Identity, then, became a matter of finding the right kind of dress in order to "be yourself."

Perhaps this explains it. The gravitational pull that led me back to jeans was actually fueled by a need to express something of myself that, for whatever reason, was best expressed by that particular form of dress. Looking a little

[6] Nathan Joseph, "Uniforms and Nonuniforms: Communication Through Clothing," *Contributions in Sociology*, 61 (New York: Greenwood Press, 1986), 179.

[7] Karlyne Anspach, "The American Casual Dress," *Journal of Home Economics*, vol. 55 (1963), 255–257 (emphasis added).

[8] Joseph, "Uniforms and Nonuniforms: Communication Through Clothing," 179.

deeper into the subject, I found Robert Lifton's characterization of what he calls "the protean man, a hypothetical contemporary man who is malleable vis-à-vis the tremendous forces of today's world, which expose him to far greater change than his ancestors ever encountered. This individual may undergo many ideological changes in his lifetime."[9] Lifton's protean man felt in many ways like a description of me. After all, I was a contemporary man who had undergone "far greater change" than any of my ancestors had, maybe even more than many of my friends. Inspired by a variety of endeavors through the years, my life and ideological perspectives evolved with each undertaking: from studying art through framing, wiring, and drywalling a large building, developing a real estate project, raising a daughter, writing, exhibiting original paintings and sculpture, along with much else along the way.

Lifton's protean man offered, perhaps, a model for how my own sense of identity had become frazzled by all the roles and activities of contemporary life. And it seemed to explain why I rejected certain aspects of my identity in favor of others or, worse yet, in favor of culturally defined conventions. Indeed, in the course of an average day, I'll go from a meeting with my college president into a classroom full of students working with concrete to my daughter's school play and back to my studio at home—just like any other contemporary, protean man or woman would. If Lifton's model partially explains why my attempt to replace blue jeans failed, perhaps a more complete explanation arises when the protean man is considered in light of another, more recent claim, offered by Joseph: "Dress is a means to express . . . identity regardless of context—jeans become the standardized dress for work, classrooms, theatre, and often formal occasions."[10] According to both Lifton and Joseph, then, jeans somehow manage to reconcile contemporary man's fragmented identity with the undeniably varied and expressive connotations of dress.

When one thinks about how strong the connections are between clothes and identity, between something so seemingly benign as a pair of blue jeans and something as loaded as personal expression, it is little wonder that jeans themselves have transformed over time from the mere work wear they once were into perhaps the hottest items available on the consumer market today. Amazingly, "blue jeans in the last thirty years have attained such worldwide popularity that they have come to be considered an American icon."[11] There are literally hundreds of brands and/or styles of blue denim jeans readily available for purchase online at the click of a mouse. All this may be due in part to what Anspach aptly identified when she wrote, "In blue jeans and [a] shirt, 'she' can become 'he'; the size 16 girl may be any age; the housewife is queen one minute, slave the next."[12]

[9] Robert Lifton, "Protean Man," *Partisan Review*, vol. 35 (1968), 13–27.
[10] Joseph, "Uniforms and Nonuniforms: Communication Through Clothing," 178.
[11] *Gentrification of Blue Jeans*. Retrieved August 19, 2002, from www.chass.utoronto.ca/history/material_culture/oynth/index.html.
[12] Anspach, "The American Casual Dress," 255–257.

It may be that jeans not only help to reconcile a contemporary fragmentation of identity, but that jeans also express what Ruth P. Rubinstein calls a "wished-for identity."[13] This means that jeans, and other kinds of clothes, can "enable a person to feel as if he or she personifies a desired social ideal."[14] To imagine *who and what we want to be* (wished-for identity) relies on a set of assumptions and conclusions that are external to ourselves, such as societal prescriptions represented in idealized images by the media. By contrast, imagining *who we think we are* (identity) relies more on the internal set of assumptions and conclusions that constitute our definition of self.

In other words, clothes may connote more than our internal sense of individuality; they may reflect external influences such as our socially prescribed hopes, fears, and fantasies, as well. My failure to replace jeans as a primary form of dress may extend beyond issues of identity alone. Such personal connotations of meaning, it turns out, are only part of the picture. Another, deeper part is the kind of meaning jeans have that is culturally constructed.

WHAT DO JEANS ACTUALLY *MEAN?*

With the links between clothing and identity, age, and gender in mind, it is also important to look at some larger social connotations of jeans and at their high place among the vast array of mass-marketed products available today. Sociologists tell us that clothing can be viewed as social artifact, a means of communication carried on through signs and symbols, or things that stand for other things. We are familiar with distinctive modes of clothing such as police or military uniforms, which we know were created consciously to signify authority and to designate social rank. Other distinctive modes of clothing that assign status, including jeans, have arisen gradually. A student recently remarked that she loved wearing "wife beaters," a term that I later learned referred to men's ribbed, sleeveless undershirts. Surely no one ever intended for such a seemingly innocent garment to carry such sinister connotations, but evidently culture defines these symbols on its own terms. And in light of the phenomenon of symbolism, one can easily imagine a myriad of culturally defined messages embodied in a simple pair of blue jeans (Figure 4).

The most conspicuous of these might be the sexual messages exuded by some of today's jeans for women and girls, with waistbands so low and inseams so short one could almost conclude the female human anatomy had magically evolved such that the navel now occupies a position higher on the abdomen than it did three years ago. As the provocative, hip-hugger clad pelvises of such pop icons as Britney Spears and Christina Aguilera prove, jeans can "say" as much about sexiness as was once reserved for lingerie. No

[13] Ruth P. Rubinstein, *Dress Codes: Meanings and Messages in American Culture,* 2nd ed. (Boulder: Westview Press, 2001), 324.
[14] Rubinstein, *Dress Codes,* 332.

Figure 4. Nicole Hagen models jeans made by an Otis student. To communicate a sexier image, rhinestones have been applied and a feather boa is added to the outfit.

doubt marketers of such products know all too well the "value" of such apparently socially acceptable sexualization of young women and girls: The contemporary youth culture devours the super-tight, low-cut trend.

On a more general level, however, one response to the question "what do jeans mean," offered from a sociological perspective, is that "jeans have variously meant membership in such groups or statuses as agricultural labor-ers, civil rights movements, youth subcultures, or foreign communist elites with access to Western consumer goods."[15] In other words, jeans have meant a lot of things to a lot of people throughout recent history. But since all clothes communicate symbolically, what kind of information do they convey as *symbols*? In his article on symbols and their interaction in the lives of art students, Mark Salmon suggests, "Symbols convey information about a

[15] Joseph, "Uniforms and Nonuniforms: Communication Through Clothing," 1.

person's age, gender, social class, race, religion, ideological persuasion, institutional affiliation, occupation, level of education, social status and so forth."[16] This echoes earlier references to clothes and aspects of identity, yet Salmon's claim extends *beyond* personal identity to include much broader factors such as social class and social status. Identity and wished-for identity, it seems, are not the only uses for personal dress. As Rubinstein explains, the meaning of dress can be understood in terms of two other primary *uses*, as well: "to protect the personal self . . . and to proclaim one's personal values."[17]

The notion of *protecting* one's personal self with dress helps explain the temptation I felt to wear more formal clothing instead of blue jeans. Rubinstein's self-protection idea extends from psychologist J. C. Flugel's earlier observation that "When people find themselves among others who are unsympathetic or among people they feel superior to, have nothing in common with, or fear, they adopt mechanisms to protect the self."[18] The notion of "dressing better" makes a new kind of sense when considered in light of Flugel's point. For it was not merely the influence of some silly convention of fashion that led me to doubt wearing jeans; it was the influence of a culturally defined need to distance myself and, in fact, to *protect* my "self" from the world around me. In some way, according to Flugel and Rubinstein, I needed to dress differently to affirm my separateness. Therefore, the motivation behind my decision to dress differently was not only a function of my feelings about reaching middle age or having a certain job status or institutional affiliation; it was also a function of a socially motivated need to portray the authority and power these "positions" logically afford. Indeed, "Power and powerlessness, authority and lack of authority, are some of the earliest [social] constructs."[19] Upon realizing this, I'm just as glad now that I abandoned my effort to put aside blue jeans, since it seems that if I had succeeded, it likely would have produced only more isolation from students and colleagues at work.

The other motivation Rubinstein assigns to personal dress choices— that of proclaiming personal *values*—is also illuminating. Personal values consist of ideas and goals that are reflected both at the level of societal behavior and through personal conduct. Unfortunately, however, these two realms often do not wholly align. Societal behavior, on the one hand, exists to justify social class hierarchy, or the "rightness" of the unequal distribution of resources and associated pride in personal success. At the social level, for example, the accumulation of wealth, and the demonstration of it, are expected. On the other hand, the realm of personal conduct is oriented

[16] Mark Salmon, "Symbolic Interactionism for Art Students," *Art & Academe*, vol. 4, no. 1 (1991), 29–45.

[17] Rubinstein, *Dress Codes*, 324.

[18] J. C. Flugel, *The Psychology of Clothes* (London: Hogarth Press, 1966), 76–77, (originally published in 1930).

[19] Rubinstein, *Dress Codes*, 303.

toward egalitarianism and equality. In other words, personal conduct concerns emotional growth and the actualization of personal talents. My initial qualms about blue jeans may have been inspired, therefore, by the disparity of underlying orientations that motivate societal behavior and personal conduct. My struggle may have arisen out of a broader sense that my place in the world, on a societal level, was out of step with my personal values, my desire for connection, and my identity. So, as I folded and stored my jeans on that first day of what turned out to be my grand, failed experiment, I unknowingly forfeited some personal values with each fold, trading them for a temporarily overarching societal value—attempting to reflect through clothing my culturally defined role and status.

If jeans "mean" only one thing, then, it might well be that they bridge the competing desires for group identity and individual expression or personal conduct. After all, the need for group identity extends from societal values. By contrast, much of our personal conduct is driven by the need for individual expression. Jeans may have become the universally worn piece of clothing they are today precisely for this reason. Likewise, jeans may have become universally worn because "in the history of fashion, no other garment has served as an example of such status ambivalence and ambiguity."[20] It does seem that in choosing to wear jeans, one subordinates one's status to work, duty, and/or individual identity. What other item of clothing does the average truck driver have in common with the president of the United States, Bruce Springsteen, and most of the electricians in America? How many of the clothes my preteen daughter wears to school can she honestly say are also worn by Claudia Schiffer? As author Alice Harris puts it, jeans are basically "the one item of clothing just as likely to be found in the biggest mansion in town as in the most modest two-bedroom ranch."[21] Jeans bridge competing desires, as well as layers of society, gender, racial groups, social classes, and presumptions of status. In this way, they foster the expression of one's personal values, *without* treading on anyone else's in the process. Jeans are inclusive, trans-social, supra-uniform.

CONCLUSION

In the end, perhaps my attachment to my jeans stems simply from the fact that they allow me to be myself, nothing more and nothing less, within a multitude of personal, social, and professional contexts, without the burden of having to "dress" for each one. Having been a creative person all my life, I grew up in jeans, studied in jeans, and now work in them. Fortunately for me and for millions of people like me all over the developed world, global culture has come to value "creative work" more than ever before, and dress

[20] *Gentrification of Blue Jeans*. Retrieved August 19, 2002, from *www.chass. utoronto.ca/history/material_culture/cynth/index.html.*

[21] Alice Harris, Bob Morris Ben Widdicombe, and Joseph Montebel, eds., Diane and Joel Avirm, *The Blue Jean* (New York: PowerHouse Books, 2002), 111.

codes have loosened in response. As Richard Florida explains, today's "creative economy no longer has one dress code."[22] In studying the layers of personally and culturally constructed meaning embodied in my blue jeans, I have discovered that attire can indicate either conformity or resistance to socially defined expectations, that appearance can be a cover for a real individual hiding underneath, and that clothes can provide a buffer between the public and private self. The implications of these kinds of discoveries for future designers of apparel seem vast, since in designing clothes, one designs symbols and signifiers for such human concerns as youth and maturity, compliance and disobedience, power and weakness, group inclusion and rugged individualism, not to mention coolness and nerdiness. To truly contribute to fashion design today, nothing less than full rigor is in order, as any legitimate contribution to that ever-changing field can, as I see it, grow only from a deep understanding of how the messages and meanings of dress form an ongoing dialogue with individuals and with culture alike.

[22] Florida, *The Rise of the Creative Class*, 119.

NOTES:

Wright in the Sin City days, 1970. (Photo: Courtesy of Michael Wright.)

Reflections/Recollections on Black and the Leather Jacket

Michael Wright

My first thoughts of a black leather jacket go to the magic and warmth of an extra skin, as it was for early man in the throes of survival. For others black leather signals power, lawful or lawless, or resonates with the macho of a street ready tough. The smell of black leather . . . well, it's a cross between the overwhelming punch of walking into a Wilson's Leather store, and rubbing shoulders with bikers at the Harley weekend in Palm Springs. And the color . . . for me, the color is key, much more of a fashion statement than the jacket itself. The color black has ebbed and flowed throughout my life, the consistent thread that weaves through my earliest childhood memories, my adolescence, and my maturity.

Michael Wright

Growing up in a small northern Washington farm community, I was accustomed to intense colors. Variations of green and gray dominated, much like Tim Burton's version of *Sleepy Hollow,* but then spring would pop and the fields danced with rainbow colors, especially the tulip fields. I associated that vibrant seasonal outburst with summer vacation and the freedom to roam, play, and discover, finally released from the local parochial school where I had my first black fashion experience.

Back then black meant close to God, especially if you went to a Catholic grammar school. I was surrounded by a world of black-robed figures, priests and nuns who made me sit up straight, march in rows, and tow the line. Priests got a break from the daily black garb by donning gorgeous colored vestments to say mass, but it was the nuns who made the strongest impression on me; they were a no-nonsense group. Nuns reminded us that only "good" Catholics went to heaven, and when I dared to question, one of these black authority penguins would sternly assure me that this was true. Even though they dressed identically from the habits that shrouded their bodies from head to toe to the swinging rosaries at their sides, they emanated differing shades of black. The principal and my first-grade teacher, Sister Carmel Joseph, towered over us with a withering Medusa look that seemed a cold black. Sister Ann Marie was an angel, young, beautiful, encouraging; she was a warm black. Sister Columbia was the disciplinarian,

wielding a mean stick for smacking hands, both sides if you were really bad. She taught by fear, representing the wrath of God, Old Testament style, and seemed a deep, dark black.

Naturally I thought that wearing black made you closer to God. It seemed to be working for the priests and the nuns, so why not me? I wore my black school uniform and became an altar boy, where I dressed like the priests, putting on white when they put on colors, and experiencing the rituals up close and personal. I liked weddings; they had music and laughter and kissing, and not much black. On the other hand, funerals required quite a lot of black, and even though the whole idea was about going to heaven, no one looked terribly happy about it.

God's black brigade kept me in line at school, but at home I was schooled by the images that flickered across the screen of my family's black-and-white television, around which we sat nightly as though it were a fireplace in winter. The experience left its mark, and since early TV was projected in neutral colors, black took on new meanings. Although I was quick to learn that the good guys in westerns always wore white, my first hero was Paladin in *Have Gun, Will Travel*. A gunfighter for hire who quoted poetry and always came out on the side of justice no matter who paid him, Paladin wore black like a badge of courage. I was so enthralled that I remember playing sick just to stay home and watch him. I learned about drama, comedy, horror, and film noir in front of that black-and-white screen. Film noir taught me that things are not always what they seem and made me beware of women dressed in black. I saw Shakespeare on television long before I read his work in school. Watching a black-clad Hamlet reciting a soliloquy was a powerful image for a young kid. I began to understand black as a form of self-expression setting one apart, much like the black worn by the priest, the police, the assassin, the biker, the artist, the outsider, and the occasional vampire.

I ran into the black leather jacket for the first time when I saw Marlon Brando in *The Wild One*. All the bad guys in the movie wore black leather, but the Brando character stunned me. He was the ultimate antihero: half grinning, half sneering, he was the leader of the pack but a loner with a conscience, misunderstood, a romantic, and yet, on some level, closer to God because he made the right decision in the end. I was hooked, and I knew that a black leather jacket was key to the attitude, performance, and drama of conscience. Unfortunately, the only access I had to black leather was through the Sears catalogue, and even that was too pricey for me.

Pretty soon I was noticing that other people I admired were wearing black leather: Elvis, Jerry Lee Lewis, Roy Orbison, and Johnny Cash. I got caught up in rock and roll, in the music that paid tribute to the jacket and the lifestyle, in lyrics like "He wore black denim trousers and motorcycle boots and a black leather jacket with an eagle on the back/He had a hopped-up cycle that took off like a gun/He was the terror of Highway 101."[1] This

[1] *Black Denim Trousers*, recorded by The Diamonds, words and music by Jerry Leiber and Mike Stoller, 1955.

had its tough moments for a Catholic kid who was still serving mass several days a week and being recruited for the seminary by the local priest, all the while noticing that a lot of the older guys in town were carrying switchblades, wearing black leather, riding motorcycles, and developing a strong female following. Seems that black just kept getting harder and harder to pin down, resonating with more and more complexity. Inevitably, I cast my lot with the local heroes but after I found myself in the police station having a face to face with the chief on the dangers of following the black leather jacket club, I backed down from any dreams of black leather rebellion.

Black as a dominant theme did not show up again until late in my university years when I took a studio art class for the first time and fell in love with the process. I discovered that art majors were a different breed with their long hair and paint-splattered jeans. As I adopted the look and realized how comfortable it was for me, I began to experiment. I loved to draw with heavy black lines and was attracted to the German expressionists and Picasso who both used black extensively. I vacillated among bright psychedelic colors though always accented by something black, be it a black leather vest, black riding boots, black jeans, or a black tee. What I noticed was when I dressed in total black people seemed to give me plenty of space. Black had presence, the power to move me through crowds. I felt a sense of confidence in the black stance.

Graduated and in need of a job, I dressed in the black garb of a rocker and joined a band called Sin City, which for a couple of years in the early seventies dominated the Seattle music scene, playing bars, state prisons, and Northwest rock concerts. Rock was theater, and hanging with Alice Cooper, the Iketts, and seeing the Doors up close from backstage was a real education for an ex–altar boy. Onstage, I dressed in black wet cloth pants, black cowboy shirts, and a motorcycle jacket—my first and a gift from a fan who wore it into my life, thought I looked good in it, and left it as a souvenir. Dark brown, a bit tight, and well-worn, it became part of my stage presence. Cool, but not black. And cool is what I craved so I pushed it, dressing and living in an ebony-colored world, wearing only black clothes. Black on the outside denoted the macabre, the unknown, sexual potence, violence, and the outlaw, although on the inside I still associated it with God and spirituality. Confusing? Yes, but black is never easy or simple.

As an artist, black was as critical to my work as it was to my wardrobe. For several years I worked entirely in black charcoal drawings, large works that expressed the energy within me. When I worked in sound art with Iconoclast, the entire experience was predicated on the color black. Iconoclast consisted of a synthesizer and eight column speakers spread around a darkened room with beanbags in the middle. Much like Oz, I would sit behind a curtain and create a landscape of sound for the listener, who would be in the middle of the black room. No two performances were the same. The idea of the black room was key to the experience so the spectator would be devoid of any external visual stimulus. The images were to be created in the mind driven by the external sound source.

Black and leather weave through my life and my work, forming a pattern, a set of consequences that I now find impossible to ignore or brush off as coincidence. I wore black to my first wedding as a sign of commitment. I associate the color with sexual power. I still have the first black leather jacket a woman gave me. When my adult daughter returned to the East Coast and her mother, she left behind an oversized black leather jacket that always calls to mind those images of black leather in the Sears catalogue of my youth—how ironic that her rebellion and mine fused into the same materiality of black leather.

Somewhere in the mid 1990s I realized that my wardrobe had gone to total black, a look I have maintained to this day. What does this kind of commitment to color and black leather jackets—I wear them on a daily basis—suggest? I have added three black leather jackets to my wardrobe over the last several years: a black leather "spy"-style trench coat, a shiny leather racing jacket (both guilty pleasures), and a nifty warm black leather jacket given to me by my sweetheart. So at this point in my life, black as a fashion statement has come to mean a series of personal attitudes and comfort around the color.

To some people, black will always identify the rocker, the outsider, and more than a few friends have remarked that I wear black as a reaction to the loss of my marriage and daughter. I won't dismiss those ideas completely because on some level they may be true, but I choose to see my sartorial alliance with black more as a rebirth, a reinvention of self. Clothes are like a shell: They make you feel good, at ease both internally and externally. Black emphasizes the paleness of the skin, the darkness under the eyes, and in conversation it forces the viewer to look at the face or the light emanating from the face. Black suggests ethical values, albeit in a Calvinistic sort of way. I have always felt that serious work gives meaning to life. Digital art is considered outsider art in most of the elitist art circles. Working on the outside in a rebellious medium seems to fit part of my idea of what an artist can be, willing to use new technologies to spread the vision.

As for discipline, black is a reminder to focus, something I constantly work on. It speaks to the seriousness and intensity of commitment to my personal artistic vision and to the work of my students. Black reminds me to question the nature of what I believe and what I stand for, to remember that the reaper stands close to all of us, a prompt to make the best use of the time I have on this planet. Black is a reminder that my life is rebellious and that knowledge is power. Black implies half of the balance in the universe. Like night and day, you can't have one without the other. Yin and yang, positive and negative, one and zero, male and female are all examples of the principle of duality in balance. Black has become a symbol of the humankind's quest for that balance and enlightenment. Black seems a fractal moment in a digital universe.

The leather jacket is an extension of the color black with all those connotations and complexities. Black dye applied to animal skin still carries all the historical implications of magic, power, and survival. I empower the color/jacket, and in return the color/jacket empowers me. Yes, black as

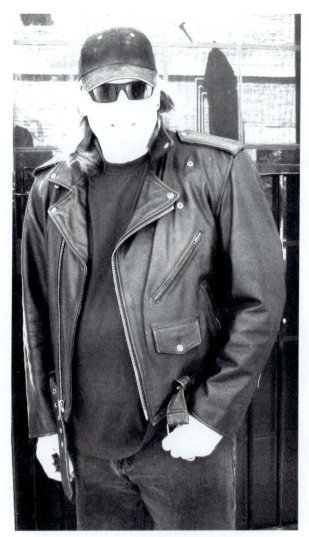

Figure 1. Michael Wright in "outlaw" garb thirty-five years later.
(Photo: Courtesy Emily Oakley, 2005.)

a dominant color theme has ebbed and flowed throughout my life. I've
settled into the color as both symbol and fashion statement. All of this may
be true, but the fact of the matter is that I feel the most comfortable wear-
ing the color black. Black is elegant, striking, easy to get dressed in, always
stylish, and makes me look slimmer . . . and I don't have to think about what
I'm going to wear early in the morning.

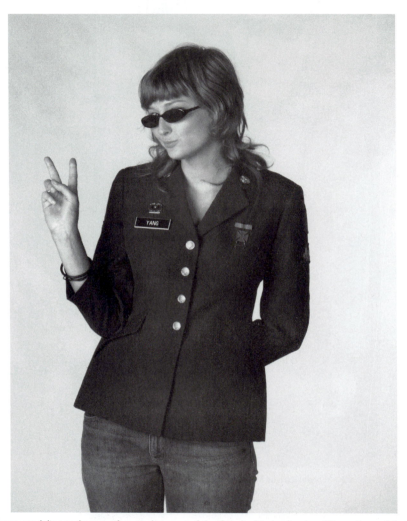

Nicole Hagen modeling an Army uniform jacket, part of the Otis Archival collection. (Photo: James Stiles)

Irony and Ambivalence: Postmodernist Issues in the Fashion World

Kathryn Hagen

IRONY—Syn. Sarcasm, satire, indicates mockery of something or someone. The essential feature of irony is the indirect presentation of a contradiction between an action or expression and the context in which it occurs.
 Jess Stein, ed. *The Random House Dictionary of the English Language*
 (New York: Random House, 1966), 753.

Since the death of modernism, circa 1965, irony has taken its rightful place, not at the head of the societal table but rather under it. Gnawing at the ankles of the cultural family, this postmodernist watchdog, chockablocked piecemeal from a multitude of subculture scribes, casts a jaundiced eye on the machinations of what Baudrillard terms our *Disney-fied social order.*[1] Disdaining discernment, he digests the profound and the mundane, regurgitating paradoxical observations that are the meat and potatoes of contemporary academia. Mass media, faced with the pop culture savvy of its primary targets, liberally sauces its propagandistic "kibbles and bits" with ironic gravy that permeates our lives with the corrosiveness of acid rain.

The effect of this blanket hypervision begs discussion. Released from its wiseguy genii's bottle, barring nuclear war or mass amnesia, irony is here to stay. We can run, but we cannot hide. No conversation, written or verbal, is unaffected by what can arguably be termed *mass ambivalence*. Our innocence has been compromised, and creative production reflects that shift. Traditional subject matter and methods in fine art, for example, are under siege, challenged by tongue-in-cheek, proto-kitsch art objects such as Jeff Koons's exorbitantly priced bronze Energizer Bunny; the accompanying full-color sex photos are the coups-de-grâce: "Marry a porno star and live happily ever after." He knows that we know that he knows, and there is little room left for even a dollop of naïveté or, God forbid, idealism.

[1] Jean Baudrillard, *Simulations* (New York: Semiotext(e), Inc., 1983), 23–26.

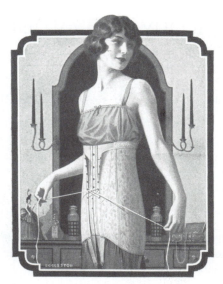

Figure 1. Illustration of a 1923 corset prized for
its practicality which was a feature of front lacing.

Given this environment, it's no revelation that mainstream culture
seems more engaged with the latest fashions than with current art, world
events, or politics.[2] Irony disdains absolutes, and fashion's penchant for
floating in a sea of commercialized ambiguity allows it to be many things to
most people. Clothing can function as therapy, as entertainment, as disguise
or camouflage, and as diversion from the unsettling state of the world.
Though feminist critics such as Simone de Beauvoir once viewed fashion as
an enslaving system that put the female form on display, today's more lib-
eral views, championed by Elizabeth Wilson, allow for the human right to
pleasure and fantasy that clothing can provide. Fashion "behaviors" in a
variety of forms are viewed as valid postmodernist exercises.[3]

But hasn't fashion changed its face as well, adjusting to these surreal
environs? Malcolm Barnard defines modernist fashion, which really began
with industrial capitalism, as having embedded specific, labor-related con-
notations. An early advertisement for a corset, for example, placed empha-
sis on the labor and craftsmanship that went into its making, the excellent
fit and performance resulting from that labor, and long-term usage that
would result from this quality workmanship (Figure 1).[4] These priorities

[2] See Interview with Dave Hickey, "Fashion and Visual Culture," *Garb, Fashion and
Visual Culture*, pages 225–231.
[3] Xiaoping Li, "Fashioning the Body in Post-Mao China," *Consuming Fashion*, eds.,
Anne Brydon, Sandra Niessen, (Oxford, England: Berg, 1998), 73.
[4] Malcolm Barnard, *Fashion as Communication*, (London: Routledge, 1996),
160–161.

that addressed people's practical requirements created a psychological affinity between laborer and consumer and addressed what was then an ideology of *needs*, more than *desires*.

Such prosaic concerns have little relevance in the current fashion system. When was the last time any of us bought a garment because it would last a long time? Postmodernist objects have little in common with those sturdy corsets of the past; rather they relate specifically not to production but to consumption, the basis of which is a constant search for the "different," whatever that may be at a specific time and place in the mind of a specific consumer. Jean Baudrillard calls this floating context the "release" or "liberation" of an object from the potential meanings that surround it.[5] Though garments can occasionally take on political significance (think of the mythical bra-burnings of the Sixties), it is largely in relationship to other objects that they can communicate any differentiation and thus function in the marketplace.

Consequently, the separation between modernism and postmodernism becomes obvious in the loss of this connection of objects to "symbolic investment" or concern for usefulness or craftsmanship.[6] The cycle of commerce-generated trend games is endless and ever shifting. Because capitalist expansion depends on perpetual consumption, the fashion system vigilantly generates enticements that draw consumers into its web. We shoppers, as the gameplayers, are largely complicit with planned obsolescence, just as eager to dispose of outmoded clothing as designers are to refill our closets every few seasons. This reduction of aesthetic objects to entertainment,[7] stripped of their relationship to productivity is, in itself, a postmodern phenomenon.

Essayist Xiaoping Li tells us that even aging Chinese women, brought up under Maoist antifashion dictates, are extremely vulnerable to capitalist constructs of femininity, which have been recently introduced in China. The mass media describes the peasant turned working girl as a Chinese Cinderella, encouraging the fantasy of her emerging femininity and empowerment.[8] Commerce favors gender differentiation, wherever it is, as performance of gender can become an obsessive and expensive exercise, reenacted around the globe.[9]

Endless trend reports in the form of various periodicals also create psychological needs and desires. An amusing and ironic example of such a cycle is the periodic production of garments that are purposefully designed to appear

[5] Jean Baudrillard, *For a Critique of the Political Economy of the Sign* (St. Louis: Telos Press, 1981), 66.

[6] Gail Faurschou, "Fashion and the Cultural Logic of Postmodernity," in Kroker, A. and M. Kroker, eds. *Body Invaders*, (London: Macmillan, 1988), 81.

[7] Scott Long, "The Loneliness of Camp," *Camp Grounds: Style and Homosexuality*, ed David Bergman ed. (Amherst: University of Massachusetts Press, 1993), 88.

[8] Li, "Fashioning the Body in Post-Mao China," 71.

[9] Anne Brydon and Sandra Niessen, *Introduction: Adorning the Body*, (Oxford, England: Berg, 1998), xiv.

"too small" for their wearer, looking essentially like they are in the process of being "outgrown."[10] This smallness, which is also tightness, places attention on the body of the wearer, rather than on the garment. Such an emphasis on this shrunken aesthetic has appeared recently in mainstream garments such as suit jackets and pants. The shrunken pant is tight and often cropped; the jacket is fitted, riding up the torso, with barely enough fabric to close a button or two. The shirt is also by necessity shrunken and often left partially unbuttoned and largely untucked. Traditionally business gear, these garments, designed tight to tantalize, become contested items, verging on the inappropriate in their own natural environs. Nor does the smaller amount of fabric used in construction result in reduced cost. Rather the cachet of diminution raises the ante of the price tag.

Further irony lays in the subtext of such an aesthetic. Featured by elitist designers on the runways, shrunken garments render Impoverishment (hand-me-downs, homeless) chic and Victim-hood sublime (restriction of movement).[11] The ribbed and shrunken *poorboy* sweater of the seventies made no bones about its origins in deprivation aesthetics. Other paradoxes follow. Disposing of perfectly good, expensive jackets and pants because they fit "too well," replacing them with more current garments that are shrunken and even 'distressed,' would be, in a more logical world, mind-boggling. In fact, it is only among the true underprivileged that rationality might prevail; when money is scarce, long-term utility may take precedence over fashion dictates.

An effective illustration of the postmodernist blurring of fine art and fashion activities is the frantic, fetishistic struggle to obtain the "must-have" designer accessories for each season. Identified in fashion magazines seasonally, the latest coveted leather bag, costing thousands of dollars, is produced, for mysterious reasons, in extremely limited quantities. Such rarified items, like limited edition art objects, attract avid collectors. Those who can afford them, lacking celebrity status, are forced to develop "insider trading" connections to retailers who can "hook them up" with the desired article. Such hard-won objects may be temporarily embedded with wonderful attributes in the minds of the owners, but even the very latest quickly becomes passé, and convincing discount copies are inevitably marketed in tandem with the real.

Such a surreal commercial system inevitably generates its own language and attracts theorists to analyze it. Roland Barthe, a French theorist, created an elaborate word system to exhaustively analyze the semiotics of the cryptic writing in fashion magazines. His book, *The Fashion System*, vividly reveals the amusing paradox beneath the typically innocuous text. Fashion, he tells us, is an essential part of the general act of "signification" in civilized society, which becomes the sign of the "properly human." It is the active and ongoing process of this empty signification of wearable objects as worthy or

[10] Lee Wright, "Outgrown Clothes for Grown-Up People," *Chic Thrills*, eds. Juliet Ash and Elizabeth Wilson (Berkeley: University of California Press, 1993), 49.
[11] *Ibid.*, 54

not worthy that renders the fashion magazine so durable an institution. While actual subject matter can be exhausted, the magazine performs a social and economic function that, devoid of content or argument, is limitless and therefore, Barthe claims, of "pure maintenance." Such enterprises are, as a result, "theoretically infinite." To say nothing significant, is to risk nothing significant.

Though lacking in content, Barthe affirms that fashion does maintain meaning, however meager, by providing an arena for humans to exercise their power to "make the insignificant signify."[12] Fashion systems signify the new, then reject it even before production begins. Consequently, time itself is stripped of long-term memory and reduced to that which is "driven out" and that which is being "inaugurated" as the latest and greatest. "Fashion *today*," Barthe tells us, "is pure. It destroys everything around it, disavows the past with violence, and censures the future as soon as this future exceeds the season."[13] Such omnipotence vested in an essentially commercial vacuum, the controlling and altering of our experience of time, must be viewed with an ambivalence that deepens in considering the verbiage of most designers who hardly lend specificity to the exercise. If designer Rei Kawakubo says, "I like black because it reminds me of death," observers will write it down verbatim, and quote her as though there is meaningful content. Spooky vagueness democratizes even the most seemingly esoteric fashion thesis, and plays into antagonistic fashion subtexts like speed freak aesthetics and heroine chic. Perception is amorphous, and we rarely "interrogate anything to find its story."[14]

Such bleak analysis can be alienating. But must we render our portrait of current fashion cycles with such strokes of bland and nebulous uniformity? Do irony and cynicism doom us to the creative rigor mortis of the poseur? Couture designers' periodic forays into the medium of camp on the runways create, at the very least, some separation from bourgeois aesthetics. Such methods can provide "a cultivated absurdity, one of the few benign methods by which the numb may be shocked back into realizing that some distinctions exist."[15] Because the constant cycle of appropriation and recycling of trends generates a continual flood of "kitsch," camp provides the aware observer with an attitude with which to view, and sometimes transform, such objects.

Not everyone is comfortable with tongue-in-cheek spectacle substituting for innovation. Valentino, a Parisian couture fashion icon, launched a verbal attack against his peers in Paris in 2005. "I want to stand apart from all the fake couture that has dominated the runways for the past few seasons," said the icon. But no specific explanation of what made it fake was forthcoming nor did he provide clarity on how his clothing would be

[12] Roland Barthe, *The Fashion System*, trans. Matthew Ward and Richard Howard (Berkeley: University of California Press, 1990), 288.

[13] *Ibid.*, 289.

[14] Long, "The Loneliness of Camp," 83.

[15] *Ibid.*, 89.

Figure 2. Rei Kawakubo for Comme des Garçons
deliberately circumvented established construction
techniques and finished by incorporating rips and frayed
edges into this woman's top and skirt. (1983)

different. "I imagined lots of pieces that a woman could have fun putting
together," was his attempt at differentiation.[16] Such a vague definition of
"real couture" by one of the masters illustrates the difficulty of separating
the higher from the lower these days by anything but price.

　　Further ambiguity can result when we, as fashion consumers, attempt
to use these postindustrial, mass-produced products that Jameson describes
as "utterly without depth" to construct an enhanced sense of our own sin-
gularity.[17] Though fashion can certainly be used to create a sort of mas-
querade in which one's identity becomes an ongoing performance,
interpreting such costumes as a reflection of "an original or authentic iden-
tity" can be a stretch.[18] Nevertheless, we can invest clothing with our own
sense of allegory, assigning a personal meaning that may or may not be fluid.

[16] fashiontribes.typepad.com/main/2005/10/tk_valentino, retrieved July 31, 2006.
[17] F. Jameson, *Marxism and Form* (Princeton: Princeton University Press, 1971), 105.
[18] Efrat Tseelon, "Fashion and the Signification of Social Order," *Semiotica*, 91,
[1 and 2], 1–14.

Not all designers avoid the issues facing fashion and its attempts to find meaningful discourse. The deconstructivist fashion movement, associated with designers like Martin Margiela,[19] Rei Kawakubo, and Yohji Yamamoto, was a revolutionary stance that, in true avant-garde style, attacked the oppressive influence of traditional fashion production (Figure 2).[20] It could also be seen as an attempt to unmask garment construction, reconnecting the viewer with the process and labor of its making and reasserting the accumulated history of the fashion object. When Margiela showed his first collection in 1989, it was against the setting of a rubble-strewn empty lot in an unfashionable quarter of Paris. His models wore clothes that were slashed and faded, with exposed linings and frayed edges that confronted the viewer with process rather than completion. Many garments looked destroyed, moving them out of the traditional realm of the commercial and into usage and aging. Ripped out jacket sleeves referenced both violence and clothing alterations.

In 1990, Margiela continued his exploration, presenting garments made from lining material with seams on the outside. Though often interpreted as a destructive impulse toward Western fashion, the exposed elaborately tailored interiors, lined and seamed, stitched and hemmed, reinforced and buttonholed, were a powerful reminder of a history of master tailoring and sewing craft.[21] Margiela's desire to return to and "re-imagine a garment's essential elements" stood in stark contrast to the circus antics on other runways. Yet the potential for nihilistic self-destruction is inherent in such avant-garde approaches in a commercial environment, as Rudi Gernreich discovered when he designed the topless bathing suit and prophesied the death of fashion. Margiela has in more recent years adapted to commercial modes in order to survive.

Nor does any good idea escape appropriation. Frayed edges and hanging threads, not to mention rips and tears, have been ubiquitous in stores the last few years, to the point that simple, clean edges are starting to look fresh and new. But ideas with some depth will often reemerge in other forms, and the recycling of existing garments to create something current is a theoretical, if watered-down, offshoot of the deconstructive path.

Given the hypothetical fault lines of the postmodernist landscape, the quest for bold, avant-garde approaches like deconstruction is arduous.

[19] Martin Margiela was born in Belgium in 1959. He studied at the Royal Academy of Fine Arts in Antwerp, and is closely associated with the deconstructionist fashion movement of the 1980s. Margiela's work is characterised by a poetic appreciation of imperfection, personality, and eccentricity. His collections have been presented on tube platforms and street corners. He says, "My main inspiration has always been the extremities and changes of daily life."

[20] Matei Calinescu, "The Idea of the Avant-Garde," *Five Faces of Modernity* (Durham, NC: Duke University, 1987), 1.

[21] "The Deconstructivist urge to destroy the standards of Western fashion was akin to the revolutionary's need to topple a regime in order to create a new world - order." Uncredited quote, retrieved July 5, 2005, at www.designerhistory.com/historyofashion/margiela.html.

To be militant or nonconformist when there are no genuine rules is simply shadow boxing. Yet ignoring the strange reality of our world is not an option for those who choose to function with open minds and eyes. While exacting an enormous existential price, ironic awareness can deepen the conversation in complex and compelling ways. If words like pretty and beautiful have become battlegrounds in the culture wars, I say so be it. The constraints of beauty have never been the female's best friend. Dressing culture arguably carries with it certain humanistic obligations that should not be ignored. The following essay uses the minimalist cipher of the white shirt to further examine these and other issues.

NOTES:

Spencer Steward and Justin Kelly wearing two versions on the white shirt. (Photo: James Stiles)

The White Shirt [deconstructed]

Kathryn Hagen

The next year (it must have been a reelection year or something), the state president's campaign slogan was "White Shirts—Uniform of the Priesthood." In every meeting we were told that the white shirt is the uniform of the priesthood. We were told that we even had to wear them to temple recommend [ed] interviews. At this point, I separated all white shirts from the rest of my clothes and tucked them into a corner of my closet. I lived the commandments as I was taught them and that didn't include mandatory dress codes. What bothered me even more was that most of my friends at church complained about the dress code but they still showed up in their "white and delightsome" Sunday best every week.
 Anonymous, Former Mormons Internet "Thread." "A Mormon Dress-code Story," *www.exmormon.org*, retrieved July 29, 2006.

For those of us who are not Mormon, the sight of two young men in white shirts and dark pants at our front door has a very specific connotation. We surmise that they are on a mission for their church, promoting their religion to willing listeners. Because they ride bicycles and carry nothing more than a few religious pamphlets, they are easy to spot, but their white shirts are also a tip-off. Carefully tucked into tailored slacks and held in place with a belt, these particular shirts do not read business, nor do they look casual. They certainly do not have the fetishistic quality of the rolled-sleeve white shirts that women write about in sexy blogs. Rather they are, in this context, carefully pressed and fitted religious uniforms: a look intended to denote the sincerity and even the purity of these earnest young men, willing to risk ridicule and rejection in the name of their faith.

The image on the opposite page displays two young, white-shirted males, but their body language and styling in no way resemble the Mormon progeny. They are posed in a casual pals-hanging-out manner that is very popular in fashion layouts. Unbuttoned, untucked, and unpressed, their styling denotes a sensual, too-popular-to-iron youth culture. Sexual preference is ambiguous, thus widening the potential audience. The idea of correct fit in the traditional sense seems irrelevant; shirtsleeves are worn deliberately too long, and these collars will likely never be confined by a tie. The grunge lineage is apparent. The open shirt, revealing a tight-knit tee, becomes a masculine twin-set. Both men wear secular jewelry; belts are either invisible or absent.

Such styling details create a potential story about the young men. Are they models in an ad? If so, would they wear these clothes differently in their private lives? Stylists, people who are particularly adept at the visual language of fashion, are hired specifically to put garments together in ways that look interesting and new. They mix clothing from different designers, add hip accessories, turn collars up and waistbands down, cuff pants, and wrap the latest long, skinny scarf around the neck. They craft the current look that inspires the target audience to wish they were dressed as well. Each detail is nuanced to provide the correct read for the project at hand. Context is the structure that dictates the parts, and a good stylist understands subtleties of various subgroups and the means to generate their interest and desire.

More than any other garment, a white shirt can be equated with a blank canvas, but it is a canvas replete with a rich history. A familiar form is, as Scott Long so eloquently states, "the result of the accumulation of traces its history has left on its present state."[1] The shirt's parts relate directly back to the armor of the medieval knights. The shirt collar, for example, derives from an ornamental necklace worn as an insignia to indicate a certain order of knighthood.[2] The bow tie, an accessory to collars, originates from 17th-century wars, when Croatian mercenaries working for Louis XIV wore cravats as a charm against decapitation. The placket of a shirt, a double or triple layer of fabric on which the fastenings are placed, goes down the center of the chest. Archaically, a *plackaet* was the breastplate of the armor.[3] Also of military origins, cuffs were the part of the armored gauntlet or glove that extended over the wrist. Such connections establish that shirt anatomy has its roots in warrior traditions, although metal breastplates and gauntlets have, through cultural evolution, been transformed into starched white cotton. A protective spirit imbued the garment, as workingmen, and eventually women, wore it into boardroom battle.

Such a ubiquitous presence has also left its mark on language. The shirt, as traditional business attire, has been viewed as a civilizing element, signifying emotional control and emphasizing a social role.[4] Therefore, if we grow impatient, we are told to keep our shirt on. If we lose our temper, we are hot under the collar. Buttoned down, a collar speaks of casual, preppy pretensions. Buttoned up, a collar is tight, ready to accommodate the "noose" or tie. A collar also functions as a controlling element on domesticated animals, the implication being that we can be collared and led to where someone else wants us to go. So if we want something from someone, or need to arrest someone, we collar them.

[1] Scott Long, "The Loneliness of Camp," *Camp Grounds: Style and Homosexuality*, ed. David Bergman (Amherst: University of Massachusetts Press, 1993), 83.
[2] The *Random House Dictionary of the English Language*, Unabridged Edition, (New York: Random House, 1966), 289.
[3] *Ibid.*, 1100.
[4] Ruth P. Rubenstein, *Dress Codes: Meanings and Messages in American Culture* (Boulder, San Francisco, Oxford, England: Westview Press, 1995), 42.

The shirt also represents monetary stability and status. If we meet financial disaster, we lose our shirt. If we care deeply about someone, we might give him or her the shirt off our backs. Symbolically, collars long separated working class from business class. Though desk jobs were the exception in preindustrial, agrarian societies, white-collar workers performed less laborious but often better-paid tasks than their blue-collar peers, who did manual work. White shirts, being easily stained, prevented their wearer from doing jobs that might involve getting their hands dirty. But today's casual "dotcommer" would as likely be found in a preppy blue denim shirt as anything, thus undermining the sartorial class system. And white collars seem more recently to be connected with white-collar crimes, like embezzlement or lying to stockholders, than conventional respectability. The recent technological revolution has created more desk jobs and fewer jobs involving manual labor. Because more companies have just white-collar workers, they have a hierarchy where the ranking is signified not by the clothing, but by the quality of the work space, the responsibilities delegated, the privileges granted, and by the salary itself.

German, 16th Century Armor

Figure 1. 16th-Century German armor.

Classic white shirts are woven, though knit shirts can pass. A woven shirt is most often left plain, functioning as a visual cipher that reflects its wearer. New, it is snowy white and pristine. Old, it may, like aged hair, get a little gray or, like teeth, slightly yellowed. Long or short sleeved, the shirt is essentially a torso envelope; its round bottom echoes the globular buttocks and the term tail refers to the tailbone. Loosely cut, a shirt billows slightly when tucked; darted, it encases the wearer snugly, like a second skin: less business, more pleasure. Traditionally male, it is steeped in starch and Eurocentric tradition: an Industrial Revolution icon. If our shirt is long sleeved, then we are given the bonus of shirt cuffs. Since fastened cuffs are another civilizing control element, we are said to impart unofficial information off the cuff. If we catch a criminal, we handcuff him, and if someone behaves badly, we may cuff or hit them as well.

Though its origins stem more accurately from undergarments than boardrooms, it is worthwhile to include the white T-shirt in our examination. Also functioning as a blank canvas, it has emerged as a highly significant garment in its own right. Most T-shirt wearers today dabble in text art, wearing tees that convey some kind of personal message, even if someone else has created it. Such displays are a way for us to answer our media-driven, sound-byte culture. Designer Vivienne Westwood was one of the first to recognize the editorial potential of tee's, using them to display everything from hate lists to political manifestos (Figure 2).

As we have stated, the styling of the shirt can dramatically alter the visual connotations, and it is worth exploring this range further. Classically, the white shirt was worn under a suit coat or blazer, with some kind of neck ornament such as a cravat or tie. The mood changes drastically when jackets are removed, buttons are undone, ties loosened, or sleeves rolled up (Figure 3). The wearer is stepping out of a business role and into a social or private stance. The loosened tie communicates an eroded sense of control. The shirt, partially unbuttoned and exposing the male chest, provides an image that is overtly sexual. Completely unbuttoned, aggression may become the subtext. Loss of control is imminent; think Tom Cruise in the film *Risky Business*.

Other gender issues arise when girls wear their boyfriends' larger shirts. The garment is implicity eroticized when worn by a nubile female. His larger shirt on her smaller body creates a negative space that implies his form, thereby suggesting a symbolic merger, which could be legal as well as sexual. Shared objects speak of increased intimacy and omnipresent desire. Wrapped in his shirt, she may be empowered by his male energy, or reduced to just another asset (Figure 4).

It is interesting to contemplate the opposite situation. Though enhanced femininity results from a girl wearing her boyfriend's shirt, the effect of his wearing her more feminine white blouse communicates problematic messages. For a culture accustomed to seeing the bare male torso, the addition of a feminine garment adds an androgenous element. Despite the fact that the rock and roll culture and the increasing visibility of gay lifestyles, to mention just two, has made androgyny interesting and even desirable, it's

Figure 2. A custom T-shirt designed for Vivienne Westwood's shop "SEX" in 1974 was a "tribal manifesto" titled "You're gonna wake up one morning and know what side of the bed you've been lying on!" On the left side were listed over a hundred things they hated, and on the right side their loves. This photo shows a sampling of their lengthy list. (Photo: James Stiles)

obvious that feminine styles undermine the wearer's masculinity. In the example shown, the transparency both hides and reveals the body, veiling the skin to create mystery; the understated ruffled sleeve communicates both a stereotypical female fashion and infantilism (Figure 5).

In general, a shirt is a shirt, but a white shirt is something else—a shirt apart. What is the significance of this absence of color? Western costume history documents innumerable images of people wearing white collars and cuffs of various forms and sizes. Some are religious figures, but secular collars, though often more elaborate, are no less white, bleached to remove all hint of color. Historical photos display affluent white businessmen and black share-croppers alike, both wearing their version of the white shirt. A bride in a white gown still carries connotations of sexuality and purity in the same way that the cowboy hero stereotypically wore the white hat. While white shirts are still part of corporate America, they no longer are the sole claim to respectability and power; other groups are appropriating the white shirt along with other

Figure 3. Justin Kelly in open white shirt. (Photo: James Stiles)

mainstream garments. Today, adolescent skateboarders are actually wearing suits, and hip young men find ways to make the white shirt their own.

In the not-too-distant past, wealthy men ordered custom-made dress shirts, constructed to their exact measurements, usually from fine linen or cotton. Such shirts were generally ordered, like doughnuts, by the dozen. The resulting collar and cuffs fit without any gaps, the sleeves were the correct length, and the buttons were positioned just right, according to the wearer's torso length. The gentleman's initials were likely embroidered on the pocket. The elegant acronym, easily visible on the custom-made "second skin," doubly validated the wearer as privileged.

In writing this essay, I came across a Georgia blog: an informal Internet information vehicle reporting a new usage of white T-shirts as a uniform for young drug dealers. An Atlanta newscast reported an investigation of police

Figure 4. Sara Streeter in open white shirt. (Photo: James Stiles)

inability to stop rampant drug sales on city streets. Young male drug pushers were wearing white T-shirts and jeans, which thwarted witnesses' abilities to definitively identify them; all they could report was seeing a man in a white T-shirt. When dozens of men on the streets are wearing the same style of white tee, the situation becomes a "needle in a haystack." According to the blog thread, a local rap group, Franchize, was promoting the idea with a song about drug dealing and cocaine use called *White Tees*. Other participants also suggested that, for some, white tees symbolized "white power," and that schools were actually sending kids home for wearing a plain white shirt.[5]

The white shirt, like the blank canvas, is poised both to reflect and influence cultural stances, continuing the cycle of tradition in which

5 Paulding.com, "Can't Wear White T-shirt?" *www.Paulding.com/forum/index. php?showtopic=9813*, retrieved July 23, 2006.

Figure 5. Justin Kelly in a woman's chiffon shirt. (Photo: James Stiles)

subversion and appropriation are clearly engaged. The following sections about Vivienne Westwood and Andy Warhol look at how a designer and an artist/designer have used irony and fashion to make important and controversial statements about culture.

VIVIENNE WESTWOOD AND THE WHITE SHIRT

Continuing the Ironic Conversation

> "In Westwood's fig leaf tights, one feels different. One is returned to the Garden of Eden, to a quasi-natural genderless state. A simple pair of fig-leaf tights."[6]

[6] Juliette Ash, "Philosophy on the Catwalk: The Making and Wearing of Vivienne Westwood's Clothes," *Chic Thrills*, eds. Juliette Ash and Elizabeth Wilson (Berkeley: University of California Press, 1993), 182.

Vivienne Westwood is a British designer whose creative genesis came out of the need to formulate an ironic response to societal hypocrisy and class struggles. Clothing is her arsenal, and many of her ideas were formulated as a result of her involvement, along with her husband, Malcolm McLaren, in an anarchist group, the Situationists, who believed in creating false and disturbing situations that would jolt people out of their routine thoughts and unconsciousness actions.[7]

Known as the mother of punk fashion, Westwood still believes that in order to make people think you have to injure them emotionally in some way. Much like a fine artist, she uses her designs to shock and raise questions through a "surmontage" of historical references layered with contemporary irony that she calls "cultural charges and triggers." "It's a question," she says, ". . . of cultivating doubt."[8]

One of Westwood's most controversial creations, shown in 1990, was a pair of fig-leaf tights: a simple pair of bubblegum-pink leggings with a fig leaf sewn on the front of the crotch (Figure 6). Another more overtly challenging version had the image of an oversized, erect penis collaged in the same bodily location. Both were combined with a white shirt and a skewed matching white tie, producing the odd effect of a girl looking like a "gent" (white shirt and tie), but wearing no trousers (pink/nude tights). Thus, the white shirt becomes a visual code representing the traditional male, and the messed-up tie signifies that patriarchal element caught in disarray with his pants down. The contrast of kitschy tights with the upper-crust icon of the starched white shirt, buttoned and unbuttoned, is essential to the semiotic message. A postmodern ambiguity, with multiple meanings, is produced by this juxtaposition of disparate garments.

Of course, such a reading of *traditional male* from a white shirt and tie presupposes an audience versed in Western culture and even in the standards of nineteenth- and twentieth-century male dress. Since the traditional suit and tie are seen less and less these days, there is a chance that today's young people might not have such a specific read of Westwood's pastiche.

In terms of the fig leaf, Westwood was first inspired by classical Greek statues. Issues of gender, androgeny, and the "vacuity of our postmodernist world" are layered in the clothing combinations. As Malcolm Barnard tells us, when fashion underlines sexuality or creates gender bending, many people feel uncomfortable or even offended, and Westwood milks these themes.[9] On the catwalk, the pseudomale female model, wearing the risqué leggings, kissed a genuine male, also in a white shirt and undone tie, wearing trousers instead of tights. In another show, Westwood herself carried out by two men, is wearing the tights and kicking her legs like an ill-behaved toddler. Loudly criticized by audiences and press for vulgarity and uncommercial attitudes, Westwood was delighted by their indignant response. She wanted to challenge the facade of

[7] Peter Marshall, *Demanding the Impossible: A History of Anarchism* (London: Fontana Press, 1992), 551–553.

[8] Ash, "Philosophy on the Catwalk," 174.

[9] Malcolm Bernard, *Fashion as Communication*, (London: Routledge, 1996) 116–119.

Figure 6. Vivienne Westwood's fig
leaf tights as shown on the catwalk in
Fall, 1989. (Illustration: Kathryn Hagen)

respectability of more conventional fashion commerce, the "stuffed shirts" of
fashion, so to speak.

Taking Westwood's usage one step further, the white shirt can also
stand in as a symbol of postmodern ambivalence toward the increasingly
compromised position of the Anglo-Saxon, white-collar, heterosexual male,
against whose cultural or creative output everything else was, in the past,
judged as secondary or inferior.

According to fashion theorist Elizabeth Wilson, postmodernism above
all expresses a mood of ambivalence, which can be translated to mean the co-
existence of positive and negative feelings toward the same thing, drawing
one in opposite directions simultaneously.[10] Indeed, Westwood's designs
have consistently reeked with ambivalence, expressing her pseudo-commit-
ment to commercial success and her unwillingness to follow fashion trends
despite her participation in the fashion structure. Nor does she care about
political correctness per se. Married to a man twenty years her junior, she re-
cently posed nude for an article in *Vogue*. "I like being an object," she said.
"It is just another form of female power."

[10] Elizabeth Wilson, *Chic Thrills*, 3–5.

ANDY WARHOL: ARTIST AND UNDERGROUND DESIGNER

"Glamour, style and fashion are loaded words, . . . [having] both positive and derogatory connotations, and yet—in the contemporary art world, they have been—until recently-almost exclusively terms of opprobrium. An artist like Warhol . . . consciously risked the denial and disdain of the 'serious' art world . . . Only now, by looking at the whole range of Warhol's work, are we beginning to see that his fascination with glamour, style and fashion was not a distraction from his 'real' work, or a debasement of the rarified, pure world of contemporary art, but an integral part of his multivalent life and work and a complex and productive response to the tensions between art, popular culture, and daily life."[11]

Andy Warhol was only fifty-eight when he died, but in those truncated but fervidly productive years, he honed his ability to mine and massage popular culture, producing brilliant if eccentric art in a multiplicity of postmodern spheres. He relished the cult of celebrity and produced searing portraits of his favorite neurotic femme fatales. His ability to turn a soup can into a visual and cultural icon made him both rich and famous, and his talent for outlandish forms of self-promotion led him to antihero art world status. But he also produced work on dark and politically controversial subjects. His electric chair series is powerful and sobering.

Traditional art mediums like painting and printmaking were only the jumping-off point for Warhol. He epitomized the term cross-fertilization, negotiating and blurring the boundaries between creative fields. His paintings became backdrops in store window displays, his celebrity subjects were featured in his groundbreaking *Interview Magazine,* and his writings mixed fashion critique with social commentary. Subversive to the core, he used his own exhibitions to challenge the high art/low art and commercial versus gallery canons; his Mao paintings were screened onto decorative wallpaper, his portraits were hung in kitsch salon-style settings, and, most daringly, a museum collection of fashion and design paraphernalia was exhibited as though it were in a department store, shocking the art world with what was perceived as "uncritical excess."[12]

Despite his notoriety, most art aficionados are oblivious to Warhol's creative inception as a successful fashion illustrator and his lifelong love affair with fashion. If Vivienne Westwood is a designer/artist, Warhol was an artist/designer with his well-shod feet constantly dipping into inspiration pools of fashion culture and theory. Clothing and style influenced and informed his work. The range of his relationships and activities demonstrates his willingness to engage art and fashion in a controversial dialogue. He preceded Margiela and Kawakubo in deconstructing designer garments for his

[11] Mark Francis and Margery King, *The Warhol Look* (Boston: Little, Brown, 1997), 29–30.
[12] *Ibid.,* 30

Figure 7. Andy Warhol, altered image, 1980. (Photo: Christopher Makos Studio, 1981, www.christophermakos.com)

1975 show "Fashion as Fantasy." Envisioning people functioning as walking art pieces, he created paper dresses with prints based on his *S and H Green Stamps, Fragile and Brillo* images. Envious of English photographer David Bailey, who made stars of models Twiggy and Jean Shrimpton, Warhol promoted two of his own "factory girls," Edie Sedgewick and socialite Baby Jane Holzer into successful fashion cover girls and icons. Warhol best revealed his own deep sense of irony when he said: "*To be successful as an artist, you have to have your work shown in a good gallery for the same reason say, that Dior never sold his originals from a counter in Woolworth's. It's a matter of marketing, among other things.*"

Andy Warhol also made good use of the ironic white shirt and tie as a symbol of his own masculinity which stood in stark contrast to the feminine alter ego that he created through a platinum wig and dramatic makeup. His demure pose lends an air of girlish modesty to what would otherwise be a masculine outfit.

Marina's tattoo: Jews in gas chambers. (Photo: Courtesy of Heather Joseph-Witham)

Ironic Bodies and Tattooed Jews

Heather R. Joseph-Witham

A 1996 *Los Angeles Times* article featured a half-page color photograph of a red-mohawked woman named Spike, who happens to be a Jew with tattoos. This interested me enough that I called my parents, both of whom are Jewish, and mentioned that I might write about it. Both had the same response. "No," they said, "you can't do that, we can't have tattoos, it's not allowed." Now I was more intrigued. In an era when tattoos are a popular culture rage and are featured everywhere from a cover of a Rolling Stones recording called *Tattoo You*, to Michael Jackson's tattooed eyeliner, why does the issue of Jews and tattoos provoke such exceedingly strong reactions both positive and negative, to so many people? Despite these responses and sometimes because of it, a growing number of Jewish individuals are sporting tattoos. Paradoxically, for some of them, this is a Jewish aesthetic expression that denies American assimilationist tendencies. Tattoos visibly communicate personal, generational, and ethnic identity in an ironic manner for those who choose ink slinging as their form of material behavior, while still seeking community approval for this art form.

Much attention is paid to the Jewish body and its outer covering of skin throughout Jewish writings and Halakha, the body of Jewish law. The body itself is viewed as "fundamentally as pure and as marvelous as the soul."[1] It is not seen as essentially unclean but can become impure through various actions and conditions. These conditions were dictated by the priests. Jews were admonished to take good care of their bodies, both because they are made in the divine image and because they will eventually be resurrected.[2] The Halakhic perspective is that "Judaism recognized divine proprietorship over all objects of creation, including the human body. Judaism expressly teaches that the individual has no proprietary rights with regard to his own body. . . . A person's body is committed to him for safekeeping, and hence self-mutilation or any form of assault upon the body is viewed as a breach of this stewardship."[3]

Skin itself seems to have intensely preoccupied various priests and rabbis over the millennia. The Talmud states that man was initially more handsome than today, as he was possessed of a coat of light. This coat disappeared

[1] Simon Cohen, "Body," in *The Universal Jewish Encyclopedia*, vol. 2 (New York: The Universal Jewish Encyclopedia, Inc., 1940), 436f.

[2] *Ibid.*, 436f.

[3] David J. Bleich, *Judaism and Healing: Halakhic Perspectives* (USA: KTAV Publishing House, Inc., 1981), 126.

when Adam disobeyed God's commandment, but traces of it remain in our nails.[4] Diseases, conditions, and mutilations of the skin are also discussed at great length in Leviticus, the third book of the Pentateuch.

The visibility of the Jewish body has long fascinated rabbis and Halakhic scholars. The first mention of tattoos is in Leviticus 19:28, which states, "You must not gash yourselves in mourning for the dead or tattoo yourselves. I am the Lord."[5] Tattoos were viewed as marks of slavery or of submission to a deity. Some theorize that the sign on Cain's forehead was a primitive tattooing and that tefillin were a kind of emblem branded upon the forehead and near the heart to show one's dedication to God.[6] The biblical passage and its associations were not clear enough for everyone, so an anonymous Mishnah in Makkot 3:6 elaborated, stating that tattooing is only a transgression if it is done with indelible ink. Another authority states that one is guilty only if he tattoos the name of an idol. This is the way the statement "I am the Lord" is explained. Maimonides, writing the Mishnah Torah in the eleventh century, expands the prohibition to include all tattooing as it "was the custom of idolaters to inscribe themselves [by tattooing] to an idol, to indicate that they were bondslaves to it and devoted to its service." Thus it was an abomination.[7]

What was at issue then is still a hotly contested topic today: Who controls the body? In ancient Judaism, as scholar Howard Eilberg-Schwartz states, "the human body was the object around which conflicting cultural representations met and clashed."[8] The body was viewed as a potentially holy site that was not to be mutilated, and rules about bodily behavior were numerous and detailed. This form of control extended from the living to the dead. A tattooed Jew was prohibited from burial in a Jewish cemetery. Some of the tattooed Jews I interviewed expressed concern about this, and many believe the prohibition to still be in place. However, several Jewish funeral homes in Los Angeles say they will bury the person anyway. When queried as to why, a funeral director informed me that suicides can also be buried now in a Jewish cemetery, as rabbis have decided that they could not have been in their right mind or "normal" when they killed themselves, and the same rule applies to people with tattoos. Therefore, some control over definitions of normative and deviant behaviors exists in Jewish custom and practice.

The art of tattooing arrived in the United States through a long and indirect journey. Various peoples throughout the world have used tattooing, from the Picts, to the Roman soldiers they influenced, to the ancient

[4] Cohen, "Body," 437.
[5] *Oxford Study Bible* (New York: Oxford University Press, 1976), 126f.
[6] Theodor Reik, *Pagan Rites in Judaism. From Sex Initiation, Magic, Moon-Cult, Tattooing, Mutilation, and Other Primitive Rituals to Family Loyalty and Solidarity* (New York: Farrar, Straus and Company, 1964), 121–123.
[7] Tattoo, *Encyclopedia Jucaica* (Jerusalem: Keter Publishing House, 1971), 831f.
[8] Howard Eilberg-Schwartz, *The Savage in Judaism. An Anthropology of Israelite Religion and Ancient Judaism* (Bloomington: Indiana University Press, 1990), 17.

Egyptians and Indians in Asia and the Americas.[9] Tattooing was first intro-
duced to the modern Western world in the eighteenth century by Captain
Cook, who noted Tahitian tattoo practices called *pricking*.[10] Tattoos be-
came notorious as sailors from overseas voyages began to get them. Captain
Cook and other explorers brought tattooed "savages" to England to display
from various South Sea Islands.[11]

Once tattoos arrived in America, they became the province of specific
groups of people. Aristocrats have, at various times, sported them, as have
craft guild members, sailors, military men, bikers, and gang members.[12]
Professional tattooers have been operating in the United States since the
mid nineteenth century, but ink slinging came to be viewed as a deviant
practice connected with sideshow freaks and socially marginal subcultures by
the 1920s.[13] Different states began to legislate against a practice that was
thought to spread disease and attract criminals.[14]

Jews in the Western world finally came to be connected to tattooing in
a tragic manner, during and after the Holocaust. Sander Gilman relates that
in the 1930s, many German Jews were uncircumcised: "Thus the need to
construct another 'mark' of difference in the concentration camps of the
1930s—the tattoo—an 'indelible' mark upon the body which uniformly
signified difference."[15] The numbers were also a symbol of the wearers' in-
humanity. One survivor said it was like being "branded like animals" and
constituted further dehumanization.[16] Another survivor related that due to
the tattoo, "We were not human beings We were numbers."[17] The per-
ception of tattooing as a humiliation is prevalent in the minds of many
American Jews and is, possibly, the major reason that an ancient prohibition
resonates so strongly with modern Jews like my parents, for whom other
Jewish rules, such as keeping kosher, are irrelevant. Jews who were tattooed
during the Shoah are set apart from other tattooees in rabbinical response.
One response advises a returnee to Torah observance to hide the tattoo of
a naked woman that he got while in the military, to wrap his tefillin at home
and then go to the shul, or to get the tattoo removed.[18] Another response

[9] Alan Grovenar, "The Influx of Tattooing into the Western World from Herodotus
to O'Reilly," *Marks and Meaning, Anthropology of Symbols*, ed. O. P. Joshi, (Jaipur:
RBSA Publishers, 1992), 73f Clinton Sanders, *Customizing the Body: The Art and
Culture of Tattooing*, (Philadelphia: Temple University Press, 1989), 9–13.

[10] Ibid., 14.

[11] Grovenar, 73f and Sanders, 14.

[12] Sanders, 89.

[13] Grovenar, 79 and Sanders, 18.

[14] Grovenar, 14.

[15] Sander Gilman, *The Jew's Body* (New York and London: Routledge, 1991), 219.

[16] Ebi Gabor, *The Blood Tattoo* (Las Colinas: Monument Press, 1987), 164.

[17] Sherry Joe, "A Survivor's Perspective on Hitler," *Los Angeles Times*, March 5,
1992, A3, A13.

[18] Avraham Yaakov Finkel, *The Responsa Anthology* (New Jersey: Jason Aronson Inc.,
1990), 195f.

answers the query of a Holocaust survivor who wants to remove her number as it constantly reminds her of the horror of the war years. She is advised to "wear the sign with pride" or the German wish to have the Holocaust forgotten will be fulfilled. She is told, "such a number should be viewed as a sign of honor and glory, as a monument to the unforgivable bestiality of those vile murderers."[19] It was in that time, when many Jews held negative views and recollections regarding any manner of tattoo aside from one forced upon a person, that modern Jewish tattooees began to emerge.

Such individuals do not appear in a vacuum. Tattooing in the United States has reached a whole new level of popularity. In 1992, it was estimated that at least 20 million people sported tattoos.[20] There is a new customer base that is reputedly better educated and more affluent than earlier customers, although to suggest that other groups, such as bikers, convicts, gang members, or sailors are no longer tattooed would be erroneous. The client base has simply grown, and with this increase comes a growth of the art form and its images. We are accustomed to seeing images of "Mom" tattoos, perhaps a devil or two, flowers, dragons of various kinds, oriental and tribal symbols, and, of course, the sailor's girl. Interestingly, the sailor's girl image was featured on a February 1997 episode of the *X-Files* television program. The inscription "Never Again" was written beneath the girl's winking smile. I presume this reference to the Holocaust was unintentional as it was never mentioned during the program, but perhaps it speaks to how the tattoos and the Holocaust have come to be subliminally related or connected in the American mind. In any case, tattooing is popular enough that there are now dozens of tattoo magazines and many annual tattoo conventions around the country. This modern renaissance and elevation of tattooing to an art form in modern discourse has certainly affected Jewish Americans and others.

Two such individuals, Tyko and Tessa, are tattooed with secular images. Although they have not met, they have much in common. Each was born to an intermarried couple, was raised by one parent and occasionally no parent, was not given a Jewish upbringing, is unaffiliated with any religious organizations, and is currently a student. Both view themselves as culturally, though not religiously, Jewish. They have also chosen tattoos to demonstrate their individuality.

Tyko, whose name is Swedish, views his tattoo as a visible expression of his interests (Figure 1). He sports a dolphin that he designed and views as "beautiful" and "harmonious," a bit "tribal," and individual rather than mass-produced. While he is aware of the Jewish prohibition regarding tattoos, he says, "I'm not concerned with my culture, with my heritage that way. It's my body, not my heritage's body." This suggests that generational aesthetics, ancient tradition, and personal identity need not clash for some individuals.

[19] Rabbi Ephraim Oshry, *Response from the Holocaust*, trans. Y. Leiman (New York: Judaica Press, 1983), 195f.
[20] Liesl Lee Gambold, *Creating Lives: Tattoo Culture in Southern California*. (Masters Thesis, U.C.L.A., 1993), 2.

Figure 1. Tyko's tattoo: Dolphin. (Photo: Courtesy of Heather Joseph-Witham)

Tessa also views her body as a forum to display personal symbols. She states, "I think tattoos are beautiful, and I just really think that the body's a canvas." She enjoys the process of choosing and getting tattooed and pierced, and she is pierced everywhere. She got her first piercing at the age of twelve and was certainly influenced to do so by her friends. At the time, she was living as a homeless squatter kid with her punk rock friends.

Tessa has put a lot of thought into her tattoos, and as they are on her back and covered, they are a more private expression than her piercings (Figure 2). Still, anything on the surface of the body is meant to be seen, eventually, by someone and is therefore not solely an inner process or a completely private expression. Tessa wears a lionfish, a beautiful and poisonous creature she says speaks to the fact that she has been deceived by many who appear approachable but prove untrustworthy. She chose seaweed because she likes the way it curves around her body. The octopus is a Chinese symbol of intelligence and power. These items belong in the ocean, which she views as her sanctuary. She separates her personal aesthetic choices from her ethnic identity and thinks that each can complement the other, although she acknowledges that her upbringing and ignorance regarding Jewish life are the foundations of these opinions. She believes her friends of the same age and similar tastes are not tattooed because they were raised in more traditional Jewish homes with value systems that preclude getting tattooed.

Figure 2. Tessa's tattoo: Lionfish. (Photo: Courtesy of Heather Joseph-Witham)

As tattooing is partially a generational choice, so is the preponderance of religious images that are appearing on bodies. Americans seeking some form of tribal identity go to places such as Nepal and Tibet to obtain religious tattoos from monks. One scholar notes that in the Chicano community "the impulse to obtain a tattoo may be religious, as expressed in Christian symbols ranging from a small, simple cross, to the Virgin of Guadalupe covering the full back."[21] Tattooing has also made inroads into Jewish popular culture, which is aptly demonstrated in a new magazine called *Davka: Jewish Cultural Revolution*. An article entitled "Tattoo Jew" included an interview with a novelist who is unaffiliated, didn't know of the biblical tattoo prohibition, and has flowers tattooed on her arm.

An individual who demonstrates the high-wire balancing act some walk when caught between tradition and popular culture is Chad Goldberg. Chad was also raised without a religious upbringing, as his intermarried parents decided he should be able to make his own choices later in life. Chad chose Judaism early on but feels he missed out on a lot by not having an early background in Hebrew and Jewish traditions. He became inspired by what he

[21] Alan Grovenar, "The Variable Context of Chicano Tattooing," *Marks of Civilization: Artistic Transformation of the Human Body*, ed. Arnold Rubin (Los Angeles: U.C.L.A. Museum of Cultural History, 1988), 209.

Figure 3. Marina's tattoo: Trains packed with Jews. (Photo: Courtesy of Heather Joseph-Witham)

calls "hardcore music," as a part of his "rebellious adolescence." The symbol for one band he liked was a black sheep. He felt an affinity with this image as it symbolized someone who was a "misfit" or an "outsider, and identified his connection with popular music and with growing up outside of any tradition." He chose the black sheep as his first tattoo, placing the picture on his arm. As Chad became more learned in the Jewish tradition through his own research, he got a second tattoo applied to his chest that he felt "really expressed something about [his] outlook on the world." It is a tree of life with two cherubim guarding the way, signifying the exile of Adam and Eve from the Garden of Eden. The tree is also a symbol for Torah itself, and it is thus a life-affirming image for Chad, one that negates the death-oriented tattoos such as skulls that many people had in punk rock circles. Chad believes his choices would have been different if his upbringing had been more Jewish. He was unaware of the tattoo prohibition when he marked himself, but at the same time he will not remove the pieces, for he believes that such an act would constitute a double transgression by marring the body twice. Also, he views the tattoos as enhancing his physical beauty. His ethnic and aesthetic identities converge with his tattoos, as he views the imagery of his pieces as similar to the history of the Jewish people, who have often been outsiders in the world. He contends that as his tattoos are now a part of him, they speak to his beliefs, and they are in perfect harmony with his manner of Jewish practice.

An even more extreme example of Jewish symbols on the body can be found on photographer and darkroom technician Marina Vain, who goes by the name Spike (see introductory image). Her appearance has brought her more than fifteen minutes of fame. Along with a *Los Angeles Times* article, she has been featured in *Piercing Fans International Quarterly* in her performance art mode, in a tattoo magazine, and on an HBO television special profile piece called *Ground Zero*. Certainly Marina's appearance has led to much negative social interaction for her, but her motivation for appearing as she does is not to engender shock. Rather, she has deeply personal reasons behind her tattooing.

Marina was born in the Ukraine, moved to Los Angeles with her family at the age of four, and had a traditional Jewish upbringing, including attending a Jewish school and a Lubavitch summer camp. Over time, however, she became more radical. When she was eighteen, she described to a tattoo artist a Star of David that she'd envisioned. He drew it, then tattooed it on the inside of her left arm, close to her heart. Marina then grew fascinated with what had happened during the Holocaust. She began to conduct extensive research into the period by reading novels, poetry, and histories, as well as viewing videos and artwork. Marina states, "For some reason I just started feeling a need to decorate myself with a commemoration for my people and what happened during a certain point in time, and I chose the Holocaust as my pinnacle point." She says that although she knew that according to Jewish law one is not supposed to mark one's body, she had to have something related to that point in history, to "take it and elaborate on it, and make it mine."

Marina has used her body to commemorate the stories of people she will never know. This form of expression parallels that of Vietnam veteran Michael Cousino, who creates miniature dioramas to show the experiences of others as they have narrated them to him. They function as "historical documents and teaching tools" in their implied narrative content.[22] Folklorist Michael Owen Jones has likewise noted that there are connections between artists and other eras, places, and people and that sometimes "folk art creations evoke history."[23] Similarly, Marina finds that although she created her appearance for herself, many people approach her. She has been able to use her body to teach others about the Holocaust, as she believes that "you cannot ignore history." The scenes on her body are specific enough to tell stories: trains packed with Jews (Figure 3), a number on her forearm (Figure 4), children Mengele performed experiments upon, a burning shul, a violinist playing as prisoners enter Aushwitz, the showers, the angel of death (Figure 5), Hebrew words that say "And now we are the last of many" copied from an art book of Holocaust survivors, a Mogen David, a quote saying "The earth hide not my blood," a canister of Zyklon B (Figure 6), and various images of flames and deaths (Figures 7 and 8).

Marina enjoys looking at tattoos and piercings and finds her own to be beautiful despite their largely negative content. She views her piercings as separate from her tattoos. She likes the way they look and has a high tolerance and even an enjoyment of the pain they give. Regarding her tattoos, she states, "I came to the realization that I'm gonna use my body for this commemoration, and that's it. I'm not gonna get a snake and a rose and a cherry on my butt." Marina has used her body to bring Judaism and its recent tragedy to as visible a state as she can. She hopes that tradition will catch up to her art.

[22] Varick A. Chittenden, "'These Aren't Just My Scenes.' Shared Memories in a Vietnam Veteran's Art," *Journal of American Folklore*, (1989), No. 102, 420.

[23] Michael Owen Jones, "Why Make (Folk) Art?" *Western Folklore*, (1995), No. 54, 260.

Figure 4. Marina's tattoo: Number on forearm.
(Photo: Courtesy of Heather Joseph-Witham).

Another individual who carries Jewish images on his body and is concerned with aesthetics and tradition is Thomas Schiffer. Thomas, 26, originates from New York and now owns a pizzeria in Venice, California. Like Marina, he was raised as a traditional Jew. Regarding values, ethics, and tradition, he is conservative/orthodox. As far as observance is concerned, he is conservative/reformed. Like Marina, he studied Holocaust literature. He also listened attentively to a grandmother intent on passing on her heritage. He first got tattooed on his left arm, where you wrap the tefillin. This is also where Holocaust victims were tattooed with numbers (Figure 9). His tattoo says, in Hebrew, *Yizkor Elohim*, "Remember God" or "May God remember." He sees this as his partnership with God and believes that one must meet God halfway in life. On his other arm Thomas has a quote from Isaiah 40:28 in the Haftorah. The Hebrew text reads, "Do you not know, have you not heard, the Lord is God, for the world, the Creator of the Earth, from end to end, He never grows faint or weary, and His wisdom cannot or may not be fathomed." To Thomas, this means wake up and hear God: While God is there, people are not irrelevant, and there is a balance between us and God. Thomas has a third tattoo on his back, a picture of a snake chasing after its own tail but not swallowing it (Figure 10). There are an owl,

Figure 5. Marina's tattoo: Angel of Death.
(Photo: Courtesy of Heather Joseph-Witham).

Figure 6. Marina's tattoo: Canister of Zyclon B.
(Photo: Courtesy of Heather Joseph-Witham).

Figure 7. Marina's tattoo: Images of Flames and Death.

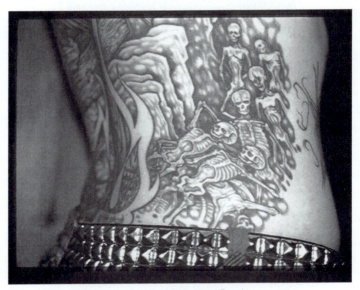

Figure 8. Marina's tattoo: Images of Flames and Death.

a dove, and an eagle within the snake circle. For Thomas, this "Jewish" image symbolizes the Garden of Eden and the balance that must be maintained.

Thomas obtained his tattoos for reasons relating to his spiritual and aesthetic identity. First, he views them as beautiful and sees the wearing of them as having changed him tremendously. Further, he knows that these symbols identify him as Jewish. As the yellow star was placed on Jews almost seventy years ago in Europe and numbers were placed on those in camps, Thomas has chosen to mark himself instead of being marked by others against his

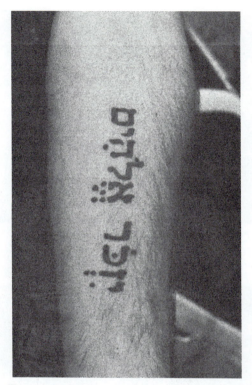

Figure 9. Thomas's tattoo: *Yizkor elohim* (remember God or may God remember). (Photo: Courtesy of Heather Joseph-Witham)

Figure 10. Thomas' tattoo: Snake Circle. (Photo: Courtesy of Heather Joseph-Witham)

will. Sander Gilman says that visibility brings with it true risk.[24] Thomas wanted this risk. He says that part of the reason is that he does not look Jewish and often denied being Jewish to others while growing up. Now, however, he's out there and visible. Like Marina, he has upended these symbols and embraced them, choosing what he views as irony over propriety. He says the Holocaust was demoralizing, but that it is time to evolve from that and choose to wear these symbols. "It's a good time to be Jews, so let's celebrate it." Further, he claims to accept most Jewish tenets and says, "I'm not here to challenge tradition. I'm just asking for tradition to accept me."

All these young Jews have decided that assimilation and invisibility, in vogue during their parents' generation, will not work for them. Their chosen form of visibility can obviously cause conflict because, despite its increased popularity, tattooing is still viewed as a deviant practice by many. However, nominal deviance and a need to be seen as an individual are trademark Generation X desires. For some of these informants, tattooing is in keeping with their age group, and for others it is within the interests of their folk groups and various affiliations. As Arnold Rubin states, "The uniquely personalized visual results of these highly individualized explorations have been characterized as comprising the hallmarks of a 'new tribalism,' a bond of aesthetic elitism which cuts across considerations of class, sex, and age."[25] They also tattoo to fit into neotribalistic social groups, to fulfill psychological needs, to create fantasies on their bodies, to meet aesthetic drives, to commemorate issues, to teach, and to express their Jewish and other identities. There is no real conflict for them to be both Jewish and tattooed. These individuals are drawing upon multiple sources to create their identities. Each is including expressions from American popular culture, neotribal groups, their generation and friends, and Jewish culture when constructing their personal and physical identities. Likewise, they demonstrate a different religious value system, as they are altering the signs and symbols of Judaism with their tattooing. The tattoo has always been an iconoclastic symbol, and these individuals embrace the irony of being Jews with tattoos. Thus, the very act of wearing the tattoo and the meanings of the tattoos themselves gain an even more extreme and rebellious status.

Tattoos are personal constructs their wearers create due to the unique environment in which they live. While tattoos are personal,[26] they are also public symbols meant for public consumption. Even when hidden beneath clothing, they are on the surface of the body and meant to be seen at times.

Thomas Schiffer notes that the ability of Jews to adapt to the cultures in which they live is part of the success of the Jewish people. Because he is

[24] Gilman, *The Jew's Body*, 236.
[25] Arnold Rubin, "Introduction: Contemporary Euro-America." *Marks of Civilization: Artistic Transformation of the Human Body*, Ed. A. Rubin (Los Angeles: U.C.L.A. Museum of Cultural History, 1988), 207.
[26] Gananath, Obeyesekere, *Medusa's Hair; An Essay on Personal Symbols and Religious Experience* (Chicago: The University of Chicago Press, 1981).

Jewish, he does not want to be solely American, but he wants to practice his own Americanized interpretation of his religion in his own way. In *Saving Remnants,* a book about American Jews, Bershtel and Graubard state, "Jews in America today are a people not 'chosen,' but choosing. This is true for the least affiliated as well as the most observant."[27] This type of choice is demonstrated aptly by these Jews with tattoos. As Thomas says, "I'm still a Generation X kind of person. . . . I inherited not only a religion that's 5,700 years old but I've also inherited automobiles, the consciousness of the day, the media. I'm a victim of the times, but I choose not to be a victim by identifying who I am."

[27] Sara Bershtel and Allen Graubard, *Saving Remnants: Feeling Jewish in America* (New York: The Free Press, 1992), 300.

NOTES:

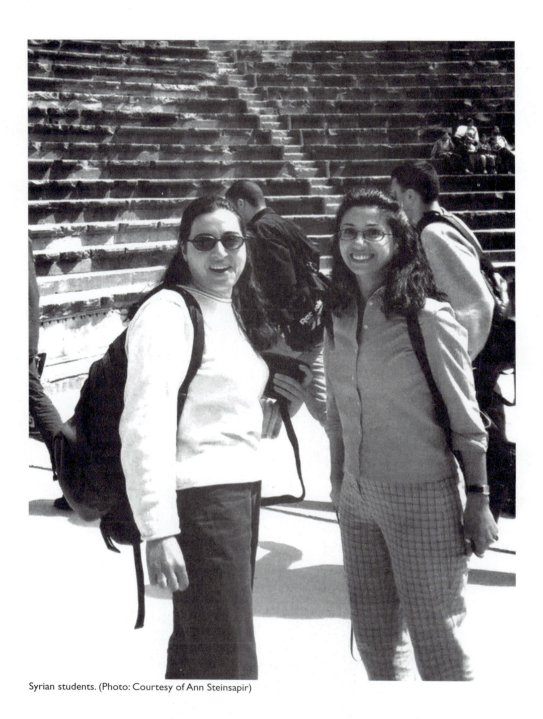

Syrian students. (Photo: Courtesy of Ann Steinsapir)

Who Am I? Who Are You? Inflected Dress in Syria

Ann Steinsapir

When you think of how women dress in the Middle East, what do you visualize? Do you see long black robes expertly concealing a body beneath, matching black veils covering heads and faces, and only downcast eyes revealed to the world? Do visions of these women seem to float in their anonymity—all identity obliterated because of fundamentalist religious views about women?

If this is your vision, you are wrong. In many Middle Eastern countries, women's dress is colorful, richly textured, even dazzling. It is also tasteful and sophisticated. In Beirut, for example, if it were not for the Arabic script used in signage, you could think you were in Beverly Hills, California. Girls parade in various styles revealing as much of their young bodies as possible, while their mothers sport the latest saucy fashions from Europe.

Syria also furnishes a feast for the eyes of the fashion observer. Both the countryside and ancient cities such as Aleppo and Damascus are backdrops for a variety of dress unmatched anywhere else in the Middle East. Syria has retained many of its traditional customs because of its political history. Unlike its neighbors, it has had a stable government for over thirty years, with the rule of the Assad family. Syria is inward looking with solid borders and a strong government policy of policing its people. This fosters a conservative attitude toward change and a pride in tradition. At the same time, Syria has had a long interaction with European powers from the time of the French protectorate in the 1920s, so there is a sophisticated and educated elite who look toward the West for intellectual and cultural inspiration. Though access to outside media and the Internet is controlled, the allure of Western popular culture is present albeit frowned upon officially. The combination of these attitudes makes dress in Syria a wonderful mixture of the traditional and the modern. The nuances and subtlety of the messages of women's clothing are especially rich.

In Syria blood relationships, clan membership, and familial ties to place are the dominant factors in creating identity. In the Syrian countryside, dress can be an assertive expression of ethnic identity. Druze women from the Hauran, a region south of Damascus, wear black dresses that cover their bodies to mid calf, but cleverly placed darts and pleats reveal the female form beneath. Women's heads are covered with white lace scarves, giving them

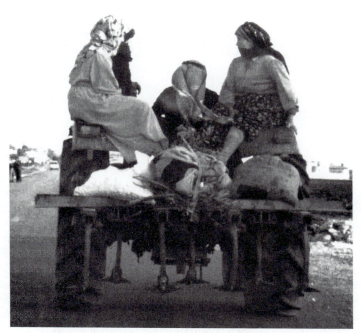

Figure 1. Syrian cart women. (Photo: Courtesy of Ann Steinsapir)

a prim, wholesome appearance. The style seems to have been conceived with their husbands in mind, as the men accompany them wearing all-black, short jackets and pants. The pants are constructed with ample space around the hips and thighs with fabric hanging loose from the crotch to the tops of the knees, then tight over the calves. Men cover their heads with a small black pillbox-like hat. Their moustaches are particularly lush, usually curling up at the ends with a bit of braggadocio, belying their taciturn and serious demeanor. The Druze have had an uneasy relationship with the Syrian government for years. Their clothes have gone slightly beyond an announcement of clan identity: They are expressions of political solidarity, too.

Women from the countryside in other regions of Syria also dress to exhibit pride in their family origins, though with less political overtones. Dress is often linked to local craft and availability of a particular fabric. Although the beautiful silks shot with gold thread, shimmering satins, and textured damasks of *A Thousand and One Nights* have given way to synthetic material, women still opt for the colorful. In eastern Syria, in villages along the Euphrates, women wear long shifts that hang from their shoulders, sometimes beautifully embroidered at the yoke and loosely belted at the waist. They cover their heads with multicolored scarves and usually have some identifying tattoos on their cheeks or chins. This "marking" is done when they reach puberty, to announce their new status as young marriageable women, but it also identifies the tribes to which they belong. Women from

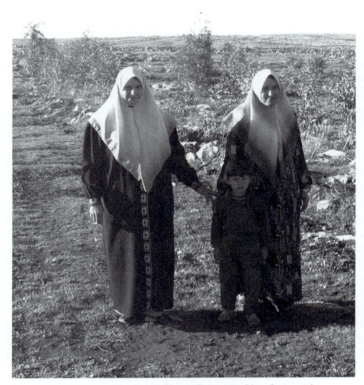

Figure 2. Syrian women in fields. (Photo: Courtesy of Ann Steinsapir)

other regions also dress to display their ethnic connections. Their loosely hanging dresses are made of brilliantly decorated floral patterns or dazzling red, magenta, and turquoise velveteens, sateens, or other shimmering fabrics. The dresses often create startling combinations of texture, pattern, and color that are wondrously effective against the backdrop of the rich, fertile countryside (Figures 1 and 2).

The Syrian style of dress is based on practical as well as religious concerns. Most of the women in the countryside are Muslim, but even in villages that are predominantly Christian, women adhere to the local custom for dress. Loose clothing makes movement easy as women perform their endless household chores. Head covering keeps their hair out of the way and relatively clean when working in the fields. It also protects the skin from the sun.

In Syria, dress is highly charged with social meaning. When women from the countryside come to the city to buy provisions or to sell their wares, they remain dressed in the clothes that display who they are within their social group and where they are from. This is one of the keys to understanding clothing in the Middle East. Dress is not a means of personal expression but rather signals where a woman fits within the intricate web of clans, ethnic groups, and religious sects. It locates a woman's place in Syrian social hierarchy and indicates her marital status.

But how do city women, whose families have lived in Damascus or Aleppo for generations, dress? One of the most charming experiences to be had when walking in Syrian cities is beholding the mixture of people and the variety of their dress. It is a treat for the eyes to look at the textures and patterns of fabric, as well as the variety of women walking together, some covered, some uncovered. Here, too, a woman's clothes signify her social position, her family identification, and her religion.

Traditions in the urban Muslim community vary significantly. In many cases, young single women in the cities dress like their sisters all over the world. Since there is a lot of interaction between the sexes in the larger cities, girls dress to attract attention. Most often, young single women wear slim-fitting pants with tops that cover their arms while following the curves of their bodies. Some, but not all, Muslim girls will put on the *hijab* head covering.

Young married Muslim women usually adopt the *hijab*. More conservative women and girls also can be seen in their street clothes covered with a long coat that is light colored in the summer and dark in the winter. The coat protects the women's bodies from the inadvertent gaze of unrelated males.

Style of dress in the cities has implied links to political expression, as it does for the Druze. The *hijab*, for example, is not proscribed in the *Koran* and seems to have developed out of traditional local styles. I have noticed in the seven years that I have been visiting Syria that more and more young women are adopting the *hijab*. I believe this is linked to recent events, both globally and regionally. The head covering serves as an outward sign of Muslim solidarity for women.

Women from the different Muslim sects are also represented in the city streets. Iranian Shi'ite pilgrims and Saudi tourists, for example, are covered from head to foot. Their faces, hands, and feet often are hidden in black, and their bodies are concealed in voluminous robes, making them look like moving soft sculptures. They look slightly out of place in the city, where even Syrian Shi'ite women do not adopt such stark clothing but choose to wear colored hijab and overcoats. Ironically, the outward covering often conceals elaborate hairstyles and the latest fashions, meant for private visual enjoyment in women-only occasions. As is done all over the world, the clothes underneath have been chosen to impress other women and flaunt status and wealth.

Jewelry is a means by which status is publicly displayed. On Fridays, the Muslim day of rest, women in the countryside wear their gold, usually bracelets. Some women have so many bracelets that they nearly reach their elbows. This is their personal wealth. In the cities, big jewelry — necklaces, rings, bracelets — is one way girls and, especially, married women show off their social position and wealth. Jewelry is also the way Christian women announce their religious affiliation, often wearing large gold crucifixes around their necks. In a country where clothing has the added significance of displaying community and religious membership, wearing religious jewelry is one way by which Christian women can join the Syrian parade of identity.

In Syria personal adornment is subsumed to religious, geographic, and tribal identity. So when I am asked what I wear when I am in Syria, I respond

Figure 3. Photo of the author Ann Steinsapir in Syria wearing modest dress for a Western women. (Photo: Courtesy of Ann Steinsapir)

that, for the most part, I dress the same way that I dress when I am in the United States. I am sensitive to the idea that dress is a way by which I communicate who I am: a woman from a Western country. I do not want to misrepresent myself and thus lose out on this significant way of displaying where I belong culturally and socially. When I am doing research in the countryside, I wear what the villagers expect a Western woman scholar to wear: khaki pants and a T-shirt. I used to wear a Norma Kaminski straw hat as a sunshade, but it tended to blow away and I spent precious time chasing after it! So now, in a concession to local practice, I have adopted a scarf wrapped into a turbanlike head covering because it is practical: It absorbs sweat and protects my head from the sun (Figure 3).

In the city, I wear what is appropriate for a professional married woman. When I do errands around town, I dress casually depending on the weather. It snows in Damascus in January, and temperatures can soar to 100°F in June. If I am lecturing or meeting professional colleagues, I wear a suit and understated jewelry: just a wedding ring and watch. I do not cover my head, except to protect myself from rain or sun or when entering a mosque. To do otherwise would somehow misrepresent myself and who I am. I am not Muslim, and I am not Syrian. Thus, in either the city or the countryside, I become one of the costumed players in the theater of the Middle East, where actors need not utter a word to communicate an infinite variety of information. Sadly, my part, the tall, blond westerner, is becoming more and more the role of the villain in recent years.

Photo collage of frum clothing. (Illustration: Kathryn Hagen)

Toward a Seamless Identity: Frum Fashion and the Experience of American Jewish Women

Kerri Steinberg

The possibility of *frum fashion* would appear to Jews of various denominations to be an oxymoron. *Frum,* understood as a colloquialism for *pious,* simply does not conjure associations of fashionably dressed women, or men. Within modern Jewish life, however, clothing and fashion, the needle trade and the garment industry, have occupied distinguished positions in both the real and fictionalized accounts of European and American Jews. Take, for example, the legendary figure of the doting, if overbearing, Jewish mother of the Eastern European *shtetl* (ghetto) who lovingly sewed, knitted, and insulated her children with extra layers of protective clothing as a defense mechanism against a hostile environment beyond the inner sanctity of the family home.[1] These same women often took up sewing to boost family income while supporting their scholarly husbands, whose study of Jewish texts was paramount.

For many contemporary American Jewish women, including those who have been raised in modern Orthodox homes, fashion functions as a semiotic demonstration of both their acculturation within American society and, more generally, the compatibility of Jewish orthodoxy within mainstream America. Indeed, in a country where the cult of the individual—a cultural construct in itself—pervades much social and political discourse, fashion offers both a means of identification with and differentiation from a particular collective. But what happens when traditional religious doctrine—Jewish, Muslim, or other—dictates a particular dress code to women who still desire to use their outward appearance as a manifestation of their uniqueness? This essay aims to examine Jewish acculturation and adaptation in America through the prism of fashion. It investigates how observant Jewish women straddle two seemingly incompatible spheres—the sacred and the profane—as they endeavor to

[1] See Benjamin Schlesinger, "The Jewish Family in Retrospect," in *The Jewish Family: A Survey and Annotated Bibliography* (Toronto: University of Toronto Press, 1971), 12.

147

fortify their ties to the larger religious Jewish community and assert their claim for recognition as distinct individuals. Two Web sites—www.4Modesty.com and Tznius.com—provide an abundance of illustrations.

In America, difference itself has become commodified, such that the plethora of choices exhibited by the advertising and ready-to-wear industries are equated with freedom. As Americans, religious Jews must balance the competing signals of unrestricted freedom they receive from the larger secular environment and the mandate of conformity proffered by the more insulated religious community. Whereas American culture and society encourage individuals to stand out and display themselves as unique, Jewish tradition encourages them to sublimate their individualistic impulses to blend into a more spiritually elevated collective. To assess how fashion Web sites cleverly negotiate the conflict posed by religious and secular expectations, we must first examine the standards of *tznius,* or modesty, in the context of Jewish Orthodox belief and practice.

According to the strictest interpretations of *tznius,* observant women must cover their extremities from head to toe. This requirement is pictured in the loose-fitting, unrevealing fashions featured in the *4Modesty.com* and *Tznius.com* Web sites. Essentially, skirts and dresses should be long enough to cover the knees when seated. High-necked blouses or sweaters are designed to cover the elbows, and opaque stockings cover the lower calves. Shoes of a comfortable and practical nature most often complete the ensemble. Traditionally, a married woman designates her status by covering her head with a *sheitel,* which may consist of a cotton scarf or wig. More fashionably inclined women might opt for a stylish hat or wig or might choose to tie their head scarves in a variety of ways, some of which are reminiscent of hair styles. While the religious requirement of *tznius* might appear restrictive from the point of view that associates style with self-expression and emancipation, according to the late Lubavitcher Rebbe (Rabbi) Menachem Schneerson,

> [The] Torah teaches us that we are not to change our mode of dress. Moreover, retaining our Jewish dress code will not cause us to lose favor and respect among our non-Jewish neighbors. Quite the contrary, the nations among whom we find ourselves will realize that we are a people who sticks to our principles. And even if doing so may sometimes prove difficult, we are not frightened by this, for we realize that by observing our Jewish dress code, observing *tznius,* we preserve our identity, guaranteeing our strength and existence as a nation and as individuals (Figure 1).[2]

Rabbi Schneerson's words implicitly valorize a sense of Jewish self-marginalization through adherence to a traditional dress code, which intends to preserve the sanctity of the Jews and to mitigate against the possibility of their assimilation and secularization. As Irving Levitz, professor of social work and psychology, reminds us in his essay "Jewish Identity, Assimilation,

[2] Rabbi Menachem M. Schneerson, *Beautiful Within* (New York: Sichos in English, 1995), 6.

Figure 1. Illustration of frum sheite.
(Illustration: Kathryn Hagen).

and Intermarriage," modern secularism is a humanly constructed, rationally based belief system, which "not unlike religion, includes normative assumptions, expectations and ideals, that provide the standard and context of acceptable human behavior."[3] Inasmuch as modern secularism posits humans as the measure of all things, we are, in theory, free to choose for ourselves our own personal goals, social and political ideals, and the lifestyle that best suits us. Herein lies the fundamental conflict between Jewish customs and religious beliefs and secularism, for from the perspective of traditional Judaism, men and women do not determine the standards of acceptable conduct; rather God does.[4] As such, personal preferences must be subdued—even surrendered—to a divine imperative. Ironically then, the most appropriate exercise of personal volition in an open society structured

[3] Irving Levitz, "Jewish Identity, Assimilation, and Intermarriage," in *Crisis and Continuity, The Jewish Family in the 21st Century* (Jersey City, NJ: KTAV Publishing House, 1995), 83.

[4] *Ibid.*, 84.

upon the ideals of pluralism and universalism is to *choose* the path of obser-
vance, thereby rejecting the humanistic concept of individualism. Ultimately,
as Levitz claims, "Individual growth and development [are] measured by how
successfully the will is conquered and the submissive posture attained."[5]

Surely this is no easy task in an open, voluntaristic society, such as Amer-
ica, whose democracy coheres around the possibility of choice and individ-
ual representation.[6] Aware of the centrality of fashion, particularly in the
urban metropolises where observant Jews have historically clustered, reli-
gious leaders aim to inspire women to uphold the standards of modesty and
not to succumb to the dictates of fashion by reminding them that they ra-
diate a sanctity that identifies them as *Bas Yisrael*—daughters of Israel—
when they wear clothing in the spirit of *tznius*. Accordingly, they both ex-
ude and inspire respect as they distance themselves from the realm of the
profane.[7] And in so doing, they overcome such insidious threats to their
achievement of sanctity as narcissism and what sociologist Norman Linzer
has labeled a "quantified time orientation," that functions to compartmen-
talize time, thereby severing the present from the past.[8] In other words, by
rejecting the secular emphasis on au courant fashions, observant women
choose to reinscribe themselves within a historical continuum of traditional
Jewish existence.

Conversely, as the article "When Fashion Is Eloquent, What Does It Say?"
claims, when religious women use their clothing to make a fashion statement,
they implicitly raise the ideals of the designers and manufacturers above their
own.[9] The frum fashion Web sites, such as 4Modesty.com and Tznius.com,
thus help observant women to overcome the collision between religious and
secular fashion imperatives by offering them modest, though fashionable attire
that signifies their religious priorities. In fact, 4Modesty.com identifies itself as
a site "dedicated to searching for clothes that reflect the modest values of
women, with FASHION weaved [sic] through the garment." Reflecting tradi-
tional (Halakhic) Jewish thought, 4Modesty.com concluding statement re-
veals, "The less you show of your body, the more you are communicating how
special you are. Our goal and mission [are] to supply you with choices."

[5] *Ibid.*, 84–85.

[6] It is important to note that in America the notion of choice, like the cult of the in-
dividual, is equally constructed and illusive. For more on this, see John Berger, *Ways
of Seeing*, (London British Corp. Broadcasting) and Roland Marchand, *Advertising
the American Dream.*

[7] "When Fashion is Eloquent, What Does It Say? Making Way for Modernity
1930–1940 (Berkeley: University of California Press, 1985). What Does It Say?" in
The Jewish Observer, Vol. XXIV, April 1991, 39. In answer to the question posed by
the title of this article, the reader is reminded that if she succumbs to the latest fash-
ion fads, her clothing may be making statements on her behalf that she surely would
not want "heard."

[8] Norman Linzer, *The Jewish Family: Authority and Tradition in Modern Perspective*
(New York: Human Sciences Press, Inc., 1984), 65–66.

[9] "When Fashion Is Eloquent, What Does It Say?," *The Jewish Observer*, 39.

Here, the operative word is *choice*. Indeed, such a concept, which is inextricably linked to the authority of the individual, would seem to indicate an adaptation of traditional Jewish religious belief to accommodate modern American values. Ironically, however, the distance between traditional Jewish values and American individuality may not be as great as one might initially suspect. In fact, taking into consideration the general purpose and context of fashion advertising and retail giants like The Gap, in particular, we are reminded how modern American consumers are continuously thrown a pitch of choice and difference, with an ulterior agenda of conformity. Indeed, the 4Modesty.com Web site acknowledges its consumers as modern subjects stating,

> A woman of the 21st century is very tight on time. There are more responsibilities than ever with family development, career advancement and community service. If there was a place in the universe a woman could visit, shop on her time schedule, get information on the latest trends and then make an informed buying decision, *life would be a little easier!*[10]

This passage recognizes the necessity and ability of these women to multitask in their roles as mothers, professionals, and community service providers in response to the demands imposed upon them by modern America. The 4Modesty.com site aims to simplify the lives of these busy women by affording them the opportunity to shop online and conveniently from their own homes. While the requirements of *tznius* certainly limit the fashion choices available to observant women, the frum fashion Web sites and the products they advertise nevertheless provide an occasion for exercising some measure of personal preference when it comes to self-fashioning. And it is precisely this window of opportunity—albeit narrow—that appeals to religious consumers, who wish to participate in the culture of consumption provided by life in America. Moreover, this self-fashioning, even if illusive and caught in an overarching ethos of conformity, is entirely consistent with the American cult of the individual and its emphasis on advancement—exactly what brought more than two million Jews to America from Eastern Europe between 1880 and 1920.

After first stepping onto American soil, many Jewish immigrants quickly found their way into needle work and the garment industry. According to Barbara Schreier in her pathbreaking study *Becoming American Women: Clothing and the Jewish Immigrant Experience* 1880–1920, those immigrants who came to America at the turn of the twentieth century, arrived at a critical juncture in the history of the ready-to-wear clothing industry.[11] Having labored as tailors and milliners prior to emigration from Eastern Europe, many immigrant women were ideally suited to supplement the family income in America by parlaying their skills into the burgeoning garment industry of New York City's Lower East Side. In fact, it has been suggested that it was the confluence of cheap immigrant labor and the still novel sewing machine that served

[10] www.4Modesty.com retrieved at August 14, 2005.
[11] Barbara A. Schreier, *Becoming American Women: Clothing and the Jewish Immigrant Experience, 1880–1920* (Chicago: Chicago Historical Society, 1994), 68.

Figure 2. Frum active wear.

to underwrite what some have called a "Jewish industry."[12] Schreier notes a 1902 issue of the *Jewish Daily News,* which highlights how Jewish women were able to appreciate the best clothing because they labored in the needle trades and garment industry.[13] Anzia Yezierska's semiautobiographical novels also provide ample evidence of the pivotal role played by clothing in the acculturation of immigrant Jewish women.[14] Even earlier, however, during the middle of the nineteenth century, Jews of Central European origin, such as Isaac Magnin, Solomon Gump, and Levi Strauss managed to parlay their peddling businesses into thriving factories and department stores.[15] So it was that Jewish livelihoods and ready-to-wear fashions were to become as complementary as America and apple pie.

[12] See Howard M. Sachar, *A History of the Jews in America* (New York: Vintage Books, 1993), 145–147.

[13] Schreier, *Becoming American Women,* 66.

[14] For more on the centrality of clothing in the process of Jewish Americanization, see Christopher N. Okonwo, "Of Repression, Assertion, and the Speakerly Dress: Anzia Yezierska's *Salome of the Tenements*" in *Melus,* Spring 2000.

[15] See Howard M. Sachar, "The Germanization of American Jewry," in *A History of the Jews in America,* 58–59.

Figure 3. Photo collage of Barbie in
frum dress. (Illustration: Kathryn Hagen)

Over the last 150 years then, Jews have accommodated themselves to
life as Americans by immersing themselves in the fashion and ready-to-wear
business, using these areas to transform themselves and to enter mainstream
America. Jewish-feminist scholar Sylvia Barack-Fishman identifies this ten-
dency in American Jews as *coalescence:* "a pervasive process through which
American Jews merge American and Jewish ideas, incorporating American
liberal values such as free choice, universalism, individualism, and pluralism
into their understanding of Jewish identity."[16] In fact, Barack-Fishman at-
tributes the emergence of product advertisements, such as those marketed

[16] Sylvia Barack-Fishman, *Jewish Life and American Culture* (New York: State Uni-
versity of New York Press, 2000), 1.

on the 4Modesty.com and Tznius.com fashion Web sites, as evidence of the phenomenon of coalescence, which might otherwise be analogized as a syncretic response to Jewish life in America.[17] Clearly, the Shabbat "Just Do It" sweatshirt offered on Tznius.com, which simultaneously conjures associations of the active sportswear leader, Nike, its agent, Michael Jordan, and Jewish observance, underscores a profound compatibility between American youth culture and observant Jewish youths (Figure 2). However, the modest doll clothes marketed on the Ms. Modesty Web site, which are downsized to fit a Barbie, signal just how deeply the American emphasis on consumption has been absorbed by the religious Jewish community and further indicate how the inculcation of an American/Jewish coalescence begins during childhood (Figure 3).[18]

From the turn-of-the-century needle trade to postmodern virtual boutiques, it seems that fashion runs through the veins of American Jewish women. Becoming American women during the early years of the twentieth century, as Barbara Schreier explains, "implied neither a willful abandonment of everything associated with the Old Country nor an unquestioning acceptance of everything American."[19] The frum fashion Web sites considered in this paper represent an updated twenty-first century effort by religious women to walk a tightrope between fitting in and standing out, both as Jews and as Americans. A recent article, "Fashionable Orthodox Walk the Runway Less Traveled," captures the exquisite synthesis of American and religious imperatives offered by fashion. Following an observant woman, Esther Rosen, while she wanders the streets of Soho, we are informed by the writer that she fits in perfectly among all the artsy types in the area because she has cultivated her own personal style.[20] The article goes on to state that "creativity has united observant women throughout the centuries of Judaism."[21] Creative interpretations of *tznius* enable Orthodox women to step in and out of their secular and sacred worlds. They are testimony to the adaptation strategies and resiliency that have enabled Jewish people to thrive in the Diaspora, especially in America. Long in measure, ample in resolve, the fashion forecast for American Jewish existence reads strong and steadfast.

[17] *Ibid.*, 1, 139.

[18] It is worth noting that Barbie, regarded by artist and critic Rhonda Lieberman as the "ultimate *shiksa* (non-Jewish) goddess," is the 1959 invention of a Jewish woman by the name of Ruth Handler. See Rhonda Lieberman, "Jewish Barbie," in *Too Jewish: Challenging Traditional Identities* (New Brunswick, NJ: Rutgers University Press, 1996).

[19] Schreier, *Becoming American Women*, 66.

[20] Lisa Keys, "Fashionable Orthodox Walk the Runway Less Traveled," in *Forward*, September 13, 2002.

[21] *Ibid.*

NOTES:

Marsha Hopkins and shackles. (Photo: James Stiles)

My Bangles

Marsha Hopkins

Jewelry is not always what it seems. People have different reasons for wearing different pieces of jewelry. Most of the time it is because it is in fashion, but many times it's just sentimental. It could be your grandmother's wedding ring or your mother's bracelet or your dad's cuff links. Football players wear Super Bowl rings out of pride; it shows what they have accomplished. This leads to another reason that people wear jewelry: It's a way to show how much wealth has been accumulated since many cultures use this as a measure of a person's wealth. There are other reasons.

My grandparents were born in Barbados and moved to Jamaica, where my father was born. My grandmother told me that wearing bangles was not a sign of wealth as it was in places such as India. Bangles represented the shackles of slavery; open bangles were broken shackles. I wondered why she and my aunts didn't wear bangles. It seemed to be a tradition from her country. I didn't ask the question, and she didn't offer a reason.

I acquired my bangles one at a time. Some are gifts; some I purchased myself. I wear them as a reminder that my people were once enslaved. I wear twelve to represent the twelve months of the year. Some of the bangles are broken circles to represent broken shackles; some are still whole to represent the shackles that are still present in the minds of some people. My bangles ensure there are no shackles on my mind. I only take them off to be cleaned; otherwise they are on my arm at all times, a constant reminder of enslavement, of freedom.

In the twenty-five years that I have worn these bangles, they have gone in and out of style. I have had to replace them from time to time, as they wear out, but the fads don't affect me. It's alright if others don't know what they mean. They are for me.

Debra Ballard wearing one of the Kimono jackets that has become a signature element of her professional wardrobe. (Photo: James Stiles)

Fashion Matters: Reweaving an Asian Cultural Identity

Debra Ballard

As a mature (arguable), professional (educator), Asian-American (with a dash of Irish) woman, I often find myself attempting to balance and blend aspects of my identities in several ways (often parenthetically), one of which is with clothing. I also am aware of the delicate boundaries between notions of myself and the fashions I choose as a site of both internal and external identity construction.

As a Sansei growing up in the early sixties on Staten Island, then and still a rural suburb of New York City, my conceptions of Japanese clothing came mostly from an Issei grandmother's gift: a beautiful, intricately adorned kimono-clad porcelain doll. The Japanese court dolls that my Nisei mother cherished, my father's gifts from his many trips to Asia, the kimono-clad wives of my father's business colleagues, my father's business (Asian textile imports), and, of course, the movies informed my awareness of Japanese fashion. Despite my attraction to the vibrant colors, textiles, and textures, the last thing I wanted to wear in my provincial, predominantly Irish and Italian post–World War II suburb was clothing that hinted even remotely at my Japanese heritage. My father's family had been interned during the war, a trauma that prompted my parents to try to make us "All American." Despite their well-intentioned efforts they were, however, doomed to fail. My father spoke in heavily accented English, worked for a Japanese company, and frequented the Far East on business trips. My mother dutifully tended the family (often serving two dinners, American fare for the kids and Japanese for my father), seldom venturing much outside of our small neighborhood because she never learned to drive. Most noticeably, we looked different and remained a combination of both foreign and familiar to our neighbors.

If "life must be viewed as a continuous socialization, a series of careers, in which old identities are sacrificed as new identities are appropriated. . . . each critical turning point of life is marked by a change of address" as Mary Ellen Roach-Higgins argues in *Dress and Identity*,[1] then my literal and figurative address change came as an adult. I moved to the much more ethnically eclectic Los Angeles, attended college (since my parents assumed my

[1] M. E. Roach-Higgins, J. B. Eicher and K. K. Johnson, *Dress and Identity* (New York: Fairchild Books, 1997), 65.

puzzling domestic ineptitude minimized my marital horizons), and married a man who enthusiastically supported my ethnic exploring. I took Japanese language courses, attended Japanese cultural community events, and generally tasted facets of Japanese culture I had entirely missed growing up on the East Coast. This included wearing kimonos.

The kimono, with its deep association as "the national costume of Japan," seemed an appropriate fashion path to encode my hyphenated identity. In her book *Kimono,* Liza Dalby argues that "No item in the storehouse of material culture maintains as strong a hold on the Japanese heart, mind and purse as the kimono. . . . love it or loathe it, the kimono evokes strong opinions."[2]

As with many things Japanese, the kimono, which originally simply meant *clothing,* was imported from China and came into use in Japan during the Heian period (794–1192). Through subtle differentiations of lines, lengths, colors, and textures, it came to communicate status, occupation, age, and gender. A social history of Japan can be traced through the changes in the kimono over a thousand-year period. However, it was during the Meiji period (Figure 1) (1868–1912) when Japan opened its ports to the outside world that the kimono took on its special national and cultural significance. With the introduction of Western clothing, the previously insular Japanese were confronted with an "other," and the kimono began to also function as a method of expressing and retaining a Japanese identity threatened by the invasive West.

The kimono came to the United States in the mid-nineteenth century. Americans have always had an interesting relationship with it as both clothing and art, generally seeing it as a transmission of the exotic, Eastern mystery, particularly from its depiction in such movies as *Sayonara* and *The Teahouse of the August Moon.* The media conveyed an image of Asian women as passive, exotic, erotic, industrious, and eager-to-please hyperfeminine objects who were nevertheless pretty much joyless and luckless.

Lapsing in popularity in Japan for a short period due to economic hardships after the war, the kimono enjoyed a postwar resurgence, although it had lost much of its significance in conveying multiple distinctions and hierarchies. Contemporary designers such as Anne Yuri Namba, Isse Miyaake, and Yohji Yamamoto have reinvented the kimono as fashionable and wearable art. This, along with a booming business in imported vintage kimonos, has increased the popularity of kimonos as a fashion commodity.

As a professional woman, I know that wearing the kimono involves a certain amount of reinvention and paradox: "Feminist detractors depict the kimono ideology as glorifying the feudal idea of women as powerless chattel."[3] In Japanese tradition, the sleeve length represents the age of the wearer (the shorter the sleeve, the older the woman). The restriction of movement in walking and sitting tends to render the wearer somewhat useless for anything other than appearance, promoting gender passivity

[2] Liza Dalby, *Fashioning Culture* (New Haven: Yale University Press, 1993), 65.
[3] *Ibid.,* 3.

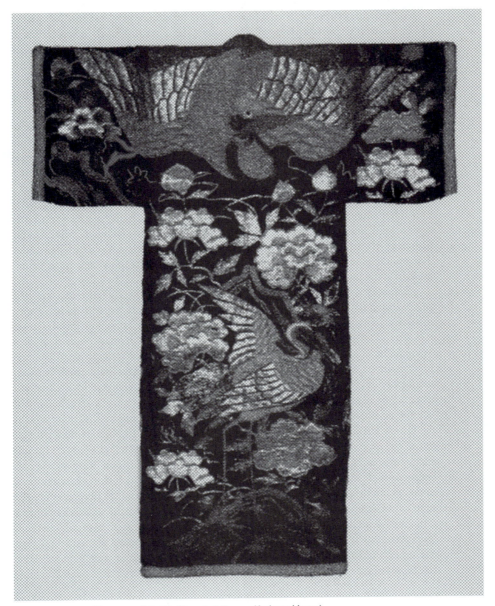

Figure 1. A typical kimono of the Meijii period. (Image: Kathryn Hagen).

through apparel. However, how I choose to wear kimonos at home and work allows me to redesign its symbolism. At work I wear either a shortened kimono or a haori, a kimonolike jacket that makes the kimono more businesslike and eliminates the mobility issue. I generally combine it with a turtleneck and pants or skirt, using it like a blazer.

My occupation brings into play a whole range of dress as identity issues. I am an administrator and faculty member at an arts college. Valerie Steele, the editor of *Fashion Theory* and chief curator at the museum of the Fashion Institute of Technology (The Museum at FIT) contends that "academics are still the worst-dressed middle-class occupational group in America."[4] However, not all academics are badly dressed, and they seem to occupy two camps: "pro-frumpy and pro-fashion."[5] The pro-frumpy faction worries that too much attention to fashion might indicate that they were not fully in pursuit of the life of the mind, an academic extension of peer pressure. "For some professors, dressing well might mean compromising the image of academic competence. . . . it might appear as if they are trying to make up for a lack of teaching skill."[6]

The pro-fashion faculty do not agree. Elaine Showalter, an English professor at Princeton University, "came out of the closet, so to speak, and admitted in *Vogue* magazine that she has a fetish for fashion. She waxed eloquent about her Cossack minidress and turquoise boots from Bologna. 'For years,' she wrote, 'I've been trying to make the life of the mind coexist with a day at the mall.'"[7]

Showalter is refreshing in acknowledging that dress and intellect are not necessarily exclusive interests. However, dress for female professors is a more complex activity than it is for male professors. "Women's clothing can become a factor in evaluation. Students, both male and female, may be critical of a woman faculty member's clothing. A man who dresses carelessly may be seen as 'eccentric,' a woman who is equally careless in her appearance will be seen as 'sloppy.' It is not unusual for women faculty to receive comments about their clothing in student evaluations, such as "Why don't you wear a dress?" or "I'd like to see more of your legs. You should wear shorter skirts."[8] Dress for ethnic female professors is wrought with additional hazards in achieving a professional balance. My ethnicity complicates my own occasional choice of kimono and haori (or Donna Karan or St. John) as work attire. One of Showalter's colleagues, Neil Painter, a black historian, believes that "the deconstruction of dress weighs particularly heavy upon minority professors. 'There is a special turn of the knife for racial and ethnic women.'"[9] The kimono, with its connotations of sexuality and subservience, risks diminishing my identity. Nevertheless, avoiding it entirely presents its own sartorial dilemma in assuming that there is a neutral position, or it sends the implicit message that I deliberately reject any hint of my obvious cultural heritage.

[4] Allison Schneider, "Frumpy or Chic? Tweed or Kente? Sometimes Clothes Make the Professor." *The Chronicle of Higher Education*. 23 January 1998, A12.

[5] *Ibid*.

[6] Emily Swatzlander, "Profs Duds Show Diversity." *The Post*, May 28, 1998. In Lexus Nexus. Retrieved June 7, 2005.

[7] Ibid.

[8] Allison Schneider, "Frumpy or Chic?," 14

[9] Bernice Sandler, "Women Faculty at Work in the Classroom: Or, Why It Still Hurts to be a Woman in Labor," August 2005.

Despite the complications and couture pitfalls, my use of cultural clothing has enabled me to comfortably express my hyphenated identity, weaving a patchwork of influences in a professional setting, though this identity is continually being culturally resituated. Recently, because kimonos have become so fashionable, popularized by the media and personalities such as Madonna, I have discovered yet a new interpretation reducing me to a "wannabe." I am occasionally uneasy that it could be seen as simply appearing fashionably multicultural or fashionably ethnic. I have some issues with this media appropriation. Yet it does attempt to blend multicultural fashion sensibility, and perhaps that is quite in sync with what I have always attempted to accomplish by blending styles. By using Japanese dress as a sign of both ethnicity and professionalism, I reclaim a part of my politically lost heritage using fashion to comfortably explore and express my gender, race, and identity.

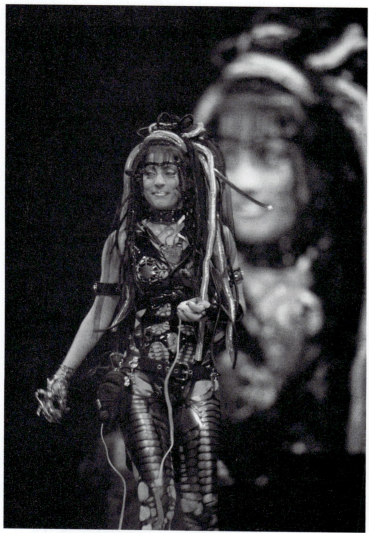

Psymbiote on stage at the 2005 Cyber Fashion Show. Her costume is designed by Jess Jarrell, DEvan Brown, and Isa Gordon of SintheteX and includes a laser cut latex suit, light-up heart rate monitor, voice-activated collar, and titanium data glove. Her wearable computer is from Charmed, and her head-mounted display from microOptical. (Photo: Karl Lang)

Cyberfashion

Kathryn Hagen and Parme Giuntini

"I am Psymbiote, your host this evening. I am a cyborg in training, an evolution in progress, the brain child and alter ego of performance artist isa gordon. With the accelerating integration of bodies and technologies, comes a future of high-tech fashion adornment: How might these trends shape us, enhance us and transform us?"

Isa Gordon, producer and narrator for
the Siggraph Cyber Fashion Show

So what, we may well ask ourselves, is the future of fashion? We are in a brand-new millennium, and technology is progressing at warp speed. Surely there is something more interesting and radical in our clothing future than double-knit leisure outfits, à la *Star Trek*. But the new couture of McQueen and Galliano is often a circus of gothic excess that has little to do with moving forward. Despite the illusion of innovation, they actually produce a dreamlike suspension of progress, mesmerizing the audience with recycled scenarios of outrageous spectacle. Nor is there much change in the insular world of ready-to-wear fashion. Most designers are still mining inspiration from periods as far back as recorded man, and the fabrics they use are much the same as those of hundreds of years before, despite the amazing innovations in textiles that offer designers and consumers a remarkable range of easy care and wearability options.

Since rayon was invented over a century ago, the "synthetic revolution" has transformed consumer expectations of clothing performance, especially in terms of easy-care, lightweight, durable, washable, and comfortable clothing for active sports and casual separates. 'Smart' performance enhancing apparel, like the Castelli YPRO3 Donna cycling short, constructed from special lycra, "hugs the muscles for compression while corrugated panels relax the hamstrings." Speedo's full-length Fastskin FS11 swimsuit reduces muscle vibration and drag so the body can glide more efficiently through the water. High-tech running shoes like the Spira Genesis ($130.00) have springs in the heels or gel padding for better cushioning for the whole foot.[1] Such innovations, however, lack significant relevance for high-end clothing which still depends on the aesthetic and tactile appeal of linen, silks, woolens, and cottons, along with natural furs and leathers. The appeal of these materials is embedded in their cultural image of expensive elegance much the way that natural diamonds carry a greater cachet of status than zircons. Nevertheless, the expectation of consumers spoiled by rapid innovation will be answered

[1] Vicky Lowry, "Pushing It," *Vogue*, Sept. 2004, 66.

by the inevitable technological progress of cross-pollination innovations between natural fibers and synthetics. For example, real leather can now be infused with lycra, giving better durability and fit.[2]

Despite the rocket speed of technological innovation, some basic factors about clothing design remain unchanged. For example, the basic structure of the body and its movements leave designers repeating the same silhouettes they have used for the last hundred years when women left their hoop skirts behind them. Meanwhile "Americanisms" like the jean and T-shirt have continually impacted traditional cultural dress, making these fashions a signifier of modern society.

Alternative visions have been offered. Designers like Andre Courrèges, Rudi Gernreich, and Mary Quant did succeed in creating an exciting sense of optimistic, Space Age modernism in fashions of the seventies (Figure 1). Courrèges' austerity, for example, had its roots in futurism, constructivism, and the Bauhaus, influences that inspired much of the original modernist output of the last century (Figure 2).[3] But in the intervening years, the postapocalyptic aesthetic of *Mad Max* and *Blade Runner* resonates more with

Figure 1. 1966 chemise by Pierre Cardin.

[2] Wendi Winters, "Science Fiction or Reality: Fibers and Fabrics Trends," *Quantum Step, Inc.*, courtesy of *FGI Bulletin*, May, 2000.

[3] Valerie Guillaume, *Courrèges*, (New York: Assouline Publishing, 2004), 8.

Figure 2. Nicole Hagen modeling a Rudi Gernreich knit dress, ca. 1970. This garment is part of the Otis Archival collection. (Photo: James Stiles)

our anxious postmodern society. Such nihilistic fashion mirrors the confused morality of our fast-lane culture and the climate of national concern and tangible distress following 9/11. How valid are utopian visions to a global society plagued by a growing awareness of war, unremitting third-world poverty, political disenfranchisement, and the potential for global epidemics, all of them brought to you courtesy of ubiquitous mass media. Some postmodern designers like Martin Margiela and Rei Kawakubo have put a more thoughtful spin on fashion evolution and utilized their collections to address larger philosophical issues which are not customarily the domain of fashion. Addressing the future in terms of decay, Margiela displayed eighteen garments in a Rotterdam gallery in 1997. Infused with spores that literally disintegrated the fabric in a matter of weeks, he dramatically emphasized the fleeting nature of youth and aesthetic beauty.[4] By fetishizing the transience of fashion, they continually refer to its castoff past.

[4] Rebecca Arnold, *Fashion, Desire and Anxiety*, (Rutgers Press, 2001), 60.

Figure 3. This 2000 ad for fashionmall.com typifies internet advertisements for online shopping. Many websites include such features as zoom-in for closer examination of fabrics and details and the ability to change different colors to make it easier for customers to purchase without seeing or trying on the actual garment.

Self-destruction and societal decay cannot be the only realistic responses to futurist queries. Despite the lack of vacation trips to Mars, many sci-fi scenarios are essentially in existence today. Technology is the underpinning of our culture, and the potential for genuine fashion reformation is inherent in this revolutionary landscape. Certainly the growing popularity of Internet shopping has transformed retail practices, much the way the globalization of labor has restructured manufacturing. The web provides a forum for alternative designers, but innovations in production and retail do not necessarily bring radical changes in design (Figure 3).

Nevertheless, quiet progressions are taking place that signal a potential for transformation. If the term cyberfashion evokes expectations of revolutionary change, perhaps complex functionality is the arena in which that genesis can take place. The idea that clothing could actually serve humankind in critical domains having little to do with status or conspicuous wealth is, arguably, a radical notion. Despite dissension as to the severity of future environmental crises, there is little doubt that the fragile human body is under

siege, with everything from sun exposure to pollutants, to crowding, to water shortages. Smart clothes are one solution. Affordable garments designed to protect and even guide us through the pitfalls of so-called "civilized existence" would arguably have wide appeal.

What might this all mean? Imagine, for example, a beautiful tailored jacket that was also "smart," automatically responding to changing body temperature, able to warm or cool the wearer and ensure the right degree of comfort while releasing a subtle but consistent wave of a chosen scent? Such technological features are already in development at companies like The Science Fashion Lab®, which "brings together the disciplines of analytical chemistry, nanotechnology, perfumery and fashion design to be the pioneers of 'Scentsory Technology.'" Their project Scentient Beings explores the new science of aroma delivery focusing on smell and the impact it has on health and well-being.

Future researchers working in nanomedicine will likely collaborate with designers to create clothing that can detect a variety of medical conditions, offer protection through deliverable medication, and connect the wearer to necessary services such as doctors and paramedics. Much like medieval knights donned protective armor, we will dress according to our vulnerabilities. Imagine an asthmatic being able to wear a jacket or blouse that can automatically detect an attack before it occurs and deliver medicine through microtubes built into a collar. High-tech underwear will sense ovulation and identify early stages of cancer and diabetes. A jacket lapel will monitor the wearer's breath and e-mail the doctor when they are under the weather.[6] Not only will clothes monitor health, they will help us navigate the environment using a variation of GPS navigation that is now customarily found in satellites and automobiles. What a boon for skiers, hikers, and ultramarathon runners who wander off track to have access to parkas, jackets, and running shorts equipped with nano-sized instrumentation to guide them home. For the blind or sight-challenged, garments could carry a personalized radar system that would alert them to objects and provide precise information to avoid obstacles.[7] This would be clothing that could literally save lives. These are important options that will change the motivational structure of consumers.

Is there a downside to a fashion future irretrievably tied to technology, the kind that follows you around, recording, surveying, monitoring, helping. . . perhaps helping too much? While few would object to techno-fashion that protects a heart patient at risk or delivers critical medication, there are other applications that raise issues far more problematic. An early innovator in Cyberwear, Dr. Steven Mann proposes the incorporation of video surveillance into a variety of garments, a system that he entitles

[6] Jenny Tillotson, "From Science Fiction to the Science Fashion Lab," http://www.smartsecondskin.com/main/sciencefashionlab.htm, retrieved June 17, 2005.
[7] A program called BlindVision provides this feature. This would also be enormously helpful for cyclists and other athletes who sometimes need extra help seeing what is around that next corner.

"sousveillance."[8, 9] Based on his belief that corporate and government surveillance has reached a dangerous level, he argues that souveillance-wear would empower us to play the same game, recording those who survey us.[10] Such issues project formerly trivial fashion options into a highly politicized arena that might well transform the landscape of the "rag trade." They also resonate with the concerns raised by Foucault and the role of surveillance in the modern world and Barthes' admonishments over the validity of photographic truth.[11] On the one hand, hasn't fashion always played a role in deception and disguise, camouflaging our flaws and providing a psychological safety net in public and private spaces? On the other, does sousveillance-wear mean that we must change our assumptions about personal, social, and political safety? Does wearing an assortment of embedded technological devices heighten our anxiety about our inability to function in the so-called "real world?" Finally, what are the consequences for fashion which has historically been focused on style and aesthetics in a future world in which what we wear is driven by technology and functionality? Is fashion fated to be little more than a vehicle for an increasing array of technologies? Is this a moment for the postmodern Luddites of the world to unite?

If you are reading this dressed in your jeans, T-shirt, and hoody, these questions may seem anachronistic, but they present issues that the millennial generations will arguably have to address. In some cases, the prototypes for apparel that includes this kind of technology exist already, have in fact,

[8] The term is derived from a combination of the French word *sous* meaning under as a replacement for sur meaning "on" in the word surveillance. The exchange of sous for sur is intended as a play on the function of surveilliance in public spaces in which the surveyed assumes the same position as the surveyer.

[9] "Dr. Steve Mann is regarded by many as the inventor of the wearable computer (computing being distinct from special purpose devices like ordinary wristwatches and eyeglasses, etc.), and of the EyeTap video camera and reality mediator. Dr. Mann has been inventing, designing, and building wearable computers for more than 20 years, dating back to his high school days in the 1970s. He brought his inventions and ideas to the Massachusetts Institute of Technology in 1991, initiating, what was to later become the MIT Wearable Computing Project. He also built the world's first covert fully functional WearComp with display and camera concealed in ordinary eyeglasses in 1995, for the creation of his award-winning documentary Shooting-Back. He is also the inventor of the wristwatch videophone, of the chirplet transform (a new mathematical framework for signal processing), and of the comparametric image processor." University of Toronto Website, http://www.eecg.toronto.edu/~mann/, Retrieved July 28, 2006.

[10] Steve Mann, "Sousveillance." Inverse Surveillance in Multimedia Imaging," Dept. of Electrical and Computer Engineering, University of Toronto, Toronto, Canada, mann@eecg.utoronto.ca.

[11] For more information on these topics, see Michel Foucault, *Discipline and Punish,* trans. Alan Sheridan (New York: Vintage Books, 1977) and Roland Barthes, *Mythologies* (New York: Routledge, 2003).

Figure 4. Psymbiote adjusts her HDM, the miniature monitor from which she reads the Cyber Fashion Show script. (Photo: Brandon Porter)

marched down the runway, been photographed, documented, but not necessarily shelved. In August 2004, Siggraph[12] hosted the fourth annual Cyber Fashion Show, produced and choreographed primarily through the vision of Isa Gordon. Transformed into a stunning "cyborg host" called Psymbiote, she also was the emcee for the show (Figure 4).[13] Visually referencing futuristic sci-fi and Japanese anime action heroines, Psymbiote wore a suit of titanium, latex, silicone, and electronic apparatus with a fully integrated

[12] ACM SIGGRAPH is an International Conference on Computer Graphics and Interactive Techniques, which has met annually since 1974.

[13] Dr. Manfred Clynes [b. Vienna, 1925], an eminent neuroscientist, coined the word "cyborgs." His concept of a cyborg was of a symbiosis between a person and a machine, creating an interaction that would enhance life, such as a man and his bicycle, but in other pursuits, such as space travel. (This original meaning has been corrupted in the age of *Terminator* movies.) Steve Mann is often considered the grandfather of modern cyborgs, the first to wear his computer on his body in the 1970s.

Figure 5. Model on the runway of the 2005 Cyber Fashion Show showing "Medulla Intimata," responsive video jewelry by Tina Gonsalves and Tom Donaldson of CLUTCH, worn with underground couture vinyl set from the SintheteX collective. (Photo: Andrew Strasser, Model: Tiffany Trenda)

control system animated with movement, sound and light, and activated by manual triggers, automatic body processes, and remote control. As her website explains, she seeks to transform herself into a seductively organic yet entirely unfamiliar hybrid organism.[14] The runway show itself, however, featured the latest cybergear from all over the United States, including an array of garments with fashion and technological appeal that could easily slip into a closet today (Figure 5, 6, and 7). The show presented everything from an audio cyber-jacket that played specific sounds reflecting the location of the wearer to a sound-reactive "hear-wear" garment that created moving light patterns built into the fabric.[15] One motorcycle jacket changed light patterns every few seconds, enabling the rider to remain visible after dark;[16] another model wore

[14] *Psymbiote: Hybrid Apparatus for Social Interface;* an evolution in progress, www.psymbiote.org, retrieved August 12, 2005.

[15] www.absurdee.com/HearWear, retrieved August 12, 2005.

[16] The maker, Charmed Technology, was the first company to commercially produce a wearable computer, the "charmit" that Psymbiote wears.

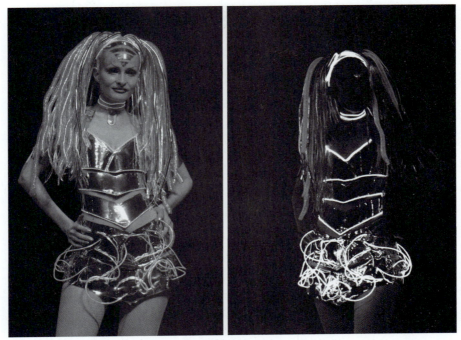

Figure 6. "Chrome Girl" by Annissë Designs is a 3-tier top and 2-tier skirt adorned with battery-powered electroluminescent wire (or "EL wire") in clear vinyl tubing. Model: Shannon Evans. (Photo: Karl Lang, Model: Shannon Evans)

a shirt filled with beads that massaged the wearer's shoulders and back.[17] Even the ubiquitous T-shirt was transformed by the addition of an electronically embedded device that provided an individuated text message across the front. Such an array of technological wonders encouraged the audience to think about clothing in a very different way (Figure 8).[18]

Though this technology is in its adolescent stages and has yet to make a solid connection with the fashion industry and the mass market, the applications already available provide a convincing argument that computerized clothing is in our future and, perhaps, in more extreme ways than we can imagine. Procedures like subdermal or transdermal implants, where clothing is literally connected electronically to the internal body, could blur the line between humans and machines and may well challenge, if not change, a future notion of what constitutes fashion.

[17] See http://www.news.cornell.edu/releases/Dec02/smart.jacket.ssl.html, Jenny Tillotson's www.smartsecondskin.com, and ICT/Anthrotronix's scent necklace)

[18] In preparing for the 2005 Cyberfashion Show, Isa Gordon has found the number of companies exploring this technology has grown exponentially, and that the level of sophistication in the designs has also greatly increased.

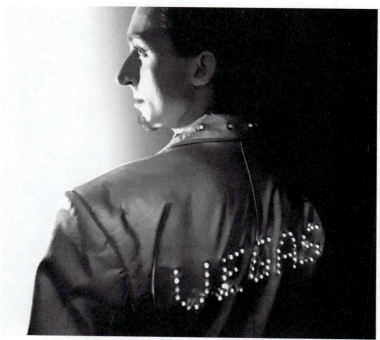

Figure 7. Model wearing silver leather "Vegas Suit" designed by Janet Hansen of Enlighted Designs. (Photo: Greg Passmore)

The reality, virtual or otherwise, is that we do not know and cannot predict what future societies will demand in the way of aesthetics and function.[19] The visual culture of sci-fi films and literature is equally conflicted. In unreal and sometimes disturbing future worlds, figures walk around in a variety of garments; sometimes identical, skin-tight uniforms that emphasize an essential shift towards androgyny while in other scenarios, the fashion choice reflects medieval dress and elaborate costuming as well as contemporary styles. In the 1970s, designer Rudy Gernreich predicted the death of fashion, and yet nearly 40 years later, clothing design is still a viable force. Spectacles like the Cyber Fashion Show may be just

[19] Jaron Lanier coined the term "Virtual Reality" and in the early 1980s founded VPL Research, the first company to sell VR products. In the late 1980s, he lead the team that developed the first implementations of multiperson virtual worlds using head-mounted displays, for both local and wide area networks, as well as the first "avatars," or representations of users within such systems. While at VPL, he codeveloped the first implementations of virtual reality applications in surgical simulation, vehicle interior prototyping, virtual sets for television production, and assorted other areas.

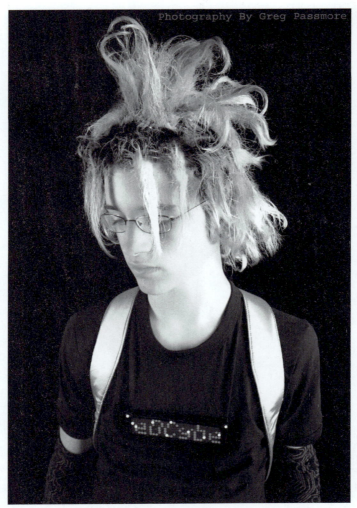

Figure 8. Model wearing "Red Alert T-Shirt" by CyberDog UK. (Photo: Greg Passmore)

another runway extravaganza intended to generate audience interest and provoke controversy. . . or we may be standing on the threshold of what fashion in the future will and must be, unable to recognize its ultimate potential.

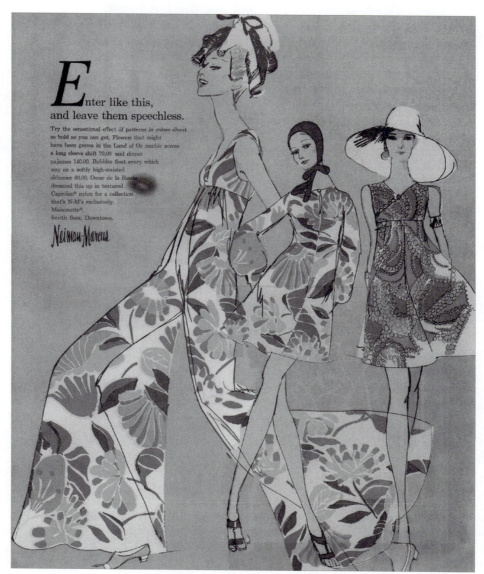

Enter like this, and leave them speechless.

Try the sensational effect of *patterns in colors about as bold as you can get*. Flowers that might have been grown in the Land of Oz ramble across a long sleeve shift 70.00 and dinner pajamas 140.00. Bubbles float every which way on a softly high-waisted skimmer 60.00. Oscar de la Renta dreamed this up in textured Caprolan® nylon for a collection that's N-M's exclusively. Maisonette®, fourth floor, Downtown.

Neiman-Marcus

Fashion illustration for Neiman-Marcus. Fashion illustrations were originally drawings that were reproduced in newspapers. This practice was eventually discontinued in favor of photographs. (Illustration: Jackie Doyle)

Part III Fashion and Visual Culture

Advertisement for designer Henry Duarte who supervised the creation of this image in his studio.
(Photo: Courtesy of Henry Duarte)

Fashion and Visual Culture

Parme Giuntini

Our culture exalts fashion, and fashion reciprocates, magnifying and glamorizing the ordinary and extraordinary. Such a mission is a worthy one for any art form, high, low, or their aggregate.

Richard Martin[1]

In 1993, when designer Calvin Klein convinced rapper Marky Mark to be photographed for a forty-foot billboard in Times Square wearing his "tighty-whitey" underwear, Klein revolutionized fashion advertising and turned designer briefs into a sales phenomenon. Such is the power of the right image in the right place at the right time. We live in an image-saturated world. Our dependence on readily available visual information increases daily, but that availability comes with its own set of complications about the truth, the value, and the relevance of images. Visual culture surrounds us, and, whether it is contemporary magazine advertising or an Old Master's oil painting, on the monumental scale of the Calvin Klein ad or in the portable ease of an iPod, we invest those images with significant power. Their capacity to affect us is always "dependent on the larger cultural meanings that they invoke and the social, political, and cultural contexts in which they are viewed," but those same contexts often conspire to present the image as neutral, truthful, and transparent.[2]

Living in a postmodern world dominated by visual culture demands a highly nuanced navigation and negotiation process that is neither natural nor fixed. On the one hand, we are supposed to rely on the truth of the X-ray and the body scan because of their association with medical science and technology. These images carry a high truth value, and we learn that dismissing them is irresponsible and, therefore, flies in the face of rational behavior. Likewise, we have been taught to associate the fine art image with the discourse of the aesthetic object. These images occupy protected spaces: galleries, museums, and the arena of art criticism. On the other hand, we are supposed to question the truth value of advertisements, films, television, and photographs

[1] Richard Martin, "Calvin Klein Culture," *Art Issues* (January/February 1996), 14–17.
[2] Marita Sturken and Lisa Cartwright, "Practices of Looking: Images, Power, and Politics," in *Practices of Looking: An Introduction to Visual Culture* (London: Oxford University Press, 2001), 25.

because of their ability to be manipulated, their association with retail, entertainment, and political or cultural agendas. Images pose an ongoing dilemma. Living without them is inconceivable; living with them involves an increasingly uneasy tension between the twin demands of skepticism and belief. The contemporary visual culture of fashion and clothing intersects with these concerns in significant ways. The context of visual representation influences the ingrained cultural attitudes that we have about clothing, fashion, and fine art. An Isabel Toledo gown in a Barney's catalogue signals an expensive retail commodity; that same gown in a museum show is framed as an aesthetic object much like that Old Master's oil painting.

Talking about clothes as material culture differs from talking about the representation of clothes and fashion in visual culture, and it is important to clarify the discursive grounds of this conversation. Costume and fashion historians typically focus on the garment itself: its design, construction, material, historical development, function, and influence. Because textiles are fragile, historical garments are accorded the same degree of conservatory care as manuscripts; they are handled carefully by professionals, stored and displayed under archival conditions. They are no longer "just clothes" but rather historical artifacts with the potential to bridge gaps in our understanding of earlier cultures and societies. They are framed as the authentic object, the quintessential representation or description in images or texts. Although pictured in a painting, a photograph, or a drawing, the representation is secondary to the physical garment itself, which occupies the primary field of study.

By comparison, visual culture is emerging from several different fields of study—most typically art history, cultural studies, and critical studies—and arguing for the critical investigation of the power of images to construct and inform culture in all spaces and all mediums. This approach is equally interested in the examination of the narratives and technologies that organize and maintain hierarchies among images as the learned and naturalized viewing responses of the audience.[3] What we see and how we learn to privilege different kinds of images, the spaces in which that seeing occurs, and the responses that different categories of images engender challenge the traditional authority of fine art as the most significant mode of cultural production and open the door to the powerful influences of popular culture, mass media, and entertainment. If our ways of seeing, categorizing, and valuing images are culturally learned and historically specific, then it is mandatory that we pay much closer attention to what genuinely influences our attitudes, beliefs, and positions.

The predominance of fashion in visual culture is associated with commercial advertising, a range that encompasses everything from magazine ads to television commercials, from industry-specific publications to high-end brochures, from catalogues to Internet websites. The aesthetic qualities, compositional complexity, and innovations achieved in advertising are acknowledged within the design industry, less so for the public that is culturally

[3] Nicholas Mirzoeff, ed., *The Visual Culture Reader,* (London and New York: Routledge, 1998), 18.

conditioned from childhood to associate advertising images with commercial gain and popular culture, not issues of design. Nevertheless, we operate in a contemporary society in which advertising constantly informs us of what we want and need to buy. Our dependency grows daily; our critical responses to the visual culture of fashion advertising must keep apace. Much like rearranging merchandise in a store, advertisers are continually changing their approaches and manipulating images and text. While the industry agrees that advertising works, there is disagreement on what works best or how consumers actually make their choices. Effective advertising often uses associative methods to promote a product—a marketing technique that links the product with a set of qualities, values, outcomes, or perceptions, some of which are not market goods.[4] The long-running magazine ad for Eternity perfume featured a close-up shot of an elegantly gowned and coifed bride juxtaposed with a small boy dressed in a white, Eton-style suit. Although the ad was not intended to sell wedding gowns or formal children's clothing, its success depended on consumers associating specific fashion elements—the white gown, veil, and ring bearer suit—with connotations of love, serious commitment, a formal ceremony, and marital success—outcomes that are neither market goods nor possible to guarantee.

Rather than a blunt call to buy that consumers associate with straightforward merchandising and, consequently, can dismiss more easily, associative advertising offers a more appealing approach. It shifts the consumer's attention from the ad's explicit content—buy this pair of shoes—to its implicit content—what these shoes will do for you.[5] These are the broad messages about consumer lifestyle that can address an unlimited arena of present or latent desire, of which the now stereotypical advertising cliché "Sex sells" is an example. Associative advertising has also resulted in increasingly more sophisticated ads that, in return, engender a more astute audience with definite opinions about what is and is not successful. As Michael Phillips humorously notes, contrary to public belief, the advertising industry is stabbing in the dark more often than performing microsurgery on the public consciousness.[6]

Most contemporary fashion advertising has adopted the associative model. Newspapers and websites still favor fairly straightforward layouts of clothing and accessories, but magazines and catalogues typically showcase their merchandise within thematically designed scenarios, employing complex compositional and photographic techniques to create dramatic images that often limit the ability to clearly see the garment but, nevertheless, heighten its appeal because of the intended connotations of the image.

A mere fifteen years ago runway shows were unabashed exhibitions of new collections: Models walked down the runway for the express purpose of showing the clothes to an audience primarily composed of high-end

[4] Michael J. Phillips, *Ethics and Manipulation in Advertising: Answering a Flawed Indictment* (Westport, CT: Greenwood Publishing Group, Inc., 1997), 109.
[5] *Ibid.*, 26.
[6] *Ibid.*

Figure 1. Cher in pirate costume, 1995. (Illustration: Bob Mackie)

fashion magazine or industry publication editors, newspaper writers, and store merchandise buyers. Today, runway shows are entertainment spectacles. Often televised and highly photographed, they are increasingly replete with special effects that can be as outrageous as some of the garments modeled. Publicists, fashion writers, and celebrities dominate runway audiences now; articles and photographs appear in popular and general interest magazines, television shows, and websites. As for the clothes—well, it's not about clothes anymore: It's all about style.[7]

Fashion visual culture permeates every form of mass communication and entertainment. Partially the consequence of exorbitant magazine advertising cost, it is also a pragmatic surrender to a postmodern culture that

[7] Michelle Lee, *Fashion Victim: Our Love-Hate Relationship with Dressing, Fashion, and the Cost of Style* (New York: Broadway Books, 2003), 94.

defiantly refuses to limit fashion's authority to any specific site or author. Consumer audiences are as apt to look to film and television for fashion information, new trends, and styles as they are to flip through a magazine. Although not necessarily filtered through any official fashion voice, the message is frequently more persuasive because of the context in which it is delivered and received. We rarely think of the female news anchor as a fashion statement, but we certainly understand the connotations around her choice of a tailored suit: Serious subjects demand serious clothing. We no longer expect female lawyers or executives to wear navy blue or black skirt suits after nearly a decade of television series in which courtroom dramas, gender politics, and style all have demonstrated that power and success are equally compatible with high fashion and provocative designs. The shift in television and film studios from designing and constructing garments to buying them ready-made has not only boosted the brand-name appeal of individual designers, but also has heightened the fashion or antifashion message of clothing by implicating it within a greater narrative. Even when specific style trends run a short course, such as the fashion for full-length, black leather coats in the wake of the popularity of films *The Matrix* and *Shaft*, it is impossible to deny the powerful influence that entertainment and mass media have to shape popular fashion tastes and establish trends.

Celebrities have replaced models, becoming the new fashion icons in magazines. The public expects to see them on the cover and to find heavily illustrated stories about them in the feature pages. Emulation, lifestyle, and retail are the new trinity. The veracity of this fashion information is updated weekly to inform consumers impatient to know and anxious to imitate. Everyone seems to win: The designers and manufacturers whose products are featured, the celebrities who benefit from continual mass coverage, and the consumer who has access to personal information on public figures. Highly visible celebrities can create a trend or promote a design line overnight simply by being photographed with a different handbag or a new pair of jeans. Their willingness to buy, wear, or favorably comment on fashion has rapidly become the requisite seal of approval, and their presence in mass media, including entertainment, far outstrips any serious fashion commentary.

Although photography is the medium most associated with the contemporary visual culture of fashion, it is not the singular force. Designer illustration is another area of visual culture that is now largely confined to the industry despite a long history in commercial work.[8] Designers typically use illustrations to develop and create their own collections and as portfolios to communicate with potential employers, pattern makers, salespeople, buyers, the media, and advertising (Figure 1). In college and university fashion departments, illustrations are the primary vehicle students and faculty use to convey creative ideas. Although part of contemporary design curricula and

[8] In spite of the fact that these could also be called *fashion illustrations,* we use the term *designer illustration* to differentiate this form of fashion drawing from that of commercial advertisements.

studio practices, the beautiful and masterly fashion drawings that once graced newspaper and magazine ads disappeared in the 1980s when they were replaced by photography and, now, by digitally manipulated images.[9] Lord and Taylor was one of the few retailers that continued to employ fashion illustrators such as Jim Howard, but it was a battle fought and lost on economic and technological terms, rather than purely aesthetic ones.

The shift that occurred from pencil and paper to photography and computer-assisted design represents more than a change in medium.[10] The photographic image carries a greater association of objectivity, the now familiar myth of photographic truth. Whatever empirical information a photograph presents denotatively, it never escapes the cultural context and connotations in which it circulates, including the other images that it references in a continually expanding visual matrix. Because so much of the visual culture of clothing is associated with retail advertising and entertainment, there is a tendency to dismiss it as commercial and self-promotional rather than to recognize the crucial role that the representation of clothing and fashion plays as an appropriate vehicle of serious social or artistic commentary. What happens when designers challenge those assumptions and consciously argue for a greater representation with the discourse of fashion, visual culture, and art?

The boundaries of fine art are guarded by an elitist discourse that frames the object as aesthetic, the gallery/museum space as sacred, and the fine artist as unique among other cultural producers. Although historically fine art has been commissioned, bought, and sold from artists who often have functioned as their own brokers and dealers, and despite the fact that galleries have a genuine commitment to making money, the language and conventions of the fine art world are never couched in the commercial or competitive vocabulary of the marketplace. Instead, fine art is distinguished by a discourse of aesthetics, creativity, and personal expressiveness, which have traditionally served to identify and separate the artist from the designer.

For contemporary fine artists, using fashion, clothing, or textiles in their work is acceptable artistic practice and provides viable mediums for creative expression. This is the case with artists such as Jane Goren and Jacci Den Hartog who have embraced fashion as a critical part of their artistic thesis. For example, Goren's collages literally incorporate specific garments, such as underpants, into the finished piece. Painters and sculptors have a long history of using clothing and fashion in their work, although contemporary artists are more interested in developing stronger symbolic or critical references through

[9] There are a few exceptions. A mini regeneration of fashion illustration has recently occurred in some European magazines, in particular the French and Italian editions of *Vogue Magazine*. Occasionally, fashion illustrations will be featured in American editions of high-fashion magazines. The work of Ruben Toledo, a well-known illustrator, regularly appears in monthly fashion ads.

[10] Computer-assisted design (CAD) refers to specific software that allows the designer to create using the computer as a tool. For example, a hand drawing can be scanned into the system and then further manipulated, or a designer can literally execute the entire process from inception to completion in the computer.

these elements. More problematic is the work of ceramic artist Joan Takayama-Ogawa whose whimsical Tea Bags offer astute commentary on both her Asian-American heritage and female concerns with beauty and consumption. Glowing with deep jewel tones and gold trim, such precious objects are not always accepted as sculpture and often find themselves categorized as decorative art.

The contested space between fashion and fine art is not so easily traveled by designers. Some such as Martin Margiella and Vivienne Westwood have ventured into the protected world of the pure white cube. In both personal and professional statements, they present their work in strictly creative terms, often using their designs to make powerful and critical social, political, and aesthetic comments rather than offering their garments as grist for the retail market.[11] Their creations—objects in textile form—have a markedly aesthetic focus, and these designers periodically function much like gallery artists, producing small collections of exclusive clothes, some of them one-of-a kind designs with little, if any, utilitarian value.

This is, arguably, difficult terrain to breach, but design in all forms and its representation in mass media and popular culture have already challenged the hegemony of fine art as the dominant influence of contemporary culture.[12] If, as we have argued, the ubiquitous presence of clothing and fashion in visual culture offers a credible claim to the construction of identity in postmodern society, then what is blocking the acceptance of fashion and designers in the fine art world? Perhaps the answer lies in a model offered by Adrian Piper, who critiques the fine art world as a market power structure and notes that it marginalizes African-American women artists. Piper argues that there is no universal position on excellence for art but that there are gatekeepers who determine and categorize those allowed into the circle of exclusivity. Without fair and equitable exposure to galleries, group shows, and museums, African-American female artists are unable to attract attention from art critics, reviewers, or art historians whose published work in respected journals and major newspapers establish credibility for the fine art world.[13] Piper's model offers an insight into a structural apparatus that may undermine the seriousness of any designer's foray into the protected world of the pure white cube. The influential role that fashion plays in visual culture lends validity to inclusion within the fine art world. Designers are not asking for recognition as fine artists, but those who have elected to make aesthetic or cultural statements that transcend commercialism should not be ridiculed. As Richard Martin notes, "The role of fashion is interjectory across culture: It permeates rather than pontificates. Fashion inherently involves everyone in a visual campaign that is never exclusive, always ingratiating, and influential."[14]

[11] See Kathryn Hagen, "The White Shirt [Deconstructed]," *Garb*, 111.

[12] See "Interview with Dave Hickey," 225.

[13] Adrian Piper, "Out of Order, Out of Sight," in *Selected Writings in Art and Criticism*, vol. 2, 1967–92 (Cambridge, MA: MIT Press, 1996), 161–173.

[14] Richard Martin, "Calvin Klein, Culture," 14.

Bob Mackie sketch selection at Otis College of Art and Design, School of
Fashion. (Photo: Courtesy of Otis College of Art and Design)

Interview with Bob Mackie

Kathryn Hagen

The entertainment medium of television has been a phenomenon since the middle of the previous century, when it first entered people's homes in vast quantities. Though the first pictures were in black and white and the first color shows made actors look like orange pumpkins, people have embraced the visual form and never let go. In terms of the various and vast influence it exerts and the sheer volume of hours that most people spend in front of their multiple screens, nothing can compete with it. The original form of live television had an immediacy that is lacking in the edited and reedited shows of today and especially in the so-called "reality series" that simulate some kind of warped truth.

Robert Gordon Mackie was born in Monterey Park, California, in 1940. Though he began as a sketch artist for film, he has made a career designing for glamorous women, largely on television. His clients have included such notables as Tina Turner, Carol Burnett, and even Mattel's Barbie. He is probably best known for designing the costumes of singer/actress Cher, whom he has dressed since the early seventies. When Cher appeared on the cover of *Time* magazine in March 1975, she was wearing a Bob Mackie gown. In 1982, Mackie turned to ready-to-wear and established Bob Mackie Originals.

Bob Mackie has been nominated for fifteen Emmys and won seven. He designed costumes for six films between 1967 and 1983, gaining three Academy Award nominations. In 1999, the Costume Designers Guild awarded Mackie the Achievement in Costume Design Award for the year. The Fashion Institute of Technology in New York held a retrospective exhibition of his work that same year.

Kathryn (K): Can you talk to us about your background leading up to your career?

Mackie: I actually was designing when I was a kid. I didn't know what I was doing, but I was designing—going to a lot of movies because I wanted to be a costume designer. I was never particularly interested in film, except for its influence on what I wanted to do. When I got out of high school, I was an art major at Pasadena City College, and I managed to get a scholarship to Chouinard. It was a wonderful school, and they had a costume department. I studied there for a couple of years, but I left before I graduated and started working with Edith Head, Jean Louie, and different designers in Hollywood, doing their sketches. My strongest area was sketching, and it

really opened doors. So I worked for a lot of different people. I was kind of the new kid on the block in those days. At first, when anyone was sick they called me. But soon I was being called in for special kinds of projects, and some designers would literally let me design. They would just tell me what it was, what the producer was thinking, "Draw some things up. I'll be back after lunch." You know? Which was the way I loved it. There were others who would draw it all in pen, then I'd have to do a big color rendering. But when they let me design, it was a good way to test if people liked what I did.

K: So which type was Edith Head?

Mackie: Well, Edith was a true executive. She had several people who worked for her doing sketches. She'd take a pencil and paper and scribble something—"Oh here, dear"—and you would look, and it would be four hen scratches. She was a smart lady, and she certainly knew when it wasn't right. But there were periods when she was doing six movies at a time, so it really was being an executive.

K: It sounds like you didn't have to struggle too much to break into costume design.

Mackie: No, not in that respect. But I thought I was struggling. I'd been out of school for several months and hadn't gotten a job. I was doing freelance work designing for the theater. I was also working at a restaurant doing dishes at night, so I wouldn't miss the job calls during the day because answering services weren't in my budget. I quit school in September, but I wasn't working until February. So I had a little bad time there when I thought, "Oh God, no one's ever going to hire me." But they did. Then I went into television.

K: How did you break into TV?

Mackie: I worked for Ray Aghayan as his assistant on the Judy Garland show, which was one year of chaos and wonderment because of all the amazing people who were on it.[1] They were having so much trouble with the

[1] Ray Aghayan (b. Iran, 1934] has worked for half a century on television, in film, and on stage. He did a brief stint as an actor and director but soon was designing costumes for live television at NBC (the three-year run of *Matinee Theatre* required a mere 13,000 outfits). In 1963, he was hired to design for *The Judy Garland Show*. He in turn hired Bob Mackie as his assistant, and a lifelong partnership was born. Aghayan has been nominated for nine Emmy Awards, winning twice. He was also instrumental in the 1960s in persuading the Television Academy to officially recognize the contribution of costume designers. He was nominated for Costume Design in 1969 for *Gaily, Gaily,* in 1972 for *Lady Sings the Blues* (with Bob Mackie & Norma Koch), and in 1975 for *Funny Lady* (with Bob Mackie). www.armeniandrama.org/people.php?p=ray-aghayan&a=z Retrieved August 4, 2006

Judy Garland made thirty-two feature films, received a special Academy Award, and was nominated for two others. She starred in thirty of her own television shows (the programs and Garland herself garnering a total of ten Emmy Award nominations) and appeared as a guest on nearly thirty more. Between 1951 and 1969, she fulfilled over eleven hundred theatre, nightclub, and concert performances, winning

show that they kept changing producers and choreographers; as a result, I met all these amazing people! And we did wonderful work on that show.[2]

K: How was Ms. Garland?

Mackie: Well, she was great—and she was horrible. She was fabulous and unprofessional. You never knew what you were going to get. When somebody really good was on, then she competed with them, and she was incredible. But sometimes she'd just be crazy, because of what she took or didn't take. It was kind of stressful, but also a great learning experience.

K: Did you have any hesitation about working in television versus film?

Mackie: No, because I was most interested in doing musicals. The studios had almost stopped doing those kinds of films. The big studio system was closing down at that time, and the independents were coming in and renting space, so it wasn't great. I didn't see a big future in film for a kid of twenty-one or twenty-two. I remember thinking at the time, "Well, Edith [Head] is almost 65 so maybe she will retire." That's how stupid you are at that age, thinking you're going to step in and save the day. Edith worked till her dying day, literally.

K: And the studios stopped having regular designers?

Mackie: Well, Edith was the staff designer at Paramount. Unless you paid to use someone else, you got her. If she thought it was an important film, she did it herself, and if not, she'd just get it done the best possible way. I mean we were doing Elvis Presley crappy little movies and Jerry Lewis movies. But those were still important in their way. But I loved television. I loved the immediacy of it. It was more like the theater, which was what I really wanted to do, but I didn't have the money to go to New York. In television, you had a week to do the entire thing. You got it on, you got it finished, and then you went on to the next one.

K: You didn't get nervous with all that pressure?

Mackie: Not really. I was working under these incredible people who I still work with now. They kind of took me under their wing, and they could see I could do stuff, but I had the security of mentors who had years of experience. Like Pat Turner who I worked with for years and years on *The Sonny and Cher Show*. They were all ahead of me, so whenever I had a project I could ask them, "Do I do this . . . or that?" It wasn't so much about design as how to get it all done, so there was a lot of support. When I did start getting my own shows, I knew what I was doing.

a special Antoinette Perry (Tony) Award for the first of three record-breaking Broadway engagements at the Palace. She recorded nearly a hundred singles and over a dozen record albums; *Judy at Carnegie Hall* received an unprecedented five Grammys in 1962. She died at the young age of 47. John Fricke, *Judy Garland: World's Greatest Entertainer* (New York: Holt, 1992, 1997).

[2] The show was a critical success but did not score well in the ratings. CBS refused to move Garland's spot opposite *Bonanza* on NBC, one of the most popular series of all time.

K: What was your first show?

Mackie: I'm trying to remember. I split the credit with Ray Aghayan on many big shows at that time, because he was still doing movies during *The Judy Garland Show*. I did a *Bell Telephone Hour* that was probably my very first one, which went live to New York!

K: Sounds exciting.

Mackie: Oh, yes. There was no waiting till somebody was ready. You were either ready or you were not on. So it was exciting. I did a lot of those summer shows: *The King Family Show*, for example, which was really fun. They were a big musical family, including the King Sisters, and they were on ABC for a couple years, and I did that on my own. And then I did *The Hollywood Palace*. Then all of a sudden the 1960s became about youth—the "Youth Quake," they called it. And I was the youngest one around. I had the right haircut, the right suit. I just looked right. I knew about mod clothes, at least they thought I did. So I got hired for everything. Just kind of being the hot one, like certain stylists today who get hired for the grooviest videos because they look right. I knew that I could do it, so I got lots of good stuff. I did so many shows.

K: So when was the first one that was a regular weekly show?

Mackie: That would be *The Carol Burnett Show* in 1967. I had done weekly shows on summer replacement. I would do an opening number and a closing number, maybe a dress for somebody. It was fun to do because it wasn't that hard. You could go home at a regular time. Once you started doing weekly variety, you just went home when you got done. Which was usually very late Thursday night, because the show was on Friday, and these were huge shows.

K: So what kind of budgets did you have?

Mackie: There was enough, though by today's standards, it wasn't nearly enough. It wasn't great. If you had to do each show on its own for that amount, it would have been hard. But when you have twenty shows, one show can be less expensive, then the next one you'll go all out. It was a little hard that first year because you didn't have any stock costumes. But we did that show for eleven years. So eventually we owned tuxedos, all sorts of white pants, the girls had silver leotards, they had this, they had that, so you can use this and add a silver bustle, and so on. You can afford to do something fun to go with the basics you already have. We had an enormous number of costumes by the third year. We never had to worry about sets of shoes, sets of everything, because we had twelve dancers who could be in as many as four numbers in each show, plus the guests and all that. The workload was very hard, but when you have a lot to do, you just work harder and you do it and it becomes a habit. I get very bored when things start dragging now. I want to do it, get it done, and go on to the next thing. I hate contemplating "Shall I do this, shall I do that?" We never had time, you know? They would tape the shows on Friday, then they would hand me the script for the next week. So I'd work all weekend designing it and buying the fabric.

K: You would buy fabric?

Mackie: Well, yeah, then I'd throw it in the trunk of my car.

K: It had to be an enormous amount.

Mackie: You know, there weren't all the downtown stores there are now. We went to International Silks or Home Silks, or Beverly Hills Silks and Woolens. International carried the biggest stock of theatrical fabrics, and they would simply let you pick out what you wanted, send the whole bolt with you after measuring it; you'd use what you needed, then they would measure it again when you came back. So you never had to think about "Well, I need sixteen and one-half yards." You just had the whole bolt. It's the only way you'd ever get anything done.

K: And how big was your sample room?

Mackie: Huge, because we were doing so much. We had a cutter and cutting tables. We probably had four to five head people with more people under them, because we were turning out at least three big shows a week, plus Vegas shows and nightclub acts.

K: When you say "we," who do you mean?

Mackie: Well, it was Courtenay Costumes. It's down to nothing now, which is fine, because I do other things. But in those days there was so much going on. It was fun, but I don't know that I could do it all today.

K: So you would have drawings of costumes for all those people to work on?

Mackie: Well, you go and you show them what it is and you give them the fabric and within an hour they show you a pattern and you look at it and they cut it out quickly because the dancers are coming tomorrow. So we would be fitting the next day on the lady dancers, and by Wednesday Carol would be in for a fitting, and the guest stars would be in on Thursday. We'd finish fitting by Thursday night, and we'd have the finished costumes by early Friday for a run through without an audience. That was your only chance to change things.

K: What an incredible pace.

Mackie: It was crazy, because you'd have two whole shows with the audiences on Friday. We'd have to make two of everything.

K: Why two shows?

Mackie: Well, for editing down to the best. Today they go back on sitcoms and do retake and retake. We never did that. We did it like a live show. Only if something drastic happened, like a trick didn't work, we'd go back and do it again. On Friday night I could make a 9:00 reservation and always keep it. I think about twice we had to stay. They were that good, and it was that well rehearsed. The guest stars were a wreck, but the stock company, Carol and Vicki and Harvey were so good. By Wednesday, Carol would know all her lines. By Friday, she was amazing.

K: And you probably weren't dealing with a vain woman. Could you do what you wanted?

Mackie: Well, everyone is vain. But to get a laugh, she would do anything. We could dress her any way, fix her hair funny, and black a tooth out. And she would have the best time. On a show like that, she would have a dozen looks in an hour. If it took her more than five minutes to make a change, it was too long.

K: My favorite was the famous curtain rod scene—Starlett O'Hara (Figure 1).

Mackie: Oh yes, that was everyone's favorite. In all those shows we did so many for her. For us, that was just another scene, but people remember it.

K: Did you ever have a show that was a disaster?

Mackie: You always have those shows where the material isn't as good as it could be. You look at the clothes and thank God you have next week, because if that was the only week you did all year, you'd be dead. I mean it would be all right, but you'd be going so fast. Sometimes when you do that, it just comes out right off the top of your head and it's fabulous, but

Figure 1. Carol Burnett as Starlett. (Illustration: Bob Mackie)

sometimes you go "I wish I'd done this and this." Still, you do it fast, and you make it work. We had a pretty good record.

K: It was amazing.

Mackie: Anyway, I did a lot of television, a few movies. I was really busy through the 1970s.

K: And how was *The Sonny and Cher Show?*

Mackie: Well, they started in 1971, Carol in 1967, so the two shows overlapped. You know Carol Burnett was on for eleven years, Sonny and Cher for seven years. Cher was definitely more difficult, because she had more changes. Plus, they tried to squeeze in two shows a week sometimes.

K: I can't imagine that. Why?

Mackie: Because they would tour on the weekends.

K: Can you talk about the famous Cher gown for the Oscars?

Mackie: You mean the one when she won the Oscar? She never wanted to go on just wearing a gown. She had been there, done that. I had done some dresses for her early on that I thought worked well, but she wanted to top herself. She would get a lot of coverage as a result, so she would wear anything.

K: Do you miss that crazy aspect at the Oscars now?

Mackie: No, I don't. I mean I would have fun, but then I'd say, "Are you sure you want to wear that?" She'd say, "Shut up, and put some sequins on that dress" (Figure 2).

K: She knew what she wanted.

Mackie: Sure. But then people started thinking that was my fashion philosophy, which it wasn't.

K: So do you have a fashion philosophy?

Mackie: Well, I don't know. I do know that when you put someone in a getup you want them to look good. It is one thing to look wild and crazy, but if you don't look good, what's the point? Especially when it is a celebrity like that, because that is what they are selling. I just like people to look attractive. That is not asking too much. I mean I love to look at fashion right now. It's a little different, but interesting. But people on the street wear clothing that is so revealing—tight tees above the navel and really low-cut pants. They often look hideous. I know fashion is cyclical, but it can't swing too fast enough for me. I go to New York once a month, and I am shocked at what they are wearing. They are walking and pulling their clothes up or down. But that is what they are selling in the stores, and it's also peer pressure.

K: Who are your favorite designers now?

Mackie: I still like some of those old-timers. I think they still do pretty clothes, like Valentino, for example. I think Galliano is amazingly creative, but is it fashion or is it just getups? It's like fashion art, like creating an assemblage of stuff, and beautifully done. You know, when I think of those kids

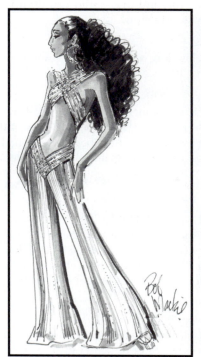 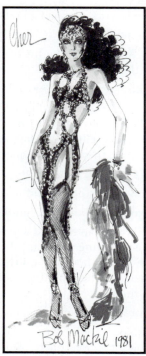

Figure 2. (Left) Cher in white jeweled costume. (Right) Cher in black beaded costume with fishnet hose, 1981. Bob Mackie continued to design for Cher, even after the Sonny and Cher show ended. (Illustrations: Bob Mackie)

[young designers] getting plopped into these couture workrooms in Paris. They can do anything, and they have incredible people to do it. Money is no object. But then do they do fashion or performance art? And as far as American designers go, Oscar [de la Renta] still does beautiful clothing. They're beautiful dresses, but they still have that something interesting. I don't know, maybe those are old lady designers, but I think they're awfully good.

K: They are chic.

Mackie: Yeah, they're chic and they're true to themselves. They're not trying to reinvent the wheel. I think that's always a mistake when you're trying to do something wacky and different. For example, I don't understand Mark Jacobs's last collection. Yes, it's innovative. I know someone said it would all look like that in a few years, but I don't think it's very pretty, or flattering. It might be different. Different is good for fashion magazines so they have something to show you, but different doesn't mean it's good.

K: Did you feel like a celebrity when you were doing those popular television shows?

Mackie: No, not a celebrity. In my field I was pretty well known, and doing Cher got me a lot of coverage, whatever that kind of celebrity is.

Celebrity means nothing really. What is important is that you do good work and someone notices. That's a good thing.

K: So the notoriety aspect wasn't that important to you?

Mackie: No, no, it's like awards. You get them, but the minute you start trying to win them, it doesn't work out. If you have a project and you think you might win an Emmy or an Oscar—if you win, then it is just a plus.

K: Celebrities didn't intimidate you?

Mackie: No, I was just there to do my job. I wasn't looking to be part of their lives. I knew them, I also knew a lot of them weren't particularly happy, that they were going through a lot of crap. I also saw people who would hang on, become part of a performer's life, but I only wanted to do what I do. If I liked them, they were friends. We'd have dinner once in a while, but being part of their lives was a whole other world. I was very serious about what I did. It takes a lot of work to get laughs, create fantasy. There was never time for playing around. But I had a good time. There is no better feeling than having an outfit walk out on stage and the audience gasps before the performer can even open her mouth. And you go, "Oh, that worked." Or you make someone who has gained weight look beautiful and really thin.

K: Are they grateful?

Mackie: Oh, sure, I think so. But no one wants to admit such things. If they say they're out of shape, then it will be true. They know that you know, but we don't talk about it. They get dressed and say, "Ooh, I look pretty good!" It's such a funny thing.

K: You have a great interest in Mexican culture?

Mackie: The first school field trip I went on in L.A. was Olivera Street to look at folk culture. It's interesting to me, so I bring it into my work and, even more, into my home.

K: You collect?

Mackie: Well, I'm not really a collector. I have a lot of masks in my home, but I don't buy every mask I see.

K: Have you saved a lot of your costumes over the years? Do you have an archive?

Mackie: Oh, sure. In fact, I'm having an auction next month at Christie's of sketches and lots of clothes. It will be a full gallery exhibit. It's the first time I've done that, and they are very excited about it. If it does well, then I will do more. It's just the tip of the iceberg. I have so much. And so many sketches. I am actually doing a book about my career right now, mostly visuals. It's fun doing it. We're creating the pages right here on the computer.

K: So what do you do in New York?

Mackie: I do QVC where we are on every hour. It is all live so you come out of there exhausted.

K: So that is a whole other aspect of fashion culture now.

Mackie: Yes, a whole other aspect. It is funny, but you can sell enormous amounts in one fell swoop.

K: So it's extremely lucrative?

Mackie: Well, it would be more so if I owned the company that sells the clothes, but I don't want to. That means going to China. We go from extra small to extra large in one item, so that's hard. Designing a blouse that can look good in that range. It's very easy to design for a specific size. But when you have to go across the board, think of the difference, just in fabric, and all for the same price.

K: Really! I know in catalogues certain sizes cost more. It must be unique to them.

Mackie: Well, on QVC there's no mixture of prices.

K: I've never watched it.

Mackie: It is kind of a phenomenon. Every once in a while I'm doing today's special value, selling it all day long, and I'll sell 60,000 units. Do you know how much that is?

K: Amazing. Is it broadcast globally?

Mackie: No, it's just in the states. It is amazing how much you can sell, how many dollars per minute an item can pull in. Then you add extra colors.

K: How do they get the production in such quantities?

Mackie: They have it in stock. It's kind of scary when they order that many. It's usually that color they liked last year: Make that for me in a different color. I had a jean jacket from last year that I cut a little longer, plus a pair of cropped pants in four different colors. The jacket had flowers, lots of embroidery plus a matching skirt—and it was amazing; We sold out before the day was over. But you get one of these that doesn't sell well, and it's disastrous, especially for a company that does it on consignment. It can be put out of business if it doesn't do well, plus it goes back, and the company is stuck with it.

K: It sounds almost like gambling.

Mackie: Well, not for me. I don't own the company.

K: Do you have any advice for young designers who want to go into costuming?

Mackie: A lot of people want to do costumes, but they don't understand how complex it is. You have to understand the performers, their personas, what they have to do in the clothes, and how the costumes can enhance their performances. It's very complicated, and it's also very hard work. But it's also exciting, and the boundaries that exist in film or theater, whether logistical or economical, can actually make you more creative. You are not designing in a vacuum for an imaginary customer. So if you want to do costumes, jump in and do anything that is offered, small theater or whatever. You will learn, and it may lead to other opportunities. Remember, don't be afraid to work hard.

NOTES:

Garb: Through the Artist's Eyes

Dancer, Jeffrey O'Connell, 1978, paper collage and Photoshop. (Photo: Courtesy of Jeffrey O'Connell)

About *Dancer*

Jeffrey O'Connell

This image is about my mother and father, both of whom were at some distance from me when I was growing up. My father divorced my mother when I was around two years old and remained very distant for the rest of my life. To me he was a phantom, and I could only imagine him. My mother, on the other hand, was close at hand physically but was so mentally disturbed that a distance began to be felt between us at a fairly early age and has continued to grow throughout my life.

The mask and old-style clothing on the male figure reinforce the phantasmic aspect of my father and increase his aura of potential power and his distance, which is expressed both by the historical quality of his clothing and by his background position in the space. He resides in a kind of temple building, formal and classical, an icon of my interior, imaginative world. He stands there like a chess piece in its box, put there by me and waiting to be played.

The ballerina costume on the female represents a combination of femininity and fantasy, an image of a performer who is to be watched from a distance. As she is also insane, the twisted tendril used for her neck and head suffices as a metaphor of this condition.

The man watches the woman at a distance. He represents my father, yes, but also myself. I had been turned into a phantom like them, similar in a way to the myth of the vampires and their prey. Such is the legacy of my family.

The whole scene is set against a mountain landscape during an eclipse. The eclipse is caused by the moon (*luna*) blocking the light of the sun, just as her madness blocked him, just as their debacle blocked my life for so many years. The action unfolds in the remote mountains where we are alone and no one can see us or hear us. It is perfect, like heaven and like hell.

Much later in life, well after this collage was constructed, I found myself drawn to Degas' dance pictures. Some of these images feature ballet dancers being shadowed by upper-class men who frequented the ballet to form sexual liaisons with the female cast. These men didn't wear masks (literally) but dressed in a way very similar to the male figure in this collage. Of the many parallels in meaning between the Degas pictures and my own, I am most of all struck by what the male and female wear and how it symbolizes their sexual identities in a mythic way. It is as if, once dressed like that, the two become players in a game that cares nothing for who they really are and only about acting out the parts the myth has assigned them. The same could be said about clothing and how it functions in our society.

Figure 1. *The Viewing,* Jeffrey O'Connell, 1985, paper collage and Photoshop.
(Photo: Courtesy of Jeffrey O'Connell)

About *The Viewing*

Jeffrey O'Connell

Two figures are engaged in modeling hats and are viewed by two children (Figure 1). The figures appear as miniature humans who the children (normal size) observe, as they would fish in an aquarium. The children's gazes are innocent yet intense. They see what we see: the two little figures are stripped to their anatomical corporeality and exhibit no shame or even awareness of their condition. "This is the truth!" they seem to tacitly proclaim, without irony. But irony there is in the parallel lives of clothes and the people who wear them, if only we begin to notice the anatomical vulnerability and mortality of these same people. How it contrasts with the allusions and hopefulness of what they wear, especially as they age. No wonder it is youth that normally is transformed into the role of the mannequin.

Fashion, before it is allusion, illusion, or delusion, is hope masquerading as confidence. It is also a gesture of civility and of keeping common cause with the particulars of the game of life. To keep the game going, like the hamster running in place on its wheel, watched more intently by children than by anyone else, we walk the walk and talk the talk. The children pictured here are particularly keen observers and glimpse another level in the meaning of this parade. Perhaps they will grow up to be psychologists—or even artists.

Figure 2. *Lone Skier,* Jeffrey O'Connell, 1978, paper collage and Photoshop.
(Photo: Courtesy of Jeffrey O'Connell)

About *Lone Skier*

Jeffrey O'Connell

We are alone somewhere in the mountains: my mother, my father, and myself (Figure 2). I am the skier, and you will notice how small I am except that I am not small but only seem so in contrast to the mountains and my parents. Yes, my parents are very large indeed. Their enormous scale befits their stature as gods, the gods who created me. As you can see, I am wearing skis. I am going somewhere and have come from somewhere and happen to be here on a visit. My parents are always here in these mountains. They never leave. In fact, they never even move. But they are alive nonetheless, very, very alive.

My mother is nearest to me. She is naked and vulnerable, as she always was and always will be. My mother is also insane, but you can see that by the shape of her head. People who don't wear clothes in a world where everyone usually does are seen as vulnerable and probably are, in most cases. It's hard to hide when you are naked, but even when wearing clothes, your head is exposed, and your neck, and your eyes, and your mouth, and your ears. From out of the top of your clothes the truth can, and often does, pop out. This is certainly true in my mother's case, as you can see, but as she is pure white and a source of light, she is redeemed.

My father is farther, farther from me and from my mother. They divorced when I was about two, and I have rarely seen him, except up here in the mountains where, if I put on my skis and make the journey, I can see him anytime I want. He's even larger than my mother, so much so that even though he's at least a mile farther away from me than my mother is, he still looks bigger than she does (perspective be damned!). I know so little of him and about him that he has taken the form of a mythic, totemic symbol looming high above everything else, even higher than the mountains themselves. He is a necktie in all its mysteriousness, and he is just as ridiculous as neckties have always seemed to me to be. He is also dark, emitting no light. He is *not* redeemed.

Figure 3. Fitting Room #13. Soo Kim and Ginny Cook, original and found photo collage, 2004. (Photo: Courtesy of Soo Kim)

Fitting Room (A series of 46 collages made up of original and found photographs, 2004)

Soo Kim and Ginny Cook

Fitting Room is a collaboration by artists Soo Kim and Ginny Cook, a series of images combining original and found photographs with the figures physically cut out of each image. Originally created for an artist book, the compilation of images presents the viewer with a series of urban and suburban landscapes. The void in each image is filled with fragments of images from the pages that follow, layered to reveal multiple landscapes and views both private and public, continually changing with each turn of the page. The figure's absence highlights the photographic setting, emphasizing the context in which an individual or model poses and performs for the camera. The viewer does not see the clothes, but rather the function of fashion. Landscapes take the place of the figure/subject/clothing, substituting fabric for ideas about time and place, allowing the figure to stand out or blend in. Thus the deletion generates a space for fantasy, projection, and identification to be negotiated by the viewer, giving presence to absence as a larger narrative around loss and desire unfolds.

Figure 4. Fitting Room #34. Soo Kim and Ginny Cook, original and found photo collage 2004. (Photo: Courtesy of Soo Kim)

Figure 5. Pericolo di Morte, 2002, mixed media installation. *Pericolo D'Morte*, Jane Goren, 2002, rope, underwear, clothes pins, glitter, acrylic paint. (Photo: Courtesy of Jane Goren)

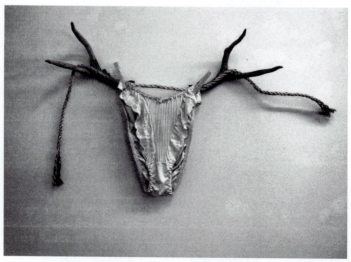

Figure 6. Horny, 2002, mixed media installation. *Horny*, Jane Goren, 2002, rope, underwear, clothes pin, deer horns, acrylic paint. (Photo: Courtesy of Jane Goren)

Artist's Statement

Jane Goren

I grew up with the old adage "Don't judge a book by its cover" and the one about "airing one's laundry in public," and of course, you've heard the one about wearing clean underwear in case you get hit by a truck. For years I thought about these and other anecdotes, looking for insights and hidden messages, leading up to two inspired shows, "Insinuendo" and "Dirty L.A. Undry," which presented a view of laundry from an orgiastic perspective. Laundry, which is a by-product of clothing and fashion, is also fast becoming a disappearing element of the American landscape. It is also essentially "women's work," which as we know is never done. In our culture today, everything seems to be about sex (women's work?), but ultimately fashion is about what we put on so that we can inspire someone to take it off! Then, of course, someone has to do the laundry.

As a person who sees everything as potential art supplies, I was working with women's underwear in order to create a statement about "woman's work" (as in "a woman's work is never done"), using the clothes line as a metaphor. I was crafting each piece individually and placing them on the floor of my studio once they were dry. This particular piece was leaning up against the wall, and when it caught my eye, I thought "Where did this animal skull come from?" before I realized it was one of the earlier pieces I had done. Georgia O'Keefe's series came to mind, and a visual and

Figure 7. Chinese Laundry 134/4 153/4 inches, acrylic and collage on paper. *Chinese Laundry*, Jane Goren, 2002, acrylic on collaged paper (Photo: Courtesy of Jane Goren)

207

verbal pun was in the making. I already had a pair of antlers on hand which I used to both enhance the piece and stabilize it on the wall (Figure 5).

The devil may have had a blue dress on, but when she took it off, she was wearing red panties! Hung on the line, they take on the look of a devil face, with the clothespins, painted red and covered with red glitter, becoming the devil horns. The title, *Pericolo di Morte,* warns that this she-devil is deadly (Figure 6).

The laundry here is collaged from Chinese newspaper—a source of information, as a line containing underwear can also be "read" as a source of intimate information (Figure 7). There is something revealing about airing one's underwear in the presence of animal bones: They both let you see what is under that fur coat. Also, we have a visual repetition of shapes and forms (skull/panties, horns/clothespins), which alludes to the skull paintings of Georgia O'Keeffe and becomes a riff on her denial of sexual content in her work.

Artist's Statement

Jon Swihart

For centuries artists have depended on models to inform figurative compositions embodying religious, mythic, and allegorical themes. My paintings and the techniques used to develop them reflect unabashed admiration for enduring realist traditions in Western art. Yet, as a contemporary artist, I derive not only information from my models, but inspiration, too.

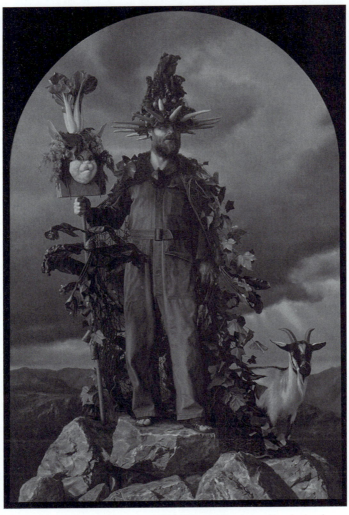

Figure 8. *Untitled*, Jon Swihart, oil on canvas, 1990. (Photo: Courtesy of Jon Swihart)

Figure 9. *Untitled*, Jon Swihart, Oil on Panel, 1980.
(Photo: Courtesy of Jon Swihart)

Some years ago, an eccentric Vietnam veteran, who grew all his food in a backyard garden, appeared at a religious costume party I attended. His "costume" consisted of old military fatigue overalls, an assemblage of vegetables, and a child's bunny mask. The noble, yet vulnerable, quality of this man's presence under his vibrant, organic headdress reminded me that compelling human content sometimes lies in unexpected places (Figure 8).

Such unusual garb is not strictly required to embody this content, however. Even everyday dress can serve. A moment among friends in jeans and T-shirts might seem banal at first glance, but in the context of simple, sacred surroundings, and with the addition of a halo reminiscent of a Fra Angelico painting, it too can reflect much deeper currents of ritual, spiritual struggle, and a contemporary search for meaning (Figure 9).

Neither the velvet robes of nineteenth century European painting nor the austere styles of modern abstraction are needed to convey the fundamental human struggle. Instead, well-painted images of the common man and woman, including these contemporary characters—in attitude, ritual, appearance, and dress—can connote a myriad of novel and moving messages about the underlying forces that drive us all.

Robert Williams:
Lowbrow Artist

Kathryn Hagen

Lowbrow or *outsider art* are terms that describe an underground visual art movement that emerged in the Los Angeles area in the late 1970s. Sometimes known as Pop Surrealism, lowbrow art stems from subcultures such as underground comics, punk music, and hot-rod street culture.[1] Robert Williams is considered to be a prime instigator of this clash between highbrow and lowbrow art. His politically incorrect agenda began with his early comics work in *Zap* and continues today.

Critic Jonathan Goodman wrote a review of Williams's 1998 New York show in *Art in America*:

> "Robert Williams's pop-culture pedigree includes being one of the earliest contributors to *Zap Comics* and a designer of customized cars in southern

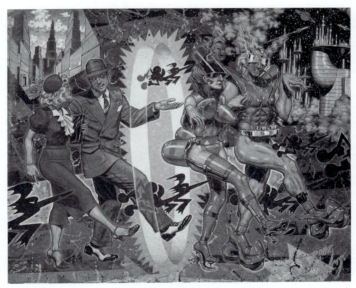

Figure 10. Robert Williams, *Vanity of the New*, oil on canvas (1992). (Photo: Courtesy of Robert Williams)

[1] Kirsten Anderson, ed., *Pop Surrealism: The Rise of Underground Art* (San Francisco: Last Gasp, 2004). Anderson investigates the issues of lowbrow art and its relationship to contemporary culture and the fine art world.

211

California. His deliberately proletarian sensibility involves raunchy jokes on sex and working-class mores displaying garish bad taste, expressed through detailed figuration, surreal dreamspaces and abstract effects resembling car decals.

[Williams] in-your-face style camouflages serious concerns. His world is riddled with a sophisticated, postmodern anxiety about culture and about the future. His images form thematic collages, which for all the bad behavior they exhibit, treat contemporary issues in an intelligent, even an intellectual, fashion. His complex comic scenarios reward extended viewing."[2]

Robert Williams's 1992 painting, *Vanity of the New*, makes good use of the desire of fashion and its followers to be modern in ways that are not always flattering or utilitarian (Figure 10). Though he critiques such vanities in his trademark style, he makes the point in ways that a hundred essays might have trouble matching. This work is reminiscent of nineteenth-century political cartoons that delighted in poking fun at extreme fashions and the up-to-date people who wore them. Amelia Bloomer, who tried to introduce the idea of pants for women before the public was ready to accept such a notion, felt the sting of such poison pens comments.[3]

Besides his paintings, Williams edits *Juxtapoz Art & Culture Magazine,* which he founded in 1994. He is responsible for helping the careers of many artists "with his taste for Americanized figurative nightmares and the blending of pin-up/religious/kitsch culture."

[2] Jonathan Goodman, "Robert Williams at Tony Shafrazi—New York, New York," *Art in America,* vol. 86, no. 10 (1998): 137.
[3] Kim P. Johnson, ed., *Fashion Foundations: Early Writings on Fashion and Dress* (New York: Berg, 2003), 59.

About *Tea Bags*

Joan Takayama-Ogawa, Ceramic Artist

In the *Tea Bags* teapot series, I use women's handbags to explore social issues of beauty, privacy, femininity, seduction, hidden and exposed luxury, social status, and social values. Formally, the handbag references several design elements, such as the handle, body, lid, and clasp of the teapot, making it a natural basis for the series. Similar to my earlier coral series, these pieces are in the Xixing tradition, which uses imitative imagery. However, my

Figure 11. Floral Tea Bag series, 2001, Joan Takayama-Ogawa, ceramic. (Photo: Steven Ogawa)

glazed colors and emphasis on social commentary make *Tea Bags* more closely related to contemporary art.

I started by focusing on three distinct themes: trophy, beaded, and floral (Figure 11). In *Trophy Tea Bags*, the mounted alligator becomes an adorning clasp, while heads, tails, and claws transform into spouts, handles, and feet (Figure 12). The surface is textured and glazed to resemble the skin that once provided women with this elegant and luxurious accessory of an endangered species. The trophy theme evolves into *Doctor's Medicine Teabag* for the healing properties of tea and the female doctor's bag of "tricks."

Figure 12. Trophy Tea Bag series, 2001, Joan Takayama-Ogawa, ceramic (Photo: Steven Ogawa)

Artist's Statement:
Jacci Den Hartog

I was responding at the time this work was done to gender issues, using clothing as a stand-in for larger cultural themes. I wanted to use clothing in an abstact way to avoid predetermining how viewers might encounter the work. I also was really interested in humor and marrying issues to the absurd. Some of the pieces are so absurd that they're about nothing and many things simultaneously: kind of a sifting together of multiple topical issues that are unrelated thematically but loomed large for me in my mind. For example, in *Pink Accident,* I was thinking about how my father always wanted a boy but always got girls, China's one child policy, and familial hopes of having a boy, girls being looked at as accidents (Figure 13).

Then I was struck by the distant memory of having an "accident," or the fear of accidentally peeing in my pants, especially in public, which was a strong childhood phobia or fear. And then just marrying all of that with this absurd, candy-colored, gooey spill surrounding the dropped pants, the fear and absurdity of being exposed, the almost edible pink, pink as such a feminine color, etc (Figure 14). I had just done another dropped pants piece, a dark one that was used as both a singular sculpture and in a ring of six in the context of a large installation about the circus. That piece was very much about brutality and dominance toward animals, especially elephants in the circus, which was a big theme in my work at that time, but the initial image came about from seeing day-to-day the brutality of the life of the homeless. I was living downtown, and one morning while driving down the street, I saw a homeless man pull his pants down and squat on the sidewalk to relieve himself. It was such an explicit and brutal image that I couldn't get it out of my mind, so I made the form. It seemed to take on a life of its own in my imagination and in different contexts in my work. I thought it was brutal, ugly and awful, and I used it in those kinds of settings.

The irony was that I made a series of them as I needed several for the circus installation. I gave one to MOCA [Museum of Contemporary Art, Los Angeles] for an auction with opening bid of $400, there was a bidding war on it, and the price went up to over $3000, so there was also something very appealing to people about the image. I made the pink piece as a sort of counterpoint to that work. *Plaything*, the big three-legged white piece, was kind of a buffoonish piece: over-the-top Fruit of the Loom, absurd underwear, also about fear of exposure, the idiot in films running around in long johns (Figure 15). Two legs would have been too much about the human figure, and I wanted the image to conjure more an idea and sensory experience and not to be too human-looking. I really wanted the work to have a physical presence that wasn't too readily identified yet closely aligned with the corporeal so that it was relatable to the human body. I wanted viewers to

Figure 13. *Pink Accident*, Jacci Den Hartog, hydrocal polyurethane, 1992.
(Photo: Courtesy of Jacci Den Hartog)

Figure 14. *Dropped Pants*, Jacci Den Hartog, hycrocal, 1991.
(Photo: Courtesy of Jacci Den Hartog)

encounter the piece physically and perceptually before they could understand it and pin it down.

The yellow stovepipe piece was very surreal. I was building the studio, putting in a wood-burning stove, and I began working with some of the stove piping forms in my work (Figure 16). I was again also thinking about underwear, the lure and sexual nature of black undergarments, the irony of something like a corset used to heighten a woman's sexuality and at the same time diminishing her vitality, and the best model I had at the time was stovepipe, so I thought it would look good if I gave the corset peekaboo

Figure 15. *Plaything*, Jacci Den Hartog, latex, 1987.
(Photo: Courtesy of Jacci Den Hartog)

holes and painted the stovepipe a kind of screaming yellow to make the whole thing "hot," in a cartoon kind of way. The color is also related to yellow street signs, and we know how to read those. The piece should relate to a "sign" in that way, the same way we "read" different kinds of clothing. We understand what they mean and what we mean when we wear them, but then differing perceptions distort the message of the read. In reality, no matter how clear we think we may be, the interpretation is inevitably skewed.

Figure 16. *Two Beach Balls On Yellow Stovepipe*, Jacci Den Hartog, steel and latex, 1987. (Photo: Courtesy of Jacci Den Hartog)

Sara Streeter: Guerilla Performance Artist

Parme Giuntini and Kathryn Hagen

Sara Streeter describes herself as a guerilla performance artist. A form of cultural production that traces its origins to futurism, Dada, and surrealism, performance art incorporates elements of literature and theatre into provocative events that critique art and contemporary culture. By the late 1960s, performance artists had established a presence for themselves in the postmodern art world through a wide variety of applications, from Georges

Figure 17. Sara Streeter in pirate costume of her own design. (Photo: James Stiles)

Figure 18. Sara Streeter in medieval costume of her own design. (Photo: James Stiles)

Mathieu who painted on stage to the dramatic exploits of Chris Burden who shot himself in the arm in public.

Streeter's interpretation of performance art carries the genre even further. Entirely spontaneous, either alone or with others, she creates multiple alternative personas for herself, complete with original costumes (Figures 17, 18). She travels to specific sites where she then acts out scenarios that relate to the location. Her art has taken her to a variety of locales, from castles in eastern Europe to the ghost towns of the California desert. She and her fellow artists continually document these performances, and some of her characters have become so real to her that she is writing their memoirs in graphic novel form.

Trained as a professional ballet dancer, Streeter also worked as an operatic costumer. As a consequence of her long-standing interest in costuming, she collects both vintage pieces and new costumes that she dismantles, embellishes, and reassembles into new forms. Mining visual culture to create a pastiche of allusions that may elude or inform her audience, Streeter draws from such influences as silent film, Mucha paintings, Vargas drawings, and femme fatales. Enriched by costumes that are critical elements to character production, her work conveys a subtext that is both studied and multilayered.

Isabel Toledo: Fashion Designer

Parme Giuntini and Kathryn Hagen

Garb is about nothing so much as the hybridization of fashion and other disciplines and the many permutations those paths may take. The increasing popularity of museum shows that feature fashions of a particular era, specific subject matter, or a singular designer is telling in that respected curators not only share that interest, but are also willing to put themselves on the line to explore what was once such contested territory within the walls of their museums. Fashion is a popular subject with the public, and some might say simply an easy road to profitable shows. Yet such an assumption of pure

Figure 19. Layered Man Bra with Denim Umbrella Skirt, Isabel Toledo Studio, 1988. (Photo: Ruven Afanador, Courtesy of Isabel Toledo Studio)

commerciality would be extremely disrespectful to people like Richard Martin, the former curator of the fashion collection at the Metropolitan Museum, who spent his life in scholarly study, writing about the cultural information that permeates clothing, both present and past.

Contemporary fashion designers whose work truly lends itself to such an in-depth study are arguably rare, but Isabel Toledo is such a designer. Cuban by birth, Toledo approaches her work in such a thoughtful and artistic way that the designs demand a forum. Married for many years to talented artist and illustrator Ruben Toledo, Isabel Toledo lives a life of creative collaboration and expression, evidenced by the extensive exhibition held at the Ben Maltz Gallery at Otis College of Art and Design in 2001. Writing for the catalogue of a recent show at Kent State University, Richard Martin explained why the Toledos are respected and accepted in whatever creative circles they might care to explore, including the rarified exhibit space of museums and galleries—the Pure White Cube (Figures 20, 21).

Figure 20. Denim Tube Jacket and Dress, Isabel Toledo Studio (First Collection, 1981). (Photo: Ruven Afanador, Courtesy of Isabel Toledo Studio)

COMMENTS ON THE TOLEDOS BY RICHARD MARTIN (EXCERPT)

Synergies among fashion designers and artists have previously existed. Dior was Dior only when delineated in the dark romanticism of Christian Bérad or the linear simplifications of René Gruau. Schiaparelli was indoctrinated into cryptic surrealism by Jean Cocteau's deft and defining diagrams. But fashion history affords no real counterpart to the yin and yang creativity of Isabel and Ruben Toledo.

Isabel and Ruben Toledo share a common approach: imaginative creation from observation. They always ground invention in the reality of needs and practices. Isabel pursues perfection, developing cut and nuance with the eye of Norell or Balenciaga, but her work always is tethered to Earth and to its medium by her pragmatic disposition. Ruben's fancy and ingenuity are tempered by his own critical scrutiny.

As Amy Spindler once reported, "Only great designers can dispense with themes and theatrics and let the work speak instead. Ms. Toledo does just that, letting fashion itself be the theme." Isabel Toledo tolerates and even prizes the life of fabrics, the flow and twists of draping and the nutty jigsaw puzzles of shape. Her pleasure in discovering creative form that moves with originality and suppleness on the body places her firmly in the traditions of sportswear. Likewise, her reliance on an image of the modern woman—one almost as energetic as she is—makes her a sportswear advocate. History haunts the clothing, never becoming vintage in its remembrance of Vionnet, McCardell, or Chanel, but becoming resonant in proving that design is a problem-solving discipline.[1]

Richard Martin
Curator, Costume Institute of the Metropolitan Museum of Art

[1] dept.Kent.edu/museum/exhibit/Toledo/RM., retrieved August 4, 2006.

Senior Mentor Project: *Tailored Jackets*, 2005, installed in Bolsky Gallery.
(Photo: Courtesy of Otis College of Art and Design)

Interview with Dave Hickey

The editors met notoriously opinionated art critic Dave Hickey at a chic restaurant near his home in Long Beach in the summer of 2004. He had just spent a year as guest critic at Otis College of Art and Design and was kind enough to give us time for an interview, primarily about the relationship between fashion and fine art. I had heard him speak a number of years before and had never forgotten the piercing effectiveness of his realistic—verging on cynical—view of the art world and its rather warped economic structure. Both of us felt certain that we would have a provocative conversation at the very least. We were certainly not to be disappointed, as you will see from the following exchange.

Parme (P): Dave, you spent a number of years around artists. There is a lot of talk today that people construct their identity by the way they dress. Do you think there is any truth to the stereotypical notion of what a fine artist looks like or dresses like?

Hickey: Well, I think you could honestly say that about 98% of successful fine artists are social people. In other words, if I had to make an off-the-wall distinction between artists who work at universities and teach every day and those artists who live in the world and show in galleries, those who show in galleries are social people; those who teach tend to be more antisocial people who can only deal with hierarchical situations. So it does not have to be how you look. There is a real temperamental difference between those who show and those who teach.

I can make another distinction because I teach writers, too. Artists are more transparent [in terms of identity] than writers. I can look at a group of artists and know they are artists because they are dressed the way they are. They have purple hair, they have a sweater set—you know, however they are, they are, and they just do that. Writers are always in disguise—dressed up like Mormon barbers or something. They are so internalized that they don't even know what they look like. So I think artists have a pretty good idea of what they look like, and so they certainly have more fashion sense than those in my business, but perhaps not as much as actors.

P: Do you have a signature way of dressing?

Hickey: Yes. I wear the same clothes all the time.

P: Really—why?

Hickey: Well, it's just simple, so I can buy a whole bunch of them at the same time. When I was a kid, the only rule for dressing as an artist then was that you buy one incredibly expensive piece of apparel. So you have ten-dollar jeans and ten-dollar shoes and then a three-thousand dollar

225

jacket, or something like that. So that's all you needed—that one thing that shows you as not being a complete stoner punk but sort of an upper-middle-class stoner punk.

Kathryn (K): And what was your one thing that you bought?

Hickey: Well, my favorite thing was a floor-length black leather overcoat. Very dramatic. I loved it.

P: A lot of high-fashion designers working today talk about their creative process and their products in the same way that fine artists do. Do you see any relationships or potential for fashion to be fine art?

Hickey: No, I don't—in the same way that architecture isn't fine art. Fine art is defined by its ability to redefine its function. It's not what Pollock does, it's not what Warhol does, what Bob Erwin does. Art can change its function—it survives by changing its function. Architecture still has to do architecture things; fashion still has to do fashion things. There are primary functions for both. As disciplines, they can be artistic, and they can be informed by art. There are probably even primal moments in fashion history when fashion did change its function, from the fifties to the sixties, for example, when fashion changed from being a disguise to self-advertising. One disguised oneself in the fifties; one advertised oneself in the sixties. But basically, the definition of fine art is that it doesn't have a built-in function.

P: What about some runway shows in which the clothes are never sold in stores, have no wearability, but are there to make a variety of statements. Is that the upper echelon of fashion, or is that a slide into fine art?

Hickey: No. What such shows do is really deprioritize the commercial and exacerbate the social. So basically you get rid of the commercial part but keep the spectacle, keep the theater, keep the thing where you can see all your friends—see how their dental work is coming. I think anything that has a determinate function is not fine art. Every artist wants to change the function of art. Fashion designers just want to be first.

P: There was an Isabel Toledo show at Otis probably three years ago. She is a New York designer who talks about her work in terms of cultural identity and art, and her husband Ruben Toledo is a fine artist and illustrator. Ann Ayres was curator of the gallery at the time, and there was a huge brouhaha because she did not want to have clothes on mannequins in the gallery. Now ultimately she lost the battle, and the clothes were shown on mannequins. But it was one of those moments when there was this huge gap within the college. You have a designer who constructs herself as an artist and a gallery director who looks at it and says that it's clothing and it was sold—or could be sold—and it doesn't belong in a gallery.

Hickey: I think that's crazy, the thing that I can't understand about fashion designers and architects. Being a fashion designer or an architect is better than being an artist. Artists are idiots. They don't make any money. They don't change anything anymore—not since the sixties. Artists are basically just little people sucking on the tits of various foundations. Why would one want to pretend to be an artist? Who's an artist we all admire? You know, it's

a third-rate occupation these days. It has no cultural significance whatsoever. You know, it's not like Warhol changed the world, not like Pollock changed the world. It's a bunch of people talking about growing up as an Eskimo lesbian or other such nonsense. It is not critical to the culture. So why would a fashion designer want to be an artist? Why would an architect want to be an artist? It's one of the stupider things that you can be. Do you know any smart artists, any well-educated artists? Terry Winter or John Curran—they're hillbillies. I mean I don't think being an artist would be anything that anyone would aspire to in their right mind. Why? To hang out with Paul McCarthy? Be still my beating heart. That's one of the attitudes that allows me to live in Long Beach.

K: Do you say all that to your students?

Hickey: Yeah. Of course. When I was a kid, if I had lunch with Leo Castelli that was a big deal. But lunch with Paul McCarthy? He's one of your class of fake outlaws.

P: Wow—this is a switch. You are one of the few contemporary art critics who even uses the word beauty. What is going to be the trajectory or the future of beauty in relation to fine art or fashion?

Hickey: Basically, what I grew up with in fine art is not fine art today. Fine art is little bitty videos of people wandering through libraries. The whole idea of an objective culture of objects doesn't exist anymore. What I call *fine art* is now some sort of fugitive craft just like chess. Everybody that knows about it knows about it. Everybody that knows about it doesn't care if anyone else knows about it. But beauty is what wins. That's how you define it. Beauty is what we decide it is. Beauty is the absence of the grotesque. That's not hard to fathom. At this moment the art world is interested in the grotesque, but that can't last.

I don't think it's an issue because the art practice is not an issue in the culture. In the last twelve to fifteen years, fine art coverage in national papers has receded by about forty percent. Forty percent less art coverage minimum in the *New York Times,* the *L.A. Times*—there's none at all in most other newspapers. Art is not a big deal. It's not important.

K: And probably fashion coverage has increased by the same amount?

Hickey: Well sure. Art used to be a vehicle of social mobility. The way you get from Port Arthur, Texas, to Captiva[1]—the Bob Rauschenbergs—from the bottom to the top. It no longer is. Costs a million dollars to go to art school. They're all suburban rich kids. Their daddies all invented Crystal Geyser water. Or he's a senator from Illinois. So that whole generative activity of social mobility has disappeared from the art world. Therefore, it's not of much interest to people who are not already rich. It's not interesting or dynamic. Fashion is dynamic. It is the present way you get from Port Arthur to Captiva, the way you get from the Bronx to the penthouses. But

[1] Private island vacation homes in Florida.

art really used to be that. Look at Warhol or Rauschenberg or Jasper Johns. They came from shit, you know.

Also, art is not a practice anymore that requires sensitivity to the culture. It's perfectly self-enclosed. If you're going to be a fashion designer, you had better know something about hip hop. If you were going to be an artist of the sixties, you had better know something about rock and roll. If you're going to be an artist today, all you have to do is know something about digital technology. It requires no acceptance of any other ways of life. All you do is sit around and talk to other artists about whatever. This is not to say that some artists are not sensitive to culture, but it's not required. And so the idea that an artist has to internalize the culture in a way that novelists did in the fifties, or artists did in the sixties—it's the fashion designer today who has to internalize the culture.

Take Todd Oldham, for example. He started out selling dresses made out of garbage bags to Dallas matrons. His whole career is based on sensitivity to what is happening around him. Do you know any artists who are sensitive to what is happening around them? Boucher is one, but he's my generation.

K: How does film fit into that?

Hickey: The problem with all representation and the weird thing with contemporary culture is that we have what we call the critique of representation. Structuralist theory holds that all perception of representation is contingent as itself—there is no wrong contingent indication. So American post–structuralism holds that if we can somehow overcome all the wicked people who are manipulating our minds there can be a pure communication of consciousness. This is crazy! Just crazy. So you have a whole discourse based on these really crummy photographs that somehow aspire to some kind of communication of innocence. There isn't anything like pure communication. Bullshit! There's no way to take rhetoric out of language, and after purging rhetoric from art for twenty years you don't have any art left.

P: You have fashion. Fashion is the new art.

Hickey: Fashion does a lot of the things that art used to do. I mean as far as socially, it provides a social world, which art doesn't do anymore. The social world of art in L.A. today with hundreds of thousands of artists is in fact smaller than it was in 1965, when it was just Peter and Billy, Al and Ed. You know? It is a smaller world than that because everyone just sits at home and nests and downloads stuff. It is not a social world anymore.

P: Do you think contemporary art is unfriendly—even alienating—to the audience?

Hickey: I don't think so. This painting of Lari Pittman, for example, is so scatological, but it can hang up in MOCA [Museum of Contemporary Art] because Lari doesn't hate you. He is not trying to shock you. It is the attitude of insult, not the content of insult. You can look at Lari's picture and say he is not trying to shock you. He is just showing you something

shocking. There is a real difference in that. I think there are a lot of good artists today, but there is nothing new.

P: I think ordinary people are not passionate about contemporary art. Yet they walk through the Louvre and the Met and they go through the rooms of fifteenth-century art or eighteenth-century art, and they stop and look and bring the kids over—is that response what is missing today?

Hickey: People don't decide what's good anymore. Who decides is professors or curators. Not even art critics decide. It's run by governments—has nothing to do with you and I. I discovered that when I did that biennial in Santa Fe. I got calls from five consulates that wanted me to put people from their country in the show. I said I'd already selected them. Well, "Could we send you some .jpegs? We really want little Bulga or someone like that in the show." And I said no, I don't take art I haven't seen. "Well, then we'll fly you here." I had enough offers from doing that show to fly around the world for two years! So that's who runs the art world. That is how curators spend their time—on planes, flying to Bulgaria, seeing the government-selected artists, flying to Denmark, seeing the government-selected artists. So basically what I do is totally outdated. But yeah, fashion is more fun. It's certainly sexier.

K: Do you see a relationship between fashion shows and performance art?

Hickey: All new genres are not really new. Performance art, video, all these, they're just stuff that searches for shock. Half of performance art in the world is going to become stand up or sit down, like Spaulding [Gray], or it's going to become rock and roll or theater, but it's not anything in and of itself. It doesn't have venues. Where does one go to see videos? Those who see videos are people who are paid to view videos. I called up the Hammer the other day and asked to talk to Annie Philbin, and they said sorry, this is the day they view videos. The whole curatorial staff is sitting in a room watching videos. They can do that because they're paid to do that. When I left Vegas, I threw away enough videos to watch without sleep for four months, that I had gotten unsolicited in the mail. I don't have time for that. I think you can make good films, and I've seen some good videos.

P: I think what you often need is more context, which you don't have just walking in to a video presentation.

Hickey: Here's what I think it is. The presumption has always been that art is basically okay, that you had to pay attention to understand it. So for many years one credited oneself in the art world by trying to understand works of art. Now it is only sufficient that someone doesn't understand. We have all this art that no one understands—that nobody tries to understand. Someone says this is art, it's not film, and that's that. The example I always use is Bridget Riley. Her work is almost impossible to look at—one of the really complex Bridget Rileys—but if you don't look at it, it doesn't bother you at all. If you don't try to look at it, you don't absorb anything she does. If you're not trying to look at it, it's over. And I think it is, really. There's not much interest. In other words, if you're not participating in an aggressive

intellectual visual sense, then it doesn't matter what's in front of you. You can have the *Mona Lisa* in your bedroom, it wouldn't make a difference. And people like stupid these days. It's okay with me.

K: So is this depressing to you that art is in this state? You put so much of your life into it?

Hickey: Well, yeah. I think being an art critic of the sort I am is a two-generation job. Maybe half of another generation. That's about it. There are no kids out there younger than that. Like radio disc jockeys or song-machine repairmen, it's a finite little job. People won't be doing it anymore. There is no reason for me to do it now, except I'm writing about very expensive art that is being bought by mature collectors who grew up in the tradition of a real art business. I'm creating a market basically. I'm happy to do that of course, but it's really over.

P: What is the response of students when you take this position in class?

Hickey: They are not even listening. They just stare at me.

P: Don't they argue with you? That passivity would be really disturbing to me.

Hickey: No, they're not interested. They're just staying out of the job market. I don't know what they're doing. But I think they have a real problem. Generally art is built on the work of the previous generation. The art of the previous three generations is simply gone. It was all ephemeral. They don't have anything to build on. As I say, I've seen fifteen Barbara Bloom room installations, but they won't see that. It's all gone. They don't have anything. They can go back to the sixties and build on that. But. . .

P: To have no response is the worst. To have them up in their seats arguing anyway, then you at least have passion. . .

Hickey: I've seen millions of works of art. They've seen none. Most undergraduates come from American universities. Most American professors wouldn't recognize art if they ran over it. Do anything but art. It's okay with me.

NOTES:

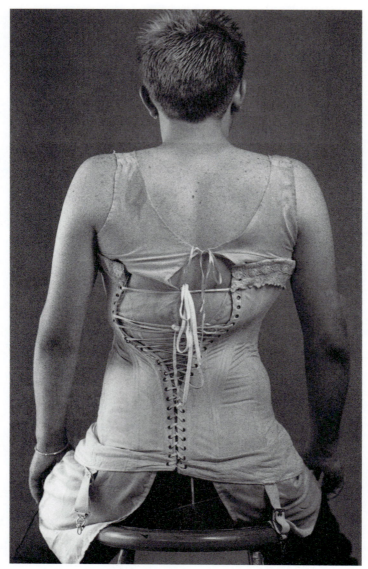

Man in corset, 1994. (Photo: Erica Hagen)

Part IV When Less Is More

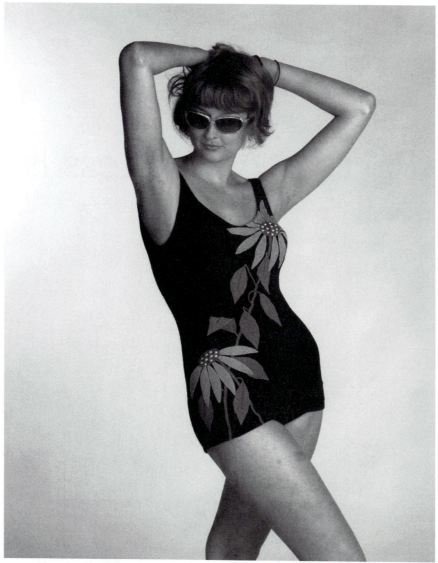

Nicole Hagen in vintage bathing suit, circa 1955, courtesy of Otis Archive Collection.
(Photo: James Stiles)

When Less Is More

Parme Giuntini

I like big butts and I can not lie
You others brothers can't deny
That when a girl walks in with an itty bitty waist
And a round thing in your face
You get sprung, wanna pull up tough
'Cause you notice that butt was stuffed
Deep in the jeans she's wearing
I'm hooked and I can't stop staring

Sir Mix-A-Lot, lyrics from the popular hit rap song "Baby Got Back"

When it comes to clothing, there is no doubt that less can be more: more nudity, more excitement, more controversy, more shock value, more public outcry, and more attention for those who dare to wear less than the cultural norm. The level of controversy generated by wearing less—rather than more—has varied wildly over the centuries. For many tribal societies living in hot climates, nudity or near nudity was commonplace. When they did adopt clothing, it was generally for purposes of adornment, to organize and identify various groups, or as protection against a "sinister supernatural world."[1] In the Western world, the degree of dress required for respectability has historically fluctuated. Despite Christian proscriptions about immodesty, women's fashions often featured low necklines that exposed copious amounts of bosom as aristocratic portraits from the fifteenth century onward show. In the early nineteenth century, women dampened their sheer muslin gowns to call greater attention to the body beneath, and by the late 1960s the rage for wearing miniskirts had made it both fashionable and acceptable for a woman to show the entire length of her leg in public while still, essentially, wearing a dress.

Today, with the exception of orthodox Muslim and Jewish religions and a few modesty-oriented societies such as the Amish, extreme inhibitions about covering the body hardly apply to most current modes of Western dress. Physical beauty is highly valued and celebrated, and the display of such youthful perfection is largely encouraged. Nude scenes have become ubiquitous in popular films, and it is not only starlets who are willing to show off their assets through minimal dress. Established actors of both sexes are increasingly letting it all show in the name of art and professional practice.

[1] Rachael d'Cruze, "Fashion's Bottom Line," *The International Writer's Magazine*, www.hackwriters.com/barecheck.htm, retrieved June 12, 2004.

Yet a state of undress still retains the ability to generate interest, and semi-nudity is an integral part of the fashion equation. The question is: "Which body part will be the next fashion erogenous zone?" The shock of exposure that Alexander McQueen achieved in 1997, when he sent models down the runway "wearing jeans so low that they displayed several inches of bum crack" is increasingly difficult to achieve.[2] Yet partial nudity is and must be fashion's answer to the public's seemingly endless desire for titillation.

In raising this subject, it is perhaps undergarments, the last layer of dress between the wearer and nakedness, that spring to mind. Certainly, lingerie has been a fascinating barometer through history, reflecting changing moral climates. Three essays in this part of the book explore the secrets hidden beneath the lace and satin of lingerie. But in the last decade or so, undergarments have emerged from their hiding places to become the ultimate layering pieces, worn over and displayed under conventional separates. Young girls substituting slips for dresses, showing fancy thongs above their low-cut jeans, or displaying lacy brassieres are a common sight. Though stores like Victoria's Secret have never sold more goods, the erotic cachet of lingerie has been diluted by this conversion to socially acceptable outer garments.

So we turn first to lingerie's closest cousin, swimwear, which retains its essential lineage as the smallest outfit a woman can wear in public today without being arrested.[3] The gradual reduction in the size of swimwear over the last century has produced many hysterical cries of public outrage that question the decency of the latest style.

Today such issues are largely moot, but the psychological price women pay for this "freedom" to expose their bodies can be enormous. Like pregnancy and childbirth, the swimsuit dilemma is a guaranteed site of female bonding cutting across class, race, and ethnicity. Show me the woman who likes to go swimsuit shopping, and it is a pretty sure bet we are talking about the young, the slender, the yet to have children. No other item of female apparel elicits such a universally common response—at once hopeful and resigned. Yet women remember their favorite suits. My own memory, at age sixteen, is of sauntering out to the public pool wearing a one-piece aqua check number with a boned bodice that regularly elicited more compliments than my other suit, a modest bikini. Only ingrained fashion conditioning kept me from wearing it every day.

Any discussion of the swimsuit is inextricably grounded in larger issues of the female body, sexuality, and display. Such a statement seems patently self-evident given the past thirty years of feminist scholarship and increasing public awareness of and sensitivity to the female body as both subject and object. Yet the anxiety and self-consciousness associated with women's

[2] Rachel d'Cruze, "Fashion's Bottom Line."

[3] Annette Kellerman, a famous Australian competitive swimmer, was known for her fitted one-piece bathing suits, which were daring for the time. At the height of her popularity in 1907, Kellerman was arrested on a Boston beach for indecency. The resulting headlines and public indignation were a death knell for Victorian attitudes toward women's swimwear.

swimwear is humorously bantered about as another one of those "things" females must face, much like menstruation and menopause. Still, we do encourage young women to wear bikinis. This is the "Flaunt it while you have it" syndrome, a subtle nod to the physical consequences of pregnancy for almost all but the affluent who can readily afford gyms, trainers, and, increasingly, plastic surgery to tone and resculpt the body.

The willingness of women to bathe in public is the result of cultural conditioning. Only a lifetime of such practices propels the adult female onto the beach or the pool deck wearing nothing more than sunblock and the components of ordinary underwear rendered in sturdier fabrics. In such a situation, women sacrifice the protective and flattering features that they expect with other garments and generally adopt a grin and bear it attitude. Consequently, wearing a swimsuit is in some ways a rite of honor encompassing a range of statements from the celebration of physical perfection to personal self-acceptance. The modern woman is charged with rising above physical imperfections, remembering that it is not how we look but who we are that matters. Fortunately, feminist challenges to the objectification of the female body have helped reframe cultural attitudes toward less than perfect physiques, especially in contemporary fine art, but there has been little impact on popular imagery, particularly advertising (Figure 1).

Apart from plus-size magazines and catalogues, swimsuit advertising still revolves around the ideal fashion model body (Figure 2). The inclusion

Jantzen made it smarter to get right in and *swim!*

SMART FOLK—active swimmers—delight in wearing the trim fitting Jantzen swimming suit. It allows such a world of vigorous in-the-water fun.

Jantzen with its original improvements is so fashioned that *it must fit* . . . never stretching out of shape . . . never binding . . . never sagging.

Virgin wool and an improved knitting process known as "Jantzen-stitch" result in lively, springy fabric of marked flexibility. Hence a Jantzen suit *always* fits trimly—and with scarcely the sign of a wrinkle.

This is the suit that changed bathing to swimming—making it smarter to get right in and *swim.* In or out of water, wet

or dry, a Jantzen always lets you look your best . . . trim, chic, smooth; but with the grace and modesty of tightly woven wool.

Jantzens are favored by smartly-clad folk at the beaches everywhere, here and abroad. Indeed, they're famed around the world.

Going abroad? In case you didn't pack in a Jantzen, you'll find your size at Selfridge's or Irette's in London; or Grande Maison de Blanc, Grands Magasins du Louvre, La Samaritaine and the smarter Parisian shops. In America the best stores have Jantzens for men, women, children. *Your weight is your size.*

Write for style folder. Jantzen Knitting Mills, Portland, Oregon. Jantzen Knitting Mills of Canada, Ltd., Vancouver, Canada.

The suit that changed *bathing to swimming*

Figure 1. A 1926 ad for Jantzen bathing suits that featured new form-fitting knit fabrics.

of Asian, African-American, and Hispanic models, along with Caucasians, ensures cultural diversity, but often of the most superficial and cosmetic kind; such models typically meet the same industry requirements, thereby reifying the notion of ideal femininity within a singular standard. Ironically, the most awaited swimsuit imagery is not in catalogues, newspaper ads, or women's magazines but in *Sports Illustrated*, whose target audience is male. For forty years, the magazine has published a special swimsuit edition so eagerly awaited that sales have jumped as much as 20 million copies in a week.[4] Although some readers respond negatively to the suggestive poses and increasing nudity of the models, as well as a digression from the magazine's focus, the swimsuit edition is solidly engrained in American popular culture, spawning not only calendars and books but also innumerable websites. The magazine pooh-poohs any comparisons with girly magazines, arguing that the voluptuous models in an array of swimsuit styles, most of which would be hard pressed to handle any water sports, celebrate athleticism and physical conditioning, a position they have supported recently by featuring beautiful female athletes in addition to professional models.

The fashion industry has responded aggressively to female issues with "the suit," as well as increased interest in fitness, youthfulness, and American consumption patterns. Swimsuits are advertised with various cover-up accessories, such as shorts, skirts, T-shirts, and hoodies, encouraging the

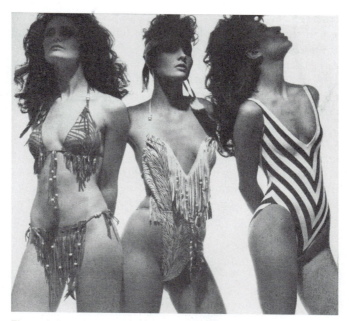

Figure 2. A 1982 ad for Norma Kamali swimsuits.

[4] Kathy Ishizuka, "Swimsuit Issue Makes Waves," *School Library Journal*, vol. 49, no. 4, 28, 2003.

acquisition of a swimsuit wardrobe that can be worn beyond the beach or
pool. Textile manufacturers have developed stronger, more resilient fabrics
that can enhance bustlines and minimize female girth. Sometimes advertised
as "miracle suits," these high-tech garments can shape and mold the body
as effectively as girdles.[5] Typical advertisements for these suits are still, how-
ever, predicated on models with flat stomachs and toned legs. A rare nod to
practicality is the Lands' End interactive website, where women can plug in
their vital statistics to preview how they will look in a suit before purchasing
from the catalogue company.

Given the cultural angst that most women associate with swimwear,
should we expect some parallel experience with men? After all, some of the
same cultural factors remain in play since men's swimwear approximates un-
derwear and is worn in public.

A different set of cultural connotations and consumer attitudes, how-
ever, shields men from such concerns. Although the late twentieth century
body-beautiful cult resulted in a growing focus on the nude or seminude
male body, there has not been a corresponding surge of mainstream male
anxiety about physical display. Since male swimwear has generally been char-
acterized in athletic, rather than erotic, terms, men escaped the moralizing
criticism associated with the emergence of modern swimwear. Even the early
1920s shift from heavy woolen styles to knitted trunks was introduced by
rowing teams who competed in lighter-weight "rib stitch" trunks developed
by the Portland Knitting Company (Figure 3).[6] The implicit association be-
tween male swimwear and athleticism has remained consistent, and style
changes have been fewer and less extreme than in female swimwear.

In fact, modern men's swimwear has remained essentially unchanged
for decades. The primary focus has been and remains comfort and ease,
regardless of the age of the wearer, the style or size of the suit. Even the most
extreme style shifts, such as the emergence of California surf style in the
1960s, have been framed by issues of comfort, ease of movement, and
associated with athletics.[7] Trunks have been longer and roomier in response
to this lingering influence, and there has been a general lengthening in
men's sportswear, championed by college and professional basketball
players. Consequently, contemporary men's swimwear covers more skin and
offers expanded protection to buttocks and thighs. New fabrics are lighter,

[5] Miracle suits generally contain spandex, a fiber that has been around for thirty years
but until recently was used primarily in lingerie, foundation garments, and hosiery.
For an overview on recent uses of spandex, see *Textile World*, Walter N. Rozelle,
"Spandex: Miracle Fiber Now Coming Into Its Own," vol. 80, January 1997, 47.
[6] On the basis of a 1921 patent for rib stitching, the Portland Knitting Co. became
the Jantzen Knitting Co. and a leading design and manufacturing firm for swimwear.
americanhistory.si.edu/archives/d9233. retrieved Aug. 14, 2005.
[7] Bill Osgerby, *Playboys in Paradise: Masculinity, Youth and Leisure-style in Modern
America* (Oxford, England: Berg, 2001), 106.

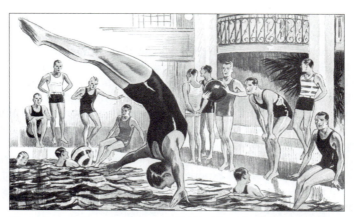

Figure 3. By 1920 men's swimwear had shifted from the long, fabric heavy silhouette to a modern, streamlined two-piece garment that allowed more freedom of movement.

more comfortable, and faster drying, eliminating concerns over clingy suits that sculpted genitals. Men's swimsuits are essentially indistinguishable from walking shorts, save for the colors and patterns.

Such differences in cultural attitudes inevitably impact the male consumer experience. When was the last time a man took an armload of swimsuits into a dressing room and exited with a dismayed expression because "Nothing looked good"? Rather than coping with hangers full of suits and an unforgiving mirror, the typical male customer buys a swimsuit like he buys underwear, trousers, or shorts—by waist size. The only weighty decisions are fabric, color, and pattern. The insecurities that plague the female customer are simply nonissues for most guys. After all, it's "just a bathing suit."

As this book goes to press, the Ventura County (California) public defender, Liana Johnsson, is soliciting support for a bill to legalize female topless bathing at public parks and beaches. Arguing for breast equality under the law, Ms. Johnsson presented her case to a recent Bar Association meeting and used video footage of large-breasted men on public beaches to demonstrate the discriminatory position women face. Though this issue can still generate controversy, given its association with women's rights, it is inevitable that optional topless sunbathing is destined to become legal in the United States as it has been in both Europe and South America for years. Arguably, while it will inflame the ultraconservative, topless bathing will probably not result in the downfall of Western culture or national morality.

NOTES:

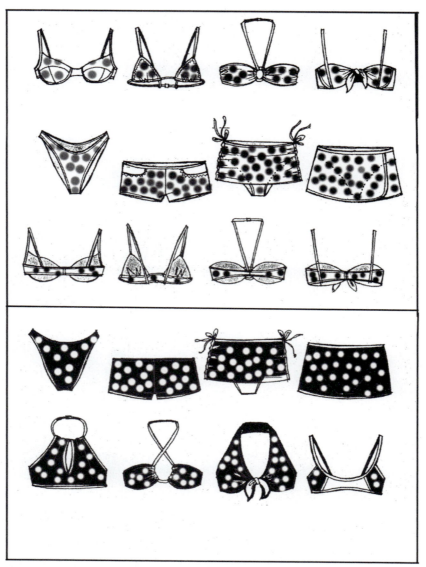

Illustration: Sumi Lee

The Semiotics of the Itsy Bitsy Bikini

Marlena Donohue

I begin with a quirky primary source, the lyrics of Brian Hyland's 1960s pop music hit, "Itsy Bitsy Teenie Weenie Yellow Polka Dot Bikini":

> *It was an itsy bitsy teeny weeny yellow polka dot bikini, that she wore for the first time today.*
> *An itsy bitsy teeny weeny yellow polka dot bikini, so in the water she wanted to stay.*

The song describes a generic "she" feeling in some sense dressed and in some sense undressed. At least the male songwriters and cultural purveyors of the sixties envisioned her experience this way, and as we shall see, this is no coincidence. She is exercising her gender's stereotypic passion for the latest garb. This is after all what we gals do, you see: We live to dress. This is not the *Sex in the City* fetish for Manolos that Hyland describes but the somewhat riskier business of donning the post–World War II *scandale celebre*: the bikini.

We're told it's her "first time." This sexually loaded phraseology is not serendipity or bad prose. It is a purposeful social construction, part of a millennium-long male tradition of eroticizing the female body and its veil—in this case two thin strips of fabric—via a complex forest of signs. Hyland's lyrics imply that our bikini wearer *willingly* dons the scandalous beachwear, yet oddly enough she does not strut her stuff like a fashion maverick or like a woman in charge of and comfortable with the body she has elected to display. Rather, this fantasy bikini wearer self-consciously, even modestly, covers up what the bikini shows, scurrying from the cover of a blanket to the cover of the water. And there—oops—the forces of nature remove the scant clothing, leaving her exposed, adrift, vulnerable, and in need of rescue. How convenient.

A more male-positioned fantasy of the bikini's life cycle and purpose one cannot conceive. A clearer pop music lesson inculcating a distinctly male use and formulation of the female body and what covers it one cannot imagine.

Nor is this sixties ditty the first cultural behavior map to masquerade as high or pop art. Countless precedents make it evident that body vessel and vessel's veil have been engineered by and for the male gaze. MTV music videos in which Britney Spears strips off her pleated schoolgirl skirt and canonical, indeed classical, museum objects function in much the same way. Titian's 1560 painting in the Uffitizi, *Sacred and Profane Love*, a reported engagement gift, depicts two allegorical women, one sumptuously dressed,

the other demurely nude.[1] The canvas is thought to have been a primer for a new wife, a visual lesson—just like the ones on MTV—regarding the oppositional roles of worldly temptress (dressed) and virgin (nude) that this Renaissance maiden would have to reconcile to please her man.

Similarly, the bikini made its appearance with a set of subtly and not so subtly coded directives. Though heralded as a revolution (for reasons that we will develop, it becomes one), the bikini was in many ways a predictable next step in a long arc of male-authored sign building and sexual proctoring.

The bikini in our famous song, as well as the bikini Annette Funicello wore in the first beach party movies, was polka dotted or checked. Again, no accident. Dots and gingham were highly popular bikini fabrics in the late fifties and early sixties (Figure 1). Dots and gingham were patterns for little girls and fabrics worn by Audrey Hepburn and Judy Garland, the two quintessential never-gonna-grow-up waifs of that epoch. These actresses *and their garb* (bound breasts and all, if we are to believe autobiographical facts about the male studio heads and their treatment of Garland), Titian's figures *and their garb,* and ultimately the bikini itself fulfill identical semiotic

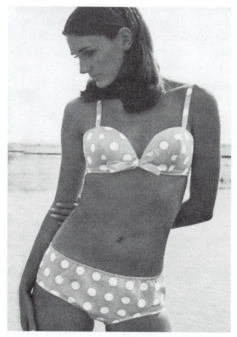

Figure 1. One of the many popular "polka-dotted" bikinis immortalized in Brian Lands' 1960s pop music hit, "Itsy Bitsy Teenie Weenie Yellow Polka Dot Bikini." This one was featured in a Catalina Swimwear 1968 ad.

[1] Frederick Hartt, *Italian Renaissance Art* (Englewood Cliffs, NJ: Prentice Hall, 1975), 534–535. The person likely offering the lesson of "morals" to the new bride was the ultra worldly vice chancellor of the Venetian Republic, Nicclo Auretio, whose coat of arms sits upon the sarcophagus/fountain.

functions—namely, to strategically *site* (and here I use this verb in the way it was developed by Meecham and Sheldon) within the body and its covering certain die-hard lessons and boundaries for female behavior: one part innocent schoolgirl (read malleable, possessable), and one part seductress (read dangerous and sexually robust).[2]

When I was fourteen, to my parents' horror, I bought a harmless, navel-covering two-piece in the most adorable pink checks (What else?). I went to a swim party where the Beach Boys' "Little Surfer Girl" blared from a vinyl disk though we lived a good forty miles from any ocean. I spent the night bobbing quickly from the cover of the water to my towel, displaying and concealing, to the delight of my first boyfriend, Steve Beltran. I had never seen a Titian, but I watched TV and listened to the radio. This was (is) female behavior woven into our longest-term art/cultural heritage, sprinkled onto our morning cereal, so to speak, and so imbedded at all levels of culture that it seemed natural and inalienable to me.

Today my female students roll their eyes at the prospect of women feeding into such behavior codes, yet they arrive to class day after day in bikini-type halters that reveal and conceal, that are constructed to convey similar dualities they think we've outgrown. Well, these are mere lasses—they'll learn. This summer I went to the beach with several forty-something friends, all educated feminists and writers. One of them wore a teeny G-string in bright orange polka dots—I could only smile. The other two spent their entire day hissing, "What is her problem exposing herself like that?"

So, what is it about the bikini that made it scandalous in the fifties, nicely naughty in the sixties, and still complexly coded even for "liberated" postfeminists of the twenty-first century?

A BRIEF HISTORY OF THE ITSY BITSY BIKINI

The emergence and accrued meaning(s) of the bikini are the more significant when we consider that at the turn of the 1900s—a scant sixty years prior to Hyland's pop hit—women sunbathed and (though rarely permitted to) occasionally swam in clothing that, for the sake of due modesty, did not differ much from street dress. Before that, there was no such thing as swimwear per se: We've seen scores of late Impressionist paintings showing bourgeois women at the beach in full-corseted street attire.

In the first decade of the 1900s, swim dresses gave way to "shocking" one-piece, pedal pusher–type jumpsuits with legging to the knees and tight-capped sleeves (Figure 2). The wholesale baring of much more skin than that (especially the midriff) had long been associated with dubious morals, women of the night, and carnivals. Outside the aesthetic veneer of classical idealized nudity, to show navel or pubis in daily life implied fallen morals. Only peep-show soft porn at the turn of the century and into the early 1900s showed women in brassieres or bare breasted.

[2] Pam Meecham and Julie Sheldon, "Female Nude as the Site of Modernity," in *Modern Art: A Critical Introduction* (New York: Routledge, 2000).

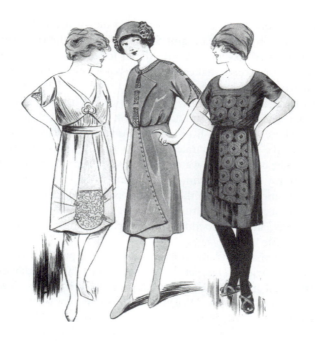

Figure 2. A collection of early 20th century bathing suits featured in Harper's *Bazaar* and *Vogue* Magazine.

Over the next four decades, global city populations grew, we waged two world wars, and we invented the auto. Women migrated to cities for work, and in this increasingly liberated mix, dress hemlines rose and low-cost leisure at the sea became more obtainable for all classes. Beachwear changed concurrently: The legged portion of the swim jumpsuit gradually went up inch by inch to form shorts, and the capped sleeves gradually morphed into halter straps. Thus, the one-piece was born.

The actual bikini, two small patches of strategic, precarious fabric that consciously exposed the navel and hips exploded onto the fashion and sociological landscape of the forties via two competing Frenchmen. Though it is difficult in the primary literature of the day, mostly consisting of salaciously slanted newspaper articles, to decipher fact from urban legend, the story of the bikini goes thus: On July 5, 1945, Louis Reard debuted his skimpy two-piece swimwear, declaring that his design used no more than thirty inches of fabric—basically a bra top and two inverted triangles of cloth connected by string. We are interested in urban folklore more for the way it reifies a broader sign system than for its veracity. That said, we are told in the French press of the day that self-respecting fashion models refused to don the bikini. Micheline Bernardini agreed to wear it, but she is said to have been a dancer at some morally dubious casino, so strutting her stuff in Reard's design for the press meant she was more dressed than usual. Reard's firm did its part to fan the fantasies and build the semiotics of the bikini by keeping the naughty Micheline in the constant limelight and proclaiming that a two-piece wasn't a bikini "unless it could be pulled through a wedding ring."[3]

Equally fascinating and revealing from a social history standpoint are the press materials in Reard's day describing the origins of the word *bikini*. The designer said he wanted a name for his new swimwear that had a catchy, high-profile, "sexy," "exotic" sound to it. He chose the sun-drenched small islands in the Pacific known as the Bikini Atoll. The Bikini islands hit the popular press worldwide in the forties as the home of South Pacific indigenous people with almost no contact with Western urban society: the West's quintessential romantic fantasy. Both Reard and the world came to know of these people and the very word *bikini* when the U.S. government removed the whole population of Bikini islanders to another island so it could test the newly developed A-bomb in a remote and vacant locale.

The something "new," "free," and "sexy" that Reard was hoping for "clicked" when the international press produced and disseminated typical tourist representations of the scantily covered Bikini natives. (I use the term *tourist representations* as do Edward Said and Timothy Mitchell to denote a particular way of showing indigenous, marginalized people—a group to which women have always belonged—as unfettered, exotic, open, loose: the opposite of rational, ordered, controlled, and civilized.)[4]

[3] www.associatedcontent.com/article/44610/theinterestingstoryoftheitsy.
[4] Timothy Mitchell, "Orientalism and the Exhibitionary Order," in *Visual Culture Reader*, M. Mirzoeff, ed. (New York: Routledge) 1998.

Telling is this early equation between an essentially female, essentially sexual accoutrement invented and marketed by men and Reard's stated and implied notions of the exotic, the dispensable, the unknown, the primitive, the raw, and the instinctual. Even in the origins of its name, the bikini comingles Western Europe's two favorite "others," the nonwhite and the female, with several of its other favorite grand narratives: techno prowess, progress through invention, force, and, of course, sex. Chicks and gadgets—some things never change. After a good run at selling skin, Reard's company folded in 1988.

Another Frenchmen, Jacques Heim, created his own late-forties two-piece bathing suit, which he called *L' Atome* (The Atom), also referencing the mysterious, "sexy" state-of-the-art nuclear tests that seemed then a testimony to the limitless power of positivist male progress in its mastery of the smallest to the largest things. Meshing colliding signifiers as only marketing can, Heim made references in the press to the atomic science behind the tests and to the minute size of both the atom and the bikini, describing his beachwear as "atomic—the world's smallest body cover."

It is no wonder that the bikini was invented in Europe. Europe had a long connection with classical nudity, both as high art in museums and as bourgeois curio kitsch. Europeans have traditionally been less protective of their bodies, though no less misogynistic about its display. A still teenage Brigitte Bardot, literally invented for public consumption by her lover/director Roger Vadim, wore a thin little two-piece in the 1952 French film hit *The Girl in the Bikini*. However, in puritanical, late-blooming America, where bohemianism took root almost at the same time as the bikini appeared—the late fifties—barriers to scanty beach garb and nonnormative sexuality were considerably higher.

It is fascinating to read 1950s accounts of the bikini's exportation to the United States from Europe, not for their factual content but as a way to track via urban lore our initial ambivalent relationship to this garb. Books tell us that World War II indirectly jump-started the bikini craze when, as part of war rationing in 1943, the U.S. government ordered a 10 percent reduction in the fabric used in nonessential clothing, including women's swimwear.[5] So, we did not choose this naughty object; rather, conditions outside our control made it necessary, indeed patriotic. I argue that the bikini's emergence was less a matter of cloth rations and more a function of predictable gender politics authored by males to selectively loosen and selectively proscribe new sexual barriers in the fifties.

Closer to truth, if grossly simplified for this essay, World War II helped the bikini enter U.S. culture in two ways: by producing an increasingly empowered workforce of women with new (if short-lived) economic freedom and by producing great masses of lovesick GIs whose prurience was served by this object of dress. During World War II, Betty Grable, clad in

[5] Pauline Weston Thomas, "Rationing and the Utility Clothing of the 1940s," www.fashion_era.com/utility_clothing, retrieved at August 15, 2006.

her signature short shorts with bustier-top became standard issue in every GI locker; midriff and hips still covered, she looked back at us over her shoulder, buttocks suggestively to the viewer. By the end of the war Grable represented a socially (i.e., male) sanctioned, even "all-American" depiction of "just enough wholesome skin."

The zeitgeist of the sixties lowered the skin bar palpably. It was the era of pop culture, of ultra prosperity, of the pill and the Hippie movement, of war protests, civil rights, and surf culture. The margins were challenging the center on all fronts, including fashion, so much so that what began as cloth rationing became irreversibly imbedded in our products and our entertainment. Hyland's hit made the Top Ten, and the ever-vestal Annette complete with a hair-sprayed coif sported the two-piece in cinemas across America's landlocked heartland. Suddenly to show *just enough* skin—hips, cleavage, a little navel—with *just enough* demure contrition was most definitely *in*.

The ambivalent response in the United States to too much skin is indicated by the following quote from *Modern Girl* magazine, dated 1978, a full decade after Hyland's song and one year before Judy Chicago exhibited *The Dinner Party*: "It is hardly necessary to waste words over this so called teeny bikini since it is inconceivable that any girl with tact and decency would ever wear one."[6] Apparently, as long as the bikini minded its manners, as long as it reified male meanings with respect to our bodies, it was tolerated as funny, zany, exotic, and attractively coy. Note the protagonist in Hyland's song; note a pigtailed teenage Goldie Hawn making her debut as the ditsy blond dancing in a teeny floral two-piece for the national smash TV comedy review *Laugh-In*. No one objected; everyone laughed.

THE BIKINI'S ANCESTORS: SKIN AS SYMBOL AND SIGN

The bikini didn't invent these unresolved semiotics but rather, as suggested by Titian, continued an overt and covert system of signs woven into the deepest roots of Western and non-Western thought beginning in prehistory and ancient times. Paradigm objects of cultural production—the *Venus of Willendorf* (Figure 3), the small carving of *Pregnant Women with Deer* on reindeer horn from Laugerie-Basse circa 14,000 B.C.E., the female effigies from Catal Huyuk—suggest that the strategically exposed female body was a potent, primal (if only speculatively understood) symbol for ideas related to fecundity. Once societies turned stable and patriarchical, once the waging of war for property replaced hunting, gathering, and

[6] Elizabeth B. Hoover www.americanheritage.com/events/articles/web/2006 0705-bikini-swimming-suit-Lousis-reard-micheline-bernardini-paris-bridget-burdot.

Figure 3. An illustration of one of the female effigies, Venus of Willendorf, ca. 14,000 BCE. (Illustration: Kathryn Hagen)

reproductive clan building as a means of survival, once the female became part of tribal property passed from father to husband, the meaning of being uncovered, as well as the gender of who was covered, gradually shifted. We need only look at the Standard of Ur to track this process of sign making around skin and its cover (Figure 4). The conquering general (central register, midpoint of piece), his status explained by his larger scale, quite obviously displays, draped over his arm in the foreground at just the center of what would have been the viewer's eye level for this city placard, the clothes he took from the now undressed—to be read as *vanquished*—enemy that falls before him. The robe held by the general, whether it belongs to the general or to the captives, is prominently displayed to suggest an equation between

Figure 4. Illustrations of Standard of Ur, ca. 2600–2400 BCE.
(Illustration: Kathryn Hagen)

body covering and power, between body exposure and weakness. It is well documented that once someone was taken in war, in the ancient world, the first act was to disrobe the captive: humiliation, power, controlled display—all this remains deeply rooted in the evolution of our skin-flashing, not-so-benign polka dots.

The coding of skin continues in images of divine Egyptian and Mesopotamian princes who always showed themselves in carefully calibrated states of dress/undress. The lower body is always covered with kilts and the upper body is always *exposed just enough* to signify muscularity and dominance and, as noted by Irene Winter, to suggest the correlate of physicality prominent today as well as in the ancient world: male sexual prowess.[7] By contrast, Egyptian concubines, musicians, sculptors, and slaves (all of low status) were almost always depicted without covering. Today the South Beach concubines' thongs function in much the same way as our bikini does: to reify a specialized meaning for nakedness that includes ideas of disempowerment.

Platonic and Christian traditions add their share of conflicted signification. In both those ancient traditions, we are born unclothed and innocent and cover partially and selectively only after we sin. (The bikini, as invented by men, permits women to reside in the unspecified nebulous zone between virtue and vice—that psychosocial space of which males are particularly fond.) As Richard Leppert and others have noted, image upon image of asexual, emotionally controlled, unclad Greek male figures come to be associated with such lofty Platonic abstractions as order, symmetry, and the

[7] Irene Winter, "Sex, Rhetoric and the Public Monument: The Alluring Body of Naram Sin," in *Sexuality in Ancient Art*, ed. Natalie Boymel Kampen (London: Cambridge University Press, 1996), 11–13.

classical myth of *cosmos*.[8] Conversely, partially draped female figures, whose often perfunctory covering reveals more than it conceals (like the bikini), come to be associated with such ideas as surface decoration, beauty, service (recall the kouroi extended a hand often holding/offering sacred food, such as a pomegranate), sexuality, and, most significantly, surfaces of desire.[9] Phidias's famous wet drapery style was more than propaganda used by Pericles to associate his strife-filled Golden Age with elegant leisure, and it was more than an index of cutting skill designed to amaze viewers with marble that could look like fine transparent linen hiding erect nipples. Phidian wet drapery, much like the bikini, conveniently relayed a special sort of controlled, nonthreatening titillation, with all that word implies: a (male) subject/actor/looker stimulated by a (female) object of scopophilia rendered in some manner vulnerable, passive, erotic, possessable by virtue of this unique state of being at once covered (i.e., not sexually aggressive) and exposed (i.e., sexually vulnerable). A clearer precedent for the dynamics of the bikini would be hard to find.

The rise of the capitalist male consumer was the hallmark of the Renaissance, and Neoplatonic poet and philosopher Marsilio Ficii, working for the best fifteenth-century capitalists, offered up Botticelli's nude Venus or a half-clad Primavera as emblems of the innocent, unfettered soul.[10] One can only imagine the frisky Medicis licking their chops in the privacy of their villa as they enjoyed soft porn peeks of Simonetta Vespucci—Florence's Gwyneth Paltrow—painted in the guise of platonic innocence and wearing an obvious semiotic second cousin to the bikini. Research on Renaissance underwear indicates that women wore no such undergarment. The partial clothing of Botticelli's design is a male invention designed to operate for male consumption in the same bikiniesque territory between allowed and taboo exposure.

From Praxilites' Aphrodites through Botticelli's nymphs, from Boucher's countless seminude "goddesses" to such grand academic machines of the sabine women by David, men have tried to convince us that the partially clad females they leered at prior to the bikini signified something lofty, like the victory of truth.

If the male authors invented aesthetic nudity while they licked their chops in front of countless half-clad "goddesses," they just as surely configured the oppositional pole—raw nakedness—in their image and for their pleasure. As Meecham and Sheldon suggest, the construct of sexually "available" skin was introduced in the late 1800s and early 1900s by such artists

<hr/>

[8] Richard Leppert, "The Male Nude: Identity and Denial," in *Art in the Committed Eye* (New York: Harper Collins, 1996), 250.
[9] Richard Leppert, "The Female Nude: Surfaces of Desire," in *Art in the Committed Eye* (New York: Harper Collins, 1996), 211–214.
[10] Giulio Carlo Argan, *Marsilio Ficino: His Theology, His Philosophy, His Legacy*, eds. Michael J. B. Allen and Valery Rees (Leiden, Netherlands; Koninklijke N. V., 2002), 327–329.

as Courbet, Manet, Schiele, and Kirchner, to name a few.[11] In images of nude models, artists began to depict openly sexual states of undress, to be contrasted from the veiled voyeurism of, say, a Degas. As Meecham and Sheldon note, by the late 1800s, sexual license communicated via bodily exposure became one litmus test of bohemian art, of the avant-gardist unconstrained by moribund traditions alien to modernity. Even as we used bodies to define artistic and social modernity, these messages remained predictably gendered.[12] The naked male stood for "creative freedom," "truth to self;" while the undressed female signaled the marginal, not the free thinker but the hooker, the diseased, and the abject (in both the common sense of that term and in Julia Kristeva's very specific sense)[13].

Most telling here is Kirchner's *Artist with Robe,* in which the undressed state of both the female model and the male artist signify social liberation but with very different nuancing. The female model disrobes dutifully, numbly, rolling down her stockings as one would punch in for a shift at work. On the other hand, Kirchner has clear agency over his state; he paints and smokes comfortably underclothed. Selective nakedness in modernity aligns the male with the choice to expose *at will*, while women continue to be represented as having no such choice. (More on *agency* as we conclude.)

It's clear that the bikini's place in social and fashion history hinges on this age-old tension between acceptable versus unacceptable exposure. Kenneth Clark intellectualized this dichotomy via his idea of *iconic, nonsexual* nudity versus everyday nakedness. To Clark, Praxitiles's *Aphrodite* is *unobjectionably nude*, but Manet's *Olympia*—who bought her silk sheets with her wages and seems comfortably unclothed (like Kirchner in his self-portrait)—is *vulgarly naked, sexually naked:*

> All those delicate feelings which flow together in our joy at the sight of an idealized human body . . . are shattered and profaned. The sublimation of desire is replaced by shame at its very existence; our dream of a perfectible humanity is broken by this cruel reminder of what, in fact, man has contrived to make out of the raw material supplied to him in the cradle, and, from the point of view of form, all that was realized in the nude in its first creation [i.e., in the sculptures of ancient Greek gods], the sense of healthy structure, the clear geometric shapes and their harmonious disposition has been rejected in favor of lumps of matter, swollen and inert.
> Kenneth Clark, *The Nude: A Study in Ideal Form*, 1956, 6–7.

Clark's fear of the sort of flagrant skin the bikini would come to celebrate is palpable. He is lamenting the actual body and championing the eternal feminine. He is attempting to reconcile the nude of high art with the naked

[11] Pam Meecham and Julie Sheldon, "The Female Nude as the Site of Modernity," 84–87.

[12] *Ibid.*, 84–87.

[13] Julia Kristeva, *The Powers of Horror: An Essay on Abjection*, trans. Leon S. Roudiez (New York: Columbia University Press, 1982), 11–13.

of daily life, defending, it would appear, the former from encroachments by the latter. Note that Clark writes this in 1956, the very historical moment when the bikini was busy inserting the real body onto our beaches and in our media. Our confrontation with skin on popular and academic fronts hit the cultural radar by the late fifties; there was no turning back and our teeny bikini played a major role in this assault.

In the late 1970s, John Berger, T. J. Clark, and others added a Marxist view to exposure, observing that states of raw undress by women—to which the bikini certainly belonged and belongs—had traditionally been linked to the lower classes, to the poor and any "other," a margin to which women have always belonged.[14] For Berger, undress had political implications: Who was naked and how said important things not just about the body but also about class and morals. Marxists saw nakedness not as the less noble of the two states but as the more authentic, that which took place outside the pretense of aesthetics. As an object of material culture that confronted us with real bodies from all classes, the teeny, benign bikini could be argued to have some transgressive Marxist valence.

From the eighties to the present, feminists finished unwrapping (pun intended) the semiotics of undress, arguing as I have that until that decade men in power authored and gendered the sign systems regarding skin. Without mentioning the bikini per se, feminists argued convincingly that whatever the epoch—classical, modern, or postmodern—*corpus* or the temporal body is always somehow linked to mutable nature, to the primitive, to decay and the feminine, while *mensa* or mind is always somehow linked to immutables such as intellect, spirit, and maleness. Margaret Walters and Helen McDonald traced oppositions such as Clark's iconic versus abject body to the patriarchical dualism found in Plato, Descartes, Kant, and the Enlightenment, noting that the Enlightenment simply borrowed gendered ideas about nudity from the very church it sought to rationalize.[15] Finally, Nead convincingly suggested that dualist schemas such as aesthetic or abject merely close down possibilities of real action for women and, under the guise of scholarship, further narrow female agency.[16]

As a consequence of this powerful work that included the 1966 birth of the National Organization for Women (NOW), the 1967 advent of (W.A.R.), and Judy Chicago's Women's Study Center at Fresno State, the 1980s saw women demanding control over their bodies. Interestingly enough, as political barriers took a very long time to soften (states refused to ratify the Civil Rights Act as a bill), on the grassroots level women's

[14] For more detailed discussions of clothing/covering and class see: John Berger, *Ways of Seeing* (New York: Penguin Books, 1972) and T. J. Clark, *The Painting of Modern Life: Paris in the Art of Manet and his Followers* (New York: Knopf, 1985)

[15] Helen McDonald, *Erotic Ambiguities: The Female Nude in Art* (London and New York: Routledge, 2000), 7–14.

[16] Lynda Nead, *The Female Nude: Art, Obscenity and Sexuality* (London and New York: Routledge, 1992), 14–16.

demand for agency over our own skin took place in and around fashion. It is not coincidence that a young Madonna performed and selectively exposed in bikinilike attire throughout the 1980s. It seems no accident that Lynda Benglis took out an ad in *Art Forum* in which she wore only her absent teeny bikini in the form of the suntanned outline it made. Nor is it an accident that she sported a massive dildo to underscore the historically male construction of the limits of exposure and to humorously and violently claim her right to same. Against the warnings of *Modern Girl* magazine and Kenneth Clark, the eighties saw the rampant spread of the cult of the bikini across U.S. beaches and backyards.

As we began to control our bodies, to demand a say over who would have access to them, who would view them, and how and when they would be displayed, the occasions for self-authored display became equally nuanced and necessarily public. In this shifting paradigm, our teeny bikini played a pivotal cultural role. The bikini was gradually usurped by women, who by the eighties used the bikini for a range of renegade, proto-feminist behaviors: to flirt, for comfort, for the sensual pleasure of feeling the sun on our skin.

CONCLUSION: THE BIKINI AS GUERILLA WAR GARB

Jacques Derrida convinced us that intertextuality permits anything to become a loaded sign and any sign to shift its syntax.[17] Our itsy bikini has been one such provocative, culturally influential floating signifier. It is no longer unusual, in fact, in the scholarship of art history and visual culture to presume that we are able to "read," and indeed learn from "reading," not just a canvas or long-established icons but in fact all cultural production: billboards to MTV, toys to ostensibly documentary news photos.[18] Extending this argument, Pollock has suggested that *images*, working just like historical text, reproduce at the ideological level of art the relationships of power between men and women.[19] I would venture to close this essay by suggesting that dress—yes, innocuous everyday garb—can be equally ideological, equally able to participate in and to subversively interrogate our ever-fluid, densely political sign making.

As we have seen, the bikini began as part of a carefully freighted and gendered complex of meanings and behavior codes, most of which were tooled by and for men. These signifiers included grown-up exhibitionism, sexual free will, titillation, girlish modesty, childlike dependence, vulnerability, and a host of other role-specific associations that, however psychologically at

[17] Jacques Derrida, *De La Grammatologie* (Paris 1967. English trans. by Spivak, Gayatri. Baltimore, 1979).

[18] Alan Sekula, "On the Invention of Photographic Meaning," *Art Forum*, January 1975, 41.

[19] Griselda Pollock, "Modernity and the Spaces of Femininity," in *Vision and Difference* (New York: Routledge, Chapman & Hall 1988).

odds in any integrated healthy female psyche, fit perfectly the erotic and political needs of material culture's main consumer/patron: the bourgeois white male.

The bikini replaced the classical drape, replaced the modernist green curtain, and was conceived (whether under the guise of eternal beauty or dangerous eros) in the same way as those visual contrivances had been: to expose pornographically—that is, by suggesting absence of agency, voyeurism, and the removal of our cover through a will other than our own. Susan Kandel uses the metaphor of partial covering—the balance between what we get to see and what is kept from our sight—which is essence of the bikini—to underscore the idea that it is neither nakedness nor nudity upon which the pornographic or the empowered female body turns but rather upon the issue of *agency*: "The pornographic regime is sited in the fold between the visible and the invisible."[20] If you look between the seen and unseen without my permission, at your leisure, and to your ends, this is exploitive: if you look at my leisure and when I wish, this is transformative, empowering.

I do not think that the male inventors of the bikini banked on its wearers usurping this attire and its symbolism as a feminist marker of empowered agency or of political, sexual, and social equality, yet we did. The bikini became a kind of guerilla war garb, taken over, claimed by us and for us, in a subtle postfeminist war waged by an unsuspecting Gidget, by Benglis in the buff, and by every woman comfortable enough to wear and bear at will. Two strips of colorful fabric became that spunky object of material culture that finally yanked the body from its privileged museum pedestal and lifted it out of male scholarship. The bikini contested the distribution and consumption of nonpornographic exposure by plunking real female bodies—yes, those "lumps of matter" that so troubled Kenneth Clark—onto our proletariat beaches, where this renegade attire could help fuel a revolution of agency.

As Kandel suggests, it is in the folds between the seen and the unseen that the bikini takes its place in history as a shifting signifier whose meanings and use morphed over time: in the sixties suggesting male-orchestrated exposure, in the seventies challenging this canon, in the eighties signaling readiness for encounter, and by the nineties actualizing self-determined exhibition. Our bikini is thus in no manner benign but, in fact, makes evident the idea that designers of fashion bear the critical job of *patterning meaning* in so much as they pattern cloth.

[20] Susan Kandel, "Beneath the Green Veil: The Body in/of New Feminist Art." In *Sexual Politics: Judy Chicago's Dinner Party in Feminist Art History*. ed. Amelia Jones (Berkeley: University of California Press, 1996, 186.

NOTES:

Menswear: French bikinis and low-rise boxers, ca. 1967.

The Speedo: A Few Brief Points

Parme Giuntini

Think: male bikini. The immediate visual is an athletic body in a Speedo. Both brand name and generic description, the Speedo is commonly associated with competitive swimming and diving, although it is typically worn for nonwater sports such as weight lifting and bodybuilding.[1] Male swimmers adopted the abbreviated suit over more conservative trunks for purely practical reasons. Less fabric and tighter fit reduce drag in the water, which is especially important in racing events and water polo, while competitive divers need to reveal more of the body, since form is critical to judging. The Speedo brand has dominated competitive swimming and the Olympics for the past seventy-two years and although both men and women compete in Speedo suits, it is the male version that I am concerned with here.[2]

American males have preferred baggy swim trunks since the 1960s, when the Southern California beach and surfing subculture first emerged and gained popularity.[3] The now iconic formula of the California surfer and his beach babe were captured in the lyrics of the Beach Boys and of Jan and Dean and visualized in countless "bikini beach" films. The visual culture of this new ideal permeated contemporary advertising and television as well, producing a desirable youth-centered lifestyle that primarily targeted the white middle class and popularized surfing culture throughout the United States.[4] Typical swimwear was a bikini for her and solid or floral cotton trunks for him, still short and fairly

[1] Speedo suits are manufactured for both men and women.

[2] Speedo suits for women are body hugging, tank-type or racer-back styles without boning, figure enhancing, or corrective features.

[3] Surfing was a long-established sport in Hawaii but relatively unknown in the United States until the early twentieth century when the writer Jack London began publicizing it after a visit to the islands. It remained a relatively elite activity through the 1920s and 1930s. Greater public awareness and popularity began after 1932 and the development of lighter-weight hollow surfboards, but it was not until the novel *Gidget* was released in 1957, followed by the film in 1959, that the sport and its associations with Southern California youth, beach lifestyles, and dress firmly entered popular culture. See Kevin Starr, *Coast of Dreams: California on the Edge 1990–2003* (New York: Knopf, 2004), 4.

[4] Bill Osgerby, *Playboys in Paradise: Masculinity, Youth, and Leisure-Style in America* (Oxford, England: Berg, 2001), 105.

form fitting. Over the next few decades bathing trunks gradually expanded, billowed, and lengthened in response to street fashion that emphasized baggy loose trousers for men, as well as the increasing adoption of the baggier surfing style by athletes for skateboarding, basketball, volleyball, and skimboarding. The increasing visual culture of films, television, videos, advertising, and magazines dedicated to these sports, all of them dominated by youthful, athletic males, helped to frame American attitudes about the male body, athleticism, and masculinity (Figure 1).

The key themes to popularizing baggy swimsuit styles among men were its effectiveness as athletic wear, its versatility in moving from the beach or pool to other activities, and its associations with youth culture. Without missing a beat, the style moved from serious surfing to skateboarding and basketball to beach volleyball, all sports that were male-dominated and required athletic ability and physical strength; these sports also attracted audiences, advertising interest, and television coverage. Baggy surfer-style trunks were the choice of both those who followed the sport and those who didn't but still wanted to look the part. Knee-length surfer jams teamed with T-shirts became perfectly acceptable school attire for thousands of juvenile and teenage boys in warm weather areas since they corresponded to most school dress codes for walking shorts.[5] Tall tanned bodies, bare chests, and sun-streaked hair, along with low-slung loose surfer trunks, ultimately

Figure 1. Gotcha surfer jams, ca. 1986, helped popularize the Southern California beach and surfing craze. They offered men an opportunity to be both fashionable and modest.

[5] Surfer jams, sometimes called board shorts, is a more specialized term for the knee-length or slightly longer, loose, baggy-style trunks. Jams are characterized by their bright colors and patterns, and they can have pockets, drawstrings, and toggles.

redefined a new ideal for masculinity and sexual allure. Where bikini films and surfer music left off, television, advertising, and teenage lifestyles filled in, reinforcing Southern California influence on contemporary men's swimwear.[6] Often combining Hawaiian elements, California surfer style functioned as a highly desirable hybrid of American and youth culture and was successfully exported to Europe and Asia.

By contrast, the female bikini remained an erotic counterpoint. Growing briefer each season, the bikini was confined to beach, pool, or resort areas where it served to display the body. The stereotype of the tanned bikini-clad female who never entered the water is not without the proverbial grain of sand since the style was never intended for strenuous sport activities. Although some films featured bikini-clad girls swimming or surfing, the associations between athleticism and the bikini were incongruous due to the widespread understanding that women did not buy bikinis to body surf.[7]

American male swimsuit preferences are established in early childhood when little boys, including toddlers, wear long, baggy trunks to imitate their fathers. The style overwhelmingly dominates retail choices, and although it is possible to buy toddler-size Speedo suits, stores stock fewer versions of the style, reinforcing early consumer associations of baggy trunks with appropriate male beach attire.

Technological advances have further contributed to the popularity of baggy trunks. Thanks to advanced textiles that are lightweight, shed water, and dry rapidly, even the longest, baggiest trunks are comfortable and easy to wear in or out of the water. Perhaps the only concession to sexual allure that the baggy suit can offer is the recent trend of wearing trunks low on the hips, but even that is somewhat mediated by the increasing length and volume of fabric.

American men primarily associate the Speedo with European tastes, gay lifestyles, and specific athletic competitions, but not as a swimwear option. Even Warnaco, the major swimwear manufacturer, acknowledges this; despite its highly publicized 2004 sponsorship of Olympiad Michael Phelps, popularity of its Speedo brief did not increase and accounts for only a small percentage of sales.[8] The bulk of Warnaco's business remains in its other product lines which include sportswear, underwear, and more conventional baggy swim trunks. For most mainstream American men, even those caught up in body consciousness and gym fever, the suit's extreme brevity and snug fit call too much attention to the wearer's body and the genital area in particular, creating an ironic gendered twist since these are the intended goals of the bikini-clad female. Even the most buffed men are

[6] Manufacturers such as Tommy Bahama, Side-out, and Quicksilver are examples of California firms that have capitalized on swimwear and sportswear.

[7] There are two notable exceptions, primarily the popularity of bikinis in female bodybuilding and in volleyball competitions.

[8] Warnaco Group, Inc., manufactures Speedo.

reminded that they look best in boxers that are "not too short, not too long, not too tight" and warned that wearing brief suits, including the Speedo style, is intended for "really, really, really ridiculously good-looking and in-shape men who don't suffer from monkey-rug back, flat ass, micro-penis, or other aesthetic disorders."[9]

Arguably, for many heterosexual American men, the Speedo communicates too bold an emphasis on the genital area and overt sexuality, rather than the nonchalance and unself-consciousness that they associate with clothing that is looser and worn for comfort.[10] Does this suggest, then, that by default we would expect more gay men to prefer Speedos because of their interest in wearing clothing that attracts sexual attention from potential partners? If so, does this mean that heterosexual males avoid such sexually provocative styles because their self-images are grounded in narrower standards of male identification? Under these circumstances, the Speedo would delineate a space of alterity whose meaning is produced not by the suit itself but by a range of connotations about the suit that help identity to become meaningful.[11] Although gay men have been credited with popularizing blow dryers, painter's pants, the gentrification of urban neighborhoods, disco music, Absolut vodka, Levi's 501 jeans, Doc Marten's boots, and Santa Fe home-style furnishings,[12] and certainly some gay men wear Speedos, there is no compelling evidence, retail or cultural, that as a group they are particularly invested in identifying with the style.[13] Additionally, some heterosexual American males defy their baggy-suited peers and wear Speedos for the most rational and practical reasons: They are lightweight, dry quickly, and make bodysurfing and swimming easier. Logically speaking, these are qualities that should weigh heavily in the suit's favor, but logic and rationality neither are nor have been particularly compelling arguments about bathing suits.

Regardless of their preference for long and loose swimwear, American men slip into Speedos for competitive swimming and diving, where the suit operates as a uniform. Along with the requisite preparation rituals for competition, which require shaving chest, legs, and underarm hair to eliminate drag and wearing a tight-fitting bathing cap (a practice only women followed

[9] Jessica Fishbein, "Sex on the Beach," *Men's Health*, 18, no. 4, May 2003, retrieved at June 30, 2005. http://unweb.hwwilsonwed.com/hww/jumpstart.jtml.

[10] Shaun Cole, " 'Macho Man': Clones and the Development of a Masculine Stereotype," *Fashion Theory*, 4 no. 2, 125–40.

[11] Ernst Van Alphen, "Strategies of Identification," in *Visual Culture: Images and Interpretations,* eds. Norman Bryson, Michael Ann Holly, and Keith Moxey Hanover and London: Wesleyan University Press and University Press of New England, (1994), 260.

[12] Sarah Schulman, "The Making of a Market Niche," *The Harvard Gay & Lesbian Review,* vol. 5, no. 1, proxyserver.otis.edu:2169/login?url=?did=506102711&sid=1&Fmt=3 &clientld=72221&RQT=309 & VName=PQD, retrieved August 30, 2006.

[13] See Shaun Cole, " 'Macho Man'," for a critical discussion of gay men and developing fashion stereotypes.

until the late 1960s), wearing a Speedo is compulsory.[14] These requirements first emerge in high school, where the Speedo is not a demonstration of personal preference but a public statement of commitment to individual or team success. Like the shaving rituals and the cap, the suit signifies competition, speed, and endurance, encoding the wearer with a powerful, masculine identity, rapidly moving beyond the appearance of ideal form to the performance of ideal athleticism. Shorn of its sexual associations and repositioned as compulsory attire, the suit appropriates the positive signifiers of any uniform associated with group success and competitive achievement. Wearing the Speedo is not a choice but a predetermined requisite. Despite the attention that the suit calls to the genitals and buttocks, it is understood to be merely a temporary change, a preemptive sacrifice that alludes to later victory. By deflecting any official discourse from eroticism or sexuality into athletic prowess and team loyalty, the wearer can then effectively identify with mainstream masculinity.

The practices surrounding competitive events reinforce the emphasis on athleticism, implicitly assuring swimmers and spectators that the Speedo functions solely as a well-designed uniform. The actual activity occurs amid water and motion, blurring the body from the observer. Out of the water, swimmers immediately wrap themselves in towels and warm-up suits, removing their barely clad bodies from public observation, a practice that is continued throughout competitive swimming, including the Olympics. Consequently, no one expects these young men to wear Speedos on the beach or at the pool any more than football players would wear tight-fitting spandex pants off the field. Speedo—it just isn't an American thing.

[14] Even that may change in the face of recent technological interest in the "fast-skin" bodysuit developed by Speedo that claims to reduce drag even further. Although some swimmers in the 2004 Olympics competed while wearing variations of the suit, it was not the dominant choice. If adopted because of its demonstrated superiority, it would be the first time that male and female swimmers competed in androgynous swimwear.

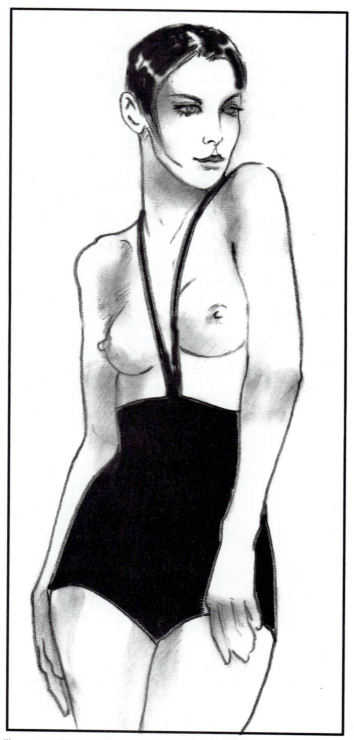

Illustration of Peggy Moffitt in the infamous topless swimsuit by Rudi
Gernreich. The original was unveiled in 1969. (Illustration: Kathryn Hagen)

Peggy Moffitt's Bare Breasts

Kathryn Hagen

The whole topless thing could have been a disaster. I didn't want to do it when he asked me. I am a puritanical descendent of the Mayflower. *I carried that goddamn Plymouth Rock on my back. . . . When I did give in, I did so with a lot of rules. I would not show myself on the runway that way. I would do so only with Bill. Since Rudi would never ever have enough money to do this, I did it for free. But I had final say on everywhere it went photographically. Not* Playboy. *Not* Esquire. *I didn't want to be exploited. Not ever. In fact I made quite a scene when in Los Angeles several years back the curators of a Rudi exhibit wanted to make another woman go topless in the monokini he had designed for me. I protested because that is equally exploitative. It wasn't just about me. It's about women. I think Rudi and I kept that from being exploitative—a real precedent then—because I cared how you do a thing rather than what you do. Everyone was outraged anyway. But at least we did it with, excuse the word, class.*

Peggy Moffitt, September 2001,
www.citypaper.net/articles/091301/cov. fall.qanda.shtn

Poor Peggy. It is hard to be muse to a genius and say no to anything, especially destiny. Rudi Gernreich, wunderkind California designer, was obviously fated to bare women's breasts, shock the world, and go down in a blaze of no-bra bras and unisex caftans.

They had both been dancers. They understood clothing as costume, using flamboyant garments to invoke mysterious, ironic personas. They agreed that movement was key to creating a specific mood. Peggy would skip down the runway in a minidress and saunter sensuously, clawing the air, in a leopard-skin pantsuit with matching cape, shoes, and hood. She also used her dance movements in stark fashion photos, designing body shapes that were an extension of the fabric's geometric designs. She helped to create a new kind of fashion art that bolstered the late sixties "take no prisoners" approach to any and all conventions.

Swimsuits were a hot topic, connected as they were to female sexuality. Free love had to be supported by freeing the physical, so Gernreich took all the interior construction out of suits and cut wide swaths out of their colorful shapes, creating bold cutouts of flesh-revealing audacity. Swimwear had come a long way, baby, and Mr. Gernrich could take much of the credit.

Hard to imagine in that crazy psychedelic time that a mere century earlier, women wore head-to-toe wool swim outfits, with coordinating lace-up boots. The added saturation weight was probably enough to drown them if they should ever actually attempt to swim. In that repressed age, female modesty was everything, and it didn't much matter if women couldn't achieve flotation.

Even in the sixties, though, modesty still had its frontiers, and cognoscenti wondered which avant-garde designer would be first to cross the nudity line and create a swimsuit that would leave the breasts exposed. Gernreich had predicted in 1962 that the bosom would emerge within five years, and naturally the fashion world was intrigued and titillated. Emilio Pucci echoed that sentiment in Italy, and it became a competition of sorts. Journalists egged them on, breeding devil-may-care rivalry.

Because the articulate Gernreich seemed to be especially tuned to the ascendancy of youth culture and the technological megastrides of the day, he had the fickle fashion press in his pocket. It was heady stuff for an immigrant Jewish designer who grew up poor and disenfranchised, chased from his country as a boy by the virulence of Aryan intolerance. Bred in controversy, he was increasingly drawn to the notion that specific fashion innovations could affect and reflect culture in ways that equaled the potency of art and politics. Stuart Timmons, who archived Gernreich's papers for the University of California at Los Angeles (UCLA), speculated that his socialist background gave him a big picture, a historical-patterns point of view that encouraged him to think beyond the latest trends.[1] The gambler in him was willing to skip through that minefield, and he did ultimately beat Pucci to the finish line, which was in a way a prelude to his own finish. Though the world loved a risk-taker, business did not necessarily thrive on scandal.

Indeed, Gernreich was a creature of extremes. His fashion philosophy bordered on nihilism, as he seemed willing, even eager, to destroy the very system that had brought him fame and fortune. "I felt I had to be experimental at any cost, and that meant always being on the verge of a success or a flop."[2] By 1967, he was dressing Barbara Streisand, and his face was on the cover of *Time* magazine. His business was grossing about $1 million a year, serious money in those days. By 1970, his gross had plummeted to $7,000, a consequence of the infamous topless suit, and his follow-up of radical unisex photos, and his even more extreme philosophical ramblings on the death of fashion. "I knew it could ruin my career," said Gernreich of his topless suit. "Fear of being preempted led me to say okay."[3]

It may seem odd to us that this topless thing was ever a big deal. Wasn't *Playboy* magazine churning out airbrushed nude bunny girl photos every month? The European penchant for topless bathing was common

[1] Cathy Horyn, "The Shock Heard Round the World," *Vanity Fair*, May 1998, 122–130.

[2] *Ibid.*, 128.

[3] *Ibid.*, 129.

knowledge. But Peggy Moffitt, modeling those controversial bits of stitched-together spandex, also called the *monokini,* projected an image very different from *Playboy* centerfolds. Aggressively androgynous, with heavily outlined eyes, pale, sullen lips, and razor-cut, geometric black hair, poseur Moffitt projected an unruffled cool that subverted any sexualized semiotic reading of her provocative swim outfit. Her narrow-hipped, adolescent boy body perfectly counterbalanced the bold display of her small, pear-shaped breasts. The thin, V-necked straps encircling her neck prevented the reading of a bikini that was simply missing its other half. More importantly, Moffitt looked mature enough to make her own decisions. Nevertheless, a respectable, adult woman choosing to pose in such a scandalous swim garment created a cultural anxiety that seems somewhat laughable today.

In a time when traditional forms of morality were beginning to crumble, Gernreich pushed the envelope, daring fashion as an "art form in waiting" to assume cultural leadership and take provocative stands that would challenge convention.[4] He was the first to triangulate fashion, culture, and politics and to use clothing as a kind of exquisite sociological message board of the here and now.[5] The famous photo of Moffitt set off a cycle of extreme exposure of intimate body parts through fashion, high and low, as a means of gaining notoriety and winning the hearts of the fashion press.

So, what, we of feminist inclination may inquire, prevents Gernreich's monokini from being just another exploitative means to display the nude female form? Was there inherent power in the topless suit due to its avant-garde pedigree, or did it remake its wearer into simply a glorified fashion sex object? Perhaps there was a personal significance for someone like Gernrich, a co-founder of the Mattachine Society in the 1950s, a pioneering movement for gay rights. In a time when gay culture was still, at least in public, carefully closeted, outing the female bosom was a revolutionary act of potential feminine empowerment that could substitute for repressed gay insurgence.

The female torso is always a disputed territory, whether revealed or concealed. Valerie Steele argues that the partially clothed body is often perceived as being sexier than the nude, and designers have exploited this by obsessive reconfiguring of revealing shapes that create both mystery and provocation: a higher-cut swimsuit leg, an exposed navel, a low-cut back, and so on.[6] If the wearing of such provocative suits is predicated on strict codes of moral behavior, how might the wearing of a topless suit subvert this essential construct?

Gernreich had never intended to produce his suit, but Diana Vreeland of *Vogue* convinced him to make and sell it, and 3,000 units were purchased, though one wonders how many were ever worn. Ultimately, the suit was

[4] Elizabeth Wilson, "Fashion and the Postmodern Body," *Chic Thrills* (Berkeley: University of California Press, 1993), 11.

[5] Cathy Horyn, "The Shock Heard Round the World," 127.

[6] Valerie Steele, "States of Undress, Lingerie to Swimwear," in Cathy Horyn, "The Shock Heard Round the World," *The Face of Fashion,* ed. Jennifer Craik, (London: Routledge, 1994).

This is the one. Rudi Gernreich's 'No Bra' bra for Exquisite Form.

Figure 1. The "No Bra" bra was designed by Rudi Gernreich in 1965.

banned by Pope Paul VI, denounced by *Izvestia,* and buried in an Italian time capsule between the Bible and the birth control pill. [7] Though some may still connect Gernreich with breast exposure, his more lasting legacy is perhaps with the "No Bra" bra, which literally changed the shape of fashion, and with the original prototype of the underwear thong. Both styles remain ubiquitous in contemporary lingerie (Figure 1).

[7] *Izvestia* functioned as a long-running high-circulation daily newspaper in the Soviet Union. While *Pravda* served as the official mouthpiece of the Communist Party, *Izvestia* expressed the official views of the Soviet government as published by the Presidium of the Supreme Soviet of the Union of Soviet Socialist Republics (USSR).

NOTES:

Illustration of Vivienne Westwood's jewel encrusted corset. 2002.
(Illustration: Kathryn Hagen)

The Corset Revival After World War II: From Submission to Empowerment?

David Kunzle

No discussion of the feminine body in the Western world can make much sense without getting a grip on the corset. . . . The corset has played not a supporting but a starring role in the body's history.

Susan Brownmiller, *Femininity*

Was there ever so compelling an object of debate and desire?

Anne Grogan, *Romantasy*

The corset surely has been the most continuously controversial garment in the history of Western fashion. Its sculpting of body shape and body posture (normally, but not exclusively female) has been deemed akin to, and sometimes worse than, the body modification of supposedly *primitive* and *barbarian* peoples. Among these, tattooing, scarification, and piercing have over the last decades invaded our popular youth culture, but it is the high fashion embrace of the corset, in the context of other fetishes and such sadomasochistic playthings as extreme spike heels, that is our concern here. Historically, the corset has suffered a demonization far exceeding that of any other garment or sartorial or cosmetic device; and this has happened at both popular and medical–scientific (or pseudoscentific) levels, accelerating since the eighteenth and culminating in the nineteenth centuries, when the corset and its supposedly customary extreme form of tight lacing were blamed for every female ailment imaginable. Insofar as the *Victorian* or *period* corset now has been revived in high fashion for inner- and outerwear, both decoratively and functionally, and has been applauded as much as reviled in the media, we may speak of the regeneration or redemption of what was once held to be most wicked. Today, in a bizarre reversal, the corset has even been credited with engendering feelings and messages of female empowerment.

Maybe the word *even* is unnecessary; perhaps *at last* would be better. It could be, if we agree with Anne Hollander, that the function of clothes generally, and the constrictive kind particularly, has been to empower: to protect and project power internally and externally. The idea that the corset

represents and creates powerlessness and submission is losing legitimacy; at
the very least, this traditional view, like that which sees sadomasochistic play
as a male preserve in which women are subordinate and often unwilling
partners, is now subject to debate among feminists, in women's studies, in
anthropology, in body art, and in body theory generally.

I have laid out elsewhere in extenso the history of the demonization of
the corset, as conducted mainly by reactionary medical men, and also by as-
sorted moralists concerned with keeping women *natural*.[1] This meant,
above all, fit to bear children, and it is the antimaternity function and sym-
bolism of the tight, waist-constrictive corset that induced fury, insult, and
despair among men who confessed themselves confounded by female per-
versity and appalled by the determination of so many females to jeopardize
the future of the human race with abortions and malformed, ill-constituted
babies resulting from abdominal corset pressure (Figure 1).

Figure 1. Anatomical diagrams of displacement caused by tight-lacing, from
anti-tight-lacing tracts. Doctors seldom had a chance to examine tight-lacers,
so their knowledge of the effects was supposition.

[1] My *Fashion and Fetishism: A Social History of the Corset, Tight-Lacing and Other
Forms of Body Sculpture in the West* (Totowa, NJ: Rowman and Littlefield, 1982),
long out of print, is now available in a second, much enlarged edition from Sutton,
Stroud (UK) under the tighter title *Fashion and Fetishism, Corsets, Tight-Lacing and
Other Forms of Body-Sculpture* (2004).

In the later nineteenth century, starting with correspondence in *The Englishwoman's Domestic Magazine (EDM)*, a popular monthly edited by the politically and socially progressive Samuel Beeton, husband of Isabella, the famous compiler of classic cookery and household management books, the *tight-lacing controversy* emerged. It was a controversy in the proper sense in that all sides, with extremes pro and con and every nuance in between, were represented. A number of women and men wrote in to the *EDM* and other magazines to defend the practice of tight-lacing and systematic figure training, offering motivations that reached beyond the quest for the admiring male gaze (and clasp) to inner satisfactions and otherwise inexpressible autoerotic sensual delights. It is also true that the degree to which the female names or pseudonyms of the writers were really those of women, rather than males, recounting their personal experience, has in itself been the subject of controversy among historians (Figure 2).

The erotically styled corset as both inner- and outerwear has entered into high fashion in the context of what amounts to the cultural normalization in the media (including commercial advertising) of fetishist and sadomasochistic referents. This is a process of the once strictly private and underground going public and aboveground, for this phenomenon could long be tracked (since Victorian times, in fact) in the testimony of individuals writing to specialized fetishist magazines, or in the fetishist columns of mainstream magazines, the equivalent of which may today be found on the Internet, where authenticity of experience and sincerity of expression cannot, generally speaking, be doubted.

At issue is the question whether women as well as men can be described as autonomous fetishists and whether women can, independent of their historically submissive role, experience autoerotic pleasure in constriction and bondage play. High fashion, feminist writing, journalism, and other vehicles

Figure 2. "The Mode and the Martyrs" from *Puck*, 1881). This cartoon illustrates the dire effects of tight-lacing.

of popular expression, such as Madonna and the designer Vivienne Westwood, as well as the increasing number of individual fetishists who choose to reveal themselves in public, on the streets, at fetish balls, and on the Internet, have answered *yes*. There is female fetishism as there is female pornography, and the very idea of fetishism has become more acceptable socially, medically, and even academically. Is the corset, even or especially in its tight-laced form, now and has it always been historically more expressive than repressive, more about empowerment than subjugation?

THE DIOR (COUNTER) REVOLUTION

The gradual disappearance of the constrictive corset in the early years of the twentieth century was hastened by World War I and the women's suffrage movement. One might have expected World War II to have dealt it a final blow. But it turned out, to the surprise and shock of many, that the seduction of the idea of postwar recovery and prosperity was to be linked with that of a return to traditional femininity. The apostle of this (counter) revolution was Christian Dior, in the fountains of whose New Look the late twentieth-century fashion corset was refreshed. The impact of this designer is considered nonpareil. At his premature death in 1957, he was named with Stalin and Gandhi as one of the five best-known people in the world. He was credited with singlehandedly having restored Paris to its centuries-old position as the center of European couture, and with accounting for 75 percent of French fashion exports.[2]

The New Look—"Flower-women, soft shoulders, full busts, waists as narrow as lianas, and skirts as corollas"—was launched in 1947, when global political circumstances offered great ambivalence: on the one hand mourning of all the death and destruction, continued austerity, fears of an already-brewing cold war, and the atom bomb; on the other, hope for better times, and the return to luxury.[3] Dior chose the latter, epitomized in tight waist and full skirt. He wanted, as he says himself in his autobiography, to speak to youth, the future, pleasure, happiness, to create not only a new look, but a new faith.[4] "He used the obvious contradiction between disciplined draping and profligate drapery . . . [the skirts of which could reach forty metres circumference]. . . . He was creating a molded upper body tapering down to a caricature-like corseted waist . . . of fabled tininess. With its dramatic bursts of abundance, the engorged skirt sets off . . . the cone-like tapering to the diminutive midriff." The silhouette was both strong and delicate, a

[2] Françoise Giroud, *Dior: Christian Dior 1905–1957* (New York: Du Regard, 1987), 15.

[3] Diana de Marly, *Christian Dior* (New York: Holmes & Meier, 1990), 19.

[4] Christian Dior, *Dior by Dior: Autobiography of Christian Dior*, (London: Weidenfeld and Nicholson, 1957), trans. by Antonia Fraser, 30.

Figure 3. Corsets were needed to achieve Dior's New Look which debuted after World War II. The model is wearing a pin-tucked cotton dress by Molly Parris, ca. 1953.

masculine/feminine conjunction epitomized in the wasp-waisted femininely tailored suit (Figure 3).[5]

The New Look corresponded in its way to the contemporary dialectic caught between hopes and fears, but the combination of sexy restriction and material abundance ignited considerable controversy. Women wearing Dior fashions were physically mobbed in the streets of Paris.[6] In America, where his triumph was otherwise swift and absolute, opposition was organized into street demonstrations and into leagues (one anti-Dior club claimed 300,000 members).[7] Hostility echoes to more recent times, against the threat of comparable fashions. In 1993, the *New York Times* remembered Dior as the author of the "fashion [which] would impose a tyranny unknown since the days when Scarlett O'Hara was trussed like a turkey [sic] for the sake of a

[5] Richard Martin and Harold Koda, *Christian Dior* (New York: Metropolitan Museum of Art, 1997), 11–14.

[6] A photograph appears in Marie-France Pochna, *Christian Dior* (New York: Assouline 1994) between pages 74 and 75.

[7] Diana De Marly, *Christian Dior*, 34.

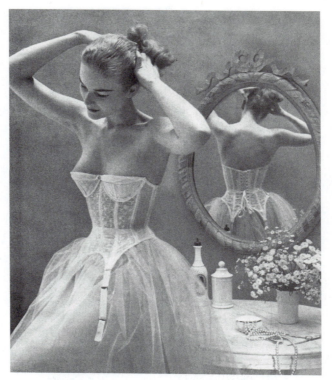

Figure 4. This 1951 ad for a Warner's Cinch-Bra promised a "dimimutive, more appealing" waist line.

17-inch waist," and which "cavalierly sentenced his devotees to nearly ten years in bondage" (Figure 4). The article goes on to evoke "sadomasochistic scenarios" "of reed-thin models furiously lacing each other up."[8] The "ten years" is wrong, for Dior's X line was soon followed by softer A, Y, and H lines.

There was certainly at the time moral cause for complaint against a fashion flaunting the privileges of the rich, when most of Europe suffered still under wartime rationing of food and clothing, and thinness (especially after the "hunger-winter" of 1946–1947) was not voluntary. A spokeswoman for the Dior clientele noted, with all apparent sincerity, that "not having eaten for years" during the war, thinness was actually an advantage.[9] The president of the British Board of Trade, the austere Sir Stafford Cripps, and other

[8] Gerri Hirshey, "From Elite to Street . . . ," *New York Times Magazine*, October 24, 1993, 113.
[9] Marie-France Pochna, *Christian Dior,* 165.

Members of Parliament were furious with Dior, but department stores saw an opportunity to boost sales and organize a little drama. During John Lewis's in-house fashion parade, "Miss Rowland, smiling more than ever, held up an enchanting little corset, pink satin and lace, which she assured us must be had by all as the necessary foundation for the smart figure. This little garment was then girded onto a slim model with such vigour that the blood rushed to her face, while Miss Rowland exhorted her to greater efforts. 'pull yourself *in* a little dear,' and we all held our breaths in sympathy."[10] Seductions such as this, while offensive to some, must have hastened the end of clothes rationing and the era when blackout curtains were recycled into clothing (shades of Scarlett again!).

Dior's "bombshell" of a fashion was inspired by a memory of his beloved mother "with her tiny, corseted handspan waist."[11] But the new corsetry, serious and innovative as it was (often so built into an evening gown that it could stand up on its own), was not really of Victorian rigor or even approaching that of some late twentieth-century designs. The wasp waist was, in the first instance, a matter of choosing models with naturally (or abnormally) small waists, with judicious padding of the bra where necessary. The choice of models was always that of the patron, Dior himself, and personal (he had no objection to hiring ex-prostitutes); he claimed in his autobiography to love them and to be loved in return. He employed too many of them, and he indulged them, overpaid them, and worked them to exhaustion, although never to fainting. "My models—they're the life of my dresses, and I want my dresses to be happy."[12] Models, all known to be tall, at this time were frequently publicized as having tiny natural waists: Pierrette Claudel at eighteen inches and Barbara Goalen at twenty, but Dior was quoted in the tabloids as the "tough employer" who wanted models with a natural waist of seventeen inches: "If she's too big, she'll be squeezed in even if she faints." Poor Gabrielle Young, worried about losing her job because at five foot, eleven inches she was all of twenty-one in the middle![13]

As noted, after the first flush of his sensation Dior soon relaxed the waist. In 1955, Jacques Fath's restoration of the waist into fashion (it had been sustained meanwhile mainly in the movies) and his corset boning of suits were greeted with panicked "Again the New Look! and Back to the 17-inch Waist."[14] Sophie Malgar, his favorite model, was said to have a natural nineteen-inch waist.[15] Such tenuity was the sort of newsworthy stuff that got the bride of the chairman of British Airways (a former model) into a published newspaper photo in her wedding dress of eighteen inches, outbid by the movie waist of the moment, Gina Lollobrigida's at an inch smaller

[10] Diana De Marly, *Christian Dior*, 30–31.

[11] Brigid Keenan, *Dior in Vogue* (New York: Harmony Books, 1981), 12.

[12] Françoise Giroud, *Dior,* 68.

[13] *Daily Mail*, May 11, 1948.

[14] *Daily Express*, July 28, 1955.

[15] *Daily Mail*, March 2, 1955.

than that, as officially measured, "'Just the size of my shirt collar,' said her husband Milko Skofic."[16]

Having tired of tight waists, how would Dior not have turned in his grave when the house bearing his name, in designs by John Galliano, explored the "perverse Freudian fantasies of an Edwardian family coming apart at the seams," with dominatrixes wearing nooses around their necks, nuns hand-cuffed in gold, fetishists wedged into tightly cinched corsets, and devilish voodoo costumes galore.

THE EIGHTIES: FASHION BACKLASH?

Forty years after the Dior New Look of 1947, we find fashion in a comparable spasm of controversy, generating both dismay and delight. The delight has been that of fashion magazines, which with the ubiquitous (especially on covers) corseted look seek to stiffen sales and the resolve of readers to diet and get thin. The dismay of the feminist social critic has been terrific, especially in Susan Faludi's enormously successful fire-and-brimstone *Backlash: The Undeclared War Against American Women* (1991), to which we may add Naomi Wolf's equally brilliant, gloomily, tragically poetic *Beauty Myth* (1990).

Quite apart from her obvious ideological stance, the carefully documented detail of Faludi's chronicle of the "fashion backlash" commands respect. Fashion, which seemed in the 1970s to have responded to concurrent efforts toward the economic, social, and political emancipation of women, in the 1980s went into reverse and worse. It was the reactionary decade of Ronald Reagan and Margaret Thatcher, of the New Right resurgent. Reaction was accelerated by the stock-market collapse of October 1987, which occasioned a "frightening slump" in the fashion industry. Christian Lacroix, followed by most of the couture houses, then presented models with "their clothes-hanger bodies swaying under the weight of twenty pounds of crinoline and taffeta," with pushed-up breasts, tightly laced waists, ballooning skirts and bustles galore, fantasy fashion for women, said Lacroix, who like to "'dress up like little girls.'" According to Faludi, when a recession and sales resistance to high fashion loomed at the end of the 1980s, Lacroix renewed his efforts, determined to "win this war" for "high femininity" against feminism, to make women listen and rein them in, sometimes quite literally, with (in 1988) "another round of ruffles and rib-crunching styles."[17]

Lacroix, "king of couture," under the heading "the clown who would be king," is credited with revitalizing the fashion industry as Dior had done. In the same spirit, Cardin offered capelike wraps so tight that (as the *New*

[16] Associated Press, June 12, 1955.
[17] Susan Faludi, *Backlash: The Undeclared War Against American Women* (New York: Crown, 1991), 169, 172.

York Times noted) the models couldn't even move on their own, and Romeo Gigli had skirts so tight models could only hobble and appeared tied up in velvet ropes.[18]

The 1980s fashion backlash was driven, claims Faludi, by the whips of pop psychologists telling women excessive independence and their "voracious narcissism" were the source of their self-inflicted woes. The media generally blamed feminism, "Women's Lib," for the empty bed and barren womb, for the failure of women to be happy. Feminism was "The Great Experiment that Failed," according to *Newsweek*. It had not produced the expected benefits: the number of women in upper management posts was declining, and the pay differential between men and women was the worst in the industrialized world.[19] Women's reproductive freedom was in greater jeopardy in 1990 than a decade earlier. The bleak picture painted by Faludi has presumably not improved since (certainly not, to judge by the allurements of a *Vogue* collage of outerwear corsets), and fashion has, if anything, gotten worse from her point of view. Faludi revives, curiously, an explanation for "fashionable excess" epitomized by the highly restrictive *cuirass* style of just a century earlier: a spinster boom and shortage of marriageable men. The "marriage crunch" was lent terrorist exaggeration by *Newsweek* (followed by many other magazines), which claimed that single women (over 40) "are more likely to be killed by a terrorist than to find a husband." Today it is estimated that twice as many women are now reaching their forties without marrying, twice the figure for a generation ago.[20]

Faludi's old-fashioned vitriol assumes, as so many fashion Jeremiahs have done in the past, that women are the helpless victims of dress dictators, rather than being capable of freely choosing between the many style options available. To that, we may oppose the view (published the same year) of Elizabeth Wilson, for whom "the political subordination of women is an inappropriate point of departure if, as I believe, the most important thing about fashion is *not* that it oppresses women."[21]

For Naomi Wolf, it is not so much "fashion"—that is, the various clothing styles sent down from above—that oppresses women, as the *Beauty Myth* (the title of her book) and the tyranny, above all, of slenderness, that "Iron Maiden" (recalling the medieval torture instrument rather than

[18] Carrie Donovan, "First Photographs of Paris Collections: Rounded Coats in Thick Woolens: Buyers Found Fall Clothes Pretty and Youthful," *New York Times,* August 27, 1957, 46.

[19] Susan Faludi, *Backlash,* 100.

[20] Daniel McGinn, "Marriage by the Numbers," *Newsweek,* Jun 5, 2006 at www.keepmedia.com/pubs/Newsweek/2006 retrieved at August 14, 2006.

[21] Elizabeth Wilson, *Adorned in Dreams: Fashion and Modernity* (New Brunswick: Rutgers University Press, 2006 13. An excellent overview of the fashion corset in this period is in Valerie Steele, *Fashion, Fetish, Sex* (New York: Oxford University Press, 1996), 86–89.

Mrs. Thatcher) into which peccant women were enclosed. Alongside this, Wolf marshals the palpable (and not at all mythical) evidence of increasing violence against women (sadism in reality and all over the media) and self-violence (cosmetic surgery and anorexia). Like Faludi, Wolf sees the political purpose of the Beauty Myth and "the great weight shift," which she calls a major historical development of the century, designed as "political castration" to counter the dangers posed by female emancipation. Like political opponents consigned by a tyrannical government to jail and death, women are thrown into the Belsen or hell of an anorexic prison camp.[22]

While anorexia and self-starvation comprise a rather distinct issue that has its own psychology, as a form of "artificial" (unnatural) body sculpture, it is curious that several writers of the copious literature on the topic have likened it to tight-lacing, not least in its lethality. The threat to life of tight lacing has been much exaggerated, but that of anorexia is documented all too well, as is its prevalence generally among young, dissident females, the same social group constituted by tight-lacers in the nineteenth century. It is also an article of faith among many fetish corset makers and wearers today that corsets are a safer and surer means of reducing weight and bulk than most of the so-called cures, pills, and diets that abound on the market. That the *corset revival* should coincide with evidence for a great increase in obesity among youth, and strenuous efforts to check it through exercise and dieting, cannot be a mere chronological accident.

In certain respects the grip of the Iron Maiden has softened: the restrictions on the shape and appearance of airline stewardesses have happily been modified. But Playboy bunnies presumably still have to conform, and a lawsuit brought by women casino waitresses against having to wear "costumes straight out of the *Story of O,* consisting of a miniskirt and plunging cleavage over an external corset or basque so tight that women bled from it under their arms" was dismissed as too trivial to consider.

The absence, otherwise, of the corset from Wolf's wide-ranging denunciation of the Beauty Myth, is curious. *Tiredness* is the main physical complaint of 70 percent of senior women executives in the United States, 90 percent in the United Kingdom. Could it be that the fashion corset, adopted by at least some of these executives for wear under their business suits, is an attempt to overcome chronic work-related fatigue?

Many—perhaps most—big European designers today have flirted more or less seriously with the period corset. We single out the work of Vivienne Westwood, who emerged from the punk-fetish world into high fashion and great celebrity (twice named British Designer of the Year). Westwood illustrates many of the most important cultural and fashion developments tangential to our present theme: sartorial cross-gendering, fusions of opulence and discipline, the empowerment of difficult-to-wear extremes. She initiated the new corset-as-outerwear, to which Jean Paul Gaultier and Thierry Mugler contributed.

[22] Naomi Wolf, *The Beauty Myth* (New York: Anchor Books, 1990), 171.

As a youngster in the 1960s, Westwood observed all the "overflowings and overflowerings . . . everything 'hung out,' or it was 'loose.' We wanted to tighten all that up, pull it in . . . be direct and stern."[23] The sternness was at first that of the shocking, menacing, subversive, and barbarous punk look of the 1970s. Her first shops (the second was simply called Sex) sold rubber, leather, and bondage gear and the usual sex aids. She looked into the s-and-m underworld, crossbred it with the biker look. She was close to the Sex Pistols. Raided for a porno T-shirt, she was fined and jailed. Her stated aim became female empowerment, expressed in punkish female and feminine/masculine clothing and involving gender interplays of all kinds. Her signature platform shoes evolved out of punkish commando boots, magnified, glamorized, exquisitely curved, power, and out of the closet. Jordan, her friend and a St. Martin's College of Art student, when commuting by train from Brighton to London wearing a complete, extreme fetishistic brothel-dominatrix outfit, attracted so many complaints that British Rail had to give her a compartment of her own.[24]

Before Gaultier, Westwood had begun putting bras and corsets on the outside. Her bustiers took inspiration from eighteenth-century English stays and stayed costumes, with their intricately cut and stiffened bodices, which she hung with heavy diamond incrustations she called *codpieces* and said "makes you feel dominant." Westwood is famed for her precise and imaginative cut, which like Dior she extended to suits and jackets, and for her use of historic, regional British fabrics. So there is something very British about her: a sense of tradition, allied to an instinct for exaggeration. The famous platform shoes have reached nine inches of sole, plus several inches of heel elevation. One pair, exhibited in a museum show, was studded with spurlike mini spikes along heel and vamp: fit to thrill the spur fetishists (Figure 5). In a film accompanying that exhibition of her work in the Liverpool Museum, summer 2001, we see the famous moment (1993) when the model Naomi Campbell fell over on the shining lavender catwalk but got herself up again, in some momentary pain, giggling, no real harm done, back onto her nine-inch power shoes. Power was always unstable. Was that little contretemps planned? Probably not, but it profited all; the accident was photographed for worldwide consumption, "immortalized the shoes," and was posterized for a show at the Victoria and Albert Museum.[25]

Westwood's major patron and collector, Lady Romilly McAlpine, as the wife of the Conservative Party Treasurer (from 1975) Lord McAlpine, who stood at the center of British political life, raised low-born clothing

[23] Fred Vermorel, *Vivienne Westwood: Fashion, Perversity and the Sixties Laid Bare* (Woodstock, NY: OverLook Press, 1996), 58.

[24] *Ibid.*, 65.

[25] Brochure to Vivienne Westwood, *The Collection of Romilly McAlpine*, and Fred Vermorel, *Vivienne Westwood: Fashion, Perversity, and the Sixties Laid Bare*, 99.

Figure 5. Vivienne Westwood, Shoe (Illustration: Kathryn Hagen).

(as it were) to the artistic and social heights. Lady McAlpine does not, however, court falls from grace or ridicule; she owns such shoes as toppled Campbell but never wears them, preferring to keep them on the mantel of her Venice home.

While the Westwood corsets in public view are not conspicuously tight laced, they have been credited with a "collective embrace of the wasp-waist," making the wearer feel "lovely and relaxed" with a "constant hug," and filling A. J. Jones, illustrator and "cyber-Goth-cum-fetishist," with the ambition to reduce to seventeen inches.[26]

THE HIGH HEEL: "TOWERS OF POWER" OR "ARCH ENEMIES"?

The full scale of opposition to the needle heels and toes of the 1950s would make impressive reading. Around 1961, all that sharpness was beginning to blunt, with the help of agony aunt Abigail Van Buren, who claimed to have received 100,000 letters of protest and demanded that the National Shoe Manufacturers "liberate the captive feet of womanhood"—as if there were no other styles available. But there was a perceived drop in sales, heels

[26] Rebecca Lowthorpe, "Perfect Bound," the *Independent* Sunday, July 29, 2002 and at www.corsetheaven.com/corsets/articles/bound.asp, retrieved at August 14, 2006.

dropped and thickened, and toes went into a bewildering variety of shapes, as if wriggling their way clear of the serpent's poisonous fangs, into innocence: almond, thumbprint, round, extra-round (baby doll). Pointed effects were left to the "provinces" of Latin America and Russia.[27] They have now returned, with a vengeance.

In the high-fashion magazines of the 1950s, the stiletto heel was shown to be of moderate height, spikiness of heel, and sufficient toe. Recent decades have seen an absolute acceptance by high fashion and its magazines of fetishistic heel heights on shoes and boots—and the idea that these are not so much for walking or even standing in as for other forms of display, reclining, threshing around, and sexualizing

The word *fetish/ism*, as well as the concept, has been normalized, completely fashionized. In *Vogue,* Gaultier's fetishistic booties, promoted as "giving shape to the fantasy of female aggression" and making the wearer "passively—but menacingly—hobbled" are preferred to the "recent logjam . . . of wooden soles, chunky platforms, clodhoppers and lumberjack boots—tough time for fetishists who fancy the fanciful and feminine."[28] The polarization of the two kinds of footwear—the hyperfeminine and hypermasculine—has been extraordinary and may represent differences of social occasion as well as individual personality; clumpishness not spikiness is the hallmark (on my campus at least) of the student body.

Another article, called "High Heel Hell," recognizing that women aren't about to give them up, offers prescription for damage control, and balances a picture of Helmut Newton's overarched foot with the usual animadversions of the orthopedists: 87 per cent of all Americans suffer from foot ailments, 86 percent of women can blame foot problems on undersize shoes, and 73 percent of all foot operations are attributable to narrow-toed, high-heeled shoes.[29] Such staggering statistics rival those once leveled against corsets.

Addictions and fetishisms are, of course, good for business. "Magnificent Obsession. Why women—and men—are infatuated with perfectly pedicured feet," with a picture captioned "fit to fetishize," promotes pedicure as well as foot fetishism. To the dread dictum "You can never be too rich or too thin" is added "or have too small a foot with too high an arch." "You can hardly walk, let alone run, in heels—but so what, when they make you look so great?"[30] Maybe the pedicurist and fetishist share erotic delights, different as they must be: "As I lay down and the lights dimmed, I confessed to my addiction to bone-crushing stilettos, which seemed to delight him. 'Ah, then

[27] Florence Ledger, *Put Your Foot Down: A Treatise on the History of Shoes* (Melksham, Wiltshire, U.K.: C. Venton, 1985), 175.

[28] Judy Shields, "Shoes Will Be Scandal," *Vogue* (U.S.), March 1993, 378–379, 427.

[29] Sirena Mankins, "High Heel Hell: High Heels Can Be Murder on Feet, but Some Women Can't Kick the Habit." www.journaltimes.com/articles/2005/08/24/health retrieved at Aug 11, 2006.

[30] *Chaltelaine,* (Toronto edition) "Don't Park Five Toes in a Shoe that Fits Four," April 1996, Vol. 69, Iss. 4, 188.

you will have lots of corns!' he said gleefully. And indeed I did." There is also a plug for the shoemaker Manolo Blahnik whose shoes (according to Madonna) are "as good as sex, and they last longer." For Manolo himself, "the shoe isn't really about sex. The shoe *is* sex."

The delights of foot and shoe fetishism have entered the elite general interest magazine, too. Witness "Heel Boy! A Meditation on the Unbearable Allure of the Well-Shod Woman" from *Esquire* magazine, in which the author encounters by chance Bianca Jagger in the lobby of a theater wearing shoes that evoked the "whole deliciously sordid history of temptation and sin itself," "a masterpiece of concealment and disclosure [which] defines the dynamic of lust itself," and which pitched the men present onto the brink of existential crisis.[31] The contribution of the novel has also been signal: Geoff Nicholson's *Footsucker* (1995) is a finely contrived murder mystery thriller revolving around foot and shoe fetishism, rendered in an exquisitely poetic light.

Historians of footwear also have helped blur the distinction between fashion and fetish. The high-fashion shoe, the idiosyncratic designer shoe, and the most extreme fetish shoe share a continuum of cultural significance and creativity. Shoe collecting is the admired passion of the rich and famous: the Duke and Duchess of Windsor, Princess Grace of Monaco, Jayne Mansfield, Diane von Furstenberg, as well as the most notorious of all, Imelda Marcos, once first lady of the Philippines, who now has a museum for her collection. *Elle* tells us of a shoe collectors' club in France with 200 members.[32]

The popular how-to book has become nakedly fetishistic. *Boobs, Boys and High Heels, or How to Get Dressed in Just Under Three Hours* (1992), from Penguin in New York no less, by the self-described designer/actress/model/businesswoman and New York and "Queen of the Night" Diane Brill, is a euphoric, rapturous romp through the delights of dressing up, especially in heels, which come in three heights: high, higher, and highest. "Forget diamonds. . . . High heels are a girl's best friend. . . . Toes pointed . . . arches peaked . . . the length of your leg pulled out. Exactly like at the moment of orgasm! Quelle coincidence!" For Brill, happily turning the world upside down, the risk is having to wear and run in flatties, which she had to do for a movie and which ruined her feet. Heels and her hymns to them straddle the twin towers central as well to the discourse on corsets, female vulnerability, and female strength: the "fragile, dainty, delicate" on the one hand and the no-less-dizzying feeling of being in "total control, on top of the world" on the other. This funny and deeply superficial book concludes that life is to be thought of as one long, glorious high-heel hunt.[33]

[31] Chip Brown, "Heel, Boy! A Meditation on the Unbearable Allure of the Well-Shod Woman," *Esquire,* November 1995, 102.

[32] Mary Trasko, *Heavenly Soles: Extraordinary 20th Century Shoes* (New York: Abbeville Press, 1989), 11–15, 75.

[33] Diane Brill, *Boobs, Boys and High Heels, or How to Get Dressed in Just Under Three Hours* (New York: Penguin, 1995), 111–125.

Brill radiates passion and laughter. A greater surprise awaits us in the re-vision of a custom often mentioned here in passing, usually as a term of com-parison, a millennial custom universally condemned and reviled in the West for its extremism and painfulness and regarded, despite all the banal, flippant comparison with Western high heels and corsets, as constituting a truly in-comparable degree of cruelty, inflicted on the very young girl child to boot: Chinese foot binding. Enter (in 2001) sinologist Dorothy Ko, who wrote *Every Step a Lotus: Shoes for Bound Feet* to accompany an exhibition spon-sored by the Bata Shoe Museum and with the publishing imprimatur of the University of California Press. She advances a "new and more nuanced pic-ture of footbinding," divesting it of its aura of perversion and senselessness. Downplaying the sexual functions of the bound foot that were the stuff of previous monographs, she emphasizes the domestic and moral symbolism and the association of "foot-packaging" and shoes embroidered by the young girls and brides themselves, with traditional female textile skills. "Isn't the arching of the foot also an expression of female labor, diligence and skills?"

Some of Ko's language reminds us of that used to defend tight-lacing and high heels, notably in conjuring up an optical illusion, by means of the cunning shaping of the shoe and binding that functions "not so much to de-stroy the mass of tissues and bones of the foot as to redistribute them," not so much crushing as "realignment" of bone and flesh. Thus do defenders of tight-lacing speak of the redistribution of internal organs and ribs. Cannily (or is it disingenuously?) Ko wonders whether the deformation and pain, which are not denied but minimized, is in some way "a projection of anxi-eties about our own bodies in our modern society."

While the sociology of the practice remains rather different from tight-lacing, involving mainly the upper classes, there was some working class and even rural participation, which seems, as with tight-lacing, to have hastened its demise around 1900: Foot binding became vulgar, no longer exclusive. Publicity also helped end it, and the prying foreign eyes of anthropologists, missionaries, and doctors (and not least the eyes of the camera) exposed a traditionally intimate mystique, typing it as cruel and uncivilized. But we have moved on: The cultural relativism apparent in Ko's book is that which has admitted all kinds of "barbaric" effects into high fashion. Let us not cast stones, she says, but recognize that the tiny lotus shoe "opens the door to a vast and meaningful world."[34]

NECK AND COLLAR

Constrictive neckwear has been a male self-imposed burden. In the sixteenth and seventeenth centuries, extravagant and highly inconvenient starched

[34] Dorothy Ko, *Every Step a Lotus: Shoes for Bound Feet* (Berkeley: University of California Press, 2001), passim.

and wired ruffs were worn equally by both sexes, but by the nineteenth century, it was the men—military and civilian—who had reason to complain of strangulation. The discipline and duty symbolized by the corset for women was transferred to neckwear in male fashion. In the later nineteenth and early twentieth centuries, women took over the high, stiff "masher collar" as part of what was recognized as the masculinizing—that is, (paradoxically) rationalizing—of women's costume generally. Entirely abandoned by women in the interwar flapper years and decreasingly retained by men, neck constriction has been recently reintroduced in high female fashion, in exotic, barbaric, and occasionally fetishistic ("corset-collar") forms bearing little relation to historic male styles.

Masculine neck styles of the last generation have been significantly relaxed: Looser collars and open necks are now permissible in the office, as is the tie knotted loosely about the unbuttoned collar. But does this not summon visions of strangulation if a formal meeting should demand the buttoning up of a shirt that may have shrunk? And there has never been anything in female fashion akin to the historic idiocy of selling shirts by collar (i.e., close-fitting neck) size.

The neck consciousness of recent fashion, which has striven for the most bizarre and exaggerated effects, is reflected in the decision for the *Extreme Beauty* show recently held at the Metropolitan Museum, New York, to divide according to the parts of the body, vertically, starting not with the head (and hats) but with the neck and shoulders. The point of the show, in what is now almost a cliché of globalizing rhetoric, was to bring a historical and

Figure 6. Illustration of high lace collar achieving a corset effect for the neck was drawn from an online photo of a boned lace collar by Lilly Lantry, 2005. (Illustration: Kathryn Hagen)

worldwide ethnographic eye to (and to justify?) the antics of recent fashion. The swannish neck, we are told, is one of the few anatomical features admired at all times and in all places. The elongated neck of the Padaung and the comparable zila of a Ndebele woman are conspicuously honored in the catalogue, with X-rays to prove the ostensibly surprising fact that the Padaung neck rings do not (cannot) stretch the spine at the neck but only depress the clavicles (collarbone), as revealed by a *National Geographic* article entitled "Anatomy of a Burmese Beauty Secret."[35] There are signs of resurgence of the custom, we are told, due to access by tourists, who can travel along the river from Chiang Mai in Thailand to a Padaung refugee village. Like extreme tight-lacing, neck stretching changes the voice, too, "as if they were speaking up the shaft of a well." The neck of the Western fashion model, wearing comparable rings in imitation of tribal custom, manages the stretched effect with an optical illusion. The corset-collar commonly worn by fetishists of both sexes emulates the effect of an extreme late Victorian–Edwardian fashion collar; high fashion today has combined them, adding the Padaung effect (Figure 6). The slave symbolism (usually requiring an attached ring and a leash) has served both the private bondage scenario and the catwalk.

LACING

Fashion has discovered what corset fetishism always knew: Zips and hooks and eyes and buttons don't do the job: Lacing is the only fitting form of closure. It connotes power, tension, release, control, micro-control. It literally and figuratively tightens and loosens and ties the knot of desire. The lacing and unlacing process is an important erotic ritual between lovers, a ritual both social and intimate (and possibly erotic) when performed with the aid of a maid or a close friend. Connoisseurs agree that self-lacing, although quite feasible even when done tightly, is done only of necessity, whether with the help of the bedpost or other point of support.

The idea that lacing, or passing of a thread through holes on an intimate part of the body, replicates the sexual act is taken up by the popular seventeenth-century Dutch poet Jacob Cats, who conjures the maiden sewing and pricking through a hole and stopping it with thread, as love is threaded or pricked through her body, the pain of it (in deflowering) stopped by its sweetness.[36] In Dutch, *naaien (to sew)* also means, in the surviving vernacular, *to screw.*

[35] Harold Koda, *Extreme Beauty: The Body Transformed* (New York: Metropolitan Museum of Art, 2002), 29; John Keshinian, "Anatomy of a Burmese Beauty Secret," *National Geographic Magazine*, June 1979, 798–801. A photograph of Padaung women in a London street is in Ted Polhemus, *Body Styles* (Cincinnati, OH: Seven Hills Book Distributors, 1989), 24.

[36] Wayne E. Franits, *Paragons of Virtue: Women and Domesticity in Seventeenth Century Dutch Art,* (New York: Cambridge University Press, 1993), 35.

Lacing is not only the historic and preferred functional means of fastening and tightening a corset, but also a primary decorative element, the appeal of which in contemporary fashion has become virtually independent of the other physical characteristics of the corset and can be more symbolic than real. Thus, the Bergdorf Goodman store in New York, promoting the corsetry comeback, had a red corset with black stays placed in a window on a revolving podium so that the detail of the back lacing could be fully appreciated by the passersby. On its June 1992 cover, *Playboy* presented its Playmate of the Year swooning in ecstasy over the shoulder of a horse, wearing a front-lacing corset, worn as it were back to front.

Lacing when closed tight in itself connotes compression, achievement. When left open, it presents an invitation, a provocation. The Horst photograph of the new corset by Mainbocher loosely laced on a fashion model—which when presented in the September 1939 issue of *Vogue* as the latest fashion idea, seemed to defy Hitler's tanks rolling into Poland—has achieved classic status; it is now even available as a greeting card. The result of much labor, it was the last photograph Horst took in prewar Paris. The history of fashion photography applauds it in classic aesthetic terms, as comparable to an Italian Renaissance portrait (only seen from the back), set in a "timeless, neutral space, with Renaissance-style ledge," and "charged with sadness and restrained eroticism."[37] It is proposed as a means to "bind you in for the Velasquez silhouette . . . specifically for the evening." The remarkable formal feature of the laces spilling over the ledge at inordinate length toward the spectator (lover?), with its autonomous still-life tangibility akin to the laces in Vermeer's *Girl Sewing*, suggests a continuum of time, patience, and perhaps physical endurance, an opening–inviting–closure, and an awakening from the dream trance of the inhabitant of the stays.

Forty-two years later, *Vogue* carried a comparable photograph, more explicitly erotic, with now-permissible bare buttocks seated on an invisible ledge, the back view seen closer, straight on and "in your face;" the laces are also half-tightened and inviting, but the waist is already contracted, while in the Horst it is only promised.

Lacing effects on dresses have been all over fashion for some time. Christian Lacroix, in a photograph by Irving Penn, plays on the rear-view lacing effect, the looseness at the (uncontracted, unstiffened) waist seeming to counter the associations with tightness, and presents an intricate linear pattern to offset the complex volumetric pulse of ballooning sleeves and craftily draped skirt. One of Madonna's famous corsets in gold-spangled lamé is all apparent repeated lacing and no apparent boning.

[37] Nancy Hall-Duncan, *The History of Fashion Photography* (New York: Alpine Press, 1979); and Horst P. Horst, *Sixty Years of Photography* (New York: Rizzoli, 1991), 24.

Another Thierry Mugler, a plain red "Corset-suit" conceals (replaces?) the boning with seaming and keeps the simplified front-lacing effect for decoration and a reminder of how waistedness is achieved beneath.[38] A spectacular corset dress in white satin and lace with (hyper)-lacing might be straight out of *Vogue*. In fact, it is by a specialist fetish corsetiere.

Lacing is, of course, used lavishly in fetishist outfits, for arms, legs, and torsos. Gaultier, to outfetish the fetish, has an evening gown in pink with built-in corset, the ribbon laces crisscrossing the whole of the back half and tightening the gown to the knees, where they open in loose loops to form a train of streamers that must surely severely hobble if not trip up the wearer. A fashion student's "anti-corset" corset design from the Victoria and Albert Museum *Curvaceous* show (2001) takes as its point of departure a lacing system extended from neck to conspicuously loose waist, with the boning leaping over the shoulder, as if it were anatomically extruded in protest (Figure 7). This is esoteric, exoskeletal critique of fashion turned inside out. But what does one make of the perverse corset, with its perverse lacing, worn by an innocent, conventional-looking girl on the cover of a conventional-looking teenager magazine? "I love my new breasts"—flattened (obscured? hidden?) by a pink corset with asymmetrical top and lacing, and a no-less-perverse suggestion of the surgical?—all splattered around with sensational verbal commands and provocations?

PERIOD CORSETS IN FILM AND OTHER MEDIA

The period corset, as the undergirding of period-costume consciousness, has been maintained continuously in film, sometimes independently of fashion and sometimes directly impacting it. The synergy between film and fashion is curious, and it is claimed that the New Look was actually anticipated by the period film in the late 1930s, especially *Gone with the Wind* and its famous lacing scene. Mainbocher was there at the same time, and it may be that the war merely interrupted an unstoppable trend.

In the New Look era, with fashion reinstated on its throne, Hollywood became—more than ever—costume-design conscious, with increased budgets and a special Academy Award introduced in 1949. The best designers were often women. The "Sweetheart Line," as it was called, "an amalgam of Hollywood film with its period nostalgia, and the high fashion of the New Look" is deemed to have prolonged the life of the New Look and positioned it as reinforcement of narrative ideas.[39]

These "narrative ideas" are seen as largely conservative, propelling women back into home, subordinating them back into marriage after an assumed liberation in factories during the war, with the corset, according to the

[38] Richard Martin and Harold Koda, *Infra Apparel* (New York: Abrams and Metropolitan Museum, 1993), 56.

[39] Maureen Turim, "Designing Women: The Emergence of the New Sweetheart Line," in Jane M. Gaines, ed. *Fabrications* (New York and London: Routledge Press, 1990), 212–28.

Figure 7. Striped black cotton outfit with extruded boning by Central St. Martin's College of Art and Design student Jean-Pierre Braganza, 2001–2002 (from *Curvaceous, Boned, Busty, Bell-shaped and Bustled* Exhibition, Victoria and Albert Museum). (Photo: David Kunzle)

received wisdom, demanding "crushed subordination and symbolic surrender."[40] The role of the corset, as we see it here, gives a rather more complex picture, engaging in what one of the best analysts of (un)dress in the movies calls a transcendently and indeed transgressively "active sexual discourse."[41] So complex is the picture, indeed, that it seems impossible to synthesize, and we can only review here a few narrative contexts in as compressed a manner as possible.

[40] Desmond Morris, *Bodywatching* (New York, Crown Publishers, 1985), 190.
[41] Stella Bruzzi, *Undressing Cinema* (London and New York: Routledge Press, 1997), 37.

The Long Island Staylace Association website (*www.staylace.com/films / index files*) lists about 425 (mostly English-language) postwar films with corset scenes and tight-laced costumes, graded according to interest and significance. A culling of these (limited by availability on video and happenstance viewing at time of release) offers a smorgasbord of the roles and meanings invested, historically and recently, in the corset: peer-pressured initiation into womanhood and sexual desire *(Two Weeks with Love);* discipline undergirding power *(The Millionairess);* emancipation from the male (*The First Traveling Saleslady);* the dominatrix and devourer of men *(Barb Wire);* vampire *(Plan Nine from Outer Space);* elegant self-restraint against gross male licentiousness *(The Cook, The Thief, His Wife and Her Lover);* gender conversion—masculine to feminine and vice versa *(Calamity Jane; River of No Return);* masochistic personality *(Portrait of a Lady);* sexual exposure *(The Great Race);* antierotic repression *(The Piano; Titanic);* and film self-parody *(Stiff Upper Lips).* Other, less characteristic themes include female bonding *(Picnic at Hanging Rock);* death *(Plan Nine; 101 Dalmatians);* and technology *(The First Traveling Saleslady).* Missing from this list is hardcore degradation, sadomasochism, and bondage, staples of the porno film and porno photograph. In other words, the view of the corset emerging from our mainstream commercial selection is generally benign and positive, amused but only occasionally comic *(The Great Race)*, mildly erotic and not directly sexual, insofar as men are rarely involved. When men themselves are corseted, the effect is always meant to be comic. In *The Great Race* the degrading effect of a corset on a man is contrasted with the enhancing effect on a woman; and there is an extraordinarily evocative moment in Alan Bennett's play *The Madness of George III* (cut alas from the film version I saw), in which on one side of the stage the obese Prince of Wales is hauled into the stays he historically wore, while on the other side we see his mad father, again historically, strapped into a straitjacket.

It may be that none of the films listed are inspired by a feminist sensibility, although I don't think that any can be called misogynistic. For a very hostile view of the period corset, one turns to the live stage (Lisa Loomer's *The Waiting Room*). My own initiation into corset magic, as a young adolescent, was via three films made or seen around 1950: *Gone with the Wind, Two Weeks with Love,* and *The Secret Life of Walter Mitty.* Walter Mitty (Danny Kaye) stumbling into a department store dressing room filled with shocked ladies attired in elaborately trimmed and colored corsets (as if they were 19th-century fashion corsets: the main narrative is set in the present) represents the exquisite embarrassment of innocent youth precipitated by error into the mysterious sanctum of hyperfemininity.

Two Weeks with Love (1950) deserves a closer look because it is the only film I know in which the corset is thoroughly the theme and plot pivot; and the corset scenarios are, moreover, imagined from the female's point of view, around an object of desire capable of creating an object of desire. The corset in this film is constituted as the centerpiece of an adolescent erotic and romantic fantasy, which soars into ecstasy. Reissued in video, it has held its own as a popular and very charming, romantic musical comedy, written by John

Larkin and costumed by Helen Rose (Figure 8). The film launches the idea of the corset as the appropriate postwar (re)initiation into sexuality and womanhood. At the start, the heroine Patti Robinson (Jane Powell), a seventeen-year-old still in short skirts being treated as well as dressed as a child, is confronted with Valerie, an older, sophisticated friend who is already embarked on a stage career, who asks Patti to lace her into the necessary eighteen inches. Demetrio (Ricardo Montalban), a suave older Cuban, appears, showing an immediate penchant for Patti, who is acutely embarrassed to find herself on the beach wearing an "infantile potato-sack" of a suit in which she buries herself in the sand to escape notice. She dreams of being with Demetrio in a boat and he wanting to embrace her but shrinking back in disgust because she does not wear a corset. She is persuaded reluctantly to attend a ball, gets to dance with Demetrio, and in a long sequence manages to fend off his feeling her childishly uncorseted waist. Increasingly ashamed of her "awful secret," she suffers taunts from her peers for her juvenile appearance and status and becomes perfectly miserable, cries a lot, and wants to die, until comforted by daddy, to whom she confesses her secret desire—not so much for Demetrio, attracted as she is to him, as for a corset that will legitimize her in his eyes (or hands). Dad understands her better than Mother (who has been holding her back) and hurries out to buy a corset for his daughter, which he presents to her rather as it were a wedding gift and passport to sexual happiness. In a stardusted, prolonged dream sequence, bare legged in a pink corset with a tutu and parasol, ballerinalike, Patti struts across the social stage as the cynosure of all eyes, dancing first alone, then with Demetrio. Her first chance to display herself corseted in reality nearly ends in disaster since, as we have learned from the conscience-stricken vendor of the corset to Patti's father, the garment in question was sold to him by mistake: It was an orthopedic one designed to lock in position if the wearer's back went into an extreme arch (an impossible concept, but no matter). This is precisely what happens in the finale to a tango Patti dances, replacing the jealous Valerie and partnered by Demetrio. Barely covering up for her inability to straighten herself out after being flung backward, she is carried off stage as her (uncorseted) mother cries, "She is laced too tight," and cuts her free. But it is the corset that has set her free, not its removal.

In her autobiography, Jane Powell declared *Two Weeks with Love* to be her personal favorite, a very special, glowing experience, especially the corseting and the dream sequence with Ricardo Montalban, on whom she had a crush. It was her first period picture, which made her wish she had been born in the 19th century.[42]

The First Traveling Saleslady (1956) also represents an emancipation, but of a very different kind: into the competitive business world of men. Set in 1897, it shows a man's world threatened by an aggressive, independent, entrepreneurial woman selling a symbol of sexy femininity. The peculiar

[42] Jane Powell, *The Girl Next Door . . . and How She Grew* (New York: Berkeley Publishing, 1988), 123–124.

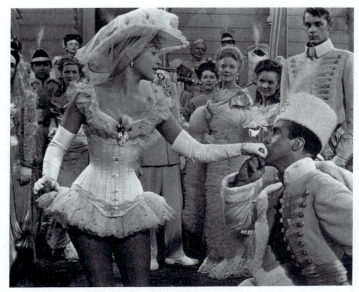

Figure 8. Jane Powell and Ricardo Montalban in *Two Weeks with Love* (1950).
(Photo: Courtesy of the Academy of Motion Pictures, Arts and Sciences)

twist here is that the corset is raised in the film from a means of innocent erotic pleasure to an adjunct of the great technology of the future, which women will help create. Irving Gertz and Hal Levy rendered the erotic power of the corset as a song that played over the opening credits promising the buyer that: "A corset can do a lot for a lady. If the buyer hesitated, she'd start modeling before his eyes, and if he got excited, blame it on her merchandise."[43]

From the start of this film, the corset functions as a symbol of sexual emancipation—that is, as a means of erotic expression in a conservative U.S. state where the Purity League scotches the simple pleasures of watching a vaudeville chorus line all in differently colored corsets. The corsetière promoting this is a Women's Rights activist named Rose Gillray (Ginger Rogers), who is thus driven violently out of business. Finding herself indebted (for unpaid corset steels) to the Carter Steel Company, which happens to be stuck with miles of barbed wire, Rose offers to sell the stuff in a part of the Wild West where barbed wire salesmen (all men of course) tend to get shot. Fiercely independent and fearlessly entrepreneurial, Rose prevails after a bitter struggle with a local Kansas ranching "king" who wants both to marry her and to prevent her from selling the barbed wire, which he sees as a threat to his ranching imperialism.

[43] A Corset Can Do a Lot for a Lady," music and lyrics by Irving Gertz and Hal Levy for the 1956 RKO film, *The Traveling Saleslady*.

The corset as feminine erotic pleasure symbol merges, bizarrely and comically, with the corset as a kind of mini-steel technology capable of adaptation to the all-important nascent steel technology of the motor car. This happens three times in the movie, in a kind of leit motif, when to rescue the latest techno marvel from its chronic paralysis, Rose pulls out a steel stay from within her bosom, just the thing to fix the spark cap, as her companion car owner Charlie agrees. Rose's resourceful action is repeated each time with emphasis and flourish, as if she were surrendering one of her bosom secrets, a kind of (phallic?) all-powerful magic wand.

In the realm of metaphor rather than real life, the corset steel merges with the barbed wire. Another invention of far-reaching economic potential likewise resisted and ridiculed by vested interests, barbed wire is the analogy when Rose is invited by the Kansas rancher to stick to "fencing in" the ladies with her corsets, rather than cattle with the wire. After she refuses to marry him, she is accused of inhabiting a "barbed wire" shell—corraled in the corset, as it were, of her masculine will to independence. The contradictions come pell-mell.

Early car enthusiast Charlie's recognition that his car "runs on Rose's stays" is a kind of marriage vow made through the merging of masculine and feminine symbols, sealing mutual love and the marriage that is denied the cattle rancher, whose tyrannical machista personality would be a barbed wire fence forcing Rose into conventional seclusion.

Thus Rose parlays her femininity (her dresses, even as a barbed wire saleslady in the Wild West, are always very tight-waisted and feminine) to masculine emancipatory ends, and her vision actually transcends that of the male, for at the very end, in a nice touch, even her technophilic husband is left skeptical and indeed shocked, as he always was, at her defense of the very idea of female emancipation, at her prophecy that travel in the future will (also) be by air.

We now take a relatively recent film that responds closely to current fashion (with costumes by the famous designer Jean-Paul Gaultier) and embodies the corset (or corset effect) as a protective female armor against male abuse and vice. Peter Greenaway's *The Cook, the Thief, His Wife and Her Lover* (1990) is an "art film" rank with abominations (down to the torture of a child), a disgusting fusion of sex and food spiced with high fashion. The husband (and thief), Albert Spica, owns a sumptuous gourmet restaurant where he holds all-male banquets for his sottish cronies, in parody of Frans Hals's convivial militia groups, one of which in huge enlargement fills a wall. The only female participant is his wife, Georgina (Helen Mirren), a beautiful, elegant woman who suffers in bitter silence the nonstop cascades of vulgarity, violence, and insult of a drunken, obtuse, tyrannical, sadistic, and, as it proves, mad husband. She is dressed in the height of (Jean-Paul Gaultier) fashion: a variety of corset dresses and corsets, the delicate restraint of which, and of her manner generally, is set in contrast to the dominant male grossness and obscenity. Through all the violence and vulgar gourmandizing of the banquets, where the choicest food is served, she never eats, except—oh so delicately—asparagus with her finger tips, in symbolic anticipation of fellatio with her lover.

Her between-course sexual trysts with her lover, in lavatory and kitchen, are significantly silent: Her only voice, otherwise battered out of her by her husband, is the plaint of finely disciplined clothing, by which she preserves some public dignity. When her husband discovers her infidelity among the Dutch cheeses in the enormous kitchen, he goes berserk in a jealous, destructive rage. The vulgarity, cruelty, and criminality of his dining cronies are also set off, in a socially satirical point, against the refined costumes and behavior of the waiters and waitresses, the latter usually attired also in elegant corset dresses; the occasional floozy invited with the male cronies wears, by contrast, a fetish outfit with "vulgar" conical bra.

In the final scene, in which Georgina forces her husband to eat the cooked flesh of her lover, whom he has sadistically murdered, her customary restraint is cast aside, and she wears a bondage-style outfit with fantastic feathers. She has become what was concealed under the corset restraint—a bird of prey and full-fledged dominatrix—so she can execute her carefully planned, mad moment of revenge, before she finally shoots the hated husband dead. Georgina's corseting has multiple functions: It represses her sexuality, which her husband spurns; it contains this sexuality until released into her lover's arms; and it conceals the potency of her lust for revenge. It works in tandem with her self-denial of the food, which—contrasts with the male's uncontrolled, vicious appetites. A critic has seen Georgina as the empowered "phallic woman," fearful to both filmmaker and film husband.[44]

MYTH MAKERS: ART AND LIFE AND FASHION

Friedrich Schlegel held that the greatest art and the greatest social power come from self-constraint, that submission to external constraints led to slavery. The corset has symbolized that self-constraint; that it should be borne by women rather than men is another matter. Arguably, men deeming their kind incapable of self-restraint have shackled themselves with external restraints; political slavery is everywhere, especially in so-called democracies, which seek escape in myth. Among the myths are those combining power and sacrifice, best visible in the great myth-making industry of the age: film.

The aestheticizing discipline of the corset has been promoted by or on behalf of actresses as part of the myth they embody of suffering and sacrifice for the sake of art. The myth has a long history, which can be traced (pre-movie) back to Anna Held in the late nineteenth century, whose wasp waist was reputed to have been achieved at the cost of the removal of lower ribs (which is certainly untrue, such stories then as now being best treated with

[44] Jon Stratton, *The Desirable Body: Cultural Fetishism* (New York: University of Illinois, 1996), 169.

skepticism). The media message of suffering through corsets imposed by pe-
riod roles has its parallel in those of imposed starvation to keep thin, which
are more credible. One believes the famous actress character played by Julia
Roberts in *Notting Hill* (1999) when she says, "I have been hungry for ten
years," whether personally true of Julia Roberts or not.

Moulin Rouge (2001), a film set in the world of French cabaret at the
turn of the century, is credited with having propelled the corseted look fur-
ther, or back into public consciousness and fashion. In a particularly clear
mutual-marketing collaboration of film and fashion, the *Vogue* editor-in-
chief caught wind of the film in its early stages of production and put Nicole
Kidman as Satine on the cover of the December 2000 issue. This and sub-
sequent features, the publicity around the super-lavish costuming in general,
and Kidman's black Karl Lagerfeld corsets—in which she is exposed most of
the time—in particular, coupled with invitations to designers to preliminary
screenings and with windows in Bloomingdale's with fetish manufacturer
corsets, were all designed to relaunch the tarty period style. The corsets were
not in themselves that interesting, but they were sufficiently severe to gen-
erate stories in the mythology of sacrifice. According to Catherine Martin,
costume designer and wife of director Baz Luhrmann, "We had to make a
leaning board for Nicole because it's uncomfortable to sit in a corset. She
suffered like you wouldn't believe. It was just agony from morning till
night." Kidman even cracked a rib from the combined pressure of being
lifted (by Ewan McGregor, who was proud to admit it) while being tightly
laced and had to be shot corsetless until she healed.[45] Kidman herself, con-
firming this, said, "I was doing things in a corset that no woman would have
done in the 1890s," adding, "I was there in these huge heels and I fell down
stairs, causing a painful injury which required surgery." Working seventeen
hours a day added to the misery.[46]

But Nicole Kidman, whose natural slenderness is enhanced in her films
while her height (six feet) is disguised, is no stranger to the corset: à propos
Portrait of a Lady (1996), in which she played Isabel Archer, whose
masochism seems expressed in her tight-laced form, she said, "We got the
corset down to nineteen inches one day, and I would be in pain and have
bruises and stuff on my body when I took the corset off. But it was a psy-
chological thing where I wanted to be restricted really, really tight so the
more repressed I was, the more I felt it."[47]

Angelica Houston also joined the roster of martyrs. For *The Addams
Family,* popular on TV and in film, she was laced into a corsetted costume
that constricted both her waist and her walk. Glenn Close as Cruella de Vil
in *101 Dalmatians* (1996) is said to have been unable to shoot more than

[45] Vali Herman-Cohen, "Clothes with Real Kick," *Los Angeles Times,* May 4,
2001; E1.
[46] Ewan Mcgregor, *Film Review,* October 2001, 40–42.
[47] Warren Hoge, "The Portrait of a Dazzler Who Found Repression Is Rewarding,"
The New York Times, Section 2, 17, January 19, 1997.

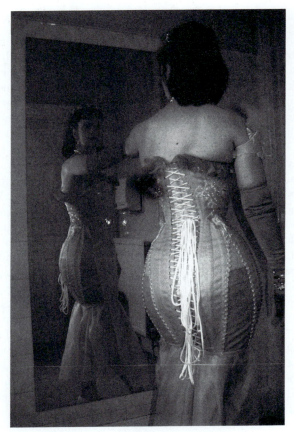

Figure 9. Corset gown by Dark Garden, San Francisco, ca. 1995. (Photo: David Kunzle)

fifteen minutes at a time, so tightly laced was she as the evil fashion designer, updated in almost-fetish wear: clawed gloves and high choker collars and a skeletal-patterned dress in which she spewed forth her deadly antimaternal, antipuppy menace. The myth gains substance with some more sophisticated self-analysis of feeling from Karin Cartlidge (in *The Cherry Orchard*): "These bloody corsets do a lot for repression: I nearly fainted in one. I find them quite sexy, actually, it's a funny sort of thing. They hold you in like a cold iron hand round your heart, therefore all your emotions just seethe away underneath it. It's like being in a sort of prison and it's quite exciting, there's something erotic about it" (Figure 9).[48]

[48] "On the Edge: The Big Interview: Karin Cartlridge," *The Times* (London), Feb. 5, 2000, Metro 8.

ELIZABETH TAYLOR

The first, and certainly the highest-ranking, practitioner of tight-lacing, which was by the later nineteenth century more a habit of discontented, inferior (lower-middle, even working) classes, was Empress Elizabeth of Austria. In her time (1860s and 1870s), her sixteenth-inch waist was scandalous; in middle and old age she became virtually a fitness fanatic, and by some accounts anorexic. Beautiful, capricious, courageous, and obstinate, she sounds like the model for the emancipated woman of later times—and for another Elizabeth in our own times, who has lived in the kind of aura generated by royalty a century earlier.

Admiration for the perfect beauty and considerable talent of Elizabeth Taylor has been matched by concern for trauma-ridden health. While never expressing herself as victimized by corsetry and tight-lacing as such (the very opposite, in fact), part of her myth is that of beauty accompanied by much physical suffering and the struggle for self-discipline. Her autobiographical diet book of 1987 presents a blend of waist pride, corseting, and eating disorder, emphasizing her battle against overeating as just one of her physically dangerous addictions. She chronicles in candid detail the enlargement of the tiny nature-given waist and how her five-foot, two-inch frame came to carry over 180 pounds. In the 1940s, one of her delights in puberty was the cultivation of a "small waist which I'd squeeze even smaller . . . I flaunted an hourglass figure on stage when most girls were still developing." In her youth, famous already, she claimed 37–19–36. The nineteen was back there in 1953 when she presented at the Academy Awards, wearing a flower-embroidered corselet. Health problems began early, exacerbated by pregnancies and overeating. Determined to keep "mum" about her first pregnancy lest MGM boss Louis B. Mayer, the "champion of womankind," discover and stop her working, "I had to keep my nineteen-inch waist pulled in until the shooting was finished." From then on, her life reads as one dominated by the struggle to keep her figure, with dramatic spurts of dieting (from 180 to 140 pounds for the stage play *The Little Foxes*), up and down, in and out, particularly in her forties. But she managed to preside over her fifty-fifth birthday party, after a period of ill health, in a twenty-two (or twenty-four)-inch gown "tight enough to choke a chipmunk," in celebration of her physical and moral recovery.[49]

From other sources we learn of her being so tightly laced that she fainted "like Scarlett" (who despised fainting) after bingeing, which added $45,000 to the cost of the film (*Raintree County,* 1957). The bingeing (on fatty foods) was a familiar occurrence of the film set, but "she could lose more weight between a Friday and a Tuesday than anyone I ever met."[50] Her waistline was a very personal obsession, beyond the demands of designers and dressers, whom she would urge always to make

[49] Elizabeth Taylor, *Elizabeth Takes Off: On Weight Gain, Weight Loss, Self Image and Self-Esteem* (New York: Putnam, 1987).
[50] Brenda Maddox, *Who's Afraid of Elizabeth Taylor?* (New York: Jove, 1977), 117.

her a bit tighter, for which the following charming exchange exists from about her eighteenth year: "I'll always remember Elizabeth saying [à propos her costume for *A Place in the Sun*] 'You can make the waist a little smaller.' 'I've already made it a little smaller!'[51] 'You can make it even a little smaller!' She had a 19 inch waist at this time and she was always trying to get us to make the waists just a little smaller." So it is not her costume designer's choice but her own that she appears so anachronistically wasp-waisted in *Cleopatra* and *Taming of the Shrew*. Yet such is the force of Taylor, and of the fashion of the moment, that the Shrew was considered the most "definitive Shakespearian costuming [by Edith Head, winner of many Academy awards] ever done for the screen."[52]

MADONNA: POWER CORSET

Singer-actress-dancer-video-and-film superstar Madonna has surely done more to popularize the corset-as-outerwear, the reinforced bustier, and the designs of Jean-Paul Gaultier, than any other single figure. She also embodies, perhaps more than any previous female superstar, the idea of female self-empowerment, independent of men (here very unlike Taylor), be they boyfriends, husbands, or managers. With 50 million albums sold, she is the highest paid and richest solo pop performer in the world, and has been called the most famous woman in the world, who ranks in power with those American women holding the highest political office. Her celebrity is such that she has become a major subject of academic discourse.[53]

Madonna openly flaunts her quest for power as "the great aphrodisiac." She was on *Glamour* magazine's Women of the Year list for "personifying women's power of self-determination.[54] She has been popularized as a symbol of liberation on the one hand and on the other hand loathed and excoriated as "America's favorite social disease."[55] She has also been proclaimed by *Vogue* as the greatest single fashion influence in the world, with an immense following of copycat teenagers, with her corset or bustier making the central contribution.[56] In its various forms (over a constant 32–23–33), her

[51] Edith Head and Jayne Kesner Armstrong, *The Dress Doctor* (Boston: Little, Brown, 1959), 121 and Edith Head and Paddy Calistro, *Edith Head's Hollywood* (New York: Dutton, 1983), 96.
[52] Robert Levine, *In a Glamorous Fashion: The Fabulous Years of Hollywood Costume Design* (New York: Scribner, 1980), 243.
[53] Cathy Schwichtenberg, *The Madonna Connection: Representational Politics, Subcultural Identities and Cultural Theory* (Boulder, CO: Westview Press, 1993), 15. and Christopher Andersen, *Madonna Unauthorised* (New York: Simon and Schuster, 1991).
[54] Schwichtenberg, *The Madonna Connection*, 242 and 244.
[55] Karlene Faith, *Madonna, Bawdy and Soul*, Toronto, Canada: University of Toronto 1997, 141; and Schwichtenberg, *The Madonna Connection*, 15.
[56] Christopher Anderson, *Madonna Unauthorized*, 307.

attire is not particularly tight, or even that sexy, but it presents an armored look with its stiffly protruding, corded bra, which is often combined with a (male) business suit. Her style combines masculine and feminine, androgynous and bisexual, the sharp and the dangerous. She has put the pointiest and most phallically elongated bras on her men dancers. She and her designers have practiced that "gender bending" inherent in late twentieth-century fashion and fashion corset. Her bustier–corset has become a holy relic; one has been auctioned at Christie's for $20,000; another was stolen from a lingerie museum in Hollywood, during the 1992 Los Angeles riots.[57]

She has also popularized, in video and photo album, other fetish-related concepts and sexual variations of all kinds, notably bondage, sadomasochism, slave scenarios, masturbation, realistic simulations of the sexual act, and fellatio (on an Evian bottle), down to a touch of zoophilia, all this spiced on occasion with "blasphemous" Catholic religious allusions, which have sparked (threats of) censorship.[58] "In America people really dig a little senseless violence. . . . Everybody feels like a bit of pain."[59] Her "enslavement" of black dancers with chains and collars is regarded as "racial deconstruction." When she herself wears slave collars and chains, it is not as a victim but in willing self-exposure: "chained to my desire."[60] She has this nice definition of S and M: "letting someone hurt you who you know would never hurt you."[61]

These desires are reputedly voracious, insatiable, fearless. But Madonna is also obsessively disciplined, and compulsively well-organized—above all, with respect to her body which unlike so many superstars she has never abused. She has endured nonstop physically demanding worldwide tours. She lives on a vegetarian diet, takes daily three-mile runs, and does grueling workouts under the watchful gaze of her trainer *terrible*. Around 1986, she was able to permanently shed fat, which she replaced with muscle and sinew, as her prowess as a dancer shows. The corset expresses above all a provocative hardness about her. When she took the stage in her black "Open Your Heart" corselet, many in the crowd of 77,000 surged out of control, occasioning violence and fainting; if the corset ever caused fainting, here it was not in the wearer but in the fans.[62]

MORE LIBERATION? FETISHISM IN PHOTOGRAPHY

The absorption of various fetishisms into the now-familiar fusions of art/fashion photography is another aspect of the cultural normalization and artistic sublimation of fetishism. Photography in high-fashion magazines

[57] Lynn Hirschberg, "The Way We Live Now: Questions for Jean-Paul Gaultier; An Artist? Moi" *New York Times*, Final, Section 6, 13.

[58] For instance, in the video *Truth or Dare* and in the photo album *Sex*.

[59] Christopher Andersen, *Madonna Unauthorized*, 285

[60] Christopher, Madonna *Unauthorized*, 271 and Cathy Schwichtenberg, *The Madonna Connection*, 93 Andersen, 271; and Schwichtenberg, 93.

[61] Madonna, *Sex*, Warner n.d., n.p.

[62] Christopher Andersen, 228, *Madonna Unauthorized*, 228, 242.

has long sought the exotic, bizarre, and outlandish, conjuring locales and desires lying far beyond the boundaries of catwalk, drawing room, or street. Fetishism is thus elevated as an exercise of Imagination, as Art. In those many albums of fashion designers who blend the display of clothing and photographic art, fetishism becomes a binding agent.

The hard-core sadomasochistic (bondage) fetish graphics of John Willie and Eric Stanton, which circulated underground in the 1950s, have to a degree (minus the narrative form) been superseded and sophisticated by photography. Eric Kroll's *Fetish Girls* is an aboveground homage to the old underground and includes such artists as Naim Paik, Weegee, and Man Ray. Kroll has worked for major magazines, such as *Der Spiegel, Vogue,* and *Elle,* has taught at major universities, and hangs Willie and Stanton (whose oeuvre he has edited) on his studio wall, next to Larry Clark and Edmund Weston.[63] He gives body distortions and extreme postures an aesthetic autonomy, with the contorted–fetishistic spilling over into the "respectable spectacular" of the literally acrobatic, contortionist, and balletic enforced physically (for instance, by extreme heels and bondage devices), as well as photographically, in a shocking, bizarre, and sometimes funny way, by means of camera angle. It is as if the camera itself were acting as a body-disruptive bondage device, sending the constraints of extreme heels (notably) into a kind of orgasmic rictus extended to the body as a whole.

The transition of world-famous photographers Helmut Newton and David Bailey to fetishistic eroticism is another mark of the last decades. Bailey's *Trouble and Strife* shows his wife Marie Helvin in explicitly erotic poses enhanced by leather and rubber outfits and extreme, explicitly phallic heels. Newton (born 1920) above all is credited by *Vogue* for making fetishism chic, for doing in photography what Gaultier was doing with his clothes. Thrilling to the "preeminent bad boy of fashion photography," *Vogue* lauds Newton's vision of women in control, aggressively female, not victims but man tamers: dominatrixes.[64] The catalogue to his retrospective in Berlin goes further, dripping with liberationist rhetoric: Newton imagines women "exactly as they are at the dawn of the new millennium: women who take the lead . . . who enjoy the resplendence and vitality of their own bodies, bodies over which they have sole command; women who are both responsible and willing."[65]

"High and Mighty" is the heading given by *Vogue* to "seductiveness reaching stylish new heights, as sky-high stilettos provide the wicked footnote to hourglass-contoured suits and dresses that radiate sultry appeal." Standard fetishist stuff, perhaps, but Newton goes further, into another more sinister, sick kind of fetishism, with extreme collars-cum-neck-braces,

[63] Eric Kroll, ed., *The Art of Eric Stanton* (Cologne, Germany: Taschen International, 1997).

[64] Georgina Howell, "Chain Reactions," (US) *Vogue*, September 1992, 530–534.

[65] *Helmut Newton, Work,* catalogue for exhibition at Neue Nationalgalerie, Berlin, Germany, 2000–2001.

Figure 10. Molded plastic bustier by Issey Miyaki from 1983.

orthopedic devices, and the downright crippled: The model sits in a handi-
capped person's wheelchair, her stiletto heel delicately poised on a footrest;
a few pages further, the same model in similar shoes limps upstairs on
crutches, helped by two dark-suited men, to a text quoting Newton in praise
of high heels; last she appears supported by a simple cane but with her leg en-
cased in a sinister steel scaffolding, part orthopedic, part architectural–sculp-
tural, part sci-fi mechanical gynoid.[66] There are elsewhere dark hints of bodily
wounds that fashion too has found exciting.

　　Newton also gives us the connection between the two apparently con-
tradictory addictions, both sweat inducing and figure refining: occlusive
fetishist fashion and the physical workout. Thus a model totally enclosed in
shiny rubber and wearing spike heels, another in robotic Perspex, and a third
in a Thierry Mugler black-patent leather, rubbery catsuit, all pedaling away
on machines, "cutting exercise time down to four minutes."[67] We pass by
other photographers who use necrophilia, suffocation, decapitation, muti-
lation, and sadism—horrid practices or concepts "author-ized" by photo-
graphic auteurs.[68] The idea of the hard-body cuirass incorporated into
historic armor, fashion old and new, and the classic S and M bondage sce-

[66] High and Mighty," (US) *Vogue*, February 1995, 215; revisited in Helmut
Newton, *Pages from the Glossies (1956–98)*, (Zurich: 1998), 508–509.
[67] Mary Roach and Wendy Schmidt, "The Machine Age," *Vogue*, November 1995,
295.
[68] Kathy Myers, "Fashion 'n Passion," Rosemary Betterton, ed., *Looking on: Images
of Femininity in the Visual Arts and Media* (London, New York: Routledge Press and
Regan Paul), 1987.

narios of Willie and Stanton, is raised to art-photo level by designer Issey Miyake's *Bodyworks*, which plays on the incongruity (and cruelty) of enclosing and fusing soft skin and flesh in hard plastic (Figure 10).

Thus fashion and fetish, with their accidental homophony, merge in what is hailed as a kind of victory for personal liberation. Why this should happen just now will be adjudicated by the future. Why the corset should have functioned as the primary visual link between fashion and fetish is an uncomfortable question for an uncomfortable age.

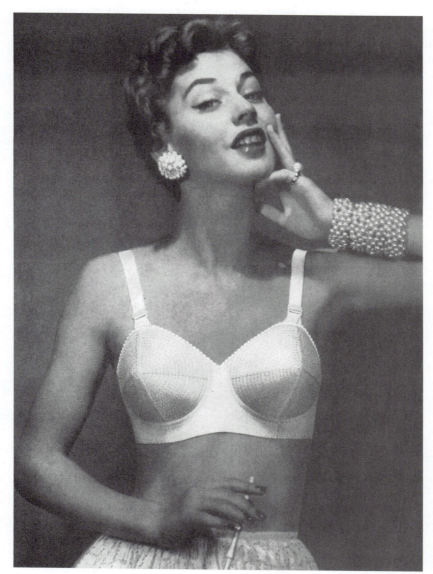

The "torpedo" bra from 1954.

Sex, Lies, and Lingerie: Betty Friedan and the Bullet Bra

Kathryn Hagen

Breasts first entered the foreground of my consciousness when an unsettling rumor spread through both sixth-grade classrooms: Jeannette W. was seen stuffing wads of toilet paper into her cotton bra in the girl's bathroom. Though puzzled by such a peculiar exercise, my peers and I were aware of the contrast between our demure, well-pressed cotton dresses and Jeannette's skintight tops, which compressed her lumpy bosom into irregular submission. The precocious sway of her hips revealed tacky petticoats dangling like dirty snow beneath her circle skirt. Too sheltered to know words like *slut,* we nevertheless reached consensus that Jeannette was morally flawed.

What we were too young to realize was that Jeannette was following a time-honored female tradition. Whether women are risking expensive cosmetic surgeries or stuffing their training bras, they are all "upgrading" key physical assets to attract and keep desirable males. Though beauty ideals vary, women have endured pain, ill health, and expense in search of the holy grail of physical perfection. Cultural artifacts such as whaleboned corsets and miniscule Chinese wooden shoes attest to the extremes to which we, as females, have gone.

In contrast to more radical physique enhancers, our artifact of choice, the Bullet Bra, seems relatively benign; yet its intriguing shape and construction made it the foundation for mass female transformation in postwar America. The spunky women with narrow hips and take-charge shoulder pads, who ran the country while their men fought World War II, simply disappeared, replaced by the exaggerated, roller-coaster curves of the ultimate modernist gadget: the fifties' wife. Amazingly, the same women played these two extreme roles. Many, like my own mother, a surgical nurse, left vital jobs to follow ex-soldier husbands to suburban homes (Figure 1). Zipped into full-skirted dresses, with tight, perky bodices, Mom became yesterday's Cosmo girl, seductive but true. The baby boom soon followed. When sex-goddess Madonna took the stage in 1999 in her original Galliano, pointed satin bra cups, she was, in fact, mimicking the conservative fifties housewife.

Such culture-altering clout is impressive for any garment. The Bullet Bra's complex résumé speaks volumes about the society that produced it and the curvaceous hausfraus who wore it. Also called the Missile Bra for its cone-shaped contours, this highly engineered garment was not just an ordinary

Figure 1. William and Eleanor Hagen in uniform. Both of them served in World War II. (Photo: Courtesy of Kathryn Hagen)

article of underwear. Rather it was a covertly aggressive piece of equipment, with weaponry antecedents. It lifted, separated, and shaped the entire bosom into an aggressive promontory, completely unrelated to naturalistic forms. Created and mass-produced in 1949 by Maidenform, under the brand name *Chansonette*, the exaggerated cup shape and circular stitching quickly attracted its more provocative nicknames. Promoted heavily, the style sold about 90 million units in 100 countries. I remember, as a young girl, staring at photographs of collegiate *sweater girls*, photographed, I presume, on Ivy League campuses. Entranced boys carried their books while they strolled unencumbered, their exaggeratedly pointed breasts preceding them, more than ready to earn their MRS degree.[1]

Though the term *sweater girl* exudes innocence, there was nothing virginal about the Bullet Bra silhouette. Along with its counterpart, the "airtight" spandex girdle, our brassiere produced the sleek curves of a cashmere seductress. Such overtly sensual fashions belied the alleged conservatism of its day. What forces generated this puzzling postwar female identity? Why did fairly conservative women embrace fetishistic, cone-shaped lingerie, overtly showcasing their breasts? What explains the silence of those for whom full-time domesticity led to boredom and depression?

Furthermore, why was the role of women in the war so downplayed? Though many educated, female executive types maintained businesses while men went overseas, they vanished into the lore of Rosie the Riveter, whose skills were, in comparison, pretty basic. These are the mysteries that this essay will attempt to solve. The decade of the 1950s projects an especially acute historical dichotomy between supposed postwar utopian highs and Cold War, chauvinist-dominated lows. It is an intriguing, paradoxical landscape in

[1] In those days, it was thought that many women went to college simply to meet and marry an educated male.

which to frame our questions. The Bullet Bra will be our smoking gun. We will dust it for semiotic fingerprints and examine it under the microscope of cultural perspective; if all goes well, the answers will be found somewhere between its rows of double stitching and special reinforced metal tips.

Let us begin then with conventional wisdom, which tells us that, despite the aggressive stance of her lingerie, the fifties housewife was an essentially docile creature. Her world revolved around raising children, keeping house, and, most importantly, making her husband, who provided her with a privileged lifestyle, happy. Ever glamorous, she met her hard-working hero at the door every evening with pipe, slippers, and a highball. She loved shopping, entertaining, and vacuuming, even in full skirts and pumps. Her children were well mannered and never needed therapy or antidepressants. Nor did she. Though she may have been tomboyish in the past, she now sought to duplicate the sensual hourglass figure of her European forebears. Her obsessive attention to home and wardrobe suggests that appearances were paramount for her. The Stepford Wife had nothing on her.

We have only to look at the iconic females of 1950s film and television to find evidence of this hypothetical feminine brain freeze. Marilyn Monroe, for example, all voluptuous curves, was lovely but childlike. Her films consistently promoted the notion that a rich husband was the ultimate feminine achievement. Songs such as "Diamonds Are a Girl's Best Friend," though tongue in cheek, reinforced the materialistic, dependent mentality. Another blonde sex kitten, Carol Baker, starred in the film *Baby Doll*, in which she wore short lace nighties and played dumb for the benefit of her much older husband. Doris Day, also a much filmed blonde, was consistently perky but clueless.

On television, Lucille Ball, in reality a tough, innovative businesswoman, depicted a perpetually ditzy housewife. Every plot showed her creating amusing havoc from which celebrity father-figure husband, Ricky Ricardo, could rescue her. Her character's periodic efforts to find professional success for herself inevitably brought disaster and humiliation. So popular was this comic affectation that Ball became the queen of sitcoms and the richest woman in TV land. Meanwhile, more traditional imaginary moms in such shows as *Donna Reed* and *Leave It to Beaver*, untroubled by ambitions beyond perfect roasts and dust-free domiciles, happily doted on husbands and offspring. The subject of female depression was never addressed in a serious manner. Success lay in shallow roles of either amusing incompetence or serene passivity.

Fortunately, research contradicts such stereotypes. Betty Friedan, the mother of modern feminism, provides a good example of the intellectual, yet ambivalent, mindset of women of that era. Though she was a brilliant, ambitious student and graduate of Smith College, Friedan admits that she was terrified of being the scholar no man would bed, let alone marry. When she did become a wife and mother, she maintained her career as a journalist covertly, even hiding her writing from neighbors as others would hide the empty Scotch bottle. Intelligence or ambition in females was then a questionable asset.

Curious as to how her fellow Smith graduates were handling their privileged domesticity, Friedan distributed a pointed questionnaire at her class reunion. Some two hundred women responded with confessions of secret pill popping or heavy drinking. Intrigued, Friedan coined the term "problem that had no name," which stated that these so-called "happy homemakers" were living a lie, wallowing in boredom, and at a loss for a meaningful identity. Demoralized by their dependence on their husbands for financial support, isolated homeworkers were living their lives through their children and mates.[2] The resulting book, a feminist "smart bomb" entitled *The Feminine Mystique*, blew the lid off this domestic facade. Adding to the fray, author Germaine Greer coined the term "female eunuch," proposing a metaphorical castration that allowed these women "to function as a glamorous, 'super-menial' who is all things to all men, and nothing to herself."[3] Women, forced to act out roles antithetical to their aspirations, probably needed a costume; the extreme getup of the genteel "blow-up doll" begins to make some sense.

Who is responsible for this backlash? Friedan laid heavy blame on Sigmund Freud and his ubiquitous "penis envy" theory. Though Freud's ideas stemmed from sessions with sexually repressed females of the late nineteenth century, they were "seized in this country in the 1940s as the literal explanation of all that was wrong with American women." Freud believed females were created by God to service the needs and comforts of men. This view credited the suddenly popular notion that women who deviated from their assigned role of mother and wife invited unhappiness. "It was woman's nature," Freud stated, "to be ruled by man and her sickness to envy him."[4]

Literal interpretations of such notions appeared regularly in women's magazines and marriage courses, warning women of the consequences of misplaced ambitions. Females, bred to duty, would not want to upset the applecart of the healthy American marriage, and if homemaker discontent were viewed as antifeminine neuroses, they would hide those feelings and soldier on. These articles even blamed feminist ideas for female sexual problems, stating that "The dominant direction of feminine training and development today discourages just those traits necessary to the attainment of sexual pleasure: receptivity and passiveness."[5] Nonorgasmic women were termed *frigid*, and even education was seen as a negative factor that could exacerbate such emotional disorders. Consequently, men were released of all responsibility for their wives' emotional and sexual satisfaction or lack thereof; any problems resulted entirely from the women's wrong thinking

[2] Betty Friedan, *The Feminine Mystique* (New York: W. W. Norton & Company, 1963), 28–29.

[3] "Chat Transcript: Germaine Greer on Feminism and War," (1999) www.cnn.com/HEALTH/women/9906/21/greer.chat, retrieved at August 14, 2006. For a fuller explanation of her theories, see Germaine Greer, *The Female Eunuch* (New York: Bantam, 1972), 63–73.

[4] Betty Friedan, *The Feminine Mystique*, 100.

[5] *Ibid.*, 115.

or actions. The perpetrators of such ideas were largely well-meaning people in unfortunate positions of influence, who embraced Freud's theories almost like a religion. Clearly, his ideas spoke to and serviced the fears and desires "peculiar to the American people at that particular time"[6]

But the wave of sensual fifties housewives did not emanate from any one source. More quiet upheavals were taking place. Despite the decade's reputation for prudishness, the subject of sex was actually a prime topic. Midwestern biology professor Alfred Kinsey had "walked into America's bedroom and snapped on the light."[7] His book *Sexual Behavior in the Human Male*, published in 1948, revealed a disturbing statistic; at least 50 percent of married men confessed to adultery at some point in their lives. Imagine the impact of this revelation on homebound women who were rearing children while their husbands were facing temptation in the workplace. Pragmatic fifties housewives likely sought strategic solutions; breasts like "missile silos" might be a potent weapon in the quest to keep his attention focused on her.

The world of fashion also had a hand in the zeitgeist of female submission. When Christian Dior flaunted his sumptuous, over-the-top New Look following World War II, savvy feminists spotted a return of restrictive straitjacket female fashions, reminiscent of the previous century. Dior's dress bodices were stiff and corsetlike, the multiyardage skirts made for expensive price tags, and the high heels—so essential to the privileged, femme fatale aura—impaired efficient movement. Specialized foundation undergarments such as the Bullet Bra were produced to further amplify the sex-glam aesthetic (Figure 2).

Designers, geared to profit motive, often participate in the creation and support of cultural hierarchies. Commerce thrives and careers blossom through planned obsolescence, and the power of couture to browbeat a certain economic strata of fifties fashionistas was at a level quite different from what we know today. To ignore fashion was to risk ridicule and loss of status, and to appear flat chested in public was an unnecessary humiliation. Brassieres like the Bullet Bra were designed specifically to amplify a woman's limited assets.

This desire to maintain a controlled public persona was not all these young wives had in common. They also shared a history of momentous

[6] *Ibid*. Friedan tells us, "But on the subject of women, Freud's followers not only compounded his errors, but, in their tortuous attempt to fit their observations of real women into his theoretical framework, closed questions that he himself had left open. Thus, for instance, Helene Deutsch, whose definitive two-volume *The Psychology of Women: A Psychoanalytical Interpretation* appeared in 1944, is not able to trace all women's troubles to penis envy as such. So she does what even Freud found unwise, and equates *femininity* with *passivity*, and *masculinity* with *activity*, not only in the sexual sphere, but in all spheres of life."
[7] Ben J. Wattenberg, Theodore Caplow and Louis Hicks *The First Measured Century: An Illustrated Guide to Trends in America 1900–2000*. (Washington, DC: American Enterprise Institute Press, 2001) Companion website: www.pbs.org/fmc/segments/progseg6.htm. retrieved at August 15, 2005.

Figure 2. Dior new look. (Illustration: Kathryn Hagen)

change. Born into the burgeoning consumer society of the 1920s, they had witnessed a deluge of such modern luxury goods as furnaces, toilets, toasters, washing machines, vacuums, and refrigeration. Radios and "moving pictures" were generating a powerful media culture, which was supersizing the power of advertising. Primed in childhood, these girls would be the perfect target audience for postwar commercial enterprises (Figure 3).

Everything changed in 1929. Millions were caught in the quagmire of the Great Depression.[8] Gender issues had little relevance on the breadlines. Nevertheless, sumptuous films, fashioned to lift the spirits of a depressed populace, showed loungewear-clad beauties, such as Jean Harlow and Mae West, often living in hedonistic luxury. Their characters were bold, intelligent women who could control men with their sensuality and expensively clad physiques. Thus, a way of managing romantic relationships may have been planted in the minds of young girls (and boys). Furthermore, the message that the feminine body could, and perhaps even should, be utilized to gain power over men was probably not lost on them.

[8] From 1930 to 1940, unemployment was at 18 percent, and one in four households had no visible means of support.

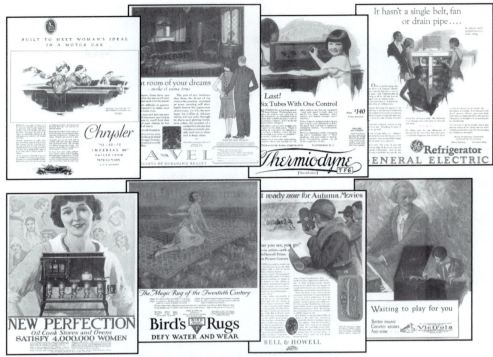

Figure 3. These advertisements are typical of the visual culture of the 1920s that created and encouraged modern consumer culture in the United States.

Like a worldwide depression, broad catastrophes can permanently scar the psyche. According to economist Milton Friedman, post-traumatic stress from this economic tidal wave reversed Americans' view of government and encouraged their patriotic acquiescence.[9] When President Roosevelt called on women to join the war effort, they eagerly complied. Government-financed day-care centers appeared almost overnight, and crash training programs taught skills that no one previously thought females capable of exercising. War-era films embraced this seminal role change, and featured female icons such as Katherine Hepburn and Lauren Bacall who were smart, witty, and built for speed. They wore pants, moved in flat shoes, and would never, in my mind anyway, have dreamed of getting a "boob job" (Figure 4).

For all intents and purposes, World War II ended the Great Depression, but victory led to the closing of government day-care centers and training programs for females disappeared.[10] A fear of renewed job shortages hung over

[9] Ben J. Wattenberg, et al., *The First Measured Century,* www.pbs.org/fmc/segments/progseg6, retrieved August 15, 2005.

[10] At the height of the conflict, U.S. factories produced a ship a day and a plane every five minutes.

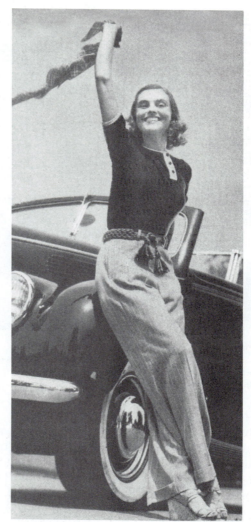

Figure 4. By the late 1930s, fashionable women were wearing
trousers cut to their proportions and renamed "slacks."

the soldiers' homecoming celebrations. Vets with GI Bill educations were en-
tering a dog-eat-dog workforce. To make room, women were pressured to
leave jobs or be fired; dream kitchens and bassinets replaced the work arena.

"In ads across the land," Betty Friedan wrote in 1952, "industry glori-
fies the American woman—in her gleaming GE kitchen, at her Westing-
house laundromat, before her Sylvania television set. Nothing is too good
for her."[11] Huge weapon manufacturers changed gears, racing to market
with pricey appliances and high-tech underwear. Social scientists provided

[11] Betty Friedan, "UE Fights for Women Workers," pamphlet, 1952.

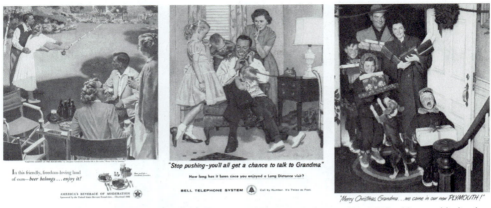

Figure 5. The American family became the star player in advertising in the post World War II years. Idealized images of the nuclear family were used to market a wide range of products.

motivational research to indoctrinate females with domestic fervor, along with an undertow of guilt and inadequacy. Thus sabotaged, women compulsively collected the latest gadgets to compensate for imagined inadequacies. A study of fifties housewives' labor revealed that, despite working with "efficiency" appliances, they clocked more cleaning hours than their mothers and grandmothers, who wielded primitive washboards and brooms.[12] The level of cultural perfectionism generated a never-ending process of cleaning, waxing, polishing, and researching gourmet cookbooks for their families' dining pleasure. Sisyphus had nothing on them (Figure 5).

Postwar America moved directly from a "hot war" to a "cold war," with an unpredictable enemy looming in the paranoid collective consciousness. The "drafting" of wives to produce future soldiers was, in retrospect, partially a result of this mental state: Intimate garments emanating from hetero male psyches may create a feminine image conforming to a hidden agenda, subconscious or otherwise. The Bullet Bra's circular-stitched, cone-shaped cups appear to have been lifted directly from the war department's missile blueprints. Rebecca Arnold refers to the "heavily cantilevered" garment that spoke of controlled but potential aggressive sexuality as the "dark underside of erotic fantasies."[13] Sexy wives would likely produce more children. Though sequential crises had potentially undermined female nesting instincts, the right kind of woman, born to duty and sacrifice, would conform for the continued economic and social welfare of her country. In the resulting production of large families, women became weaponry of another sort and eventually sacrificed 50,000 of their sons to the Vietnam debacle.

[12] Betty Friedan, *The Feminine Mystique*, 231.

[13] Rebecca Arnold, *Fashion Desire and Anxiety: Image and Morality in the 20th Century* (New Brunswick, NJ: Rutgers University Press, 2001), 70–72. Arnold calls the pointed brassiere a "feminine suit of armor, to simultaneously seduce and threaten the onlooker."

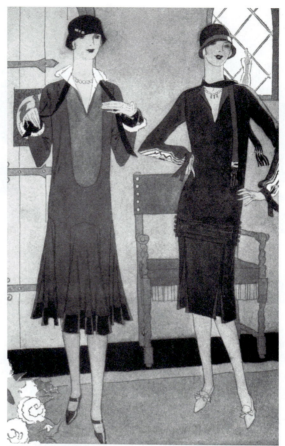

Figure 6. These flapper era dresses by Caroly Modes, ca. 1925, illustrate the narrow hipped, bustles desexualized silhouette that was the height of fashion in the 1920s.

In illuminating the role of the Bullet Bra in this scenario, we must ask whose desires it reflected. Did it empower or did it objectify? Certainly, the answer varies, depending on the context. Today millions of women opt for surgery to make permanent changes in their breast size and shape, and most would claim that such enhancements are empowering. Though our vanity-infused culture takes such priorities for granted, the prevalence of these extreme beauty practices is a strong indicator of the place that breast image holds in modern society. But the level of that power has varied historically. And if, as Elizabeth Janeway tells us, female sexuality is the glue that holds societal structures together, how that "game" plays out at a specific time can be telling.[14] Changing patterns in "flesh manipulation" may indeed illuminate the seesaw nature of male–female relationships in unexpected ways.

[14] Elizabeth Janeway, *Man's World, Woman's Place: A Study of Social Mythology* (New York: Dell Publishing Inc., 1971), 48.

Respectable Victorian females, for example, followed societal dictates of extreme modesty, disguising their actual form with layers of elaborate garments. Yet in an evening outfit, their bosoms were often practically spilling out of their dresses, and no one thought the less of them. Perhaps the strong maternal role that wives played in that era lent an aura of pillow-like comfort to the bosom, which somewhat neutralized its sexual content.[15]

The opposite situation applied to the twenties flappers for whom hem-lines rose and legs were exposed for the first time. These young, rebellious women, high on independence and good times, bound their breasts tightly with cloth, producing a flat, androgynous silhouette. Choosing also to remain thin and crop their hair, they essentially undermined the traditional hallmarks of womanliness with their appearance. Ironically, the same reversal happened between the fifties and the sixties. Though fifties icon Jayne Mansfield meas-ured 41–18–35, Twiggy, the ultimate sixties model, was 32–22–32.

Such body measurements defined fifties sex idols, and women in gen-eral were often reduced to a set of double-digit figures; the ideal 36–24–36 was one that few could attain.[16] Breasts, liberated by baby bottles from their primary role as infant food source, became essentially cosmetic objects and sex toys for the American male.[17] It is not surprising that the first brassiere commercial appeared on television at this time, for breasts were becoming big business.

America's roller-coaster attitude toward breasts reflects their signifi-cance in a culture that eroticizes, worships, and objectifies them. Though not all cultures privilege the breast erotically, Americans are bombarded with images of perfect bosoms, real or otherwise. Yet public breast-feeding, de-spite its resurgence, is still a rarity. Though undertones of maternal longing resonate in male breast obsession, the actual suckling of infants seems to be an unwelcome, even uncomfortable, sight.

For women, our breasts are front and center, competing for attention with our faces. It is hardly surprising that young girls, subjected to only per-fect breast images, feel inadequate. Comparing unfavorably to peers in terms of a physical ideal, we all suffer psychological consequences. The pressure to be "Victoria's Secret perfect" has certainly contributed to the huge surgical enhancement "*market*." Indeed it is men who envisioned and developed the

[15] The mothers of our fifties females ultimately benefited from cultural upheavals like the Model T and World War I. The U.S. War Industries Board, needing metal, asked them to stop buying wire-stay corsets; approximately 28,000 tons of metal were "liberated" for other uses. Catherine Bardey, "Lingerie, A History and Celebration of Silks, Satins, Laces, Linens and Other Bare Essentials," (New York, Black Dog & Levonthal Publishers) 2001, 78.

[16] Catherine Bardey, Lingerie: A History & Celebration of Silks Satins, Laces, Linens & Other Bare Essentials (New York: Black Dog & Leventhal Publishers: 2001), 127.

[17] Carolyn Latteier, *Breasts, The Women's Perspective on an American Obsession* . . . Tran-script from June 4, 2002 "All About Breasts," on the Discovery Health Channel www.newshe.com/allaboutbreasts1 retrieved at August 14, 2006.

profitable science of plastic surgery, creating the ideal woman with sharp knives and needle stitches.

These omnipresent coercions have elicited angry responses from some women. As essayist Cathy Laws writes, "Along with our kissable mouths, give-it-to-me eyes, sexy hair, nice asses, long legs, and tight vaginas, our breasts came to define our womanhood. If a woman is no more than the sum of her body parts, her intelligence, flair, creativity, and insight are rendered useless. Who cares if she's brilliant? What are her tits like? It's the ultimate dismissal."[18]

As one who grew up in the fifties, I can attest that the anger we felt about gender inequities did not coalesce until later decades. Aggressive feminist writings were unheard of. Given the seemingly smooth surface of the domestic landscape of that time, few were prepared for the extreme cultural upheavals of the sixties that shredded the illusion of docile social tranquility. Rebellious youth were credited with generating violent changes, and the assumption was that their more traditional parents simply gawked helplessly, paralyzed by generational incomprehension.

Daniel Horowitz, writing about Betty Friedan's early activist life, suggests that there is indeed evidence "of the artificiality of the separation of a turbulent Sixties from the supposedly complacent preceding years."[19] He argues that no radicalism like that of the sixties can emerge without a preliminary groundswell, eroding the conservatism of the preceding decade. Though many educated women, such as Friedan, went "underground" in the fifties, radical wartime concepts of independence were likely passed on to offspring. Certainly, encouragement of female independence was the theme in my upbringing, and my mother happily returned to nursing to finance our educations. Such maternal indoctrinations arguably helped to generate sixties and seventies protest movements—and cast a new light on women, like my mom, who were raising future activists.

In conclusion, we may say that the causal web underlying the actions of the 1950s female was complex and multilayered, and, in truth, the secrets of the Bullet Bra remain personal and private. Was its aggressive stance simply a concoction of the male cold war psyche, or was it an omen of a feminine defiance soon to emerge? Were these rigid undergarments subconsciously converted into armor in gender battles waged behind bedroom doors?

Brassieres demonstrated their psychic significance as a potent symbol of feminine rebellion in the sixties. Though actual bra burnings remain in the realm of myth, many females did discard their bras, symbolically shedding

[18] Cathy Laws, *Breasts in Our Culture:* Breastfeeding in Western Culture & Art, Female Intelligence Agency, www.007b.com/breast_taboo: This is the Female Intelligence Agency Website which is dedicated to taking an arguably controversial approach to the study of women's breasts.
[19] Daniel Horowitz, "Rethinking Betty Friedan and the Feminine Mystique: Labour Union Radicalism and Cold War America," *American Quarterly*, Vol 98, No.1, March 1996, 30.

repressive sexual strictures. Mitigated by the mighty pill and increased financial independence, women could finally take control of their own bodies. No longer subject to unwanted pregnancies, the liberated female directed her gaze on the male with equal sexual ferocity. Today's burgeoning lingerie racks and rampant surgical procedures, though controversial in feminist terms, can nevertheless be viewed as female empowerment and a direct result of this self-aware surrender to female carnal desires. The independent, upwardly mobile woman, with a "brain for business and a body for sin,"[20] is still changing the rules of courtship and commerce, and the fallout is yet to be understood.

[20] Quote from the film *Working Girl*, 1988, starring Melanie Griffith and Harrison Ford. Directed by Mike Nichols, and released by Twentieth Century Fox.

China White, Jane Goren, 1999, recycled window, ridged glass, rope, clothes pins, rope, Chinese Army underwear, digital print, acrylic paint. (Photo: Courtesy of Jane Goren)

Panty Lines

Sheldon Forbes

Always remember and please never forget: You must always wear clean underwear, just in case you get into an accident and have to go to the hospital. You know you've heard it before. Mothers don't always teach us about underwear, but if they do, at bare minimum they teach us that. In fact, that lesson may have been the first time you realized that when you were the most vulnerable, total strangers would be thinking critically about your undergarments. Imagine with me if you will, doctors, nurses, interns, and the guy who mops the floor, none of whom know you from Adam (or Eve as the case may be). Nevertheless, they're all standing around at the nurses station mentioning your unmentionables. When you finally wake up from that coma, you'll have quite a reputation with the hospital staff. Whether that reputation is good or bad will depend solely on whether or not you listened to your mother.

When I was little, my mother bought me those panties with the days of the week printed on them. You know the ones. They were genius. Those panties would serve a useful purpose to someone waking from a coma with a desperate desire to know what day it is. But then Mom also bought me panties with little pink flowers on them. Big mistake. They were so pretty, I always felt like showing them off. She switched me to panties that were just plain white to avoid a scene. Some of her selections were high riders, and some were low. One time she bought me a pair I later learned could be referred to as granny underwear. Those rode too high and hung too low at the same time.

About the time puberty sets in, American school children are introduced to a couple of new concepts to reduce the inevitable odor of overactive glands, the locker room and showers of gym class. There, the intimidating truth is immediate: Health care professionals are not the only outsiders who will be critical of the choices our mothers have made for us. One quickly learns that granny underwear has no place in the young girl's locker room. The guys have it a little easier. If you believe Michael Jordan, it doesn't matter what you wear as long as they're Hanes.

You guys out there may have been "tightie-whitie" men at birth, but if it hasn't already happened, at some point you too will have to decide whether or not your mother's first impression of you is going to follow you til the day you die. But remember this, my friends: Fashion is not the only consideration in a person's choice of undergarment. As men and women mature, gravity becomes an important issue in the selection of underwear. Needless to say, girls breasts develop, and boys, well, let's just say their voices drop. Both genders find themselves in need of support, if only to prevent injury. To make matters even more interesting, those same glands that make

our bodies develop and force us to expose our undies to our peers, also create within us the biological imperative to set in motion the process of individuation from our parents. We begin to make choices that position us in the world en route to creating families of our own. In the locker room, we are immersed in a sea of choices alternative to those our mothers made. So at that precise moment, gravity and peer pressure conspire to force us into a choice of our own. But aside from basic concerns about support, how do we choose what's right for us? Do we deviate from our mother's predilection and decide for ourselves which style of underwear is best? If so, by what criteria do we form our preferences?

At first, it might seem that the "cool" kids are our locker-room underwear role models. Why wouldn't they be? Cool boys seem to attract cool girls and vice versa, so their methods must be sound. Let's say that Victoria and her boyfriend Lance are the absolute epitome of cool. By all accounts, by their mere existence, they wield influence with a capital I. Almost everybody wants to be like them because, psychologically speaking, almost everybody wants to be liked. But it's more than that. Remember that biological imperative I mentioned? Aligning ourselves with people in power is one of the ways we humans attempt to attract the highest-caliber mate. Lance and Victoria did it. Surely they must know the secret to dating success. Who can blame us for picking apart every aspect of their personhood just so we too can be successful in our quest for the perfect mate? The locker room might be a huge factor. How else will you get to the bottom of Victoria's secret? But are Victoria's skivvies really the answer?

When you're uncertain how to attract a mate, everything counts, especially underwear. Your mother taught you to be conscious of the consequences of your underwear choices. You transfer that awareness and couple it with your locker-room experiences and realize that to make the best possible impression on your mate during the first unveiling, if you will, your undergarments had better be clean and as stylish as possible.

Initially, you may reason that you have nothing to fear. After all, unless your potential mate has been hanging out in the locker room of the opposite sex, how can his concept of "girl cool" be yet defined? That would be great: I mean, you could be wearing granny underwear, but as long as it's on the woman he desires, won't it seem to him to be the coolest thing in the world simply for lack of comparison? But wait, he comes from a family, too. What if he's seen his mother or sister's delicates drying on the line. What if that's his "cool" role model and you made different choices? If he's only seen granny's undies out to dry, you may be in the clear. But then again, this is the third millennium. Like the rest of us, your mate is bound to have seen lots of other people in lots of different styles of underwear. Think of the newspaper ads, catalogues, and movies you've seen.

Ah, the movies. Brad Pitt: Boxers or briefs? Celebrities are the cool kids on a national, sometimes international, scale. What we see them do or say affects us in the same way Victoria did, only this time, both the number of players and the size of the playing field have grown. The influence celebrities wield causes advertisers to fall in line, grappling with one another for the

exclusive right to hand out large sums of money to the celebrity who will agree to be seen in a certain brand of underwear, all in the gamble that the public who witnesses the subversive advertisement will take the bait and buy that brand, now made cool by association. Victoria and Lance may have influenced the fashion choices of their peers, right down to their unmentionables, but ask yourself this: Did Victoria's cool make her style fashionable, or did fashion make Victoria cool?

Sadly, or perhaps thankfully, not everyone gets to sit at the cool kid's table. There is radical power in realizing that neither Lance nor Victoria are the *be-all-and-end-all* in any way, shape, or form. Most people find themselves looking elsewhere for identity and self-esteem. Remember all those cliques in high school? Well, those were nothing less than groups of like-minded people united in solidarity against anyone who would try to kick them down. Strong individuals dictated their own fashions. They themselves decided which style of underwear was cool to them, assuming of course that they wore any underwear at all. And if those people were no longer looking to their families or the cool kids for leadership, you can bet they were diligently searching society for like-minded role models. What do chess masters wear? How about artists, physicists, or musicians? They may ask: "What is the traditional costume of *my* people?"

That brings us back to celebrities. If a celebrity's persona aligns with our own self-image or the image of the self we strive to achieve, or even the image of the self we hope to project to the world around us, then we quite literally *buy* into the fashion that gave that particular role model his or her style. And that, my friend, is how Brad Pitt's underwear got into my pants.

Oh sure, at first it was just a little playful role-playing between my partner and me. You see, in confidence I divulged that I felt a kinship to the characters Pitt played on screen. So one night, I was presented with a little gift—you know, for the bedroom. It seems that as style goes, women wearing men's boxer shorts is something akin to women wearing nothing but their lovers' oversized dress shirts. You've probably seen that in the movies, too. It is strangely erotic when women cross gender lines. It is the nature of taboo to be titillating: stolen peeks at lacy underthings breaking the conventions of modesty from beneath a dress in a public place; the ensuing fantasy; the escalating intrigue as that dress comes off in private, inch by inch revealing a secret world of lace; the slow tease as one strap of the lacy negligee falls to the side and the other is compelled to follow. Yep, one little hint of lace and it's "Gentlemen, start your engines."

But what happens when men cross that same line going in the other direction? I'm reminded of *The Rocky Horror Picture Show* and images of Tim Curry dancing around in lady's lingerie. Both the movie and the image are a cult classic, but transvestism is rarely lauded by mainstream America as sexy. When women wear corsets, brassieres, and stockings, it's usually for support and fashion, sometimes for assignations in the boudoir. When men do it, it seems a bit odd. At best, it's seen as good clean parody, a spoof of sorts. At worst, it's ridiculed as perversion. Wearing women's underwear is not always pretty.

Women definitely corner the market on transgressive titillation in the undergarment category. But before you think that the men who enjoy cross-dressing are getting the short end of the stick, remember that wearing lingerie is not always pretty for women either. Besides the contraceptive nature of granny underwear, sheer fabrics and tight-fitting clothes take an equal toll on the illusion of feminine perfection.

There's the visible panty line. The elastic that holds up women's panties sometimes creates an unnatural line in the fat of a woman's uppermost leg and rear end. That line is considered by some to be aesthetically distracting. The sheer, formfitting nature of many of today's fashions makes visible panty line a fashion don't. While the line does serve to confirm that the wearer has observed convention, not everybody applauds her restraint. What is a woman to do? She could go pantyless. Think of propriety. Imagine how mortified your mother would be if she had to face the health care professionals knowing that you had been in an automobile accident wearing no underwear at all!

How does the proper woman both satisfy her mother's morality and still look her best? Enter the invention of the thong. Now before you ask "What's up with that?" let me describe for the uninitiated what a thong is. It is a pair of panties that consists of fabric panels similar at front and middle to a standard pair, but instead of the tried and true rear panel, the panties are held in place by a T configuration of, so-called, floss. The thin strings cross high enough on the hip to be invisible within a pair of lightweight slacks or a tight-fitting dress. The reason the T configuration acquired the nickname *floss* is because of the chafing that sometimes occurs between the buttocks of the wearer. Said chafing is caused by the, shall we say, "hidden" string as the woman moves. The whole concept of a thong gives many women tremendous psychic discomfort, much in the same way that the mere mention of a groin injury prompts the average man to groan. There's got to be a better way.

Thong or no, the so-called nude look can have the same stimulating effect as the illicit glimpse of lace. But instead of the transgression being consummated by the stolen gaze of the voyeur, the courtesan and flaneur become complicit as that which was once stolen is now offered freely.

Going without underwear is delightfully disobedient. People who "go commando" (as it is called) are thought of as rebellious, unpredictable, and maybe even a little dangerous. So for those men who choose to allow their "boys" the freedom to roam, for whom boxer shorts are their fathers' constriction, going commando is a rite of passage. It's a lifestyle, a matter of adventurousness. It's the very definition of personal freedom. And besides, chicks dig it.

Now before you get your knickers in a twist, thinking that there's a double standard operating here regarding gender and shame, let me reassure you that the same standard is in operation for both sexes. You see, both are constrained by tribal convention. During childhood, we are taught which of our behaviors bring pride to our parents. We are taught conversely those that bring them shame. Girls are supposed to grow up and in essence

become their mothers, while boys are expected to cut the cord and become men, surpassing their fathers. Both genders teach and are taught the rules governing the tribe and society at large. Both are bullied by expectations. It is the propagation of *shoulds* and *musts* that keep any good hegemony in motion. In all fairness to the parents who disseminate the shoulds and musts, let me remind you that they too once were the children of parents. Fashion is born of fashion cast aside. So when a boy goes commando, he transgresses his mother's ideology, and that's a good thing—after all, none of the guys in the locker room like a mamma's boy. When a woman goes commando, or in the case of the thong suggests a willingness toward that impropriety, she too transgresses her mother, but unlike the men, she has to reconcile her choice (whether for fashion or lust) to both the morality of her mother's peers and to the desires of a younger age. It helps that her potential mate is probably relishing her commando choices because, even though it is his obligation to bring home a girl just like mom, he shares the girl's secret desire to be free of tribal responsibility and, even if in just this one small way, fantasizes that freedom is just within reach.

To the point: Whether or not you're certain that the person standing next to you is wearing undergarments or, shall I say, regardless of whether or not the gaze is stolen or offered freely, without social convention there can be no transgressive pleasure.

There's a whole feminist discussion that I'm skimming over here about how a patriarchal, phallocentric society forged our notions of beauty, and about how brassieres and the like were invented by men, and about how their ideals concerning the shape of female anatomy have dictated the fashion and construction of the foundation garments of each age. I will reserve that in-depth discussion for another essay. Suffice it to say that our opinions as a society have indeed been formed and that as enlightened individuals we choose either to participate in the prevalent ideology or to abstain.

I like to think of the many women who have chosen to partake, who enjoy the sensation of wearing sexy lingerie all the time. Not just for show and not just for sex, concealed deep beneath the folds of her outer apparel, lacy things lie in wait. For those women, lacy secrets help stimulate the anticipation that at any moment unexpected and exhilarating things could happen. Whether or not those things actually do happen, one thing is certain: Feeling desirable is just as important, if not more important, than feeling desired. One's self-esteem governs comportment, and it is comportment that telegraphs appeal to prospective mates. And that brings us full circle back to Victoria and her boyfriend Lance.

In the burgeoning appetites of our adolescence, as well as in the rutting season of our adulthood, confidence reads strength, and strength is a universally sexy thing. Victoria and Lance had power because "cool" resides in the mantle of confidence: the larger the mantle, the greater the appearance of one's dominance.

As we've seen, not only did Lance and Victoria build their self-esteem by borrowing fashion concepts from celebrities like Brad and Angelina-whoever,

they likewise invented their dominance by displaying borrowed self-confidence to their less secure peers. By capitulating to its rules of governance, those peers unwittingly validated both the dominance of the "cool kids," as well as the dictates of popular culture that defined "cool" in the first place. The initially counterfeit confidence of Lance and Victoria was continually reconstructed by the adulation of innocence (read ignorance), which is, by nature, confidence building.

If we allow ourselves to participate in the tyranny of contemporary fashion, we do so bearing the responsibility that comes with knowingly contributing to an age-old structure of oppression, for we are no longer innocent of its propagation but, like the courtesan, we are complicit.

My mother used to tell me that the reason popular kids modeled themselves after the fashions of the day, and then ridiculed those of us who didn't was because they were insecure in their personhood and just too lazy to think for themselves. I guess Victoria and I weren't so different after all.

So, always remember and please never forget that *underwear is the foundation of fashion,* not only because it contours our anatomy, but also because it supports our sense of self in those spaces where our nakedness is inevitable.

NOTES:

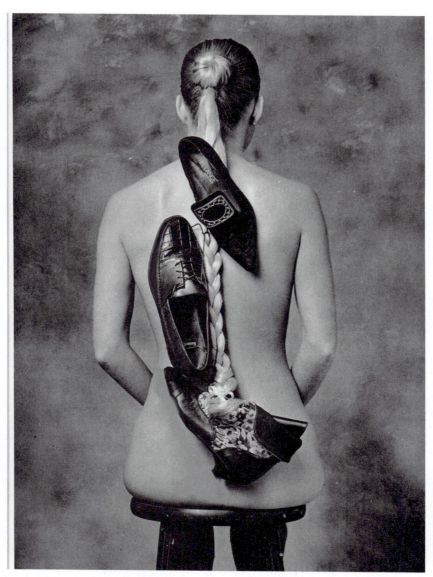

Shoe Cascade. (Courtesy of James Stiles)

The Light Fantastic

Paul Vangelisti

Collage: definition

In these moments before the rhythm find you
Slip into sheer pleasure and outlast the day.
"Please," you say, "let's leave sex to the angel,"
tossing your hat to him across the room.
Waiting for a look or anything trippingly
out the door, oh yeah, you've got attitude.
and the cool now to kick it up a notch or two,
Caramel or black suede awakening,
what's more perfect than your pale step (shown,
easy circles filled with whispers, dreamy spheres
of chants, sophisticated, yet natural.
A babe in the woods, you think in the mirror,
beautiful, strong and rather brilliant,
but is outerwear the utmost assure?
Are the feet directed, the getaway
sure enough to feel the end of your body
sink right into something sensational?
Who says you stop playing with the display?
An enlightening way to heal the mind,
chance like change eases fickle aging
one step at a time, one sheer arch to will,
one fine glance of tossing hair and shoulders
pivoting your transport to that exotic land.
End your indulgence on the sweetest note;
transformations, leather on skin, assure
a lingering embrace of salty ocean night.

Lisa and Joseph Spahn, June 22, 2002. (Photo: Courtesy of Ray Ballard)

Part V Feminine Icons

Debutante and her parents, June Ball, 1993. (Photo: David Balfour Photography)

Iconically Yours

Parme Giuntini

In the fall of 1976, *Charlie's Angels* debuted on American television amid a blitz of publicity. One of the first shows to feature action-oriented female heroines, the series was also a showcase for Farrah Fawcett, whose voluptuous body, perennially tanned skin, and mane of golden hair almost immediately secured iconic status for the actress. The "Farrah phenomenon," as it was dubbed, swept across the nation as millions of young American women rushed to beauty salons in search of the "Farrah cut." Coinciding with the increasing influence of feminism, Fawcett embodied a new female ideal in a prize-winning combination that meshed beauty, athletic ability, and independence with a sexual appeal that was both virginal and erotic. Although not the first identifiable female icon—arguably, the list stretches back to include such historical figures as the Virgin Mary and Georgiana, the Duchess of Devonshire, whose taste, wit, and fashion sense captivated upper-class English society in the 1780s—Fawcett joined an elite group of women whose influence on popular culture attained nearly cult status. Spurred by an unassailable public desire for the new, the "Fawcett phenomenon" was fueled by widespread and consistent visibility; through the 1980s, her image was ubiquitous in film, television, magazines, newspapers, advertisements, posters, and promotions, even toys.

The charismatic power of any iconic figure ensures the ability to attract and maintain a following and establish a cultural presence with sufficient influence to shape public taste. Historically, men accomplished this through well-publicized feats of personal daring, political power, and, more recently, athletic prowess, but iconic status for women has typically been grounded on beauty, sexual allure, and fashion, giving the edge to actresses and celebrities. Although Dorothy Hamill's 1976 Olympic performance at Innsbruck and subsequent career with the Ice Capades ensured media attention, even establishing a rage for her signature wedge haircut, she offers little sustained competition with figures such as Jackie Kennedy, who cemented the image of a youthful Democratic administration with her costume pearls, high-fashion wardrobe, and pillbox hats, or Audrey Hepburn, whose portrayal of Holly Golightly in the 1961 film *Breakfast at Tiffany's* permanently linked female allure with "the little black dress."

Given the close association of fashion with female allure, romantic success, and sexual prowess, it is not surprising that specific categories of female dress have achieved iconic status themselves, such as elegant lingerie, evening wear, and wedding gowns. As Jeanne Willette notes in her essay, a film or television heroine may achieve blissful love in nondescript dress but

generally at the price of female subordination.[1] Female power can be inscribed in jeans, severely tailored suits or, as Miranda Banks explains in her essay on Wonder Woman, a gold breastplate and blue satin shorts.[2] However, the general public is culturally trained to expect that romantic transformative moments or events be accompanied by the kind of iconic garb that signals success. The satisfaction that audiences feel when watching that transformation is critical since it usually signifies not only specific cultural expectations, but also taps into personal experiences that for most is limited and, therefore, all the more precious.

For the average American woman, wearing glamorous evening clothes is an opportunity limited to two or three momentous occasions: high school proms, debutante balls, and weddings, a *quinceanera* celebration if she is Latino or a bat mitzvah if she is Jewish. The situation is somewhat different for the rich and the famous. The former have never relinquished the requisite social calendar of opera openings, black tie benefits, and charity balls offering ample lifetime opportunities to indulge in fantasy "dress up" gowns. Celebrities have it even better, especially the young, the thin, and the beautiful. Their popularity and public visibility guarantee the scrutiny of television cameras and fashion commentators anxious to see who wears what. As a result, even the most prestigious designers willingly lend or give celebrities original gowns for Oscar and Emmy nights. This practice dates back to the early twentieth century when the first couturiers, such as Paul Poiret, dressed models in their latest designs and sent them off to the races at Longchamps or opening night at the theater.[3]

The postmodern American penchant for casual dressing that permeates contemporary fashion and culture further contributes to diminished opportunities for formal evening dress. Apart from gala parties for opening nights that target an elite membership, typical dress for stage shows and operas is hardly distinguishable from Saturday night at the local movie theater. Even restaurants that still insist on coats and ties for men find it impossible to circumscribe parallel guidelines for women. This abandonment of strict dress codes for more flexible approaches has further limited the opportunities for many women to wear special occasion clothing.[4] Not surprisingly, designers

[1] Jeanne Willette, "What to Wear When Falling: A Girls' Guide to Fashions of Failure or How to Lose Success and Gain a Man," *Garb*, 353–364.

[2] Miranda Banks, "Red, White, and Breastplates: Clothing a Superhero," *Garb*, 345.

[3] Nancy J. Troy, *Couture Culture: A Study in Modern Art and Fashion* (Cambridge, MA: MIT Press, 2002), 84.

[4] The corporate world is one barometer for dress codes. Both general and business etiquette books now emphasize awareness of individual office or corporate dress preferences, rather than assume a generic preference for the standard business suit. These preferences can be categorized somewhat regionally. Typically, corporations in Eastern and Midwestern states favor more traditional standards, while the Western states tend toward relaxed dress. As an example, with the exception of private clubs that still generally mandate dress codes for formal dining areas, very few restaurants in Southern California insist that men wear ties and jackets.

today frequently incorporate luxury fabrics and evening accents into daytime fashions; women are apt to wear satin blouses with their jeans, team lavishly lace-trimmed or sheer blouses with business suits, and lunch in summer dresses that are often strapless or backless. Ironically, while the protocol governing evening clothes has become much less stringent, manufacturing technology and synthetic textiles have made once expensive luxury fabrics such as silk, satin, chiffon, and organza more affordable to mass markets.[5]

Given the paucity of opportunities for most women to forgo their working attire or weekend jeans or sweats for something long, beaded, satin, or décolleté, it is hardly surprising that so many of them jump at the few chances they have to wear elegant clothes. Regardless of their significance as female rites of passage and in the case of weddings as legal and sacred commitments, these events are defining moments for most women in which dress, glamour, sexual desirability, and female identity are irretrievably fused. The entire dress-buying process, for brides in particular, is dominated by a discourse of transformation. Women are urged to select the gown that makes them "feel like a princess," reminded that there are no rules governing acceptable styles, and assured that no one will outshine them.[6] Fueling the entire process is the recognition that this is the ultimate Cinderella moment, a literally material transformation, and their last chance to indulge in glamorous dressing.

While prom dresses can be passed on, shared among friends, or taken to college, wedding gowns are often memorabilia by the morning after. Brides are advised to clean and permanently store their gowns, immediately transforming wedding attire into artifact. Hermetically sealed in quilted cases with small plastic viewing windows, the gowns are tucked into attics, high shelves, or slipped under the bed, remaining fully visible only in photographs and albums that document their brief moment of glory. On the one hand, such ritual attention has become rather unquestioned; it is after all "the dress." Permanent preservation not only reifies the gown's personal significance, but also removes it from the wider sphere of cultural production, a most desirable choice from the industry's position. On the other hand, it remains the antithesis of normal clothing behavior in which we justify the most expensive purchases by promising to wear them often, at least more than once.

I last wore a glamorous gown over a decade ago, to a debutante ball— which itself sounds far removed from ordinary life and experience, but then,

[5] This trend is especially noticeable in custom-made clothing. Many bridal designers and manufacturers offer gowns in various fabrics ranging from expensive silks to polyester blends. For a more in-depth examination of the modern history of textile manufacturing, exportation, and consequences on luxury fabrics, see A. J. H. Latham and Heita Kawakatus, eds., *Asia-Pacific Dynamism, 1550–2000,* (London: Routledge-Curzon, 2000).

[6] The exception being for very conservative religious sects such as Orthodox Judaism, in which brides must have shoulders and arms covered. Even churches that request modest gowns have recognized the pervasive influence of fashion, especially in the past decade when strapless gowns have become so popular.

that's the point of wearing a gown, isn't it? Dressed in a black and gold strapless, full-skirted net confection, for which I felt compelled to buy black elbow-length gloves to get the full effect, I literally drifted through the evening with the only reminder of reality being somewhat sore feet from rather high heels. The gown is long since packed away—and impossibly out of style. But like those wedding and prom dresses, it remains eternally present in formal photographs, a silent testimony to notions of elegance and feminine allure that defy any critiques of postmodern culture or feminist theory.

For a postmodern society, glamorous evening attire is often fantasy dress, running the gamut from elegant gowns that could slip into an antebellum party as easily as dogwood to fetishistic styles that would be comfortable in a dominatrix's closet. This kind of dressing up need not be about good taste or appropriate styles. The allure is the potential for a momentary respite from the mundane and quotidian, and given the opportunity, most women find it hard to resist. Such high-volume magazines as *W, Town & Country, Vogue, Elle,* and *Cosmopolitan* regularly feature the well-dressed rich and socially registered at evening events. Even more influential is the media coverage of high-fashion runway shows and celebrity showings at Oscar and Emmy nights. These red carpet events are as hotly anticipated for the glimpses of Hollywood haute couture as the awards themselves. They offer millions of television viewers the opportunity to gape at the extremes of evening wear ranging from Julien Macdonald's millennial designs to the 2005 Oscar obsession with satin and trains.[7]

Who needs those kinds of dresses anyway? They were expensive to buy and clean, generally required additional purchases of constricting foundation garments and special shoes, and were not necessarily designed for comfort, as any woman who has spent more than thirty minutes in a beaded gown and a chair can tell you. Not only that: Every formal gown inherently trails the added burdens of class distinction and gendered femininity—they may be attached by a thread, but their presence is palpable. With the postmodern mantra of individuality, comfort, and casual clothing comes the ostensible freedom from styles and standards that rigidly designated class and gender. Ironically, along with that freedom comes the undeniable elevation and romanticization of formal dress. The entire process of consumption, display, and documentation of formal dress has become ritualized, if not fetishized. Eliminating the necessity of formal dress has failed to diminish its allure, its importance, or its economic viability as the twin bridal and prom gown industries so vibrantly demonstrate. Women may be wearing jeans out to dinner, but a lot of them still have silk and satin on the mind.

[7] Fashion and commerce have always been closely entwined, and celebrity promotion and associations with design houses and name brands have become fairly commonplace. Dolce & Gabbana outfitted 'N Sync and Dido for their 2001 tours and Austrialian pop star Kylie Minogue in 2002. Halston has dressed Mariah Carey for her tours, and Tommy Hilfiger sponsored Britney Spears's 1999 summer tour. Television shows like *Sex in the City* made high-end designers such as Manolo Blahnik familiar globally. See Michelle Lee, *Fashion Victim: Our Love-Hate Relationship with Dressing, Shopping, and the Cost of Style* (New York: Broadway Books, 2003).

NOTES:

Justin Kelly and Adrina Madatyan, Prom night, 2001. (Photo: Courtesy of Kathryn Hagen)

Prom Dreams/Prom Dresses

Parme Giuntini

It was a slim, spaghetti strapped, white silk organza number lovingly made by Mom, a most exacting seamstress who zipped me into the dress and then stitched on the straps to make sure that they were snug. Adorned with crystal drop earrings and a white cashmere pearl-dotted shawl that she lent me for the evening, I felt the height of sophistication, as far removed from my brown blazer and plaid box-pleated uniform skirt as a girl can get. Not only was I glamour personified, but that dress also met the rather specific criteria that the good nuns at my school demanded: It was not black, not strapless, not décolleté in the front nor too bare in the back.

Parme Giuntini

A familiar, almost cliché, event occurs regularly every spring at high schools throughout the United States. Young women whose customary attire is jeans and miniskirts, who blank out at the phrase *formal dress* and associate gloves with baseball, transform themselves into temporary teenage goddesses in long gowns, upswept hairstyles, glittery jewelry, and high heels. They cautiously wobble down stairs, across living rooms and foyers, to the admiring glances of their families who record the phenomenon in still or video form. Then they waft out the door with their tuxedoed escorts into cars or limos, to be whisked off for that quintessential American teenage rite of passage: prom night.

The term *prom,* derived from the word *promenade* and the sixteenth-century English practice of leisurely strolling in public for the purpose of being seen, has been understood by Americans to mean a high school formal ball or dance since the 1930s when American yearbooks began covering proms.[1] These events offered an egalitarian option to middle-class teenagers who were generally excluded from debutante balls, a rite of passage wealthy Americans also adopted from late nineteenth-century Europe, in which young women were formally introduced into adult society and displayed to eligible bachelors. Proms also gave teenagers who were not college bound an opportunity to participate in adult formal social activities, including the

[1] Karal Ann Marling, *Rites and Regalia of American Debdom* (Lawrence: University Press of Kansas, 2004), 172.

requisite rituals of special clothing, invitations, and flowers.[2] By the 1950s, the popularity of proms was firmly established in the United States. In most high schools, proms were the culminating social event, so prevalent that, while attendance diminished during the challenges of 1960s counterculture and antiwar movements, proms reemerged in the late 1970s as even more a fixture of mainstream youth culture.[3]

High school activities such as varsity sports, cheerleading, or skill-specific clubs typically prioritize a small group of students as primary performers. Proms, however, are promoted as schoolwide events, championed for their egalitarian inclusiveness and frequently described as quintessentially teenage rites of passage despite evidence that they often succeed in fragmenting, rather than cementing, student solidarity.[4] This promotion occurs in a variety of ways, from parents nostalgically recalling their own prom nights to films, advertisements, videos, and television shows all conveying the same message: Prom is the most momentous night of your life.[5]

Like the youth culture in which the event is embedded, proms are remarkably resilient and adaptable to changing circumstances, trends, and attitudes. In schools where racial tensions threaten to fragment the social environment, minority students have opted for alternative proms. Increasing costs for formal clothes, limousines, prom bids, and post-prom parties have propelled students into part-time jobs and, in some cases, into organizing fund-raisers. Even such traditional customs as electing a prom king and queen, traditionally framed as the most popular and attractive heterosexual high-profile seniors, have been successfully challenged by gay and lesbian students. Consequently, proms remain the outward signifiers of success despite being internally flawed.[6]

What has remained consistently critical to the event is its insistence on formal attire, and in the youth culture of postmodern America that translates readily into fantasy attire and high-fashion allure. While males, too, have responded to style changes in formal dress, most particularly shifting from the traditional tuxedo to edgier looks that include band-collar shirts, colored shirts and accessories, vests, or even morning dress or tails complete with top hat and walking stick, the focus of prom fashion and the industry itself is the female.

[2] Amy L. Best, *Prom Night: Youth, Schools, and Popular Culture* (London: Routledge, 2000), 6.

[3] *Ibid.*, 8.

[4] *Ibid.*, 21.

[5] *Ibid.*, 19. Since the 1980s proms have been a recurring theme in films, videos, and television shows. Whether the intention is to depict the prom as a positive teenage experience or to use it as the context for teenage tensions, problems, or humorous escapades, its prevalence in mass media has significantly contributed to how teenagers envision prom night.

[6] Alan Richard, "Alternative Proms Gain in Popularity," *Education Week,* vol. 23, no. 37, May 19, 2004, 1, 2.

Currently proms and prom dresses are part of a vastly expanded industry assisted by Web sites, magazines, and professional planners. Although both genders attend the actual event, the popular construction of the prom is a gendered narrative, almost always told through a female voice and involving a transformation that is fundamentally mapped through her body.[7] The message is communicated relentlessly in special prom publications, such as *TeenPROM* and *Prom Guide*, which hit the newsstands in early spring; seasonal articles in traditional teen-focused magazines such as *Seventeen;* and countless websites that offer detailed advice on every aspect of prom ritual. Much like the rhetoric around weddings and bridal dresses, proms are also framed as a once-in-a-lifetime event, a rite of passage, the "Cinderella Moment." A successful prom night is predicated on finding the right dress, the prime component in the transformative process. Everything stems from *the dress*, including what your date may or may not be able to wear since men, even teenage ones, can no longer be trusted to turn up wearing the obligatory black tuxedo. According to *Prom Magazine*'s 2004 reader survey, the average teenage girl will try on twenty-three gowns before making her choice, spending an average of $214—pocket money to a few but a significant chunk of change to most. Adding on the expenses of hair, makeup, shoes, and jewelry can bump up the total expenditure for Cinderella several hundred dollars. To circumvent the ultimate prom dress disaster, some stores now require customers to register each dress and school and, in some cases, have refused to sell an identical dress to another girl attending the same prom. Web shopping, custom-designed gowns, borrowing, and vintage gowns expand the scope of choices and extend prom dress shopping beyond department stores and malls, reinforcing a female consumer ritual that for most young women is at least as important as the event itself.

Prom dresses have always mimicked the styles of adult high fashion, but trends have shifted in response to more overarching fashion trajectories and the growing preferences and influence of youth culture in general. Teenagers in the 1950s wore the same full-skirted strapless styles as their mothers, complete with boning and voluminous crinolines that rigidly shaped the body in yards of protective taffeta and netting. By contrast, prom gowns from the 1990s on have mirrored the contemporary interest in easy construction, fluid fabrics, and maximum exposure—not necessarily the gown your mother would wear. Like the corresponding late twentieth-century obsession with youth, diet, exercise, and physical perfection, these gowns are far more body conscious, the styles more revealing and less dependent on undergarments that artificially shape and mold. Could a typical mom slip into one and dance the night away? Given the national statistics for adult obesity, the increasing preference for casual dress, and the growing singularity of youth fashion, the answer is probably not. Mom's last formal occasion was her wedding, she's thirty pounds heavier, and prom dresses, like proms, are for the young. Consequently, the fashion baton has been wrenched away from mothers and thrown to popular young

[7] Amy L. Best, *Prom Night*, 35.

celebrities and teen models with high visibility in film, television, and fashion magazines. Savvy designers such as Allen B. Schwartz of A.B.S. have established high-profile and profitable collections by offering copies of the most popular celebrity Oscar gowns within weeks of their televised appearances on the red carpet—just in time for the spring prom gown buying frenzy.[8]

Perhaps the single most critical feature about proms in recent years, and consequently the most debated issue, is the implicit sexual activity associated with the event, especially with proms and the loss of virginity. Arguably, this has always been an ad hoc event; certainly boned bodices, merry widow bras, defensive crinolines, and stiff netting never stopped a determined couple in the 1950s. However, proms have shifted from formal high school dances held in crepe-paper–hung gyms or the local church hall into lavishly decorated parties booked into downtown hotels or cruise ships and often followed by all-night postprom parties. Prom-associated decorations, entertainment, food, clothes, and transportation have become increasingly more expensive, glamorous, and sophisticated, and those concerns have permeated contemporary culture, primarily through films, videos, and television. Inevitably, the onslaught of this visual culture has reframed prom expectations, behavior, and female prom fashion.

Capitalizing on the increasingly accepted sexualization of teen culture since the 1950s, the entertainment industry has provided American audiences with films and television series that often exploit the prom as a critical rite of passage toward adult sexuality. Within the narrative of pop culture, the significance of fashion cannot be underestimated, since dress is critical to the depiction of these fictional film and television characters, especially those who become household names because of their popularity with American audiences. Television kicked it off with the enormously popular series *90210,* meshing middle-class teenage behavior with Beverly Hills allure, and *Dawson's Landing,* which followed the exploits of small-town teenagers, while the raucous film, *American Pie,* focused on the determined sexual efforts of prom-bound teens. More current television shows, such as *One Tree Hill* and *The OC,* continue the visual chronicling of American teenage life, which typically includes a sexually charged prom scenario featuring a fashionably dressed and physically arresting cast.[9] Films such as *She's All That* and *Never Been Kissed* have specifically focused on the visual transformation of young women that culminated with prom night.[10] Like teenage Pygmalions, the lead characters were shifted from stereotypical teenage outsiders—often characterized by unfashionable clothing, eyeglasses, and awkward behavior—into elegant, sophisticated women, appearing on prom

[8] "Oscar Dress Knock-Offs and More," *The Early Show,* March 2, 2005. Retrieved at August 3, 2005 www.cbsnews.com/stories/2005/03/02/earlyshow/living/beauty/main677562.shtml.

[9] Amy L. Best, *Prom Night,* 20.

[10] *Ibid.,* 35.

night in glamorous, sexy gowns that communicated essential change through style.

Prom fashion has kept apace. Plunging necklines, sheer inserts, extreme slits, backless designs, and—most alarming for some parents—gowns with little or no built-in foundation, or need for them, have dominated teenage evening wear for nearly a decade. Along with the virtual abandonment of panty hose and the continuing trend for high-heel slides and open-toe shoes, it is reasonable to estimate that thousands of young women dance prom night away wearing little more than a thong underneath a clingy satin gown. For the most adventurous, two-piece prom styles expose the midriff and drop below the navel, one-piece designs feature transparent inserts that offer their wearers an opportunity to display this new erogenous zone, and some gowns lace up the back or sides to reveal generous amounts of skin while fairly screaming their associations with lingerie and corsets. Remarkably, the virtual difference between a prom gown and a high-quality nightgown can be as little as a transparent bodice, a zipper, and a slightly heavier grade of satin.

Not every prom-bound girl opts for the most erotic look, a fact established in the past few years as a growing conservative teenage population has persistently championed stylish but more modest designs. Nevertheless, the prom gown cause celebre for 2005 was #376, a black two-piece design by Xcite that combined a deeply V-necked bikini top with a low-rise floor length skirt. Dubbed the "It Dress," the style had already sold over a thousand dresses before it gained widespread notoriety through appearances on *Fox News, The Today Show,* and *Entertainment Tonight.* In newspaper accounts about the dress, interviewees commented on its inappropriateness for prom nights, and even store owners who stocked Xcite designs were quick to say that #376 was not one of their selections.

In some ways the commotion over such extreme prom styles echoes earlier fashion tempests around miniskirts, tight sweaters, high-rise tops, and low-rise pants. Always the testing grounds for extreme styles, public high schools have generally been successful in establishing student dress codes for campus and academic events. Proms, however, most definitely fall into the nonacademic category, and given the expense, anticipation, and emotional investment that they involve, many administrations are hesitant to specifically define unacceptable fashions, preferring to defer to parental discretion and the hope that students will follow common-sense rules and community tastes rather than risk public embarrassment. Private and religious high schools can and often do set firm guidelines for prom gowns, but few public high school principals were as willing as Kathy Carlton to set down a prom dress code that forbids the "too low or two piece," even going so far as to identify acceptable prom gown websites and to preview gowns for acceptability.[11]

[11] Candy Williams and Carla DiDefano, "Many Prom Goers Favor Elegant Over Risque," *Pittsburgh, Tribune Review*, Retrieved August 12, 2005. www. pittsburghlive. com/x/pittsburghtrib/5_314529.html.

It's early spring as I write this. Prom fever is in the air. Prom dresses are a hot topic in magazines, stores, and on the Internet. Millions of young American women in a multiplicity of shapes, sizes, races, and ethnicities are actively engaged in the search for the perfect dress. For some of them, that final choice will undoubtedly create a buzz, but then, that was probably the idea. For all of them, the process is a daunting series of options, considerations, and consequences structured around a dress that is already laden with gendered and cultural expectations, and all intentions culminate in an evening of self-presentation and public display.

NOTES:

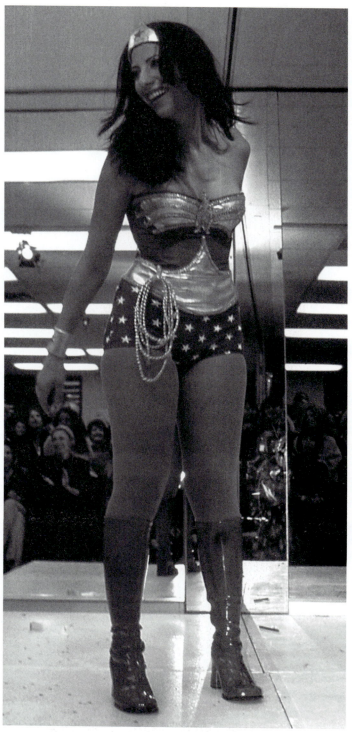

Otis College of Art and Design student in Wonder Woman costume.
(Photo: Courtesy of Otis College of Art and Design)

Red, White, and Breastplates: Clothing a Superhero

Miranda Banks

There may be no more iconic example of the heroic working woman than Wonder Woman. While there are plenty of other hard-working, heroic women one might consider, both real and fictional—from Mother Theresa, to Minnie Mouse, to Melanie Griffith in *Working Girl,* to Hillary Clinton, to pop singer Madonna, to Rosie the Riveter, to Oprah—no other working girl is as instantly recognizable. That is in part because when she is on the job—the job of fighting evil—Wonder Woman wears a specific costume designed with the intention of making her immediately identifiable, to stand out from a crowd, even from a distance. Wonder Woman, first as a comic book heroine in the 1940s, but most importantly as a television heroine in the 1970s, defined female on-the-job superheroism.

With few exceptions, in particular the Bionic Woman's sweat suit and the Powerpuff Girls' monochromatic frocks, superheroines prefer tight-fitting clothing so they can move easily as they perform their action-oriented daily duties, while their audiences enjoy seeing the full extension of their bodies in motion. Wonder Woman's voluptuous, statuesque, powerful body packed into her brightly colored, gilded costume is constantly in motion, working to save the day. But this is only one of her costumes—and only part of her job. Wonder Woman has a dual identity: She is also Yeoman Diana Prince, a shy, austere, bespectacled naval secretary in the U.S. military. In both roles, she is a woman working for freedom, justice, and the American way.

Often in the analysis of film, television, or even comic books, the focus is placed on the narrative. Yet in the case of Wonder Woman, it is the image, the icon, that is most significant in the creation and the celebration of her as a heroine, rather than any particular story or plotline associated with her character. In the case of a comic-book-turned-television heroine, a dedicated fan base can grow simply from the look of the character rather than the quality of the narrative. Through a detailed analysis of her costume, it becomes clear that it is her costume that is iconic and has made Wonder Woman the standard-bearer of the ideal working-woman-as-superhero. Over the course of the past sixty years, Wonder Woman's costume has defined her character and has become the key to the selling of her unique brand of superwoman heroism. After considering an overview of Wonder Woman's origins and comic book history, one can then see both

how Wonder Woman is a character defined by the contradictions inherent in her costume and that it is precisely her ease in embodying these contradictions that make her such a compelling icon of a successful, heroic career woman.

Wonder Woman's first appearance was as a comic book character. *Wonder Woman* was created by Dr. William Moulton Marston, an educational consultant for DC Comics, who felt that girls needed to have a strong female archetype who had

> all the allure of an attractive woman but with the strength also of a powerful man. Frankly Wonder Woman is psychological propaganda for the type of woman who should, I believe, rule the world (Daniels, 22).[1]

Wonder Woman fights crime and evil without using guns: As a true superhero, her power comes from within. Like all citizens of her homeland, Paradise Island, Wonder Woman was born with superstrength; but as princess and heir to the throne she, like her mother, was destined to be a benevolent leader of her all-female Amazon community. Called to service at the dawn of World War II, Wonder Woman left her idyllic island to work for justice, liberty, and, most importantly, the American military in its fight against fascism. She debuted as a character in *All Star Comics,* Volume 8, the December 1941–January 1942 issue. The story of her origins was told a month later in *Sensation Comics,* Volume 1. By the summer of 1942, she had her own self-titled comic book series and was named secretary of the Justice Society, later known as the Justice League of Superheroes. While there were a number of superheroines before her, including Hawkgirl and the Red Tornado in comics and the Woman in Red and Miss Fury in newspaper comic strips, Wonder Woman was the first heroine to gain a wide readership.

By the time Lynda Carter appeared on television in 1976 as the famed superheroine, the character Wonder Woman was already a household name: She was visible in comic books, in toy stores, and in the cultural vernacular. In fact, *Wonder Woman* the television show was an ancillary market for DC Comics; the series was just one of many venues through which the company sold its product. So while the television program only lasted for three seasons and the series was a spin-off of the comic book, its cultural and social resonance has lasted for thirty years. The television series, both through its original distribution into millions of households in the 1970s and after years of syndication and reruns, has become the most popular incarnation of the superhero. Lynda Carter is still considered the one and only actor associated with Wonder Woman. While this may change soon with the coming of *Buffy the Vampire Slayer* creator Joss Whedon's film version of *Wonder Woman,* as of now it is the television program that has set the visual standard for this working woman. For the purpose of this essay, I will focus on the television

[1] Les Daniels. *Wonder Woman Collector's Edition: The Golden Age of the Amazon Princess.* Masterpiece Edition. (San Francisco: Chronicle Books, 2001), 22.

program *Wonder Woman,* in particular its first season, which, like the original comic strip, was set during World War II. My reasons are twofold: It is the television series that has been most available for wide cultural consumption, and it is only on the television program that an actual woman wearing the Wonder Woman costume materializes in the eyes of audiences.

Wonder Woman's costumes have changed quite radically over the course of her sixty years, yet there are two that are most commonly associated with her, namely her uniform as a secretary working in the United States Military Intelligence Agency and her superhero costume. In one, she is disguised by her plebeian ordinariness, her democratic uniformity and belonging, and the complete masking of her body; in the other, she is designed to be looked at, admired, feared as someone different, unique. There are similarities, though. Her body does stay the same: neither muscular nor soft. And yet, as is seen in Wonder Woman's transformation, the contradictions between what is expected and how Wonder Woman is dressed begin. In her book *Tough Girls: Women Warriors and Wonder Women in Popular Culture,* Sherrie A. Inness contends that the heroine's clothing defines her as tough, and therefore, more masculine:

> Clothing is an important element in the performance of toughness because it serves as a visual reminder that a woman has distanced herself from femininity. Masculine clothing also suggests a woman's capacity for action and leadership.[2]

Yet in her spinning transformation from Diana Prince into a superheroine, Wonder Woman does precisely the opposite: She becomes both more powerful and more feminine. As Yeoman Diana Prince, her body is masked by her dark blue military uniform, which is almost designed to make her sexless. As a superhero, Wonder Woman's costume emphasizes the awe-inspiring curvature of her body.

In theory, both of Wonder Woman's outfits are designed for battle: One is a military uniform, and the other is a costume designed to wear while fighting. Interestingly, though, Wonder Woman's military uniform is not as flexible or as combat ready as her skimpy superhero costume. According to Paul Fussell in his book *Uniforms,* clothing designed for battle should be impenetrable and express confidence, efficiency, and control. It should force the body into an erect position, thereby making the wearer look powerful:

> The shape delineated by the [military] uniform is that of an ideal combatant—athletic, obedient, wonderfully self-controlled, tightly focused, with no looseness or indication of comfort.... The [military] uniform was made to stand up straight in, and its full meaning is not available when the wearer is sitting down.[3]

[2] Sherrie A. Inness. *Tough Girls: Women Warriors and Wonder Women in Popular Culture.* (Philadelphia: University of Pennsylvania Press, 1998), 25.

[3] Paul Fussell. *Uniforms.* (Boston: Houghton Mifflin, 2002), 14.

In her job as naval secretary, Diana Prince wears military attire, which implies a role of power and physical ability, yet it is a uniform that would never work in her favor in a military operation. Buttoned tightly up to her collar in a thick, inflexible jacket, unable to move her legs freely in her pencil skirt, she looks controlled and focused but not at all ready for battle. Rather, in her role as Diana Prince she sits demurely, if somewhat uncomfortably, behind her desk, or she stands behind her boss. Far from battle ready or athletic, she looks merely obedient and passive. With her enormous horn-rim spectacles, severe bun, and notepad in hand, Diana Prince was created as a cover that would be unremarkable. Her sartorial conservatism positions her as common and, therefore, forgettable—the perfect alter ego for a superhero.

In comparison, Wonder Woman's costume is unique. It is designed to be looked at and to express everything from strength, power, and, without complication, complete femininity. In her costume, Wonder Woman leaps over buildings, lassos villains, hurls missiles, lifts cars, and rarely stops running. Notably, though, Wonder Woman never sits down—except when she flies in her airplane, something viewers see only from a distance. Otherwise, the stiff structure of her costume looks as if it would not comfortably allow its wearer to find a relaxed seated position. While outrageous in its significantly reduced garment volume that exposes so much of Wonder Woman's body, the costume is surprisingly combat friendly and color blocked to visually reinforce her allegiance to the United States. In the pilot episode of the series, Wonder Woman's mother, Queen Hyppolyte (played by Cloris Leachman), gives her daughter the costume that she has designed for her, explaining its symbolic significations. "The colors were chosen to show your allegiance to freedom and democracy. The skirt can be discarded it if should prove cumbersome. The material is indestructible." Yet an even closer examination of this costume yields further significations.

The contradictions inherent in Wonder Woman's costume and her blithe composure as she wears it, arguably are what define her character. She is both extraordinarily powerful and hypersexualized: For Wonder Woman, this is not a contradiction or even a complication. In her tight-fitting red satin bustier intricately adorned with a golden eagle, star-studded blue and white satin shorts, and her knee-high, high-heeled red boots, Wonder Woman is an awe-inspiring spectacle. Since Wonder Woman never performed any feats of daring without her costume on, it has been assumed that it is the clothes themselves that make the Woman. As Susan Douglas says in *Where the Girls Are:*

> Once she was in this outfit, there was nothing she couldn't do. She stopped tanks with her bare hands, snapped assault rifles in two as if they were toothpicks, lifted up trucks, hurled bad guys though the air, and leaped tall buildings in a single bound—all in her red spikes. . . . At the same time that Wonder Woman's breasts seemed poised to burst forth from their Playboy bunny-type container, Wonder Woman reasoned calmly with Steve about

the crime in question and gave him ideas, suggestions, and solutions for how to foil the bad guys.[4]

Wonder Woman's costume is a fantastical, sexual container for her extraordinary body. Encased in her red and gold breastplate, Wonder Woman's breasts are visually highlighted, just as her snug-fitting shorts emphasize the curvature of her hips and expose the entire length of her thigh—and yet, she moves so comfortably in her costume that she is completely unfocused on her own sexuality or sexual attractiveness. She is only focused on the task at hand. Her breastplate both highlights her ample cleavage and, at the same time, exposes her broad shoulders, making her both sexy and dignified, feminine and powerful.

With no room in her costume to hold on-the-job weaponry, Wonder Woman's accessories bridge the gap between fashion and function. Her golden lasso matches the golden brocade of a military officer's uniform. As well, its circular shape hanging on her front hip emphasises that her weapons, like her power, are inherently female. Her bullet-deflecting bracelets were formed from a metal found only on her native island: In the comic book, it was called *amazonium;* on the television series it was called *feminum*. Either way, this metal is defined, as well, by its intrinsic female power. These bracelets are fashionable, functional, and suggestively sexual, in part alluding to her power as a potential dominatrix. And yet Wonder Woman is inherently good and ultimately asexual.

Wonder Woman is most often classified as a superhero, not as a careerist, and never as a wife or mother. While Diana Prince may pine for Major Steve Trevor, Wonder Woman never lingers long enough for Steve to even ask her out on a date. Wonder Woman is a single girl with no boyfriend, no husband, and no children, yet she has more in common with the average American working woman than one might at first assume. Not only is Wonder Woman an American working woman, but the modern American woman is, in fact, expected to be a veritable superhero. Much as *Wonder Woman* stood out as the only girl-oriented superhero comic book at its inception, so too did the heroine in the male-dominated field of comic book heroes. She was the first female in a traditionally male genre and a young woman holding down three jobs, trying to bridge the gap between the disparate aspects of her personality: royal leader, soldier, and superhero. Interestingly, though, none of these roles places her in a domestic space: She is a woman who inhabits national and international public spaces. Because she is so completely outside the realm of the domestic, she is that much more clearly identifiable as a woman working in a male-dominated world. To be effective in such a patriarchal space would be enough of a challenge, but Wonder Woman is anything but an Everywoman—or is she?

While Wonder Woman was created in 1941, there is good reason why she is still popular after more than sixty years. The prevailing vision of today's

[4] Susan J. Douglas, *Where the Girls Are: Growing Up Female with the Mass Media.* (New York: Times Books, 1995), 216.

American woman is one of a veritable superheroine—able to singlehandedly find success in her career and at home, juggle work, stay fit, and be a capable domestic, comfortable in her womanhood both as a feminist and as feminine. This new representation celebrates the modern woman who effortlessly glides among these different roles not just with ease but with alacrity. Central to this representation of modern womanhood is that having it all—great style, a great house, a great partner—and doing it all—career, family, social life—are in fact simple. Any difficulties she might experience finessing these sometimes contradictory notions of womanhood should not be discussed or even visible to an outside observer. In other words, being successful in all aspects of her life should be as easy for her as it is for Wonder Woman to negotiate the disparate aspects of character with grace and efficacy—while still retaining her femininity. Ruth P. Rubinstein, in her book *Dress Codes: Meanings and Messages in American Culture,* argues that clothing is inextricably linked to gender expectations. Cultural and social value is attached to the definition of character. For Rubinstein, rejection of the traditional gender roles for women is usually achieved, at least in part, by a transformation to a more masculine, or even far less feminine, style of dress.[5] And yet Wonder Woman is both a tough, capable hero and a curvaceous, feminine beauty. She does not have to choose between the two. This can be seen not only in her actions and her success in her job, but this successful slippage between the different aspects of her personality and her work is illustrated as well through her costume.

Besides those aspects of her costume that easily identify her character, there are also commercial reasons for why Wonder Woman survives where other heroines have fallen off the cultural radar—and the toy shelves. More than any of these heroines, and in fact quite literally in her mythology, Wonder Woman is timeless. Not only was she associated with one particular actress (who could grow old over time), but for the first thirty-five years of her existence she also was biologically ageless. As a comic book heroine, she has lasted on and off for sixty years. In 1972, she was adopted as a feminist role model when she appeared on the cover of *Ms. Magazine*'s inaugural issue. The television series *Wonder Woman* lasted three years and was lucrative, but ultimately the audience was not there. Yet Wonder Woman lives on: *Wonder Woman* reappeared on television in the animated program *The Justice League,* an updated version of the 1970s *Super Friends.* In 2000, gossip spread that Catherine Zeta-Jones was interested in playing her in a cinematic adaptation—the same year that another megastar played this heroine.[6] Her

[5] Ruth P. Rubinstein *Dress Codes: Meanings and Messages in American Culture.* (Boulder, CO: Westview Press, 1995), p. 99.

[6] Harry Knowles. "Catherine Zeta-Jones as *Wonder Woman*?" Ain't It Cool Web site: *nitti.aintitcool.com/display.cgi?id=5003* January 14, 2000. Retrieved January 13, 2005; Sean L. McCarthy, "We Wonder: Who Will Play Super Woman on Big Screen?" *The Boston Herald,* December 21, 2004, 003.

first plastic incarnation arrived on shelves ten years before the television program aired in 1976, and the latest doll was included as part of a Wonder Woman book set released in 2001. To the delight of many doll fans, the consumption of the body of Wonder Woman achieved a new level when the most popular female doll, and Mattel's greatest working girl, wanted to *become* Wonder Woman, too: In 2000, the toy company released "Barbie as Wonder Woman."[7] Even now, with Wonder Woman coming to cinemas, it is not so much the woman but the wonder of her costume that transforms a working girl into a superhero who delights her fans.

Wonder Woman is the supreme icon not just of the working woman but also of merchandisable heroic femininity. She is a model of the potential for success in the aggressive use of other media outlets as research and design for merchandisable products: Here was a comic book that helped sell a television program and a doll and, over time, vice versa. Not all *Wonder Woman* products have fared well in the marketplace, but the timeless, iconic nature and the broad range of modes available for consumption of the character have worked in their favor. The potential for financial profit is extremely compelling for toy manufacturers, film and television producers, publishers, game manufacturers, and the like, if they can all work together: A pretested product that already has a strong fan base is a much safer option than an unknown, unbranded character. Ultimately, while in fiction she may work to save the world from violence and tyranny, in today's marketplace Wonder Woman's most important job is selling herself.

[7] Les Daniels. *Wonder Woman Collector's Edition,* 179.

Falling . . . (Illustration: Kathryn Hagen)

What to Wear When Falling: A Girl's Guide to Fashions of Failure or How to Lose Success and Gain a Man

Jeanne Willette

Male aestheticians from Kant to Reynolds have shunned fashion as a minor detail. As the late Naomi Schor pointed out, the detail is relegated to the female, the feminine, the unnecessary, and the supplementary. Kant relegated detail to the margins of art, to the realm of drapery and of the frame. Besotted with newly discovered classicism, Reynolds painted fashionable women but scorned detail as a form of decorative flourish that was an inessential intrusion into the significant (male) field of the universal and the eternal. Modernist philosophers considered details to be a kind of Rousseauian masturbatory exercise, a guilty excess projecting beyond the essential. But a postmodern Derridian reading of details can reveal not God but significant fragments that mark stages of a narrative. Far from being nonessential and incidental, details, in all their fearful femininity, will be foregrounded in this reexamination of the time-honored fairy tale—that of the *transformed* woman. As in all transformations, this is a visual one, using fashion as a signifying system to tell the story.

The favorite "chick flick" theme of all time is the story of the Transformed Woman, otherwise known as the *makeover*. From *Now Voyager* to *Pretty Woman*, the makeover is historically a story of a woman being raised up from dowdy depths to fashionable heights, making her appear the equal of the male, at least in terms of couture. Since time immemorial, the legends of female alterations have been part of a rich and repetitive oral history that has since been passed down as folklore. Bruno Bettelheim pointed out that folk tales and fairy stories seldom mean what they say. The Cinderella story is a metaphor for female unworthiness in relation to the male, expressed by the abject state of the heroine, whether Cinderella or Eliza Doolittle, who is relegated to the working class and is consigned to the fate of wearing rags. Rags are the ultimate statement of formlessness. As Julia Kristeva pointed out in another context, the woman must always be abject relative to the man. She is deficient and must be adjusted.

Every girl's favorite part of the Cinderella makeover story is the transformation of the servant girl by the sympathetic fairy godmother. With a

wave of a magic wand, the servant is changed from being covered in cinders to a princess in a ball gown. The prince is really incidental, a mere excuse to get dressed up. The persona of Prince Charming is usually a blank slate upon which female readers project their ideal man. The female imagination has been trained to stop at the moment of revelation of worthiness: The foot slides into the glass slipper, too fragile and delicate for her to run in, and she is claimed. From fairy tale to wedding ceremony, a woman is improved through a change of clothes to signify her transfer to another man. The reunited pair lives "happily ever after," not in rags but in royal attire. Lest there be any hint of social climbing and social mobility, the servant is revealed to be truly one of the gentry. The theme of mistaken identity or of being out of one's true place signifies the rightness of the transformation. The down-trodden victim has risen to the occasion, buoyed by her clothes, but she is, in the end, to the manor born. It is important to understand that the old-fashioned Cinderella is of noble birth due to her father's rank and that her position owes nothing to her own abilities. Folk tales and customs predate upwardly mobile capitalism and, as shall be seen, collide with middle-class ambition, especially that of women who want to transform themselves.

The time-honored fantasies of female social elevation through fashion have been transferred from bedtime stories for children to mass media for adult women. The theme of the transformed woman is constantly renewed by magazines, television, and film. In an age of advanced technology, movies have become our own postmodern folklore, the people's art, par excellence. Despite male scorn for the so-called *chick flick,* such films can be highly lucrative, attract a large audience, and impact over half the population—women. Chick flicks are the ideal vehicles for the social training of women in a world that still belongs to men. Aimed at women, these films, never-theless, work for the benefit of men, teaching women that nothing in life is more important than the man. Chick flicks are innocent of the passage of time. Few traces of the Women's Movement can be found, and there is little difference between films made in the 1950s and films made in the 2000s, fifty years later. The fashions for these films will often be caught in a semi-otic time warp, as though purchased in a thrift store for oppressed women.

However, time has passed. Women's liberation did happen, and women entered into the world of men, necessitating a change in the Cinderella story, and not for the better. The basic format has been lifted from old Doris Day films, in which the woman's career is a mere pretext for meeting Prince Charming. It is difficult to sell a fifties format to a twenty-first century woman, and the new version of girl meets boy has to go to scripted convo-lutions to force the woman's abjection deemed necessary for the expected "happy ending." Chick flicks are inverted tales of transformation, based on ancient makeover stories in which the woman in question must be re-created for the sole purpose of becoming what the man wants her to be. Unlike the transcendence of the hero's journey, these are earthbound tales of female transformation through fashion, reinforcing the imbalance of power between the genders. To maintain male power, the chick flick must turn the Cinderella story upside down: The rising woman must fall. These stories of

enforced failure employ what one can call *fall fashion* to connote the woman's plunge into abjection: a riches-to-rags story.

Whatever forms these stories of falling take, they all have elements in common: the fear and dislike of men for women and the need to hurt the woman to bring her under the control of the man. The urgency of the need to control women has intensified with the growing independence of women. The necessity to control them increases as they approach middle age and serious success. The chick flicks often begin at this point. The woman has made it on her own and will soon pass acceptable childbearing age. Indeed, she may escape male control altogether. In these stories, women strive for success, but they will never be allowed to succeed or survive without a male. The theme of mistaken identity is maintained. The career woman is a housewife, after all, revealed in all her submissive glory in the end. Unlike Cinderella, there is no glass slipper but suburban slacks and shirts, as seen in TV commercials for cleaning products. Instead of gain, there is pain for the woman. She must pass an endurance test to signify her willingness to submit. The agony endured by the Little Mermaid for her Prince Charming underscores this requirement. Women are objects to be exchanged among men as the anthropologist Claude Lévi-Strauss has indicated. Thus, the woman in these fairy stories must signal her readiness for exchange through her choice of attire, which shows the price she has paid. The Little Mermaid must give up her tail for human legs and experience the pain of the owner of Jimmy Choo shoes with each step.

What happens to the modern-day Cinderella who strives for success outside the realm of marriage? What pain and agony should these women endure? What sacrifices should they make? The notion of a woman existing beyond the control of a man is alarming enough, but her foray into the world of men arouses extreme anxiety. Movies do the *cultural work* or the *dream work* for contemporary society. Laura Mulvey has suggested that films must act to quell (male) anxiety. The woman must be subjected to scrutiny to investigate ways to control her. Women and their costumes, Mulvey has stated, bring the film to a halt, so that the viewer can gaze upon the woman as a spectacle. One remembers Grace Kelly in *Rear Window* (1954), twirling around, swishing her black and white full-skirted gown, as she introduced herself. James Stewart felt threatened by Kelly's fashionable attire and scorned her attention to fashion detail. By the end of the film her glamour is gone, and she is seen wearing blue jeans and loafers, ready for housewifehood. Mulvey wrote that Stewart became interested in Kelly only when he was able to examine her at a safe distance through the lens of his camera. Men, this analysis suggests, need to see women, not as human beings, but as pictures or images that satisfy their need to believe in female helplessness.[1]

The arc of the Cinderella story line is reversed from the traditional low-to-high transformation. The woman goes from success to failure, ready to

[1] Laura Mulvey, "Visual Pleasure and Narrative Cinema," in *Visual and Other Pleasures* (Bloomington: Indiana University Press, 1989), 23.

be rescued from a plotline that has reduced her to a condition of helplessness. Her story can be seen in the telling details of costume, which are subtle and powerful at the same time, channeling semiotic messages of social significance. Although in his book *The Fashion System* Roland Barthes explained the semiotics of fashion from a literary and Marxist perspective, it is also possible to apply feminism to the reading of the signs of fashion.[2] Costumes are more than clothing. Clothes, fashion, attire—all visual signals—act first to cause concern and then are utilized to reassure, not that the woman is independent and will succeed but that she will fail. The question is this: Who needs to be reassured? Thirty years ago, Martina Horner's studies revealed that there are women who fear success.[3] And why not?

Movies use clothes that make a woman's success seem dangerous and alienating and her failure to be inevitable. In *What Women Want* (2000), Helen Hunt dresses for (un)success in sleeveless dresses with matching coats reminiscent of those of Jackie Kennedy. Hunt's professional costumes are unprofessional and signify that she is ultimately destined to be fired from her job. Like Jackie O, she is at the mercy of the whims of men and is as helpless as a woman of 1960. The purpose of her costume is that of masquerade, as Joan Rivière has noted, enabling her to "pass" through the gender bar in business without arousing male anxiety.[4] But the masquerade can backfire if, in her disguise, she achieves too much success. The consequences of such success are negative, and she will be punished for daring to signal by her clothing that she is independent of men.

Chick flicks begin with a sharp-dressed woman and end with a woman stripped not just of success but also of the masquerade she employed to invade the world of men. At the end of the movie, the heroine is re-dressed in a housewife-and-mother outfit. Then and only then does Prince Charming find her suitable, so to speak. We know that Reese Witherspoon will stay in *Sweet Home Alabama* (2002), giving up her high-powered fashion career in New York, when she dons a mille fleur print, off-the-shoulder peasant dress, floating above cowboy boots, definitely not a costume one would wear in New York. In *What Women Want* and *Sweet Home Alabama,* both women must sacrifice and experience pain and humiliation before they can "win" Prince Charming. If one recited the tale of the chick flick verbally, the story is one of cruel abuse of a nice woman by an unpleasant man.

The modern chick flick reverses the anonymity of Prince Charming, who is now a known factor. Rather than a cardboard figure who appears briefly, the Chick Flick Prince is a large and usually negative presence. Mel Gibson undermines Helen Hunt and sees to it that she is fired. Josh Lucas

[2] This is a general reference to the overall aspect of Barthes' ideas. Roland Barthes, *The Fashion System*, translated from *Systéme de la Moda* by Matthew Ward and Richard Howard (New York: Hill and Wang, 1983).
[3] Martina Horner, "Toward an Understanding of Achievement—Related Conflicts in Women," *Journal of Social Issues*, 1972, Vol. 28, 157–175.
[4] Joan Rivière, "Womanliness as a Masquerade," *International Journal of Psychoanalysis*, Vol. 10, 1929, 37.

refuses to be a husband to Reese Witherspoon but also refuses, in a childish and passive–aggressive manner, to allow the divorce to be finalized. Neither man hesitates to ruin the hard-won careers of these women. It is difficult to imagine why any intelligent woman would want to be with such men. The question is how to sell a plot, necessitated by the political unconscious, which demands that the woman be brought down to her rightful, submissive level. Prince Charming may be aggressive, immature, and hostile, but he must be plausible as a love object and must don a masquerade in order to get beyond the audience's keen instinct for injustice. The fictional Prince Charming is made palpable by the costume of the movie star and the image of the movie star. The star's image shines through the masquerade of the character that is being played. Helen Hunt will forgive Mel Gibson for destroying her because, thanks to his earlier movies, we are aware of his assets. Attractive stars and good-looking clothes are the visual eye candy, making the bitter medicine of the falling of the female go down sweetly.

In *You've Got Mail* (1998), the pleasant and famous faces of the leading actors also mask a very painful tale. The sweetness and cuteness of Tom Hanks and Meg Ryan light up a dark story, written not by a dour male bent on the destruction of women but by a mother–daughter team, Nora and Delia Ephron, and produced by women, Nora Ephron and Laura Donner. This film is perhaps the cruelest decline from dress to undress since *An Affair to Remember* (1957). There, Deborah Kerr, playing a successful singer, is brought down when she is run over by a taxi. The sacrifice of mobility is drastic, but the prize is, after all, Cary Grant. When the utterly desirable and charming Grant comes to rescue her, she is immobilized on a couch but is dressed festively and expectantly in celebratory red. Kerr's disability works as a visual metaphor for the lowering of the status of women in the genre of romances and romantic comedy. In *You've Got Mail*, Tom Hanks reverses the charm of the prince. His character is particularly nasty and undesirable and is bearable only because he is Tom Hanks, star of *Big*. Few films degrade women more effectively than *You've Got Mail*, and when comparing the two films one remembers that back in the dark ages of the fifties, Cary Grant also made a sacrifice for the woman he loved. There will be no such accommodation or compromise in *You've Got Mail*.

Like many chick flicks, *You've Got Mail* is catalogued at chain stores as a comedy, as if one can laugh at the story of a successful woman ruined by a ruthless man. The failure and punishment of women is indeed the major trope of many a chick flick. This trope does double service. It discourages women from striving and reassures men that they will be loved no matter what they do. *You've Got Mail* is a quintessential postmodern film with its multiple appropriations and references to other films. As a drama of mistaken identity, it is first a remake of *The Shop Around the Corner* (1940), originally starring James Stewart, the nice boy of his time, and Maureen Sullivan, the nice girl of her time. The story about a man and a woman who corresponded without knowing each other's identity was set in a bookshop in Budapest. As a story about books, *You've Got Mail* allows the male character, Joe Fox, to appropriate an early example of feminist writing, *Pride*

and Prejudice, for his own ends. Jane Austen wrote of a woman who was prejudiced against a man for the wrong reasons. *You've Got Mail* reverses the plot, for Meg Ryan is prejudiced against Tom Hanks for very good reasons: He is a liar and the force behind the destruction of her life and livelihood. Mr. Darcy acted as a force of good, while Joe Fox consciously destroys a competitor and then, when he has won, asks for her forgiveness. The film is bearable only because of the collective cultural consciousness of an audience that recalls, for example, that Dabney Coleman was the evil boss in *From 9 to 5.* A slippage between the actors and the characters they play is deliberately employed, borrowing the Hitchcockian device of casting in roles of extreme nastiness actors known for their agreeable and moral characters from earlier movies. Tony Perkins in *Psycho* is a case in point. "Jimmy" Stewart was cast against type by Hitchcock. The super-responsible hero of *It's a Wonderful Life* and *Mr. Smith Goes to Washington* made his neurotic woman-hating protagonists bearable for the audiences of *Rear Window, Vertigo,* and *The Man Who Knew Too Much.* Because the viewer remembered his uprightness in earlier roles, the film could sustain the way in which the plot forced the female character to love a pathological male character. Doris Day could overlook her husband's cruel and insensitive behavior toward her because he was, after all, Jimmy Stewart. Hitchcock's motivation for casting against type was sadistically cynical, but in contemporary chick flicks, the impetus can be interpreted as what Jameson would term "a political unconscious," an imperative to keep women down.[5]

Without the innocence or the moral compass of its predecessors, *The Shop Around the Corner* and *Pride and Prejudice, You've Got Mail* is notable for its ruthlessness toward Meg Ryan's character, Kathleen Kelly. Seldom has a woman been brought down with such relentless determination. Helen Hunt is sandbagged so fast she never gets the chance to fight for her life. Reese Witherspoon submits to the charm of line dancing without a fight. But Meg Ryan begins *You've Got Mail* as a bright and vibrant woman with education and expertise in her field, children's literature. She will fight for her life. Her "little shop" has been in her family for decades and is her inheritance and her emotional investment, as well as her livelihood. On the surface she seems quite harmless, occupying her little corner in the world, her little shop. She is not attempting to invade male territory. She is merely in the way of a male who is not happy until he totally dominates his territory. The audience instantly categorizes Meg Ryan's place within the business hierarchy by her clothes, which indicate that she is no threat to corporate interests. She is so out of big business that she has no need to wear the "feminine masquerade."

Her fashion statement is carefully crafted as the West Side intellectual—or "pseudointellectual" as Dabney Coleman contemptuously puts it—who lives somewhere between Greenwich Village and SoHo in one of those

[5] Fredric Jameson, *The Political Unconscious. Narrative as a Socially Symbolic Act* (Ithaca, NY: Cornell University Press, 1981), 20–21.

old untouched neighborhoods one imagines still exist in New York City. Intellectuals, of course, wear black as a signifying costume in New York, but Ryan's clothes are serviceable down to her sturdy shoes and, since she is Meg Ryan, her character is never dowdy. She is urban without the punk edge, more like a postgraduate who doesn't have to go corporate and can wear pullover vests and black leggings. After all, she runs her own business and sets her own dress code. Although she "practically lives" with a man, she seems innocent. Ryan is a "nice girl" (this audience perception is before Ryan's public affair with Russell Crowe). All of her outfits cover her body completely. Although her skirts are short, they are soberly straight, and her legs are always covered. In winter, she wears leggings; in spring, she wears slacks or long skirts. Her necklines are always buttoned-up necks, turtle-necks, high necks, never scooped-out necks, not even slightly open. Her outfits are black in winter and taupe in spring. Meg Ryan is not exactly the neatly wrapped package that *Pride and Prejudice's* Elizabeth Bennett was, but she comes as close as a twentieth-century woman could. Her clothes po-sition Ryan semiotically in the zone of perpetual student, a somewhat im-mature state, a condition of waiting for the right man. But first she must sacrifice or be sacrificed. The film will not rest until she has lost her boyfriend, her store, her employees, her income, her heritage, her hopes, and her future.

As with so many of these films, the downfall of this independent small-business owner begins with the entry of the man of her dreams into her life. Her clothes symbolize her seriousness and her protected state of unadver-tised availability to the man who would be her nemesis, Tom Hanks. On the job, he wears the corporate uniform of the armorlike tailored suit. His suits are all dark gray, and his shirts and ties are also very dark, unleavened by any hint of light color. The briefcase and the suit signify his dominance and power in strong contrast to the cute and low-key outfits that cause Ryan to blend into the bookshelves. Although Hanks is a hard-driving corporate force invading the neighborhood, he is disguised as a nice guy though his filmography—how bad could the co-star of *Bosom Buddies* be?—by his "sub-urban father" costumes and by the presence of his extremely young aunt and very young brother. His name Fox is a clue, and he sets himself upon the henhouse. He and his family are twentieth-century versions of eighteenth-century rakes: multiple generations of men who are serial abusers of women. Still, he is free to pursue Meg Ryan who, we all know, is perfect for him because Hank's dog, a golden Lab, and his loose-fitting weekend outfits foretell his future as a conventional father who is looking for a conventional wife and mother. There is a rival woman who is too dark, too strong, and too successful. There is a rival man who is too light, too weak, and not suc-cessful enough. Hanks is not too handsome but is nice looking, and his mild appearance shields Ryan from his take-no-prisoners mentality. We know she, with her cute face softening her sober black sweaters and her prim white collars and cuffs, is suitably sexy because we remember her in *When Harry Met Sally* (1989). Like Baby Bear's porridge, Tom and Meg, wearing the costumes of their former films, are perfect for each other.

But there is a problem. The story is bifurcated between the mistaken-identity ploy—the contrast between the public rivalry and the private connection through e-mail—and the David and Goliath story. The public has been trained to root for the underdog. It is doubtful that the audience would have accepted the destruction of a man who showed the courage and ingenuity of Meg Ryan in standing up to the forces of homogenization and the lowest common denominator. And yet, because she is female, the viewer accepts her downfall. The woman is betrayed by everyone she depended upon. Everything she believes in proves to be false. The nobility of her struggle for "reading" over "commerce" is over. She has been destroyed by a bookstore owned by a man named Fox (in the henhouse). She has been devoured. The script makes the point that there is no place for Meg Ryan in this world. The man she trained as her assistant is given a job in the Fox bookstore, a job for which she is better suited. A young male clerk who knows nothing about books has a job. She, who is an expert, is not allowed to succeed, much less survive.

Her total abjection, her nadir is shown by her illness. The script takes away as much of her attractiveness as possible. She is costumed in striped pajamas when Tom Hanks decides that he has done enough and comes—like "froggie"—"a-courtin'." Hanks, in complete disregard for her privacy, forces himself into her apartment while she is sick, without defenses and protected only by her Burberry raincoat. This is the low point of the film. Another film would have this woman not at home, not sick, but out at a bank, planning to move her business to another neighborhood. But this is a romantic comedy and not a story of a woman's quest for success—and the two genres are mutually incompatible in a universe where success is measured by a woman so ill and so without resources that she is not even allowed the dignity of being clothed. *You've Got Mail* sends the message through pajamas: Only a fallen woman is undressed enough for marriage.

We know now that she is totally destroyed, *that* she must submit to this man who has ruined her life. The audience must accept the final climactic pairing of Tom Hanks and Meg Ryan, despite the bitter and unpleasant story so far. That they will be a couple has always been a foregone conclusion; we have seen *Sleepless in Seattle* (1993), so we accept the inevitability. While Kathleen Kelly would have kept on fighting, the adorable and blonde Meg Ryan doesn't even look as if she can take care of herself. She needs to be rescued by her Prince Charming. Had she been dark-haired, a Courtney Cox, for example, her surrender would not have been believable. This film has made the woman a desperate and destitute damsel in distress, and she has no choice but to accept Tom Hanks's mating ritual. As he courts her, their clothing becomes more and more alike. They meet in the neutral territory of their neighborhood on weekends. They wear the same colors, taupes and blue-grays, as conservative and traditional as the style of their clothes. The timeless clothes have not changed since the fifties. She has become completely de-eroticized, for they even wear the same style of trousers. He dresses down to meet her level, and she dresses more softly to meet his requirements. In the world of "romantic comedies," time stands still.

In the fifties, women "did not work," and in the nineties Ryan seems to be drifting in similar unemployment. We can only assume that she somehow owns her upscale shabby-chic brownstone apartment or that it must have rent control dating, like the plot, back to the forties. Rather than look for a job, she writes a children's book and remarks that, if she hadn't lost her business, she would have never had the time to write. The script thus gives Hanks the credit for whatever success she is able to salvage, both as the correspondent who encouraged her to become an author and as her destroyer who forced her to grasp at this rather tenuous straw. Writing one children's book does not an income make, and the script forces her into the security of a marriage with the man who rendered her destitute. Bit by bit, Tom Hanks has taken away her control of her life and guides her in the direction he wishes, on his terms. The audience may be so charmed by his courtship and so beguiled by the delightful New York neighborhoods in the spring that the décor will act to hide his manipulative campaign. In the final scenes, all is revealed in an ending so unrepentantly corny that some form of perverse (Hitchcockian) irony must have been at work. Meg Ryan meets her unknown correspondent in the 9th Street Garden, blooming with brightly colored flowers, acting as a backdrop of her mild and neutral (read submission) beige dress. The dress is the ultimate sign of fifties femininity and of a womanliness that does not call attention to itself and thus needs no masquerade. The flowers of the garden are a familiar sign of fertility and a prediction of fecundity to come. The script has isolated this woman so that no other plausible candidate can present himself. Without friends or family, Meg Ryan is left with no alternative for a mate but the man who has destroyed her life. As he comes toward her, she is waiting—women always wait—dressed up for her e-mail partner, and we note that he hasn't even bothered to change his clothes for the occasion. He doesn't have to; he is, after all, Tom Hanks.

The ultimate semiotic masks are the words *romantic* and *comedy*. Prompted by the terms, the largely female audience is treated to a feast of clothes and a parade of fashion and tricked into thinking that abuse is romantic and that ruin is comedic. The pleasant power of the images of the stars sells the downfall of the female and makes her untimely end acceptable. The small gains hard won by women over the past few decades have apparently aroused profound fears that must be worked through in the collective unconscious of the film audience. Fredric Jameson's "political unconscious" demands a sacrifice.[6] The need to ritually suppress women is eternal. The romantic comedy has never gone out of style and defies the reality of women's lived experience. Today, some women are allowed to succeed somewhat, but we need only to look at the frozen hair of Hillary and Condi to know what else has been iced over. Women in a man's world must wear pantsuits to symbolize their submission to the "Law of the Father."

[6] *Ibid.*, 24.

For the rest of us, fashion is the only place where women can escape. Here in the world of couture, women are desired and respected and revered. But in the "romantic comedy," fashion is used against the woman and ultimately betrays her. Being a visual pleasure is a brief experience, and the game of dressing up is ended when the woman is dressed down by the kiss of a Prince Charming. Everyone laughs. Everyone sighs. The real price of beauty is not the price tag but an independent life. A woman "owned" and "claimed" by a man must signal her "taken" state with clothes that cover. Instead of fashion, she wears camouflage and fades away into the landscape, an unrepresentable and unrepresented sign. Meg Ryan is dressed in a neutral color as the soundtrack plays "Somewhere Over the Rainbow," a song once sung by a girl child. A viewer of a certain age might note that the music is not Mick Jagger's famous ode to the female orgasm, "She Comes in Colors Everywhere." The adult life and the sex life of Kathleen Kelly/Meg Ryan are over. In a Lacanian economy of loss and gain, Ryan must lose everything to gain the pot of gold at the end of the rainbow: wifehood. At the end of *You've Got Mail*, she weeps, as well she might. Given her lack of alternatives, she will accept this defective Prince Charming. Such is the forgiveness of women.

NOTES:

Nicole Hagen in wedding gown. (Photo: James Stiles)

Here Comes the Bride

Parme Giuntini

Married in white, you will have chosen all right. Married in grey, you
will go far away.
Married in black, you will wish yourself back. Married in red, you'll
wish yourself dead.
Married in blue, you will always be true. Married in pearl, you'll live
in a whirl.
Married in green, ashamed to be seen. Married in yellow, ashamed of
the fellow.
Married in brown, you'll live out of town. Married in pink, your spir-
its will sink.

<div align="right">An Old Victorian Poem</div>

When I was a little girl, playing dress up in my mother's wedding gown was the ultimate rainy-day activity, achievable only by several hours of very good behavior and accompanied with ritual surpassed only by a priest donning vestments for mass. My mother kept her gown in a cedar chest, carefully folded in crinkly layers of tissue paper. Slowly she would shake out a bridal fantasy: yards of creamy white skinner satin; a sweetheart neckline; tight-fitting long sleeves that ended in a point; an interminable row of small satin buttons, each with a matching satin loop; a train, a glorious, cover-the-entire-den-floor kind of train; and the pièce de résistance: a small satin rose-bud Juliette cap with clouds of floating veiling. It was a once-in-a-lifetime dress, bearing no resemblance to her normal world or wardrobe. She never expected to wear it again, nor cannibalize it for other uses such as christening clothes.[1] Such a dress could have been the headliner for a large and elaborate wedding, but Mom was married at 8:00 in the morning with only family and close friends present. After the ceremony the guests returned to her parents' house for breakfast. Freshly confident from wartime success, buoyed with the promise of future affluence, and ready to splurge after years of rationing, my parents, like many other young American couples, eagerly embraced the "white wedding" trend with its more formal celebrations and elaborate attire.

[1] Elizabeth H. Pleck, *Cinderella Dreams: The Allure of the Lavish Wedding* (Ewing: University of California Press, 2003), 95. Since the 1930s, bridal magazines have encouraged brides to buy their own dresses, rather than rent or borrow a dress, which has heightened the preciousness of the gown.

For most women, a wedding gown remains the single most expensive and symbolic item of clothing they will ever buy and the only garment they will never throw away. That alone accords it special attention, since the behavior is at once remarkably capitalistic and extraordinarily sentimental. And, as the now well-known story goes, it wasn't always so. Until 1840, when Queen Victoria walked down the aisle in a white gown with a twenty-foot train, women, even royal women, married in a variety of colors. Although their gowns could be costly and elaborately decorated, they were intended to be worn again and, as such, were not the single occasion, event-specific outfit of the modern bride.

The modern white wedding gown is the pivotal contemporary icon of romantic mythology and a $40-billion-a-year industry accompanied by professional planners, specialized merchandise, and extravagant retail fairs.[2] Certainly church and reception sites have to be booked well in advance, along with photographers, caterers, florists, bands, and limos. But all these details fade into the shadow of "the dress," which occupies the lion's share of magazine space in popular publications such as *Modern Bride, California Bride*, and *Brides*, as well as countless bridal websites.[3] Not surprisingly, the wedding gown is also the object most likely "to provoke an intense emotional response from the congregation."[4]

While Queen Victoria wore white to symbolize purity and virginity, any strict association with the color and a particular moral state of being is immaterial today, along with notions that wedding gowns should be demure, chaste, and cover the shoulders. This was not the case in the immediate post–World War II decades, which ushered in the first taste for elaborate weddings and established the white wedding gown as a signifier for traditional matrimonial commitment. Although wedding gowns were certainly influenced by major fashion trends—skirts, for instance, could be fuller or narrower—they also gradually acquired a host of stylistic elements peculiar to the gown and the event, among them elaborate ornamentation, period features such as sweetheart necklines, and medieval-like long pointed sleeves. Public familiarity with much-photographed brides reinforced these cultural and stylistic conventions. Baby boomers watched a demurely dressed Elizabeth Taylor march down the aisle in the film *Father of the Bride*, while Grace Kelly made her much-publicized transformation from American movie star to European princess in high-necked, long-sleeved lace and satin.

[2] Some large department stores began to hire bridal consultants as early as the 1920s, and the National Bridal Service was founded in 1926, but it was not until the 1950s that jewelry stores nationwide first began to carry silver, crystal, and china to attract brides. In 1952, Jerry Connor founded the American Association of Professional Bridal Consultants and began to offer instructional packages to jewelers interested in capitalizing on the burgeoning bridal market. By 1979, the wedding industry was fully established with professional planners who would orchestrate the events.
[3] Elizabeth H. Pleck, *Cinderella Dreams*, 91.
[4] *Ibid.*, 82.

American presidential daughters wore similarly traditional gowns, and Princess Diana, in what was the most photographed wedding of the twentieth century, may have opted for opulence in fabric and spectacular length in train, but also chose a modest ruffled neckline and elbow-length sleeves.

Ornamentation was another defining feature of wedding gowns that rendered them significantly different from other formal evening wear. Consequently, brides were often festooned in ruffles, elaborately jeweled bodices and sleeves, yards of reembroidered lace, seed pearls, and trailing gossamer veils. The very singularity of such opulent formal attire at a daytime event heightened the importance and significance of the wedding gown, and since simple luncheon or punch and cake receptions dominated until the 1970s, elaborately clad brides customarily wafted around church meeting rooms, women's and Elks' clubs, or even their own backyards with much the same aplomb that Jackie Kennedy displayed in the now-famous photo showing her in an elegantly full-skirted gown and heirloom lace veil while enjoying the al fresco wedding lunch.

Ornamentation and formality aside, two seemingly unyielding features of the wedding gown have only eroded in the past decade: maidenly modesty and exclusivity. From its inception, the white wedding gown was only worn by first-time brides, generally as part of a religious ceremony, although no truly hard and fast rule governed the ceremonial aspect. Brides who were married by a justice of the peace in court chambers were not barred from wearing a wedding gown, but practical considerations of space, place, and travel undoubtedly made it less appealing. Regardless of where you married, however, etiquette ruled that only first-time brides were entitled to wear the elaborate white gowns and veils that signified their virginal state, regardless of the veracity of that status. Widows, divorcees, and—ironically—even mature first-time brides were expected to dress differently for their weddings and protect the status and romance associated with the white wedding. Elaborate white gowns and veils were out of the question; the only acceptable options were suits or modest evening gowns in pastel tones, beige, or dove gray. Needless to say, the accompanying bridal attendants and reception guests were expected to maintain parallel decorum in their simplicity. These were etiquette, not fashion rules, and as such, they carried a higher semiotic charge and, if flaunted, more serious social repercussions. The bride shouldered the lion's share of risk in these situations; her choice of wedding outfit demonstrated not only her awareness of propriety and good taste, but also acceptable female behavior. Were grooms, first time or other, consulted in these situations? Probably, since it is reasonable to expect that being male did not necessarily indicate complete ignorance of mainstream wedding practices, but the prevailing wind blew all responsibility into the bride's corner.

Appropriate attire for anyone entering a church or a synagogue was fairly conservative until the 1990s; brides and their attendants were expected to conform to the same prevailing standards. Financial ability and social status determined wedding opulence, but religious decorum governed how much skin a bride could show. The rules were relatively simple: What

worked at Saturday or Sunday services was also appropriate for wedding gowns. Consequently, regardless of how elaborate the gown, it would be designed with sleeves to avoid bare shoulders and have modest front and back necklines. As stylistic restrictions, these were not deal breakers but rather long-established customs whose value was couched in the language of *propriety* and *decorum*, terms that have been significantly altered and redefined in the wake of the sexual revolution, feminist theory, growing secularism, and later marrying ages.

Although wedding gowns are still designed with sleeves, high necklines, elaborate beading, embroidery, and voluminous skirts, during the past decade many American brides have opted for simpler lines, clingy and flowing fabrics, less ornamentation, and—in the single most controversial assault on bridal decorum—strapless and spaghetti-strap styles. Admittedly, it was a shock at first—strapless gowns in church—but now the style is as commonplace as chocolate wedding cakes. Enter Vera Wang, who almost singlehandedly reinterpreted the white wedding gown. Paring down the confectionary "more is better" approach, Wang turned her personal wedding crisis—the inability to find a gown acceptable for a mature and sophisticated bride—into a thriving design house and in the process shifted the perception of the wedding gown from Cinderella in a full skirt to femme fatale seduction. Vera Wang made wedding gowns sexy.

Despite the dress codes that they initially breached, Wang's sleek, pared-down, body-conscious designs coincided with a new demographic profile for American brides and their weddings. Older, well educated, self-supporting, fashion-conscious, consumer-oriented, and sexually active, these brides preferred to follow a religious ceremony with lavish wedding festivities, and they played a leading role in orchestrating the events. Abandoning the simpler cake and punch receptions of their parents, they opted for lavish postceremony parties complete with multicourse, sit-down dinners, live bands, and dancing. They replaced the traditional bridal tea with bachelorette parties that run the gamut from modest restaurant dinners to drinks at male strip clubs to spa or Las Vegas weekends. Honestly, what chance did modest necklines and sleeves have against sexy, slinky, strapless gowns that drift down the aisle shielded by a tulle veil as easily as tear up the dance floor?

The wedding gown is either remarkably resilient or those women who intend to wear them are remarkably determined. The gown has survived the "barefoot flower child" approach, which threatened to replace silk and satin with muslin, homemade dresses, and hand-crocheted lace—definitely not options for a fashion industry that demands a six-month construction period and is steeped in luxury fabrics. Feminism nurtured a new generation of women who not only decided if they would wear white to the wedding, but reframed color as a fashion choice, not a moral imperative. After all, if white gowns looked wonderful the first time around, they probably would look just as good, maybe even better, the second or third. Today, brides have the resounding support of a savvy industry that recognizes that what is on the reception table, so to speak, is less "This is what you should wear" and more "What do you feel like wearing?" After all, it is your day.

NOTES:

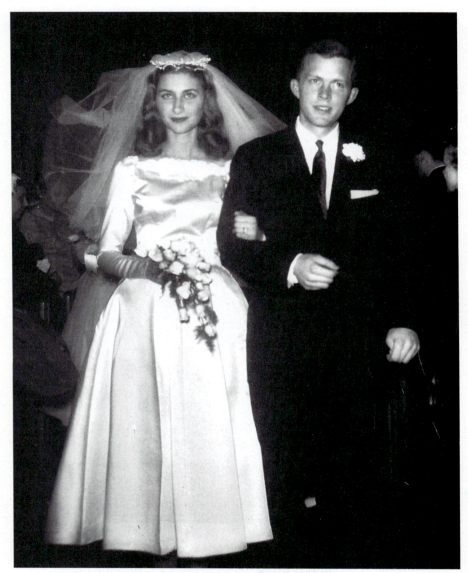

Patricia Stiles at her first wedding, 1959. (Photo: Courtesy of Patricia Stiles)

"Till Death Do Us Part"—or . . .

Patricia Stiles

"The bride wore a deep ivory satin gown trimmed with Alençon lace and seed pearls and a matching shoulder-length veil. She carried a bouquet of cream colored roses." A quote from the wedding page of the *Port Washington News* but clearly my mother's words. I was the bride, but the wedding belonged to my mother. It was the late fifties, a time when girls went to college to find a husband and, as an afterthought, perhaps a career to fall back on. They married out of college at nineteen or waited until they had finished at twenty-two, but they married. Living together was not an option. I realized, just recently, after looking at other friends' wedding pictures from that era, that we all looked alike. It was uncanny. Were we all wearing the same gown? Well, not quite. But from our high, delicate necklines, princess-line silhouettes and hair tucked into a chignon, right down to our prim little smiles, the resemblance was frightening.

What innocents we were. We had no idea what was ahead of us. And who could predict that the sixties would blow so many of our marriages apart, that those boys that we'd married either because our parents approved or disapproved, would never last until death did us part? Not by a long shot. We could hardly guess that the marriages our parents believed would legitimize sex, give us direction, and offer us security and children would very likely be put asunder by the sixties.

When I look at this wedding picture now, I think I can detect my uncertainty. I am not really there, clearly not in command. I am demure and sedate: a shy star. The gown itself captures the essence of fifties women. In some way it harkens back to the gowns of Victorian times. It is modest, prim. A princess line defines the shape, and the skirt is long, referred to as "ballet length" at the time. Ironically, it's constructed to limit movement—another component to keep women in their place: lack of movement as a metaphor. The silhouette is form fitting, particularly from the waist up, as it always is in times of repression. As in the Victorian era, the silhouette of the fifties celebrates the hourglass figure, the ideal being a full bust and small waist. I can only guess that it's meant to remind us of the difference between men and women.

And beneath my gown I am overdressed. I am wearing a well-constructed, heavily padded bra and, in addition, panties, a garter belt, stockings, and on top of that a full-length slip. Perhaps it was considered a sign of virtue, something akin to a chastity belt, this feminine armor beneath our clothes. Who would have predicted that in less than ten years, the sexual revolution would

see women braless under their tops, sporting bikini panties and miniskirts, waistlines discarded, and those garter belts, stockings, and slips long gone?

I puzzle at my costume, even now, as I view my old wedding pictures. What am I doing in this heavily constructed ivory satin gown? I was an art student, a proclaimed bohemian. In my real life, I wore paint pants, or black stockings, and long, loose tops. This gown was hardly an expression of me but rather essentially a symbol of the times. Was I too young to have my own look, or was it just my bad luck to grow up in the wrong decade? There is something grave and enduring in my march down the aisle. Yet I am doing precisely what I had been groomed for. And in the end, what most of us did in those days was exactly what was expected of us. We got married.

And here I am, almost ten years later, doing it all over again. Getting married. It's the late sixties, and this time *I* am in charge. We have chosen an acclaimed pacifist minister to marry us in a Unitarian chapel. We carefully remove all religious symbols from the chapel, so as not to offend our respective families of different faiths. At the last minute our celebrated

Figure 1. Patricia Stiles the second time around, 1969. (Photo: Courtesy of Patricia Stiles)

clergyman goes off on a peace march, leaving an assistant we've never met to perform the nuptials. Is it a bad omen? Not for the ever-optimistic children of the sixties. After all, we are writing our own vows. Our wedding is less about embracing the institution of marriage than it is about embracing each other. I am finally making my own choices.

Or so I believed. But why? Why did I feel I had to rush into marriage? I had just *been* married. If the sixties roared in like a lion, the fifties seemed to have left without a whimper. I think now that was deceptive. The dramatic difference between the two decades would indicate an enormous leap, although on a deeper level I don't think it was quite that simple. For my generation of women, the fifties had taken their toll. We weren't nearly as liberated as we wanted to believe. Married women who were gay or those who chose to leave their marriages to opt for a career were just beginning to emerge from their bonds of matrimony. No longer did anyone tell us we *had* to get married, but it was ingrained. Marriage was still about winning the brass ring.

However, for the baby boomers, as well as those of us born at the beginning of the forties, the decade had tremendous power. It changed us all. I remember the sixties as a time of enormous creative energy and excitement, of radical protest and flower power, of change and experimentation. Music exploded, rock and folk rock, and fashion went right through the roof. The sexual revolution was underway, and there was a new sense of freedom in the air for both men and women. Sex dominated the scene, as well as the dance floor. "I can't get no satisfaction!" bellowed Mick. And although the country was in a state of polarization and upheaval over the Vietnam War, there was a sense of community for the young that had never existed before. Protest songs surged to the tops of the charts. A popular rock group sang of brotherhood and love: *"Everybody get together, try and love one another right now."* And did we ever!

It was an exhilarating time to be young, and the clothes said it all. There is probably no decade in history that saw such a radical change in fashion. Like the music, clothes were youth-oriented, sexy, and outrageous, but above all they captured the "anything is possible" energy of the sixties. Waistlines were out; bras were banished. Clothing lightened up and loosened up. Construction was minimal, movement no longer restricted. The silhouette was loose, androgynous, emphasizing the legs instead of the bust and waist. The hemlines crept up each year; until at the end of the sixties they barely covered the top of the thigh. Everyone thought leg liberation was groovy, except for the stuffy over-thirty crowd. And who would trust anyone over thirty?

A slim boyish figure was definitely the look, which is commonly the ideal in times of feminine revolution. In the twenties, as well, the breasts flattened out, waistlines disappeared, and hemlines moved up. In that decade, the flappers smoked and drank in public and showed their legs for the first time. While the feminists of the twenties won the right to vote, the second wave of sixties feminists won other victories. Women gained entry to careers of their own choice: doctors, lawyers, architects, truck drivers. It was no

longer necessary to find a man to support them, to strike that fundamental bargain at the heart of marriage. They no longer needed to marry to have sex or simply to get out of their parents' house. As in the twenties, women in the sixties rebelled, and their clothing, particularly their silhouettes, expressed their discontent.

In the true spirit of the counterculture, I designed my own wedding dress. Flaunting this girlish pink confection, I see myself, now, like a parody of the sixties. What was I thinking? This peculiar fashion statement looks to me like some strange conglomeration of *perky mod girl* and *flower child*. I have big hair, pale lips, eyes outlined and shadowed like some flamboyant Kabuki actor, and lids hung with a gigantic flirty set of false eyelashes. The silhouette is a loose empire, the hemline mid-thigh. It's minimally constructed in a soft pink flowery chiffon, with a velvet sash. A large matching chiffon bow trailing an abundance of flowers sits on the back of my head.

Was this really the way women dressed in the sixties? And if so, weren't we following the trends, just as we had in the fifties? I think the major difference is in the fact that young women could reinvent themselves in clothing that was fun, that reflected a culture that encouraged creativity and freedom, no matter how silly it may look to us now. In the fifties, we dressed like miniature versions of our mothers. This decade promised us that we could "do our own thing." If the fifties belonged to our parents, the sixties were all ours.

Marriage. . . . More than twenty years later, children grown, I'm giving it another try. It is the early nineties. We choose not to marry in a church or chapel but instead have the ceremony on a friend's deck, overlooking the ocean. We have known each other for many years and have lived together for three. Someone once referred to a friend's multiple attempts at marriage as "the triumph of hope over experience." In the postmodern era of serial monogamy, it seems the natural order of things.

My wedding dress. . . . Compared to earlier times, this dress is anticlimactic at best. Fashion has cycled back to a more conservative era, and here I am, on the threshold of middle age. For me, simplicity and elegance are the goal. In my search for a wedding dress, I finally settle for one that is not ravishing but becoming.

The nineties is a time when a variety of directions converge. No one style defines women's fashion. As a result, the look, if there is one, lacks the bold concise statement of past decades. Architecture, as well as fashion, blends modernism, postmodernism, and deconstructivism and molds them into new configurations. As we drift into the late nineties, we will see fashion become younger, sleeker, and, as a reflection of the corporate world, more uniform.

It is the end of the century, a time of reflection, a time to take stock of what has survived from previous generations. Designers are casting an eye to the past. What *have* we learned from past decades, and what in the end has changed? One trend that appears to be permanent is the concept that fashion no longer means discomfort. Clothing has become more casual,

Figure 2. Patricia Stiles, 1992.
(Photo: Courtesy of Patricia Stiles)

softer and less constructed. Dress codes have become infinitely more relaxed. At my nineties wedding, women wore everything from long flowing dresses to shorts and harem pants.

Another element that seems to have survived is an acceptance of *individual style,* which began in the sixties and suggests a creative way for women to define themselves. Sex is also here to stay. Although not as flamboyant as in the sixties, miniskirts are still out there showing off women's legs. By the middle of the decade, even brides will be showing skin as they march down the aisle in their satin slip dresses or strapless, backless sheaths. Ethnicity and natural fabrics that were born in the seventies continue into the nineties and will keep popping up in future generations, as well. As if in celebration of the twentieth century, the fashions of the nineties are heavily linked to the past: satin bias-cut gowns, slip dresses, bell bottoms, A-line shift dresses, and miniskirts, to name just a few. Retro looks from practically every decade flood the market.

My own wedding attire is reminiscent of the twenties, a dress with a soft, loose jacket. The silhouette is relaxed, androgynous, and slightly large, a

shape particular to the early nineties. The fabric is silk, the hemline mid-calf, and the construction minimal. I would never choose a dress like that now. It's just *too* conservative and understated. Perhaps the dress was a symbol, a stab at stability or a wish for a more solid life.

Considering my wedding pictures of the past, I can see that I'm a different person in all of them. Each one says something about me and about the particular decade I've lived in. Each one projects some sort of hope—or ambivalence. But what strikes me most is the incredible power of the times. If I had been born twenty years later, would I have married three times? Probably not. The number of unmarried-couple households multiplied by ten times from 1960 to 1998, and hardly more than half of the adults in this country are currently married. I think it's fair to assume that younger women will come to marriage later, if at all. They will marry for more informed reasons, and they most likely will marry fewer times.

Once again it brings me back to the enigma of fashion: that mysterious interpretation of the time we live in that dictates the way we dress. When I revisit my past lives and examine these three women in their wedding attire, looking not at all alike, I am astonished at the enormous impact that fashion, in its many forms, has on our lives and, as women, how readily we embrace it.

NOTES:

Sara Streeter, Performance artist. (Photo: James Stiles)

Ending It. . . .

Parme Giuntini and Kathryn Hagen

One of the advantages of coediting a book over solitary authorship is undoubtedly the continual opportunity to exchange ideas, an experience for us that has ranged from casual comments to lengthy discussions, from immediate, almost intuitive agreement to vastly differing positions, priorities, and theoretical preferences. Coediting is a bit like cohabiting: To be successful living with someone else's mind, there has to be sufficient space for sharing as well as independence, an ability to recognize and capitalize on each other's strengths and expertise, and the flexibility to blend divergent positions into a cohesive whole without jeopardizing the critical, and often, divergent points. These factors are even more important when the collaboration is crossdisciplinary because the landscape of crossed or blurred boundaries, and the incorporation of different areas into the construction of a new whole, necessarily entail a negotiation of interests and priorities that must be acknowledged. It is our sincere hope that *Garb* readers, many of whom are students working in fashion, cultural studies, or gender studies departments, will have had a similar experience in engaging the material and that, rather than emerging from the experience with a singular trajectory, they will find themselves better informed to address the complex issues surrounding clothing, dress, fashion, and popular culture.

That is, not surprisingly, the position that we found ourselves in when we began writing this conclusion. Rather than a neat finish requiring little more than a summation of the main ideas that we set forth in the introduction, we realized that the essays, both ours and those of the contributing authors, as well as the chapter introductions that we frequently wrote together, had raised more questions for us, often propelling us in different directions. While this is ultimately, as the cliché goes, "a good thing," it was initially unsettling, exposing not only the inherent difficulties that any final position or determination requires, but also, and more importantly, revealing the basically unstable nature of clothing and dress in the construction and communication of meaning, personal, and social identity.

One of our ongoing conversations has revolved around the future of fashion, an unmapped frontier that ranges from the extremes of the technologically driven model of cyberspace designs to a unisex vision of clothing that is environmentally safe and culturally neutral. Our discussions never ended in any consensus; instead, we found ourselves with a list of questions that continued to expand. Who, if anyone, assumes a leadership role in a postmodern world that is no longer dominated by the couture

design houses with their highly publicized runway shows, historically the vehicle for introducing seasonal collections? What are the ramifications of the globalization of the fashion industry and the growing number of emerging designers? We have grown accustomed to the infusion of variety and innovation, but what are the consequences of that proliferation of styles and the insistent demand that we continually change in order to remain essentially the same—fashionable. What has fashion sacrificed or gained by embracing the ethos of street and subcultures, targeting a youth market, and adopting the celebrity, who jockeys between glamorous couture design and the ubiquitous uniform of jeans and a T-shirt, as the ideal public mannequin? Are personal taste and individual style oxymorons in a world where, as Frank Thomas argues, the consumer has been deftly snared in a corporate and advertising coup that recognizes their needs and desires and responds in kind? Difference, rebellion, antifashion, self-expression: If that is what you want, if that is what you think defines identity, innovation, and personal style, then that will be the postmodern mantra and we will be your guru.[1] However, as Valerie Steele notes, whether people hate fashion or not is a moot point: It is here to stay despite its artificiality, relentless change, and obsession with eroticism and vanity. For many women and increasing numbers of men, this is a small price to pay in exchange for the opportunity to engage in aesthetic fantasy.[2]

Regardless of the kind of clothing, accessory, or bodily adornment, *Garb* tells a story about the wearer, even if that story is not consciously narrated. We have consistently argued for the role that self-identity plays in any discussion or interpretation of fashion and culture and, arguably, this has become a naturalized position for us, the result of our combined interest in critically examining the semiotic connotations and cultural consequences of framing fashion as communication. Likewise, we acknowledge the influence of living in California and teaching in an art college, dual environments that seem to encourage, if not nurture, dress as a creative form of self-expression and to entertain the notion that fashion can occupy the same space as fine art.

Immersion in this web of self-presentation has raised some thorny issues. How does a discourse that emphasizes individuality and self-expression in dress intersect with ethnic or traditional cultures whose choices, especially with female dress, appear considerably more restrictive? What are the consequences of such a logocentric view in a global culture? These questions notwithstanding, we still agree that the ubiquitous presence of mass media in visual culture has clearly prioritized a Western attitude toward fashion, consumption, and style in which individuality and self-expression take center stage. Does this mean that consciously adopting extremes of fashion or unusual and innovative combinations of clothing indicates greater creativity or a stronger sense of independence? Is the teenager or college student who

[1] Frank Thomas, "Why Johnny Can't Dissent."
[2] Valerie Steele, "Why People Hate Fashion."

routinely dons jeans, T-shirts, and hoody without a moment's pause as much a part of the crowd as the businessman whose daily appearance in suits is as regulated as the uniforms for policemen, surgeons, or local fast-food cashiers? Does the comment "I don't care as long as it's comfortable, it's just clothes" indicate a position on antifashion, a dismissal of the hegemony of the retail industry, or a genuine investment in ease and comfort at the expense of fashion or style? Are individuality and self-expression in dress an occasional habit for some rather than a daily activity? Are we less ourselves in what we must wear rather than what we freely choose? How critically is personal expression affected by what we can afford to buy or by what we have the courage to try? These are questions that continue to meander through a variety of disciplines, to shift the way that we think about ourselves within a particular community or a global one. They structure the connotations that we develop, the stereotypes that we maintain, and often the judgments that we make. There are no easy answers, no fixed positions, and no possibility of ending the discourse. But, then, it was never really just about clothes.

Selected Bibliography

Anspach, Karlyne, "The American Casual Dress," *Journal of Home Economics*, vol. 55, no. 1 (1963), 255–57.

Arnold, Rebecca, *Fashion, Desire and Anxiety: Image and Morality in the 20th Century* (London: I.B. Tauris, 2001).

Barack-Fishman, Sylvia, *Jewish Life and American Culture* (New York: State University of New York Press, 2000).

Bershtel, Sara, and Graubard, Allen, *Saving Remnants: Feeling Jewish in America* (New York: The Free Press, 1992).

Best, Amy L., *Prom Night: Youth, Schools, and Popular Culture* (London: Routledge, 2000).

Bleich, David, J., *Judaism and Healing: Halakhic Perspectives* (Jersey City, NJ: KTAV Publishing House, Inc., 1996).

Brill, Diane, *Boobs, Boys and High Heels* (New York: Penguin, 1995).

Brown, Maurice, and Korzenik, Diana, *Art Making and Education* (Champaign: University of Illinois Press, 1991).

Brunsma, David, and Rockquemore, Kerry A., "Effects of Student Uniforms on Attendance, Behavior Problems, Substance Abuse, and Academic Achievement," *Journal of Education Research*, vol. 92, no. 1 (September/October 1998), 53–62.

Cartwright, Lisa, and Sturken, Marita, "Practices of Looking: Images, Power, and Politics," in *Practices of Looking: An Introduction to Visual Culture* (London: Oxford University Press, 2001).

Chaplin, Heather, "Tween Picks," *American Demographics* vol. 21, no. 12 (December. 1999).

Chittenden, Varick A. "These Aren't Just My Scenes: Shared Memories in a Vietnam Veteran's Art," *Journal of American Folklore* 102 (1989).

Clark, Kenneth. *The Nude: A Study in Ideal Form* (New York: Pantheon Books, 1956).

Clarke, Alison, and Miller, Daniel, "Fashion and Anxiety," *Fashion Theory: The Journal of Dress, Body & Culture*, vol. 6, no. 2 (June 2002).

Cohen, Simon, "Body," in *The Universal Jewish Encyclopedia*, vol. 2 (New York: The Universal Jewish Encyclopedia, Inc., 1940).

Cole, Shaun. "Macho Man": Clones and the Development of a Masculine Stereotype," *Fashion Theory*, vol. 4, no.2 (June 2000), 125–140.

Dalby, Liza, *Kimono: Fashioning Culture* (New Haven: Yale University Press, 1993).

Daniels, Les. *Wonder Woman Collector's Edition: The Golden Age of the Amazon Princess*, Masterpiece Edition (San Francisco, Chronicle Books, 2001).

Davis, Fred, *Fashion, Culture and Identity* (Chicago: University of Chicago Press, 1992).

Douglas, Susan J. *Where the Girls Are: Growing Up Female with the Mass Media* (New York: Times Books, 1995).

Eilberg-Schwartz, Howard, "The Problem of the Body for the People of the Book," in ed., Howard Eilberg-Schwartz, *People of the Body: Jews and Judaism from an Embodied Perspective* (Albany: State University of New York Press, 1992).

Entwistle, Joan, *The Fashioned Body: Fashion, Dress and Modern Social Theory* (Massachusetts: Blackwell Publishers, 2000).

Finke, Avraham Yaakov, *Responsa Anthology* (N.J.: Jason Aronson Publishers, 1990).

Florida, Richard, *The Rise of the Creative Class: And How It's Tranforming Work, Leisure, Community and Everyday Life* (New York: Basic Books, 2002).

Flugel, J. C., *The Psychology of Clothes* (London: Hogarth Press, 1966).

Foucault, Michel, *Discipline and Punish: The Birth of the Prison,* trans. Alan Sheridan (New York: Vintage Books, 1979. Originally published in French in 1975.)

Fussell, Paul, *Uniforms* (Boston: Houghton Mifflin, 2002).

Gabor, Ebi, *The Blood Tattoo* (Las Colinas, Tex.: Monument Press, 1987).

Gambold, Liesl Lee, Creating Lives: Tattoo Culture in Southern California, master's thesis, University of California at Los Angeles, 1993.

Gilman, Sander, "The Visibility of the Jew in the Diaspora: Body Imagery and Its Cultural Context," from the B. G. Rudolph Lectures in Judaic Studies in *The Jew's Body* (New York and London: Routledge, 1991).

Govenar, Alan, "The Changing Image of Tattooing in America," in ed.,O. P. Joshi, *Marks and Meaning: Anthology of Symbols,* (Jaipur, India: RBSA Publishers, 1992).

_____, "The Variable Context of Chicano Tattooing," in ed., Arnold Rubin, *Marks of Civilization: Artistic Transformations of the Human Body* (Los Angeles: Los Angeles Museum of Cultural History, University of California, 1988).

Hall-Duncan, Nancy, *The History of Fashion Photography* (New York: Harry N. Abrams, 1979).

Harris, Alice, *The Blue Jean* (New York: PowerHouse Books, 2002).

Higonnet, Anne, *Pictures of Innocence: The History and Crisis of Ideal Childhood* (London: Thames and Hudson, 1998).

Inness, Sherrie A., *Tough Girls: Women Warriors and Wonder Women in Popular Culture* (Philadelphia: University of Pennsylvania Press, 1998).

Joe Sherry, "A Survivor's Perspective on Hitler," *Los Angeles Times,* March 5, 1992.

Jones, Michael Owen, "Why Make (Folk) Art?" *Western Folklore* 54 (1995).

Joseph, Nathan, *Uniforms and Nonuniforms: Communication Through Clothing,* *Contributions in Sociology,* Number 61 (New York: Greenwood Press, 1986).

Kazmaier, Martin, *Sixty Years of Photography* (New York: Rizzoli, 1991).

Keys, Lisa, "Fashionable Orthodox Walk the Runway Less Travelled," *Forward,* September 13, 2002.

Kline, Stephen, *Out of the Garden: Toys and Children's Culture in the Age of TV Marketing* (London: Verso, 1993).

Knowles, Harry, "Catherine Zeta-Jones as Wonder Woman?"Retrieved January 14, 2000, at www.aint-it-cool-news.com.

Kristeva, Julia, *The Powers of Horror: An Essay on Abjection,* trans. Leon S. Roudiez (New York: Columbia University Press, 1982).

Ledger, Florence, *Put Your Foot Down: A Treatise on the History of Shoes* (Wilts, England, Melksham: 1985).

Lee, Michelle, *Fashion Victim: Our Love-Hate Relationship with Dressing, Fashion, and the Cost of Style* (New York: Broadway Books, 2003).

Leppert, Richard, "The Male Nude: Identity and Denial," in Art and the Committed Eye: Culture, Society, and the Functions of Imagery (Boulder, CO: Westview Press, 1996).

Levitz, Irving, "Jewish Identity, Assimilation, and Intermarriage," in *Crisis and Continuity: The Jewish Family in the 21st Century* (Jersey City, N.J.: KTAV Publishing House, 1995).

Lieberman, Rhonda, "Jewish Barbie," in *Too Jewish: Challenging Traditional Identities* (New Brunswick, N.J.: Rutgers University Press, 1996).

Lifton, Robert. "Protean Man," *Partisan Review,* vol. 35 (1968), 13–27.

Linzer, Norman, *The Jewish Family: Authority and Tradition in Modern Perspective* (New York: Human Sciences Press, Inc., 1984).

Marling, Karal Ann*, Rites and Regalia of American Debdom* (Lawrence: University Press of Kansas, 2004).

Martin, Linda, *The Way We Wore: Fashion Illustrations of Children's Wear 1870–1970* (New York: Charles Scribner's Sons, 1978).

Meechham, Pam, and Sheldon, Julie, "Female
Nude as the Site of Modernity," in
Modern Art: A Critical Introduction
(New York: Routledge, 2000).

McCarthy, Sean L., "We Wonder: Who Will
Play Super Woman on Big Screen?"
Boston Herald, December 21, 2004.

McDonald, Helen, *The Female Nude in Art*
(New York: Routledge, 2001).

Mirzoeff, Nicholas, ed., *The Visual Culture
Reader* (New York: Routledge, 1998).

Mitchell, Timothy, "Orientalism and the
Exhibitionary Order," in ed., Nicholas
Mirzoeff, *The Visual Culture Reader,*
(New York: Routledge, 1998).

Obeyesekere, Gananath, *Medusa's Hair: An
Essay on Personal Symbols and Religious
Experience* (Chicago: The University of
Chicago Press, 1981).

Osgerby, Bill, *Playboys in Paradise:
Masculinity, Youth, and Leisure-style in
America* (Oxford, England: Berg, 2001).

Oshry, Rabbi Ephraim, *Responsa from the
Holocaust,* trans. Y. Leiman (New York:
Judaica Press, 1983).

Phillips, Michael J., *Ethics and Manipulation
in Advertising: Answering a Flawed
Indictment* (Westport, CT.: Greenwood
Publishing Group, 1997).

Piper, Adrian, "Out of Order, Out of Sight,"
in *Selected Writings in Art and Criticism,*
vol. 2, 1967–1921 (Cambridge, Mass.:
MIT Press, 1996).

Pleck, Elizabeth H., *Cinderella Dreams: The
Allure of the Lavish Wedding* (Ewing:
University of California Press, 2003).

Pollock, Griselda, "Modernity and the Spaces
of Femininity," in G. Pollock, *Vision and
Difference* (New York: Routledge,
Chapman & Hall, 1988).

Probert, Christina, "*Swimwear in Vogue Since
1910* (New York: Abbeville Press, 1981).

Reik, Theodor, *Pagan Rites in Judaism: From
Sex Initiation, Magic, Moon-Cult
Tattooing, Mutilation, and Other
Primitive Rituals to Family Loyalty and
Solidarity* (New York: Farrar, Straus,
1964).

Roach-Higgins, M. E., Eicher, J. B., Johnson,
K. K., *Dress and Identity* (New York:
Fairchild Books, 1997).

Rosenberg, Janice, "Brand Loyalty Begins
Early," *Advertising Age,* vol. 72, no. 7
(February 12, 2001).

Rubin, Arnold, "Introduction: Contemporary
Euro-America," in ed., A. Rubin, *Marks
of Civilization: Artistic Transformations
of the Human Body* (Los Angeles: Los
Angeles Museum of Cultural History,
University of California, 1988).

Rubinstein, Ruth P. *Dress Codes: Meanings
and Messages in American Culture*
(Boulder, CO: Westview Press, 1995).

Sachar, Howard A., *A History of the Jews in
America* (New York: Vintage Books,
1993).

Said, Edward, *Orientalism* (New York:
Vintage, 1979).

Sanders, Clinton R., *Customizing the Body: The
Art and Culture of Tattooing* (Philadelphia:
Temple University Press, 1989).

Sandler, Bernice. "Women Faculty at Work in
the Classroom: Or, Why It Still Hurts to
Be a Woman in Labor." Retrieved
August 2005 at www.bernicesandler.com
/id29_m.htm.

Schlesinger, Benjamin, "The Jewish Family in
Retrospect," in *The Jewish Family: A
Survey and Annotated Bibliography*
(Toronto, ON: University of Toronto
Press, 1971).

Schneider, Allison. "Frumpy or Chic? Tweed
or Kente? Sometimes Clothes Make the
Professor," *Chronicle of Higher
Education,* January 23, 1998, A12.

Schreier, Barbara A., *Becoming American
Women: Clothing and the Jewish
Immigrant Experience, 1880–1920*
(Chicago: Chicago Historical Society,
1994).

Starr, Kevin, *Coast of Dreams: California on
the Edge 1990–2003* (New York: Knopf
Publishing Group, 2004).

Terell, Tom, "The Second Wave," in ed.,
Alan Light, *The Vibe History of Hip Hop*
(New York: Three Rivers Press, 1999).

Trasko, Mary, *Heavenly Soles: Extraordinary
Twentieth Century Shoes* (New York:
Abbeville Press, 1989).

Troy, Nancy J., *Couture Culture: A Study in
Modern Art and Fashion* (Cambridge,
MA: MIT Press, 2002).

Van Alphen, Ernst, "Strategies of Identification," in eds., Norman Bryson, Michael Ann Holly, and Keith Moxey, *Visual Culture: Images and Interpretations* (Hanover, NH, and London: Wesleyan University Press and University Press of New England, 1994).

Wilson, Elizabeth, *Adorned in Dreams: Fashion and Modernity* (New Brunswick, NJ: Rutgers University Press, 2003).

Winter, Irene, "Sex, Rhetoric and the Public Monument: the Alluring Body of Naram Sin of Agade," in ed., Natalie Boymel Kampen, *Sexuality in Ancient Art* (Cambridge, England: Cambridge University Press, 1996).

Wolf, Naomi, *The Beauty Myth: How Images of Beauty Are Used Against Women* (New York: HarperCollins, 2001).

Index

Nov 16/07

Pearson Education, Inc.

YOU SHOULD CAREFULLY READ THE TERMS AND CONDITIONS BEFORE USING THE CD-ROM PACKAGE. USING THIS CD-ROM PACKAGE INDICATES YOUR ACCEPTANCE OF THESE TERMS AND CONDITIONS.

Pearson Education, Inc. provides this program and licenses its use. You assume responsibility for the selection of the program to achieve your intended results, and for the installation, use, and results obtained from the program. This license extends only to use of the program in the United States or countries in which the program is marketed by authorized distributors.

LICENSE GRANT

You hereby accept a nonexclusive, nontransferable, permanent license to install and use the program ON A SINGLE COMPUTER at any given time. You may copy the program solely for backup or archival purposes in support of your use of the program on the single computer. You may not modify, translate, disassemble, decompile, or reverse engineer the program, in whole or in part.

TERM

The License is effective until terminated. Pearson Education, Inc. reserves the right to terminate this License automatically if any provision of the License is violated. You may terminate the License at any time. To terminate this License, you must return the program, including documentation, along with a written warranty stating that all copies in your possession have been returned or destroyed.

LIMITED WARRANTY

THE PROGRAM IS PROVIDED "AS IS" WITHOUT WARRANTY OF ANY KIND, EITHER EXPRESSED OR IMPLIED, INCLUDING, BUT NOT LIMITED TO, THE IMPLIED WARRANTIES OR MERCHANTABILITY AND FITNESS FOR A PARTICULAR PURPOSE. THE ENTIRE RISK AS TO THE QUALITY AND PERFORMANCE OF THE PROGRAM IS WITH YOU. SHOULD THE PROGRAM PROVE DEFECTIVE, YOU (AND NOT PRENTICE-HALL, INC. OR ANY AUTHORIZED DEALER) ASSUME THE ENTIRE COST OF ALL NECESSARY SERVICING, REPAIR, OR CORRECTION. NO ORAL OR WRITTEN INFORMATION OR ADVICE GIVEN BY PRENTICE-HALL, INC., ITS DEALERS, DISTRIBUTORS, OR AGENTS SHALL CREATE A WARRANTY OR INCREASE THE SCOPE OF THIS WARRANTY.

SOME STATES DO NOT ALLOW THE EXCLUSION OF IMPLIED WARRANTIES, SO THE ABOVE EXCLUSION MAY NOT APPLY TO YOU. THIS WARRANTY GIVES YOU SPECIFIC LEGAL RIGHTS AND YOU MAY ALSO HAVE OTHER LEGAL RIGHTS THAT VARY FROM STATE TO STATE.

Pearson Education, Inc. does not warrant that the functions contained in the program will meet your requirements or that the operation of the program will be uninterrupted or error-free.

However, Pearson Education, Inc. warrants the diskette(s) or CD-ROM(s) on which the program is furnished to be free from defects in material and workmanship under normal use for a period of ninety (90) days from the date of delivery to you as evidenced by a copy of your receipt.

The program should not be relied on as the sole basis to solve a problem whose incorrect solution could result in injury to person or property. If the program is employed in such a manner, it is at the user's own risk and Pearson Education, Inc. explicitly disclaims all liability for such misuse.

LIMITATION OF REMEDIES

Pearson Education, Inc.'s entire liability and your exclusive remedy shall be:

1. the replacement of any diskette(s) or CD-ROM(s) not meeting Pearson Education, Inc.'s "LIMITED WARRANTY" and that is returned to Pearson Education, or

2. if Pearson Education is unable to deliver a replacement diskette(s) or CD-ROM(s) that is free of defects in materials or workmanship, you may terminate this agreement by returning the program.

IN NO EVENT WILL PRENTICE-HALL, INC. BE LIABLE TO YOU FOR ANY DAMAGES, INCLUDING ANY LOST PROFITS, LOST SAVINGS, OR OTHER INCIDENTAL OR CONSEQUENTIAL DAMAGES ARISING OUT OF THE USE OR INABILITY TO USE SUCH PROGRAM EVEN IF PRENTICE-HALL, INC. OR AN AUTHORIZED DISTRIBUTOR HAS BEEN ADVISED OF THE POSSIBILITY OF SUCH DAMAGES, OR FOR ANY CLAIM BY ANY OTHER PARTY.

SOME STATES DO NOT ALLOW FOR THE LIMITATION OR EXCLUSION OF LIABILITY FOR INCIDENTAL OR CONSEQUENTIAL DAMAGES, SO THE ABOVE LIMITATION OR EXCLUSION MAY NOT APPLY TO YOU.

GENERAL

You may not sublicense, assign, or transfer the license of the program. Any attempt to sublicense, assign or transfer any of the rights, duties, or obligations hereunder is void.

This Agreement will be governed by the laws of the State of New York.

Should you have any questions concerning this Agreement, you may contact Pearson Education, Inc. by writing to:

Director of New Media
Higher Education Division
Pearson Education, Inc.
One Lake Street
Upper Saddle River, NJ 07458

Should you have any questions concerning technical support, you may contact:

Product Support Department: Monday–Friday 8:00 A.M. –8:00 P.M. and Sunday 5:00 P.M.-12:00 A.M. (All times listed are Eastern). 1-800-677-6337

You can also get support by filling out the web form located at http://247.prenhall.com

YOU ACKNOWLEDGE THAT YOU HAVE READ THIS AGREEMENT, UNDERSTAND IT, AND AGREE TO BE BOUND BY ITS TERMS AND CONDITIONS. YOU FURTHER AGREE THAT IT IS THE COMPLETE AND EXCLUSIVE STATEMENT OF THE AGREEMENT BETWEEN US THAT SUPERSEDES ANY PROPOSAL OR PRIOR AGREEMENT, ORAL OR WRITTEN, AND ANY OTHER COMMUNICATIONS BETWEEN US RELATING TO THE SUBJECT MATTER OF THIS AGREEMENT.